First published in the French language by Éditions du Seuil, Paris, under the title
Jaune: Histoire d'une Couleur by Michel Pastoureau
Copyright © 2019 Éditions du Seuil, Paris

Translated from the French by Jody Gladding

English translation copyright © 2019 by Princeton University Press

Requests for permission to reproduce material from this work
should be sent to permissions@press.princeton.edu
Published by Princeton University Press, 41 William Street, Princeton, New Jersey 08540
In the United Kingdom: Princeton University Press, 6 Oxford Street, Woodstock,
Oxfordshire OX20 1TR

press.princeton.edu

Jacket illustration: František Kupka (1871–1957), *The Yellow Scale*, c. 1907. Oil on canvas,
31 × 29 1/4 in. (78.7 × 74.3 cm). Museum purchase funded by Audrey Jones Beck. The Museum
of Fine Arts, Houston. © 2019 Artists Rights Society (ARS), New York / ADAGP, Paris

All Rights Reserved

ISBN 978-0-691-19825-5

British Library Cataloging-in-Publication Data is available

This book has been composed in Portrait Text and Neutraface

Printed on acid-free paper. ∞

Printed in Slovenia

1 3 5 7 9 10 8 6 4 2

YELLOW

MICHEL PASTOUREAU
TRANSLATED BY JODY GLADDING

THE
HISTORY
OF A
COLOR

PRINCETON UNIVERSITY PRESS
PRINCETON AND OXFORD

Yellow is a gay, soft, and joyous color,
but in poor light it quickly becomes unpleasant,
and the slightest mixing makes it
dirty, ugly, and uninteresting.

Goethe

Defining what constitutes color is not an easy exercise. To understand this, we only have to open a dictionary. It is always difficult for authors to offer a clear, pertinent, intelligible definition, within a reasonable number of lines. Often the text is long and involved, and still somehow incomplete. Sometimes it is inaccurate or fairly incomprehensible to most readers. With the word *color*, dictionaries rarely fulfill their function adequately, in French or any other European language, or any language on the planet, for that matter.

There are various reasons for these difficulties. Not only has the definition of color varied widely over the centuries according to periods and societies, but even just within the present age, color is not perceived the same way across the five continents. Every culture conceives of it and defines it according to its own environment, history, knowledge, and traditions. In this regard, Western thinking is by no means the final authority, much less the "truth," but only one kind of knowledge among many. Or not even one kind. Often I find myself participating in interdisciplinary conferences on color that bring together researchers with diverse backgrounds: sociologists, physicists, linguists, ethnologists, painters, chemists, historians, anthropologists, musicians. We are all very happy to meet with one another to discuss a subject that is dear to us, but after a few minutes we come to understand that we are not discussing the same thing. Each specialty has its own definitions for color, its own classifications, certainties, and sensibilities. Sharing them with others is not easy, even impossible sometimes.

Over the course of centuries, color was first defined as matter, then as light, and later as a sensation: that of light falling on an object, received by the eye, and transmitted to the brain. In many languages, the etymology of the word designating color emphasizes the first of these definitions. Originally, color was conceived (and perceived) as a material, a thin film covering beings and things. That is especially the case in Indo-European languages. The Latin word *color*, for example, from which derive the Italian, French, Spanish, Portuguese, and English terms, among others, is part of the large family of the verb *celare*, which means "to hide," "to envelop," "to conceal." Thus color is that which hides, covers, clothes. It is a material reality, a second skin or surface that envelops the body. The same idea is already present in Greek: the word *khrōma* (color) derives from the word *khrōs*, which designates the skin or any bodily surface. The same is true in German and most Germanic languages. To consider just one example, the term *Farbe* comes from the Germanic **farwa*, which means skin, film, envelope. Other languages, whether Indo-European or not, express similar ideas. Color is a material, a surface covering another surface.

The lexicon is one thing, however, and scholarly theories are something else. Early on, color stopped being considered simply matter, becoming also and especially light, or rather, a part of light. Aristotle, one of the first theorists, viewed color as a weakening of the light from the sun coming into contact with objects, and he proposed the oldest chromatic scale known, ranging from light to dark: white,

yellow, red, green, purple, black. In the West this arrangement of colors remained the basic scientific order until the late seventeenth century. Or more precisely, until 1666, the year that Isaac Newton carried out his famous experiments on the prism and succeeded in dispersing the white light of the sun into variously colored rays. Having done so, he proposed a new color order to the scholarly world: the spectrum, an order within which there was no longer a place for either black or white, and where colors formed a sequence unrelated to the Aristotelian classification in use until then. In the eighteenth century, this new Newtonian order—violet, indigo, blue, green, yellow, orange, red—gradually emerged as the standard reference in most of the sciences, first among them physics, followed by chemistry.[1] That is still the case today.

Defining colors as light and no longer simply as matter constituted a major turning point in the world of science and technology. Scientists gradually learned to master and measure colors, to produce and reproduce them as they pleased. Artisans learned to break them down into multiple shades. Henceforth controllable, verifiable, and reproducible, color gradually lost some of its mystery, especially since artists themselves, as early as the eighteenth century, submitted to the laws of physics and optics, articulating their palette around the spectrum and distinguishing primary, complementary, and even tertiary colors.

More recently, the neurosciences have taken an interest in colors and have stressed the importance of visual and perceptual phenomena; color is not simply a material coating or a set of subtle variations of light, it is also and especially a phenomenon of perception. It emerges from the conjunction of three elements: a source of light, an object upon which that light falls, and a receptor organ, that is, the human being equipped with complex apparatus—simultaneously anatomical, physiological, and cultural—formed by the eye-brain pair. Opinions begin to diverge when the human being as receptor is replaced experimentally by a simple recording device. For the hard sciences, what is

recorded is still color, measured in wavelengths. For the human sciences, what is recorded is not color but simply light; color does not exist if it is not perceived; that is, not only is it seen with eyes but it is also decoded with memory, knowledge, and imagination. "A color that is not seen is a color that does not exist," declared Goethe already in 1810, in the third part of his famous *Farbenlehre*. Today, however, various tests and experiments show that a person blind from birth who reaches adulthood possesses almost the same chromatic culture as a sighted person, thus contradicting Goethe as well as Newton.

The colors of the physicist or chemist are not those of the neurologist or biologist. But neither are the colors of the neurologist or biologist—at least not entirely—those of the historian, sociologist, anthropologist, or linguist. For these disciplines—and more generally for all the human sciences—color is defined and studied first as a social phenomenon. More than nature, pigment, light, eye, or brain, it is society that "makes" color, that gives it its definitions and meanings, that organizes its fields and modes of operation, that articulates it into multiple codes and value systems. Without society, without culture, there are no neatly outlined, named, categorized colors; there are only infinite colorations forming an improbable continuum.

*

If defining color is not an easy task, defining yellow is even harder. To say that it is the color of a lemon, saffron, gold, or ripe wheat—as one generally reads in dictionaries—is not false but does not really constitute a definition. As for asserting that yellow is the color located in the spectrum between this or that wavelength, such a proposition would only satisfy a physicist. What can the human sciences do with a definition like that? Nothing, absolutely nothing.

The case of yellow is by no means unique. The same comments could be made regarding any color whatsoever. The Austrian philosopher Ludwig Wittgenstein reminds us of

8

this in a quote that remains justly famous and that I like to cite in most of my books because it seems to me among the most important ever written with regard to colors:

If we are asked what the words *red, yellow, blue,* and *green* mean, we can of course immediately point to things that are those colors. But our capacity to explain the meaning of those words goes no further. (*Bemerkungen über die Farben*, I, 68)

Despite this limitation, in the chapters that follow I have attempted to relate the long, slow history of yellow in European societies, from the Paleolithic period to the present. That has not been an easy task because it is a turbulent history, and the documents for studying it are less expansive than for other colors. In any given period, yellow is less conspicuous than red, black, blue, or even green. There are various reasons for that but one overrides the others: gold very often occupies a large part of the place reserved for the color yellow. Writing the history of yellow in the West thus also means writing in part the history of gold, an abundant and difficult history since there are so many areas gold enters into and so many issues that its study raises. The historian often has more to say on gold than on yellow. Gold presents us with a host of questions because it is not only a color, it is also light and matter and is well documented in every period (at least beginning with the third millennium BCE). As for yellow, it seems to play hide-and-seek with the researcher. Sometimes it is very present in the documentation, sometimes it remains inconspicuous, even hidden (as in the early Middle Ages). Then it becomes necessary to substitute gold, which in and of itself constitutes a vast problematic and chromatic ocean.

In order not to drown in that ocean, in order for this work to retain reasonable dimensions, for it to remain truly a history of yellow and not a history of gold, I have tried my best to keep gold at a distance, to call on it only for the periods and cases in which it was indispensable: ancient mythologies, the origin of coins, medieval heraldry,

alchemy, baroque art, and a few others. Despite the documentary silences I sometimes encountered, this book is very much a history of yellow, constructed around a few solid axes allowing us to find our way in a shifting and multiple chromatic labyrinth.

★

The present book is the fifth in a series undertaken twenty years ago. Four works have preceded it: *Blue: The History of a Color* (2001); *Black: The History of a Color* (2009); *Green: The History of a Color* (2013); *Red: The History of a Color* (2017), all published by Seuil and Princeton University Press. As with the preceding books, the plan for this one is chronological; it is very much a history of the color yellow, not an encyclopedia of yellow, and even less a study of yellow in the contemporary world alone. I have tried to study this color over the long term and in all its aspects, from lexicon to symbols, and by way of everyday life, social practices, scientific knowledge, technical applications, religious values, and artistic creations. Too often histories of color—what few exist—are limited to the most recent periods or to pictorial matters alone, which is very reductive. The history of painting is one thing, the history of colors is another, and much more vast.

That said, as with the four preceding works, this one only appears to be a monograph. A color never occurs alone; it only derives its meaning, it only fully "functions" from the social, lexical, artistic, or symbolic perspective insofar as it is combined or contrasted with one or many other colors. Hence, it is impossible to consider it in isolation. To speak of yellow is necessarily to speak of red, green, blue, and even white and black.

These five works form an edifice I have been working to build for almost half a century: the history of colors in European societies, from Roman antiquity to the eighteenth century. Although, as readers will find in the pages that follow, I range considerably beyond and before those

periods, it is within that—already quite ample—slice of time that the essence of my research lies. Similarly, I limit my research to European societies because for me the issues of color are first of all social issues. As a historian, I am not competent to speak about the whole planet and not interested in compiling, second- or third-hand, works by other researchers on non-European cultures. In order to avoid making foolish claims, plagiarizing, or recopying the books of others, I have limited myself to what I know and what was the subject of my seminars at the École Pratique des Hautes Études and the École des Hautes Études en Sciences Sociales for almost forty years. A warm thanks to all my students and doctoral students, as well as my auditors, for the fruitful exchanges we had then, and which I hope will continue.

10

Scales of Yellow, Gray, Green, Pink

Colors and music are closely related and share a common vocabulary: tone, shade, scale, harmony, value, not to mention the adjective "chromatic." Aristotle already emphasized this kinship between sounds and colors, but it was only in the eighteenth century, after Newton's discovery of the spectrum, that notes and colors began to appear in single diagrams. Yellow found its place between *fa* and *sol*. Paul Klee, *Monument im Fruchtland*, 1929. Bern, Zentrum Paul Klee.

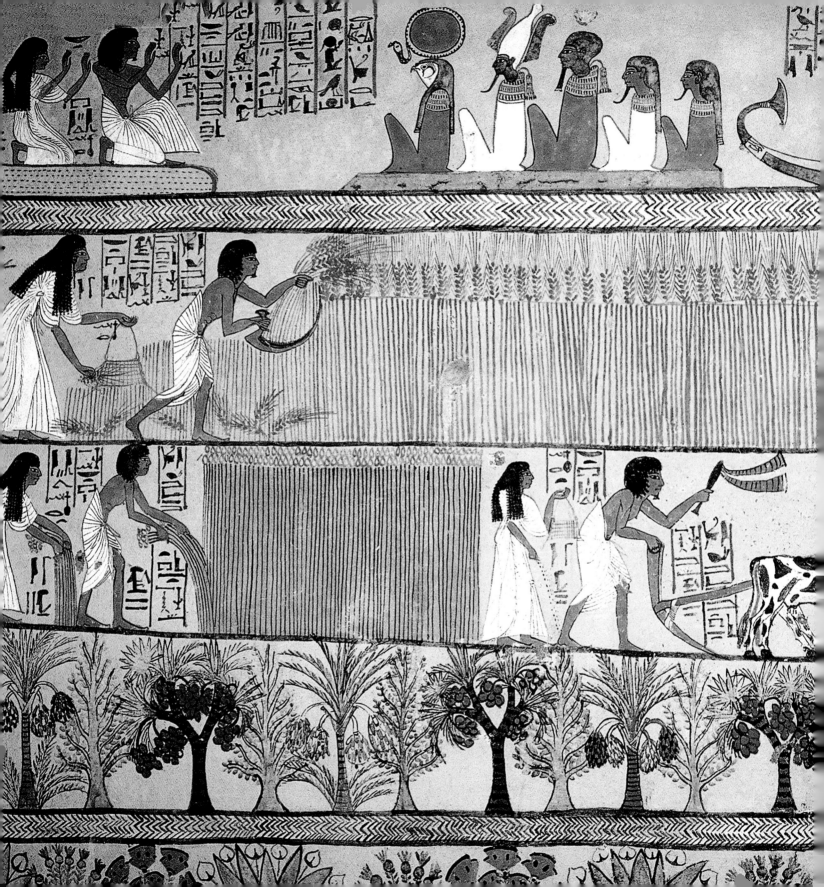

A
BENEFICIAL
COLOR

(FROM EARLIEST TIMES TO THE FIFTH CENTURY)

Defining yellow, as we have seen, is a difficult task, but identifying the period in which human beings began to make it into a specific chromatic category is perhaps even more difficult. And it happens that the two questions are linked. In truth, color is not a fact of nature but a cultural construction; it is society, not nature, that "makes" color. Of course plants, minerals, and many other natural elements present multiple colorations that human beings—like other animals, but much later—gradually learned to observe, recognize, and distinguish for utilitarian ends (to spot ripe fruit, dangerous creatures, favorable soils, beneficial waters, and so on). But those colorations were not yet colors strictly speaking, at least not for the historian. For the historian, as for the anthropologist, ethnologist, and linguist, colors only truly appear when societies begin to group those colorations observable in nature into several large sets, limited in number but coherent, and when they gradually isolate some from others, to which they eventually give names. In this way, the origin of colors really does appear to be a cultural construction and not a natural phenomenon, whether physical or physiological. That construction took place at different times and following different rhythms according to society, latitude, climate, utilitarian needs, symbolic goals, and aesthetic concerns. And according to each color as well; they did not all emerge at the same time, at least not in the West.

In this slow, complex process, three large sets seem to have been developed before all others: red, white, and black. That does not mean, of course, that other colorations like yellows, greens, blues, browns, and purples did not exist; they were found abundantly in nature. But these colorations did not become "colors"—that is, categories established by society and conceived in an almost abstract way—until later, sometimes very much later (blue, for example). Moreover, that is why the red-white-black triad long retained superior lexical and symbolic power in many areas.[1] And that is perhaps more true for red than for white or black. Indeed red was the first color to be made and then mastered in Europe, first in painting, as early as the Paleolithic period, later in dyeing, in the Neolithic period. It was also the first color to be linked to stable, recurrent ideas that played an essential role in social life: strength, power, violence, love, beauty. Red's preeminence also explains why the same word signifies "red" and "color" in some languages, "red" and "beautiful" in

PREVIOUS SPREAD

The Riches of Agriculture

Agriculture constituted the principal resource of the Mediterranean Basin and occupied the majority of the population, as much in Egypt as in ancient Greece and Rome. Recalling the color of gold, the golden yellow of ripe wheat and grains, fruit and honey, and even the coats of certain sheep and cattle, enjoyed very positive symbolism: light, warmth, happiness, fertility, prosperity. The Latin lexicon reflects this link between the fruits of agricultural labor and the color yellow: *croceus* designates saffron yellow, which tends toward orange; *luteus*, a dull yellow from weld and broom; *helvus* and *melleus*, yellows the color of honey; *vitellus*, the yellow yolk of an egg; and *flavus*, the golden yellow of all that ripens in the sun. Mural painting representing the labors of the field. Deir el-Medina, Egypt, tomb of the artisan Sennedjem, c. 1280–1270 BCE.

14

Ancient Gold Coin

Gold stater of Philip II of Macedon, head of Apollo with laurel wreath, c. 320 BCE. Paris, Bibliothèque nationale de France, Cabinet des médailles.

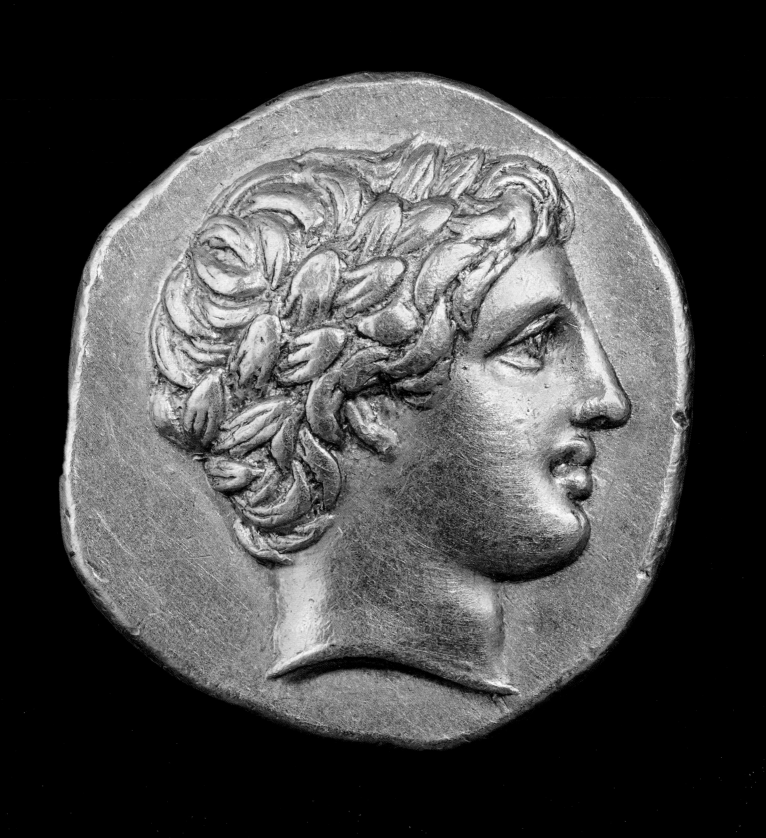

others.[2] Gradually, white and black were added to red to form an initial triad around which the oldest color systems were constructed. Ancient mythologies, the Bible, tales and legends, toponymy, anthroponomy, and especially the lexicon provide a wide range of evidence for this.[3] Green and yellow only joined this original triad later, the dates varying according to the culture, but rarely before the Greco-Roman period. As for blue, it does not seem to have become a color entirely its own, definitively ranked with the other five, until well into the Christian Middle Ages.[4] That does not mean it did not exist before then, obviously, but its various colorations had not yet been grouped into a single coherent set, abstracted from their physical occurrences.

Pompeiian Yellow

In Pompeii, most of the yellow tones found on walls are ocher based (limonite, geothite), sometimes with carbonate of lime added. Various receptacles discovered in many villas teach us that once heated, these yellow ochers were transformed into red and even brown pigments. Centaur and maenad. Mural painting in the "Villa of Cicero" in Pompeii, c. 40–60 CE. Naples, Museo Archeologico Nazionale.

16

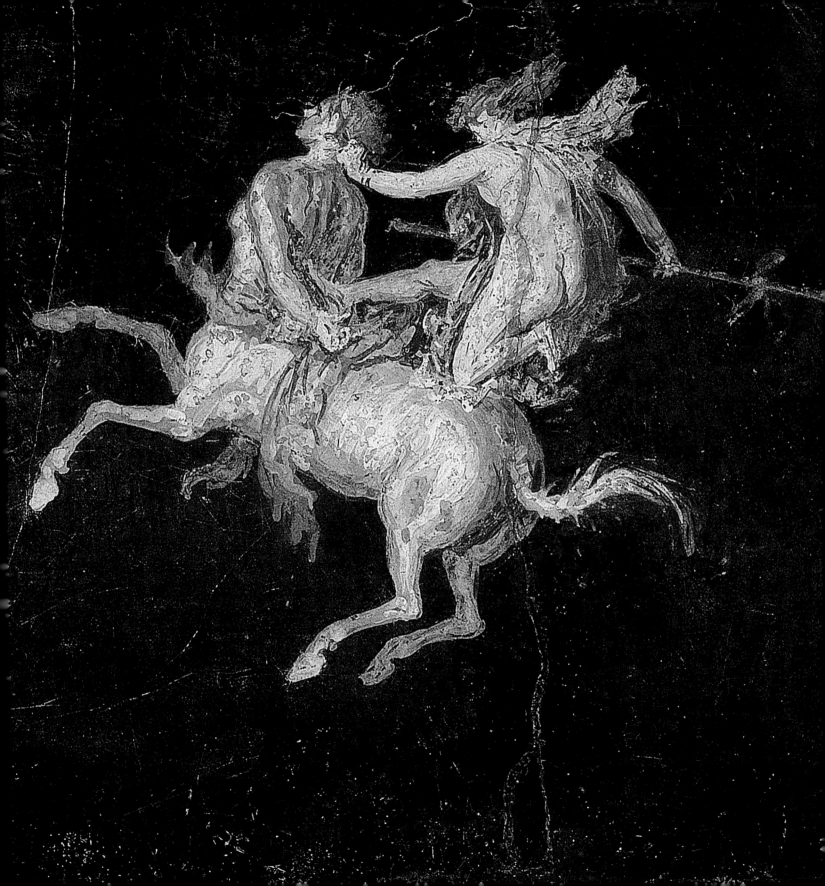

THE OCHERS OF THE PALEOLITHIC PERIOD

It is impossible to know what kind of relationships prehistoric men and women maintained with the color yellow. At best one can imagine that yellow tones were abundant in their natural environment, much more abundant than reds or blues: plants and minerals of all sorts, of course, but also the fur and plumage of certain creatures, sun and stars in the sky, lightning and meteorological phenomena, flames of forest fires, mud and water in rivers, and so on. However, we are the ones who include all these yellowish tones in a single chromatic category that we call "yellow." Did humans do that as early as the Paleolithic period? Nothing could be less certain. And if it is likely that they associated the sun early on with notions of heat and light, there is no proof that they extended those notions to plant or mineral elements with similar coloration.

Nevertheless, yellow was among the first colors that humans produced for painting, first on their own bodies; then on stones, rocks, and various personal objects; and finally on the walls of caves. We know nothing about the first body paints. At most we can venture the hypothesis that they had a clay soil base and that they served as protection against the sun, diseases, insects, and even forces of evil. But no doubt they also had a taxonomic function: to distinguish groups or clans, establish hierarchies, mark points in time or rituals, and differentiate gender (red ocher for men, yellow ocher for women?) and age groups. This is all conjecture nonetheless.

Studying the traces of ocher present on objects that served as tools or receptacles is less theoretical. Much material evidence has been preserved for us: stone pestles for reducing ocher to powder; seashells for collecting and transporting the material thus obtained; bird-bone tubes for projecting it onto a wall; flat stones used as palettes; sticks of hardened ocher for drawing. In addition to these more or less "ochered" tools found in caves, there is the ocher in tombs that was used to cover, embellish, and protect the dead. Red ocher is dominant throughout and

Pigments of the Upper Paleolithic

Paleolithic paintings do not present a very extensive palette: reds, blacks, browns, a few yellows, all in a variety of shades; sometimes a bit of white, never blue or green. The blacks have a plant carbon or manganese oxide base; the yellows come from clay soils rich in ocher; the reds come either directly from blocks of hematite, one of the most widespread iron ores in Europe, or from yellow ocher that was heated. Usually, ocher deposits, so useful to painters, were found near caves, or even, as in the case of the Chauvet cave, inside them.

Woolly rhinoceros, c. 32,000–30,000 BCE. Vallon-Pont-d'Arc, Ardèche, France, Chauvet cave, back hall.

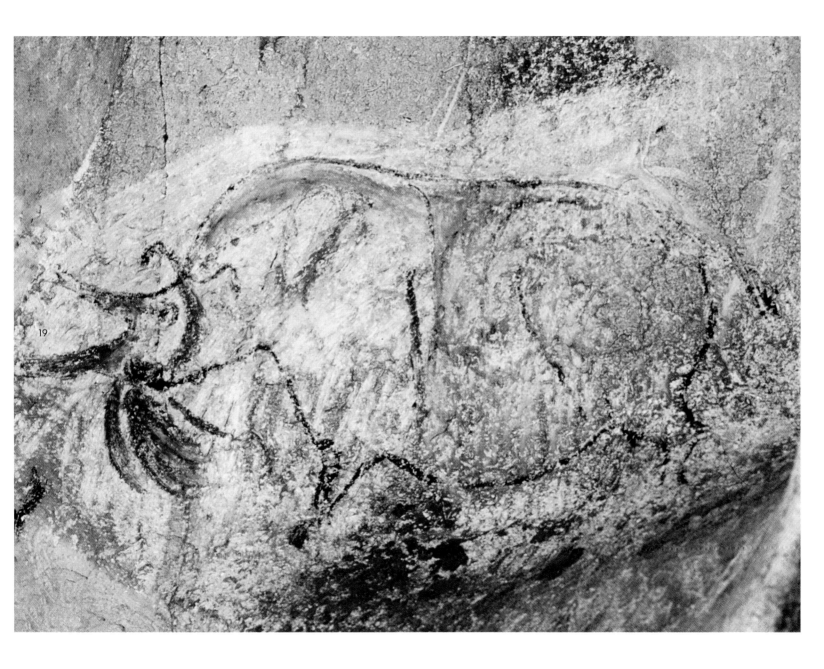

19

Painted Pebbles from Mas-d'Azil

The decorated cave of Mas-d'Azil, located in what is now Ariège, at the foot of the Pyrenees, has revealed many mammoth, bear, and rhinoceros bones as well as abundant movable objects dating from 17,000 to 10,000 BCE.

Among these objects are many stones painted with ocher in yellows, reds, and browns. Today they are found in various museums in France and Europe. Saint-Germain-en-Laye, France, Musée d'Archéologie Nationale.

seems already to fulfill prophylactic, deictic, and aesthetic functions. Yellow ocher is not absent but it is less common and less old (about 45,000 or 40,000 BCE for the earliest traces). Attempting to know what it represents returns us to conjecture.

The best place to study the prehistoric painters' palette is on cave walls where it is most complete, rather than in tombs or on objects. That palette is, in truth, limited, even in great works like those found in the most famous caves: Chauvet, Cosquer, Lascaux, Pech-Merle, Altamira, and a few others, dating from 33,000 to 13,000 BCE. The number of shades present there is minimal, at least in relation

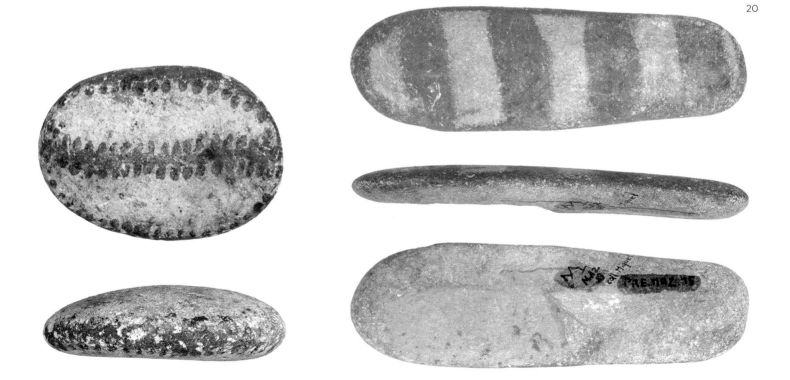

to later practices, whether Egyptian, Phoenician, Greek, or Roman. There one finds primarily reds and blacks, sometimes yellows and browns, more rarely whites (undoubtedly more recent), and never greens or blues. The black pigments have a plant carbon or manganese oxide base; the yellows come from clay soils rich in ocher; the reds have a hematite base, one of the most widespread iron ores in Europe, but they also quite frequently come from yellow ocher that was heated. Thus the questions are not so much those of sources, relatively easy to identify, as those of production. How did the painters of the Paleolithic period learn to transform a natural earth element—an ore—into a product that could be used for painting—a pigment? Similarly, where did they get the idea of heating yellow ocher to obtain red ocher, or even brown ocher? Can we already speak of a chemistry for colorants? In fact, various finds have proven that certain yellow ochers were heated in stone crucibles to rid them of water and change their color; some of those crucibles survive today and still show traces of color: yellow, red, and brown.[5]

Thanks to laboratory analyses, we also know that some yellow and red pigments were enriched with products now considered to be charges, meant to alter their covering power and their relationship to light, or even to facilitate their application on walls: talc, feldspar, mica, quartz, various fats. Surely, chemistry is very much present here. Burning wood to make charcoal to use for drawing is a relatively simple technique. But extracting blocks of clay from the earth, washing, diluting, filtering, and drying them, then crushing the collected lumps of ocher with a pestle to obtain a fine yellow powder, and finally mixing this powder with chalk, vegetable oils, or animals fats to give it different shades or make it adhere better to a rock surface is another, much more complex process. And it was already known and practiced by cave painters some fifteen, twenty, even thirty thousand years before our era.

Yellow ocher is a natural clay soil, very fine and colored by iron hydroxide. It is generally found in sandy strata composed of up to 80 percent quartz. After it is extracted, it must be separated from this sand (always in greatest quantity) and rid of its impurities. To do this, the clay must be more or less finely ground, then dispersed in water; sand and impurities settle to the bottom while the lighter particles of ocher remain in suspension. After filtering, evaporating, and drying processes, these ocher particles are collected and combined to form a sort of dense, fine-grained paste, soluble in water. Diluted and mixed with various fats and charges, this paste can be used as a pigment with often very intense coloring power. For the painters of the Paleolithic period, it was thus a relatively easy material to find and to use, neither toxic nor precious, light resistant, and able to take on many different shades of yellow.

With regard to actual pictorial techniques themselves, perhaps it is too early to speak of true "formulas," but we can sometimes observe a great variety of shades of the same color on a single wall. That is frequently the case with reds but can also be observed with yellows. No tones fall within the range of yellows tending toward green or those we now call "lemon yellow." They are all closer to orange, beige, or brown, presenting hues that could be described, from lightest to darkest, as straw, chamois, apricot, honey, russet, tawny, bister, bronze. Is this diversity on the same wall and for works dating from the same time deliberate, determined in advance, and implemented using learned procedures (mixing, diluting, adding charges, choosing specific binders)? Or is it the result of the work of time? It is difficult to know because we are not seeing the shades produced by those pigments in their original state but as time has transformed them. In any case, even in caves that remained sealed until the twentieth century, the gap between the original state and the present state is always a significant one. Moreover, we are looking at these paintings in light conditions that bear no relationship to those experienced by the prehistoric painters. On a computer screen or in a photographic print, all colors are misrepresented. And on site, electric lighting does not produce light similar to that

21

of torches, obviously. But how many specialists remember that when they study the cave paintings? And, simply among visitors, who is truly aware that between these paintings and the present, millions—billions?—of color images from all eras have intervened, images that neither our gaze nor our memory has been spared? These images are distorting filters; we have consumed, "digested," and recorded them in a kind of collective unconscious. Time has done its work, millennia have passed, the art has continually been transformed. That is why we do not see and will never see the cave paintings as our distant prehistoric ancestors did. That is true of the forms; it is even more true of the colors—and perhaps even more true for the yellows than for the reds and blacks.

Thus the earliest evidence of yellows produced by humans are these ocher-based pigments; for a long time they were the only evidence. The first traces of dyeing did not appear until much more recently, as late as 3000 or 4000 BCE. But even if no earlier fragments of dyed cloth survive, the appearance of dyeing must date back further, following soon after weaving, during a period when human beings were already sedentary, practicing agriculture, and living in well-organized societies.[6] Clothing increasingly fulfilled functions that were not only utilitarian but also symbolic and taxonomic, similar to those of earlier body painting: classifying individuals within groups and those groups within the whole of society. To these ends, color already played an essential role.

The oldest surviving traces of dye come from the Indus valley; they appear on cotton and fall within the range of reds. But it is possible that humans were dyeing in yellow before dyeing in red since there are a greater number of wild plants with tinctorial properties for this color than there are plants used to obtain red. Actually, most plants contain color constituents capable of dyeing any textile fiber yellow: "it almost seems that any cloth boiled with a few handfuls of leaves, bark, grass, or flowers will come out yellow."[7] Recent discoveries seem to confirm this long history

of dyeing in yellow: weld seeds found during excavations of lakeside settlements located on the shores of many Swiss lakes (Pfäffikon, Zurich, Neuchâtel). The oldest of these lakeside settlements date back to 3000 or 4000 BCE.[8] Of course we cannot confirm that those seeds were harvested to use for dyeing, but we must note that weld, a tall herbaceous plant that grows in many kinds of soil, was the main plant used for dyeing in yellow from antiquity until the nineteenth century in Europe. And was it already being used in the Neolithic period? Probably so.

THE YELLOW METAL

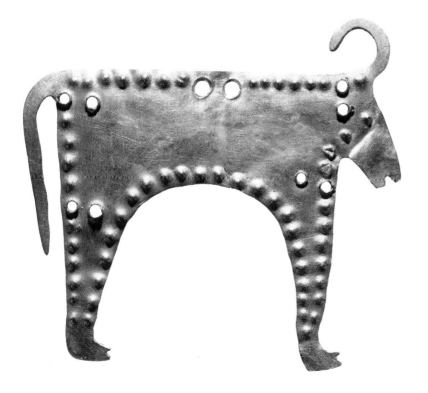

Let us linger briefly at the end of that period prior to the appearance of writing when many societies were no longer nomadic and humans were already producers, farmers, builders, artists, artisans, and finally dyers. Color was already fully part of their daily lives, and yellow undoubtedly occupied an important place there. It was present in the minerals, plants, and animals that surrounded them, as well as on a great number of objects they used (made of stone, bone, clay, wood, hide, and wicker), not to mention fabrics and clothing henceforth dyed. It was also in the products they collected from their own agricultural activities. Beginning with grain, oil, honey, wax—all products for which yellow remains the symbolic color even today. In many languages, their names were used to construct part of the repertoire of adjectives designating that color.

In fact it was in the late Neolithic period and in the age of metals that the first lexical references to yellow are established in the West. The sun was no longer alone in that role, as demonstrated by various enduring expressions that appeared very early: "yellow as honey," "yellow as wax," "yellow as ripe wheat," "yellow as blond hair," "yellow as bile." The lemon, which is familiar to us as a referent, is not part of this list because it only arrived in Europe eons later. But gold finds a place there early on and gradually surpasses the sun as the principal referent for yellow.

The Varna Necropolis

Discovered in 1972, the vast necropolis in Varna (Bulgaria), with nearly three hundred tombs, revealed the most ancient gold objects ever found in Europe: jewelry, scepters, weapons, tools, belt buckles, plates bearing the images of animals. They can be dated to between 4600 and 4200 BCE and attest to the presence of various cults (solar, agrarian, funerary) on the shores of the Black Sea. Solid gold plate in the shape of a bull, c. 4600–4200 BCE. Sofia, Bulgaria, Natsionalen Istoritcheski Muzej.

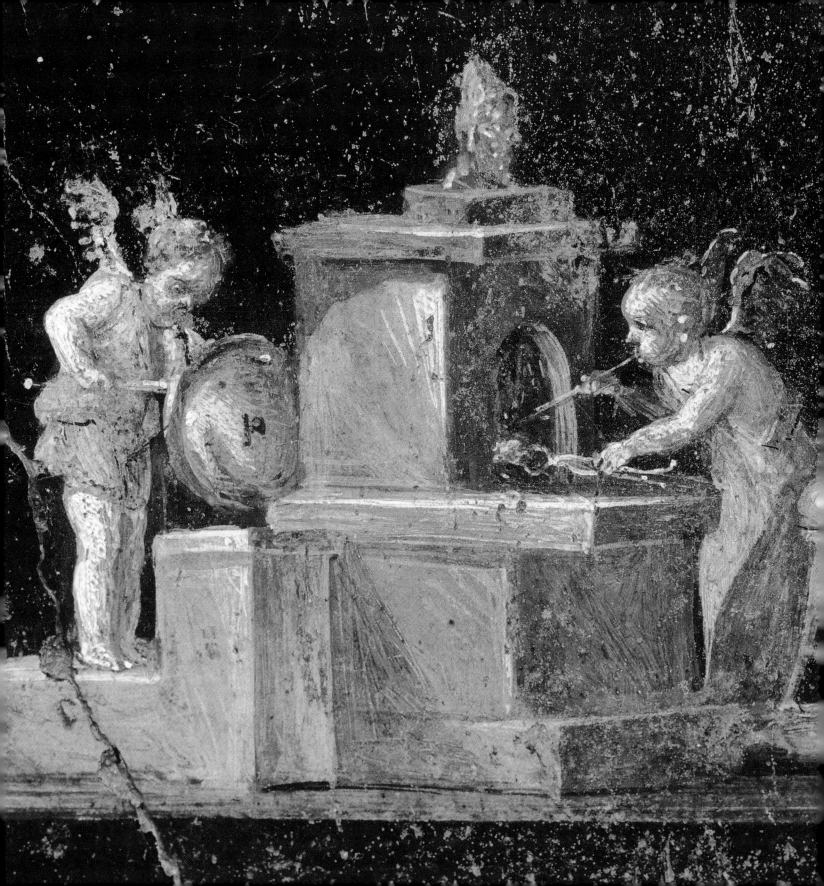

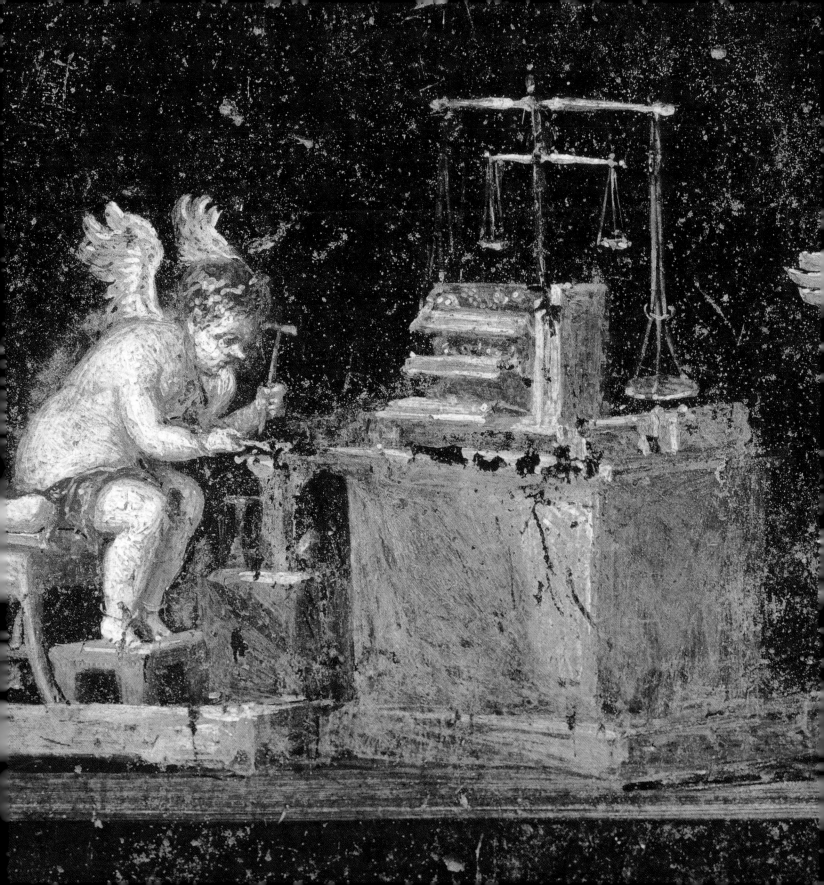

Gold and Silver Work in Rome

In Rome, goldsmiths and silversmiths formed a powerful and respected (but also closely supervised) guild. For the patricians and nouveaux riches they made silver dishware and gold jewelry, as can be seen in this allegorical painting found in one of the most beautiful houses in Pompeii; among the various occupations performed by these winged cupids, goldsmithing holds a central place. First century CE. Pompeii, House of the Vettii, fresco in the large triclinium.

Previously, prehistoric men and women seem not to have been interested in gold, which is absent from tombs and votive sites. But in the late Neolithic period and Chalcolithic period (the bronze age), that was no longer the case; not only is gold increasingly present in sepulchres, but it also begins to be offered to the gods and then to be hoarded.

From then on, the history of the precious metal and that of the color yellow tended to merge and have never parted ways. To the point that, from the seventeenth century to the present, most dictionaries begin their definitions of the adjective *yellow* thus: "that which is the color of gold. . . ." Moreover, this is not new; two thousand years ago, the Latin adjective *aureus* was already making the link between the color and the metal, sometimes meaning "gilded" or "in gold," and sometimes meaning "yellow," a bright, saturated yellow. And as a noun, this same word meant a gold coin of much value, worth twenty-five silver denarii or one hundred sesterces.

In its native state, gold is most often a beautiful vivid yellow, dense and luminous. It is sometimes found alone, sometimes mixed with soil, sand, or gravel, but never as a composite with other metals (except silver). In rivers, it is present as small particles (flakes), elsewhere as smaller or larger masses, free of gangue and easy to extract (nuggets).

What makes it so precious, of course, is its rarity, but also its stable nature, unalterable in air and water, as well as its exceptional malleability. Modern experiments have shown that a grain of gold (fifty-three milligrams) can be drawn out into a strand two hundred meters long and flattened into a sheet that could cover a surface of 360 square meters. Moreover, its singular strength allows a strand of gold three millimeters in diameter to support a weight of 250 kilos without breaking.

Ancient societies did not have all these figures, but they knew that gold was easy to extract, transport, and work, and that unlike most other metals, it could be hammered cold. They also and especially knew that it was rare, splendid, sparkling, and that it attracted the eye and elicited desire. Beginning in the third millennium BCE, they increasingly distinguished it from other metals—something they had hardly done previously—and made it a sign of prestige and power by transforming it into elements of finery, jewelry, weapons, and precious tableware. That is why gold objects became more and more numerous in tombs over the course of time, first for chiefs, kings, and princes, later for high-ranking women. Gold objects were also left in sanctuaries as offerings to the gods, who themselves were sometimes represented in the form of solid gold statues—something never done for humans. Early on as well, the precious metal was hoarded in various forms—rings, necklaces, balls, pearls, strands, plates, strips, chains, ingots—before serving as an instrument of exchange, concurrently with silver objects and other products (grain, livestock, fabric, and clothing). Metal coins, on the other hand, invented by the Greeks of Asia Minor, only appeared much later, in the seventh century CE. The first coins were sometimes gold but more frequently electrum (an alloy of gold and silver).[9]

Because gold is soft, to transform it into precious objects and then into coins, it had to be alloyed in variable proportions to other metals (silver, copper). This was the origin of gold metallurgy and technology that gradually transformed the artisan specializing in this material into a true

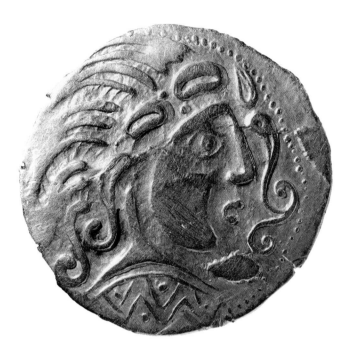

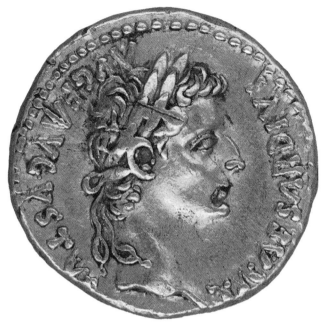

artist.[10] Never again would the goldsmith be confused with the bronzesmith, much less with the blacksmith. This specialized work with gold seems to have begun very early, much earlier than was long believed. The oldest gold objects discovered to date were in a vast necropolis near Varna (Bulgaria) among significant funerary materials: rings, necklaces, bracelets, plates, objects in the form of animals, and others resembling penis sheaths. Recent analyses have dated some of these objects to between 4600 and 4200 BCE.[11] Perhaps this is the birthplace of the European goldsmith trade, on the shores of the Black Sea, or more widely in the lower Danube valley and the Balkans?

Did gold's prestige contribute early on to the enhanced value of the color yellow? In classical antiquity that is certainly the case. Earlier than that, it is difficult to say. But there are places where gold and yellow can be linked, as in Egypt, in the tombs of a few pharaohs where royal finery and votive objects in gold abound and where the walls of the sarcophagus room are painted yellow, perhaps to signify immortality or, more simply, to represent papyrus. Sometimes the sarcophagus itself is solid gold, as is the case

Ancient Gold Coins

Precisely identifying the distant origins of currency is a difficult exercise, so long and varied is the list of materials used as means of exchange before metal coins. Metal coins first appeared in Lydia (Asia Minor), then around the Aegean Sea in the seventh century BCE. Their use expanded rapidly throughout the Greek world. The earliest coins were first electrum (alloy of gold and silver), then gold, and then silver, with bronze only appearing later. *Left*: Gold stater of the Parissi, 1st century BCE. *Right*: Aureus of Tiberius struck in Lyon, 34 CE. Padua, Musei Civici agli Eremitani.

with Tutankhamen. Moreover, brilliant and incorruptible gold, extracted abundantly from mines in Nubia and the great eastern desert (between the Nile and the Red Sea) was considered to be the flesh of the sun and divinities issuing from it. That is undoubtedly the reason why in funerary paintings—clean and brilliant, to the point that they sometimes seem almost new—the bodies of gods and goddesses are often painted in vivid yellow, by means of orpiment (a natural arsenic sulfide), while those of humans present red or reddish-brown flesh for men and yellow or yellow-beige flesh for women.[12]

Although it is impossible to speak of the symbolism of color—it is too early—we are not prevented from assuming a link between gold and yellow or thinking that the prestige of the first reflects onto the second. Among the Egyptians and in much of the ancient Near and Middle East, gold, the divine metal that maintained close relations with the sun and was sometimes even considered to be the sun buried in the earth, was associated with ideas of light, heat, power, wealth, beauty, perfection, and immortality.[13] Is the same true for the color yellow? Perhaps, at least for the warm, vibrant, brilliant shades of the color. But it is impossible to prove this, especially since gold is not always looked upon favorably. It has its bad aspects as well, prompting covetousness, greed, theft, violence, war, injustice, and betrayal—all vices and crimes for which the Bible and mythologies provide much evidence.

Gold in Ancient Egyptian Tombs

There was an overabundance of gold in the tombs of the pharaohs: jewelry, necklaces, bracelets, pendants, pectorals, gold coins, vases, mirrors, sarcophagi, funeral masks, and furniture plated with gold, like this cedar cabinet entirely covered with gold, found in Tutankhamen's tomb.

A few mines were worked in the mountains located east of Luxor, but most Egyptian gold came from Nubia, Ethiopia, and southern Arabia. Gold-plated cabinet from Tutankhamen's funeral chamber, c. 1330–1320 BCE. Cairo, Egyptian Museum.

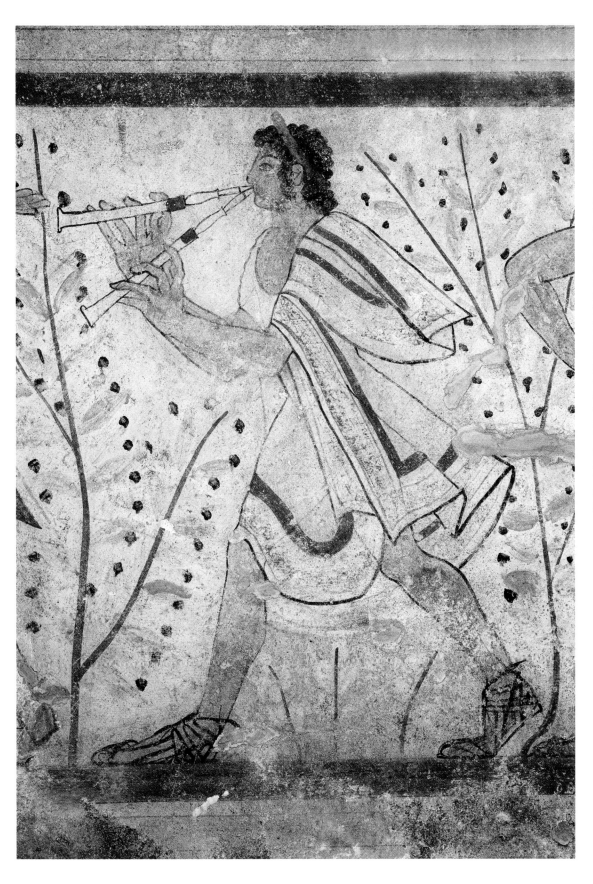

Etruscan Mural Painting

The Monterozzi necropolis, located near Tarquinia in central Italy, shelters many thousands of tombs dug into the rock. About two hundred of them were decorated with mural paintings that constitute the most important evidence on Etruscan painting, which was strongly influenced by Greek painting. The yellow pigments were essentially ocher based. A few traces of orpiment and massicot (lead oxide) can also be found.

Tibia player, detail from a mural painting in the tomb of the Leopards, Tarquinia, Monterozzi necropolis, first half of the 5th century BCE.

MYTHOLOGIES OF GOLD

Golden Apples from the Garden of the Hesperides

The Hesperides were the nymphs of the Sunset, daughters of the giant Atlas. They lived in a marvelous garden, located in the far west of the known world, and their apple trees produced golden fruit belonging to the goddess Hera and guarded by a dragon with a hundred heads, believed to be invincible. The eleventh labor required of Heracles by Eurystheus, king of Argos, consisted of seizing those apples and delivering them to him. After many attempts, the hero succeeded in doing so, but when he presented the apples to Eurystheus, the king refused them. Heracles then offered them to the goddess Athena who had protected him in his quest. Athena wisely had the golden apples returned to the garden of the Hesperides. Hydria with red figures (*detail*), c. 420–400 BCE. London, The British Museum.

Leaving aside the Bible for a moment, let us see what ancient mythologies can teach us about gold, its various meanings, and its possible ties to the color yellow. Let us begin with Greek and Roman mythology, the richest in material, so abundant are the stories and legends that feature this precious metal.

The first thing we learn from them is that a hierarchy exists within the world of metals and that gold ranks highest: it is a perfect metal, impervious to time; it is the sign of power, wisdom, happiness, and prosperity. The best illustration of this is the myth of the golden age that distinguishes four periods in the history of the world: the golden age, the silver age, the bronze age, the iron age. This symbolic classification obviously bears no relationship to our modern technical system for naming the various phases of prehistory: the copper age, bronze age, iron age, and so on. Hesiod, writing in the seventh century BCE, is responsible for this myth of the four ages of the world. In his poem *Works and Days*, he explains that the history of humanity begins with four races succeeding one another, each evoked by a metal (gold, silver, bronze, iron). The first, the race of gold, lived in happiness and harmony, while the last, the race of iron, contemporary with Hesiod, had forgotten what justice, mercy, and morality were.[14]

Following Hesiod, many authors vied with one another to elaborate on this framework. Replacing "races" with "ages," they turned it into a trope that permitted them to celebrate the past, especially the very ancient past, and denounce the vices and woes of the present. The most expansive on this subject, those who provide the historian with the most details, are the Latin poets: Catullus, Virgil, Tibullus, Horace, and especially Ovid.[15] The golden age is the one of delights: humans living intimately with the gods, pure hearted and carefree, exempt from pain, weariness, and old age. Peace, love, and justice reign throughout; spring is eternal, war is unknown, and nature is kind. Berry bushes produce abundant, delicious fruit, and the

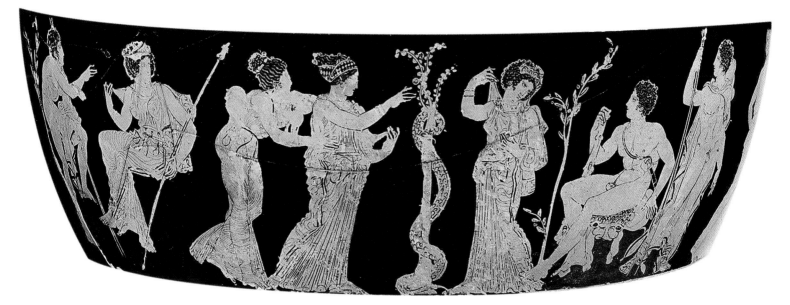

31

wool on the backs of sheep comes dyed in vivid, varied colors, without any human intervention. The silver age begins when Zeus succeeds his father Chronos. This is the period when humans, who have annoyed Zeus, become mortal; they must work to fulfill their needs, live according to the rhythm of the seasons, confront heat, cold, and hunger. Then comes the bronze age. Henceforth humans are hardhearted, they experience violence, make war, and must struggle against monsters and dangers of all kinds. Finally the iron age arrives, a horrifying time of endless war when vices reign supreme and humans no longer know anything but fear, suffering, and death.[16]

Without really understanding it, an anonymous author from the fifteenth century took up this myth of the four ages of the world and applied to it the correspondences that his period often established between colors and metals. This led him to perceive a yellow age, white age, red age, and black age.[17] Heraldry followed the same path in symbolizing everything by color and making the age of yellow the one of happiness and the age of black the one of misfortune. There is nothing comparable to be found among the ancient authors, and even though the Latin poets—Ovid in particular[18]—use the expression *aetas aurea* to characterize the age of gold, the adjective *aurea* really refers here to the metal, considered symbolically, rather than the color.

The myth of the four ages considers gold favorably and holds it in highest regard. Other myths and stories are more nuanced, for instance, the story of the golden apples in the garden of the Hesperides, which Heracles had to obtain as his eleventh labor. Having killed his wife and three sons in a fit of madness, the Greek hero found himself forced by the oracle of Delphi into strict obedience to his cousin Eurystheus, king of Argos, who envied and hated him. Eurystheus imposed on him twelve superhuman tasks, six in

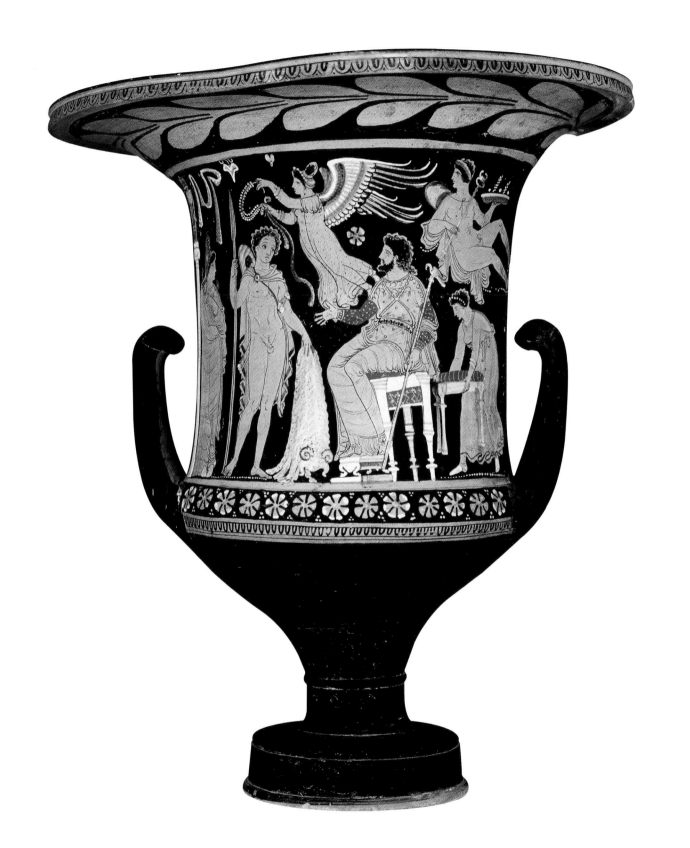

Peloponnese, six in the rest of the world. The eleventh consisted of seizing for him the wonderful fruit that grew in a garden at the foot of the Atlas mountains, at the western edge of the known world. This garden, protected by a monstrous dragon with a hundred heads, belonged to the Hesperides, the three nymphs of Sunset, daughters of Atlas and Night, with melodious voices and remarkable beauty. These fruits were the property of the goddess Hera, whose enduring hatred for Heracles made her endlessly persecute him. Finding the garden was not easy, seizing the apples even harder. Heracles succeeded nevertheless, after numerous adventures and enlisting his nephew Iolaus and the giant Atlas to help him. He finally delivered the golden apples to Eurystheus, who only wanted to verify that the labor had been completed and left the apples to Heracles. At a loss, Heracles offered the apples to the goddess Athena to thank her for coming to his rescue on many occasions. Not wanting to risk Hera's wrath, Athena wisely had the apples returned to the garden of the Hesperides, where they would never again be removed from their place.

Jason Delivering the Golden Fleece to Pelias

The famous Golden Fleece won by Jason as commanded by his uncle Pelias came from a winged ram with golden horns, whose sumptuous wool was said to shine like the precious metal. The animal had been filled with gold by Hermes and then sacrificed to the god Ares (or Zeus according to certain versions). Its fleece possessed magical powers and was guarded by a formidable dragon in distant, mysterious Colchis, on the eastern shore of the Black Sea. After a long and perilous voyage and with the help of the Argonauts and then the sorceress Medea, Jason succeeded in obtaining it and delivering it triumphantly to Pelias. But Pelias did not keep his promise: to restore to Jason the kingdom he had usurped, in exchange for the Golden Fleece. Krater with red figures, c. 340–330 BCE. Paris, Musée du Louvre.

The story of the eleventh labor contains many famous episodes (Heracles wrestling the monster Antaeus, then his encounter with the Pygmies, setting Prometheus free from his torture in the Caucasus, Heracles holding up the heavens for Atlas) and comes down to us in multiple versions. Although they may differ on many points, they all emphasize the dangers of this quest and the futility of its end: the golden apples returning to their starting point. The lesson is clear: trying to take possession of a precious good is perilous; keeping it for oneself can only led to catastrophe; it is wise and proper to return it to its owner. As early as the Roman period, some authors began to wonder what those golden apples meant, what fruits they represented, how many there were; were they really apples, or perhaps quinces, pears, or citrons? Nineteenth-century scholars imagined them to be oranges, or even mangoes, fruits that were then unknown in Europe and that would have fascinated the early Greeks who might have encountered them in Asia. All that is speculation. Let us be content with "apple," the word signifying most pulpy fruits in ancient languages—yellow apples, so that the metaphoric link between gold and the fruit can easily be established. A golden apple may only be yellow in color, and as there are three nymphs, Heracles's booty must have included at least three apples. Were they all the same color? The names of the Hesperides may suggest that we can find three different shades there: bright (Aegle), reddish (Erytheia), and "color of dawn" (Hesperia).[19]

The story of Jason and the Argonauts' expedition in search of the Golden Fleece is also one of a quest full of dangers and, although crowned with success, more or less futile. In exchange for reclaiming the throne of Thessaly, usurped by his uncle, Jason must retrieve the precious fleece of a sacred ram, filled with gold by Hermes and offered to the god Ares. This wonderful fleece was found in Colchis, that is, far to the east, suspended from an oak tree and guarded by an invincible dragon. With fifty companions, each more valiant and ingenious than the last (Heracles, Castor and Pollux, Orpheus, Laertes [the father

of Ulysses], and so on), Jason embarked on his ship, the Argo ("the Swift"). After a long voyage, with numerous adventures and trials of all sorts, he finally reached Colchis, on the banks of the Phases river, known for containing gold. There he enlisted the help of the sorceress Medea who was in love with him and managed, through trickery, to claim the Golden Fleece. The return voyage was a true odyssey, comparable to the (later) one of Ulysses. In the end Jason was able to present the Golden Fleece to Pelias who, despite his promise, refused to cede the throne to him. The Golden Fleece ended up in a cauldron where Medea boiled it to perform some magical operation intended to lead to Pelias's death. The story of Jason and Medea continues, tumultuous and tragic, but there is never another word about the Golden Fleece. Once again, the quest was long and futile, as vain as any quest for so precious a material good, especially if it is a gold object belonging to a deity.[20]

The story of King Midas is different but leads to a similar conclusion: any mortal filled with greed who seeks to possess gold, huge quantities of gold, is severely punished sooner or later. Midas, the legendary king of Phrygia, one day saved the life of Silenus, the foster father of the god Dionysus who, in gratitude, promised to grant Midas his first wish. The king immediately asked for everything he touched to be changed into gold. This wish was granted, but very quickly proved lethal; everything Midas held in his hand was transformed into the precious metal, notably food and drink. He could no longer drink or eat, so that, on the point of death, he implored the god to rid him of this fatal power. Taking pity, Dionysus made Midas bathe in the Pactolus river which, like the Phases, flowed with flakes of gold henceforth. Thus the king was cured of his greed (but not of his stupidity, as other stories demonstrate).[21] In any case, this strange story seems to constitute the oldest evidence of a strong and enduring tie between envy or avarice and the color yellow. This link was already evident in ancient Rome, then frequently presented in images from the late Middle Ages, and still very much present in the art and literature of the early modern period. Envy, avarice, jealousy, and greed have long had close connections to the color yellow.

Greek mythology is not alone in discussing gold, adventurous quests for it, the dangers of possessing it, and the conflicts and crimes it spawns. Celtic, Slavic, Nordic, and Germanic mythologies do so as well.

Let us consider, for example, the last of these and look briefly at what we can learn from the Rhine gold legend, which did not become grafted to the legend of Siegfried and the Nibelungs until much later. Originally, the Nibelungs were dwarfs who lived in the mountains "in the fog country" (the proper noun *Nibelungen* means "those of the fog"). They possessed a fabulous treasure of precious metal and three magic objects: a sword that made one invincible, a cape that made one invisible, and a gold wand that replenished the treasure trove whenever objects were removed. The treasure had previously been stolen from the daughters of the Rhine, river nymphs who had taken vows of chastity to better protect their father's gold. Henceforth it was buried under a mountain and guarded by the dwarf Alberich and a ferocious dragon. Following a disagreement over how to divide the treasure, the two kings of the Nibelungs appealed to the young Siegfried, son of the king of Niederland, to arbitrate their quarrel and divide the treasure fairly. But Siegfried betrayed them; he killed them, seized the magic cape and sword, vanquished the dragon, bathed himself in the dragon's blood (which made his body invulnerable), stole the treasure, and forced Alberich to serve him. After numerous adventures, Siegfried married the fierce Kriemhild, sister of the Burgundian king, but he fell victim to Queen Brünhild's jealousy and the treachery of Hagen. The traitor Hagen killed him with a sword blow between the shoulder blades where a single linden leaf had kept the dragon's blood from penetrating. Kriemhild then took bloody vengeance, resulting not only in her own death and Brünhild's but also in the destruction of

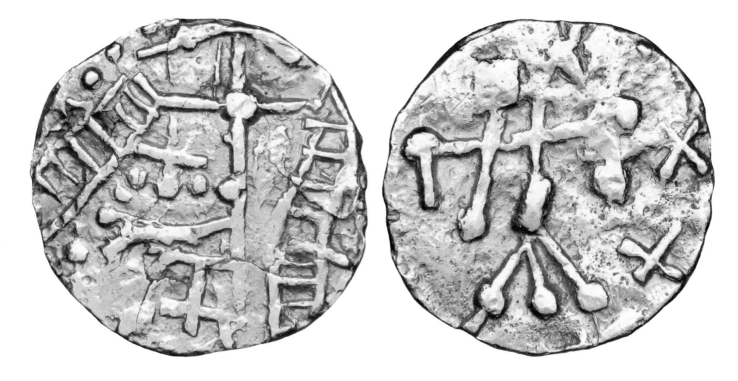

Rhine Gold

In the fifth century, the Burgundians occupied a large area around the confluence of the Rhine and the Main; their capital was Worms. It was in that city that the *Song of the Nibelungs*, written in Middle High German about 1200, located the court of Gunther, king of the Burgundians and Siegfried's brother-in-law. Siegfried defeated the Nibelungs and seized their fabulous treasure, which they had stolen from the daughters of the Rhine. After much drama and bloody revenge, after the death of Siegfried and the annihilation of the Burgundian people, the treasure was finally returned to the Rhine and restored to its place at the bottom of the river where it would forever remain.

Burgundian coins in gold, "Triens à la victoire," 7th century. Paris, Galerie Les Chevau légers.

the Burgundian people. The treasure was returned to the Rhine, to a location forever unknown.

This dense story with its vast number of episodes has been passed down to us in multiple versions, Nordic and Germanic. The most famous one, on which Richard Wagner would base his Tetralogy, is found in the *Song of the Nibelungs* (*Nibelungenlied*), an epic written in Middle High German at the very beginning of the thirteenth century. But many older versions exist, containing one part or another of the legend. Nevertheless, they all seem to be structured around a single theme: the theme of accursed gold.[22] Although this yellow metal may be the symbol of power, even of sovereignty, it becomes the object of many taboos that, if violated, always lead to great misfortune. Furthermore, it inspires jealousy, covetousness, greed, theft, war, and destruction—better to leave it where one finds it. In fact, after tragic confrontations and destruction on all sides, the treasure of the Nibelungs returned to its place of origin, in the depths of the Rhine, exactly like the golden apples stolen by Heracles that find their way back to the garden of the Hesperides.[23]

Gold in the Pactolus River

Having been granted by Dionysus the gift of transforming into gold everything he touched, King Midas was no longer able to drink or eat; food and liquid immediately solidified into the precious metal. Midas implored the god to take back his appalling gift. Dionysus took pity on him and commanded him to go wash in the waters of the Pactolus river. The king was freed from his torment, and the waters of the river began to flow with flakes of gold. Nicolas Poussin, *Midas Washing at the Source of the Pactolus*, 1627. Ajaccio, France, Palais Fesch, Musée des Beaux-Arts.

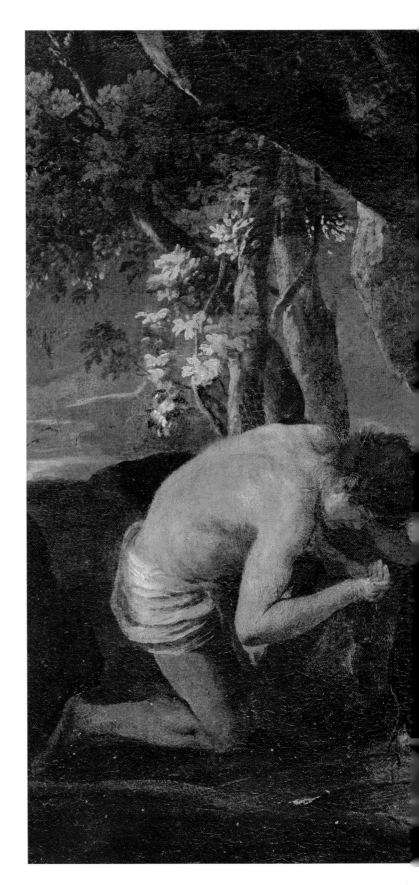

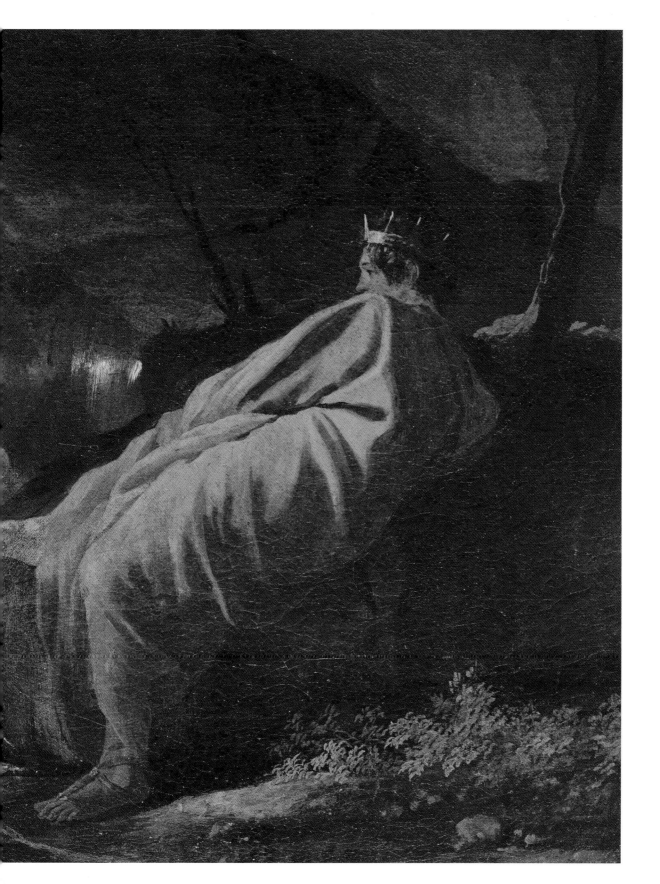

SUN WORSHIP

Viewed from the earth, the sun generally appears yellow, at least in good weather in the middle of the day. For astrophysicists however, its true color is white, because it is white light that the star sends toward the earth. This light is composed of different colored rays that the atmosphere filters, deflects, or reflects. Because they have the shortest wavelengths, violet and blue in particular are dispersed and more or less reflected from the solar spectrum when this white light crosses through the various layers of the atmosphere (which explains why the sky is blue when the sun is at its maximum intensity). The dominant color in the solar spectrum thus becomes yellow or yellow-orange when the sun is at its zenith, and yellowish red, pinkish red, or even red when it is rising or setting.

Obviously these are modern scientific explanations, unknown to ancient societies. Nevertheless, although ancient societies may not have always represented the sky as blue—far from it, in fact—they seem to have usually seen the sun as yellow. Thus a link between this color and light was established very early. Yellow is luminous, radiant, and dazzling. It is also hot because the sun emits heat and warmth. For this reason, early on, yellow appeared as a beneficial color and remained so for centuries. It was not until well into the Middle Ages, as we will see, that the negative aspects of yellow would overtake its positive values.

Let us pause for a moment to consider the ancient sun. King of the stars, source of heat, light, and fertility, enemy of darkness and the forces of Evil, it was deified very early, giving rise to various cults in the Old and New Worlds. They were not all as bloody as in the case of the Aztecs, who offered human sacrifices to the sun for fear that it might stop in its course, lose its energy, and cease to rise each morning. But many societies saw it as the basis of all life, the ancestor of their gods, and sometimes of their kings or their people. For the Egyptians, for example, Ra, the most ancient sun god, who made his journey each day by boat, was considered the creator of the universe and the father of the first

Artemis-Diane, Goddess of the Moon, the Hunt, and Wild Nature

Artemis (Diane for the Romans) was the twin sister of Apollo. Just as her brother was the god of solar light, she was the goddess of lunar light, among other things. Thus she was closely associated with two colors: white and yellow. In Greece, in many places of worship dedicated to her, the priestesses wore yellow. A virgin and wild in nature, she possessed many attributes like her brother did. One of them, the bow and arrow, can be seen here. Mural painting found in Villa Ariane on the Varano hillside near Stabiae, 1st century CE (?). Naples, Museo Archeologico Nazionale.

39

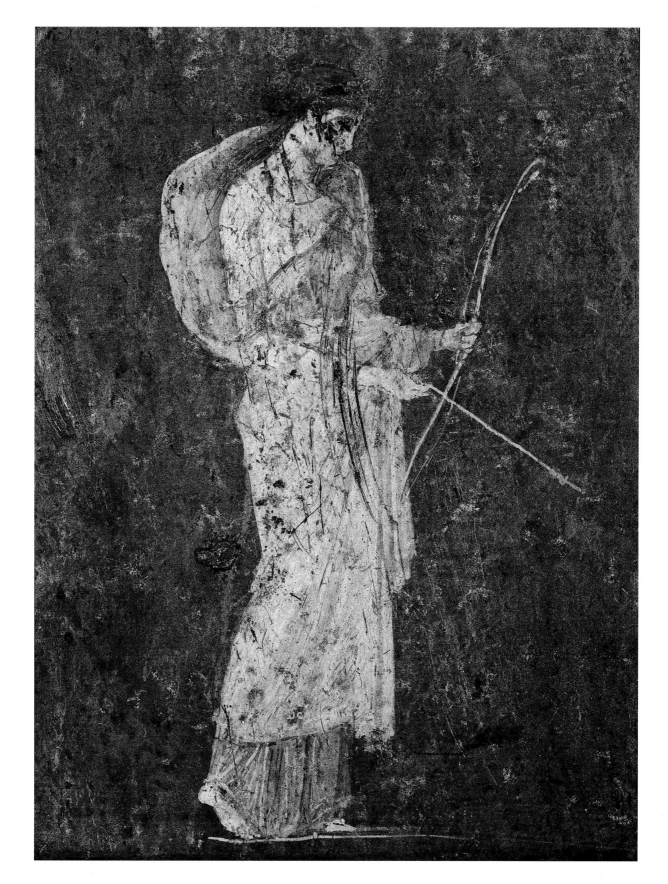

pharaohs. In fact, throughout the biblical period, almost all Near and Middle Eastern cultures practiced some form of sun worship, in temples that were always oriented toward the east, where it rose, and served by priests dressed in yellow, its color. The Hebrews were the exception however; for them, the solar star was not a divinity at all, but only a light fashioned by Yahweh on the fourth day of Creation and placed in the firmament.[24] This idea would be adopted much later by Christianity, which tried its best to eradicate pagan solar festivals by locating the two most important Christian holidays, Easter and Christmas, at the same points on the yearly calendar—close to spring equinox and winter solstice.

Ra in His Boat

God of the sun and divine fire, Ra crossed the vault of heaven each day in his sacred boat, combating the forces of darkness with heat and light. His voyage led him from the east to the west. At dusk, he became Atum (the setting sun), then disappeared under the earth where he was thought to make the same journey in the opposite direction. In images, he is generally represented in human form but with the head of a falcon crowned with the solar disk, usually red in color, sometimes yellow. Ra is shown here preceded by Thot, the lunar god with the head of an ibis. Painted wood fragment from the casket of Tachepenkhonsu, sistrum player associated with the cult devoted to sun god Ra, c. 700–600 BCE. Paris, Musée du Louvre, Département des Antiquités Égyptiennes.

40

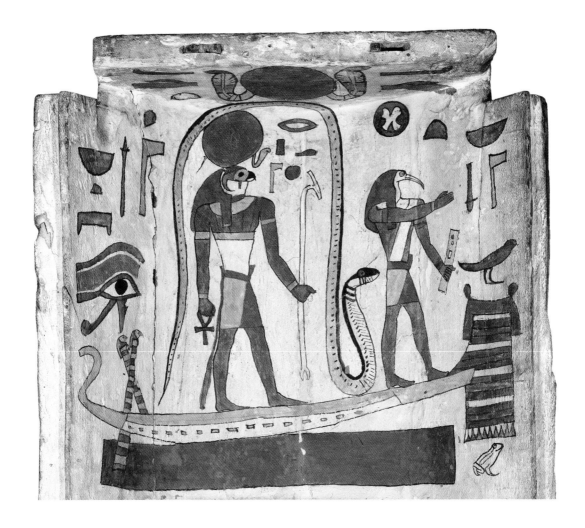

PREVIOUS PAGE

Yellow Pigments in Egypt

Egyptian painters had access to quite an extensive palette of yellows. First and foremost were the ochers (hydrated iron oxides) of various compositions providing a variety of shades ranging from bright yellow to light brownish yellow. Then came orpiment (arsenic trisulfide), sometimes used to replace or evoke gold; its shades ranged from bright yellow to deep orange. Finally, over the course of the first millennium, a new pigment appeared: massicot (iron monoxide), which provided duller tones and was used especially for painting backgrounds.
Astronomical ceiling of the funeral chamber of Pharaoh Ramses IX: the Amduat (*detail*). Thebes, c. 1107–1100 BCE. Luxor, Valley of the Kings, tomb KV6.

Bust of Helios

As a deity personifying the solar star, Helios was often represented with a halo or crown of sun rays. That is the case with this bronze bust from the Roman period, found near Tripoli and perhaps copied from another bust representing Alexander the Great; both have long hair and wear a chlamys.
Bust of Rayed Helios, 1st century CE. Paris, Musée du Louvre.

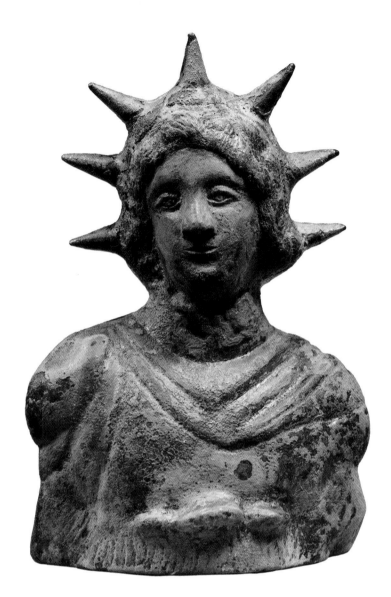

42

But let us stay for now with pagan antiquity. In Greek mythology with its hierarchized pantheon, the solar star Helios was a deity of the second order with limited powers. For example, he had to solicit the aid of the Olympian gods to punish mortals who committed wrongs against him. Thus the Odyssey tells how Helios had to ask Zeus to take vengeance for him against Ulysses and his companions who stole (and ate!) the huge cattle he pastured in Sicily, magnificent oxen with immaculate white coats and horns of gold. Crossing the vault of the heavens each day in a chariot of fire, Helios saw everything that happened in the sky and on earth. That is why he often played the role of informer and was not well liked by other gods. He was the one, for example who warned Hephaestus that his wife Aphrodite was cheating on him with Ares; he was also the one who told Demeter that her beloved daughter Kore has been kidnapped by Hades, the god of hell.

In Rome, Helios was assimilated to the god Sol, an ancient Sabine deity that, like Helios in Greece, was worshipped less and less over the centuries (before experiencing a resurgence in the Late Empire).[25] A few authors relate his name to the adjective *solus* (sole), arguing that each

day, after eclipsing the other planets, Sol appeared alone in the sky. Pliny specifies that he is yellow, like gold, but that it is a white light he casts over the other stars and the earth.[26] In ancient religions and mythologies, no matter what form the sun took in representations—disk, radiating circle, wheel (with or without a cross), simple face, or even a swastika—it was almost always shown or described as yellow. That was its color in the ancient imagination, and it remains so into the present; still today, when children draw the sun, they color it yellow.

Whatever the significance of Helios and Sol, they only symbolized the solar star. For the Greeks and Romans, the true sun god was Apollo, a rich and complex deity that possessed many privileges among the gods of Olympus. Mythology recounts his adventures, exploits, love affairs, and fits of anger; iconography generally represents him with the traits of a young man of radiant beauty, a perfect body, and long, blond curls. This was the Greek god most often represented, a brilliant, luminous god, both poet and musician, beneficent healer, who dispelled the darkness and

43

The Chariot of the Sun

Helios set off each morning in his chariot drawn by four horses. He was "the one who sees and hears all things," as Homer said. He did, in fact, keep watch over gods and humans and reported what he saw or heard, creating various conflicts in doing so. Originally quite distinct from Apollo, god of solar light but not of the solar star, Helios came to be merged with him sometimes. In iconography, they are both represented as handsome young men with blond hair. But only Helios's head is encircled with rays similar to those of the sun. Red-figure krater, c. 430–410 BCE. London, The British Museum.

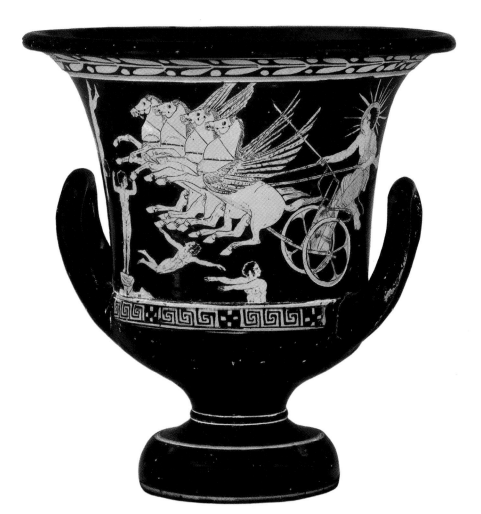

Apollo, the God of Blond Hair

Apollo was the richest figure of the Greco-Roman pantheon and the god most often represented. He is usually shown with the traits of a young man of great beauty, his blond hair all in curls; this was a god of light who dispelled the darkness and brought mortals peace and happiness. He possessed a wide repertoire of attributes, among them the lyre, the aulos, and the laurel branch, as seen on this mosaic. Apollo was also a musician god; when the Muses declared him victor over Marsyas, who had unwisely challenged him, he condemned Marsyas to being flayed alive. Apollo condemning Marsyas. Paphos, Cyprus, House of Aion, tile mosaic, early 4th century.

brought mortals harmony and peace. One of the many epithets adjoined to his name was *Phoebus*, "the bright one," "the shining one." Apollo was a god of light.

Like Apollo, many other deities traditionally had blond hair: Athena, Demeter, Hermes, and above all Aphrodite who was said to rinse her locks in the waters of the Scamander river to make them more silky and blond before young Paris rendered his famous judgment. The waters of this river that fed the plain of Troy were believed to dye the fleece of the sheep that bathed in it a particularly luminous yellow. Aphrodite imitated the sheep, giving rise to her resplendent golden hair, and she was chosen by Paris as the most beautiful of the goddesses.

Thus all ancient sun worship and related mythologies emphasize the very strong bond between the color yellow and brilliance, energy, youth, beauty, and fertility. It was the color of numerous divinities and of everything consecrated to them, from gold offerings to the garb of the priests serving in their temples, and not forgetting the animals sacrificed to them with their requisite gilded horns. But yellow was also and especially the color of light, not so much early light, which is soft white or even pink as that of dawn, but more light at its zenith, which illuminates and makes fertile the world, before becoming increasingly red and fiery. In the ancient color classifications—notably the one attributed to Aristotle that dominated until the end of the eighteenth century—those three hues, white, yellow, and red, form the beginning of all chromatic sequences, which are generally organized from lightest to darkest: white, yellow, red, green, (blue), purple, black.[27] The Newtonian spectrum is still far away.

44

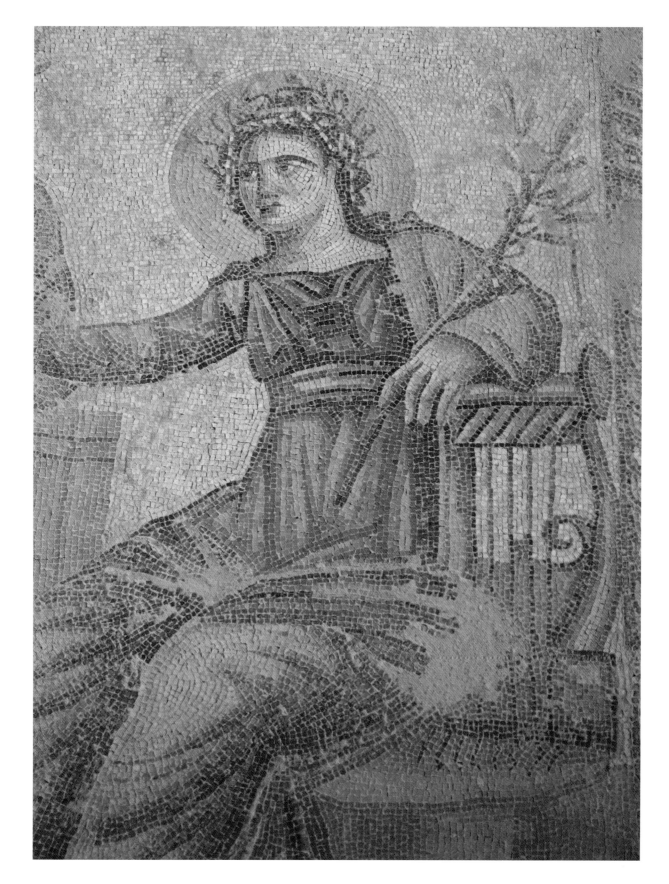

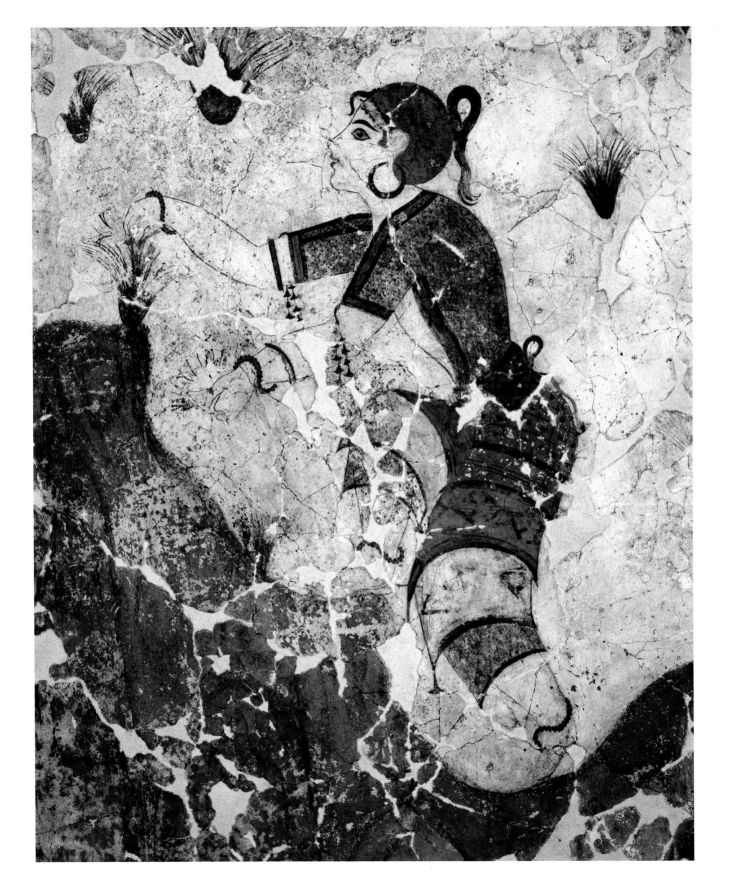

DYEING IN YELLOW

Saffron Gatherer

Saffron played an important role on the Greek islands beginning in the Minoan period. It was used in cooking, medicine, perfumery, and dyeing. Queens and princesses wore yellow clothing dyed in saffron as a sign of high rank. This mural painting discovered in the ruins of an Akrotiri house on the island of Santorini shows a woman gathering the stigmas of saffron crocuses and filling her basket with them.

Mural painting found in the ruins of the Xeste building on the Akrotiri hillside, Santorini, middle of the 2nd millennium BCE.

Despite the prestige of purple and its considerable place in tinctorial occupations in the imperial period, the Romans were not great dyers. Their expertise in this area was essentially inherited from the Egyptians and Phoenicians, or even the Hebrews and other Near and Middle Eastern cultures. For certain colors—blue and green in particular—they were even less skilled than the Celtic or Germanic peoples, who dressed much more colorfully and wore every color, frequently combined in bichrome patterns of stripes or checks. In Rome, monochrome was cultivated. The colors dominating in masculine clothing were white, red, and brown; yellow was generally reserved for women while other shades were considered more or less eccentric. That was true at least until the end of the republic; during the empire, Roman matrons, under the influence of Eastern and "barbarian" fashions, introduced a palette of increasingly varied colors into their wardrobes.

In Greece, the moralists mistrusted dyeing and, more generally, grooming, makeup, and anything related to bodily appearance and clothing; these were useless artifices, deceptive, indecent, and immoral practices. Plato proves to be one of the extremists on this subject:

> Beauty is simple, pure, unmixed, far removed from the perversion of colors and all human vanities.
> Seeking to beautify oneself through clothing is an evil, hypocritical, base, servile thing; grooming deceives not only through forms but also through fabrics, colors, cosmetics, and artifices of all kinds.[28]

In the eyes of the philosopher, painters were no better than dyers. They cleverly exploited the weakness of human perception by creating colorful illusions that abused the eye and disturbed the mind. For Plato, and for Aristotle as well (although to a lesser degree), color is always deceptive because it conceals what it covers and makes

us see something other than the reality and simplicity of beings and things. It is a perverse counterfeit that must be rejected.[29]

Rome was more tolerant, and color was not regarded in such a negative light, even if many authors, like the very learned scholar Varro, related the word *color* etymologically to the verb *celare*, which means "to hide," "to cover," or "to conceal." Color was what clothed and hid beings and things. The dyers were its first artisans. Even though they belonged to a guild that was scorned (they were dirty, their workshops were foul) and strictly supervised (they were violent, restless, quarrelsome), they were indispensable to the smooth functioning of the social order. Through its styles, materials, and colors, clothing not only identified one's gender, age, status, and social class, but it also revealed one's level of wealth, office, rank, and profession. Sometimes it evoked a holiday or formal occasion that called for wearing certain clothes rather than others. Its function was social and taxonomic before being practical or aesthetic.

Very early on Roman dyers formed a guild specialized according to color and dyestuff. At the end of the republic, detailed professional regulations, the *constitutio tinctorum*, distinguished eleven categories of artisans. There were five for the red tones: the *sandicinii* (who produced madder-based reds); the *coccinarii* (kermes-based reds); the *purpurarii* (luxury reds that were murex-based); the *rucellarii* (ordinary reds, orcein- or lichen-based); and the *spadicarii* (dark and brownish reds from various wood bases). Three for oranges and yellows: the *flammarii* (carthamin-based oranges); the *crocotarii* (saffron-based yellows); the *luteolarii* (weld-based yellows). And three for blacks and browns: the *nucitarii* (dark tones from the bark or roots of walnut trees); the *castanearii* (browns from the roots of chestnut trees); the *atramentarii* (blacks with an ink or ink-related base). There is no mention of whites, blues, or greens. In fact, until very late, Roman dyers seem to have been especially successful in the range of reds, oranges, and yellows, less so in the range of blacks and browns, and mediocre in the ranges of blues and greens, relegated to the *infectores usitati* (dyers of minor shades). Dyers did not make any progress in those last two color ranges until Germanic fashions came into vogue in Rome and other large cities during the empire, first only briefly in the first century CE, then more significantly and enduringly in the third century, a period when greens and blues became the rage in women's clothing, to the great dismay of the "old Romans." For them, these were *colores floridi* (frivolous colors) already denounced two centuries earlier by Pliny.[30]

For the moment, let us stay with the range of yellows. The principal materials used by the Romans were the same ones that other ancient peoples used (and which would continue to be used for centuries by medieval and modern dyers).

The most expensive and prestigious dye was saffron-based, from a bulbous plant (crocus) with yellow (or violet) flowers and a strong fragrance. Once they were harvested, dried, and then reduced to a powder, the stigmata of the pistils provided a product used in dyeing, perfumery (in temples especially), medicine (to regulate blood flow), and cooking (as a spice). It was a very expensive product because it took an enormous quantity of pistils to produce a small amount of dye, spice, or perfume. Certain regions in the empire almost made an industry of cultivating saffron, but because the plant was fragile, requiring light soil, intense manual labor, and delicate care, the high price of saffron was unaffected. As a dye, saffron provided splendid tones of bright, slightly orange yellows, but it was not very stable. It was used especially for fabrics intended for women's clothing—in particular the *stola crocota*, a long, pleated gown, cinched at the waist, worn by elegant matrons—and the garb of certain priests.[31]

Less expensive was weld (*lutum*), a tall, hardy plant that grew wild in many areas, especially along paths in rocky or sandy soil, although it was cultivated as well almost everywhere because of its remarkable dyeing powers. The whole plant, including its long roots, had tinctorial properties. First it was dug up and dried in sheaves in the sun, then it

48

was immersed in water to obtain a dye that was easy to use as long as it was combined with a strong mordant, generally tartar or alum. Weld-based dyes produced quite beautiful yellow tones, very solid but less bright and less orange than saffron.[32]

To obtain a more ordinary dye, dyers turned to broom (*genista*), a thorny shrub with yellow flowers that grows in dry soils. As with weld, the whole plant possessed dyeing properties and provided a solid dye, but the tones obtained were dull and cold, more yellowish than bright yellow. Nevertheless, broom was harvested not only to be used for dye; in ancient Rome it already had multiple uses. Its fibrous bark was used in textiles, its light wood provided excellent kindling, its branches served as roofing for cabins, its leaves were a favorite fodder for livestock, and its flowers were a powerful diuretic. Moreover, its stalks, bound together and fastened to the end of a stick, were transformed into a broom, a rustic object that would be used in Europe for more than two millennia.

Limited to the circumference of the Mediterranean basin, safflower, a hardy thorned plant resembling thistle, was used by dyers to obtain red tones as well as yellows that tended toward orange or pink. In this latter case, they took the attractive descriptor, "the color of dawn."[33] The dye was very beautiful but not very resistant to light. Only the plant's flowers had tinctorial properties; dried and reduced to powder, they provided a product that resembled saffron and that was sometimes fraudulently sold as such. This "bastard saffron" possessed the distinctive characteristic of being usable cold and without a mordant, but the dye, as beautiful as it may have been, was not stable. Along the shores of the Mediterranean, a better alternative was henna, whose dried and crushed leaves could also be used cold but produced more stable tones, principally in the range of reds and browns, but also oranges and sometimes even yellows.

Saffron, weld, broom—these were the three principal dyestuffs used for dyeing in yellow in the Roman Empire. They would remain in use throughout the Middle Ages, at least for "large-scale dyeing." After that, the arrival of Europeans to the New World introduced other dyes produced from indigenous trees or bushes (black oak bark, fustic, American blackberry leaves), but until the age of synthetic dyestuffs, these new products would never completely rival the old ones. For "small-scale dyeing," that is, inexpensive, local dyeing, the leaves of various trees (alder, birch, fig, apple) were used for centuries, as well as St. John's wort flowers, thistle or parsley leaves, and onion skins.[34]

DRESSING IN YELLOW

Thanks to sculpture, Roman clothing is quite well known to us. It was not cut or sewn, but flowing, folded, and draped. It was not the styling but the figure that gave it form, arranged and adjusted according to social class, climate, era, and circumstance. For a long time, dress changed little, remained somber, and resisted novelty. But at the end of the republic, things changed; appearance began to play a larger role both in how one carried oneself and in what one wore. Subsequently, at the beginning of the empire, different fashions (Greek, Eastern, "barbarian") made their debut, increasingly diverse and changing over the course of time, especially with regard to women's clothing. Whatever the period, cloth and clothing were precious goods that were kept in a chest (*arca*) or a wardrobe (*armarium*) and were sometimes passed down from generation to generation. Even the clothes of slaves (generally dark-colored tunics) were saved.

Because Roman sculpture lost its polychromy and only a small number of Roman paintings have survived, we must rely on texts to learn what colors were worn in ancient Rome. But historical texts and narratives are more long-winded on the exceptional or scandalous cases than on the everyday, while literary texts heavily embroider reality. What credit should we give Ovid's remarks, for example, in his *Art of Love*, when he rails against the abuse of purple by certain upstarts or takes pleasure in describing in great detail the delicate shades of clothing worn by pretty women in his day?

Flora, Goddess of Flowers and Spring

The Romans loved flowers but they grew mostly indigenous species, neglecting to establish exotic species in their gardens. In addition to decorating temples and sometimes private residences, these flowers were used to make garlands and crowns; they were also used in medicine, cooking, and perfume. If we are to believe the poets, the favorite floral colors were red, white, and yellow; blue and violet flowers were less popular. In honor of Flora, goddess of all that blooms, special spring games and celebrations were organized: the Floralies. Mural painting found in Villa Ariane on the Varano hillside near Stabiae, 1st century CE (?). Naples, Museo Archeologico Nazionale.

What shall I say about clothing? What good are these excessive brocades and this wool fabric dyed twice in Tyrian purple? There are so many other less expensive colors. Why wear your entire fortune on your back? . . . See this azure blue, like a clear sky, free of rain clouds brought by the southern winds. See this yellow similar to gold . . . and this green that imitates the color of water; it seems to me that this is the dress of the naiads. And this dye that resembles saffron? It is the color of Aurora's cloak, when, still

51

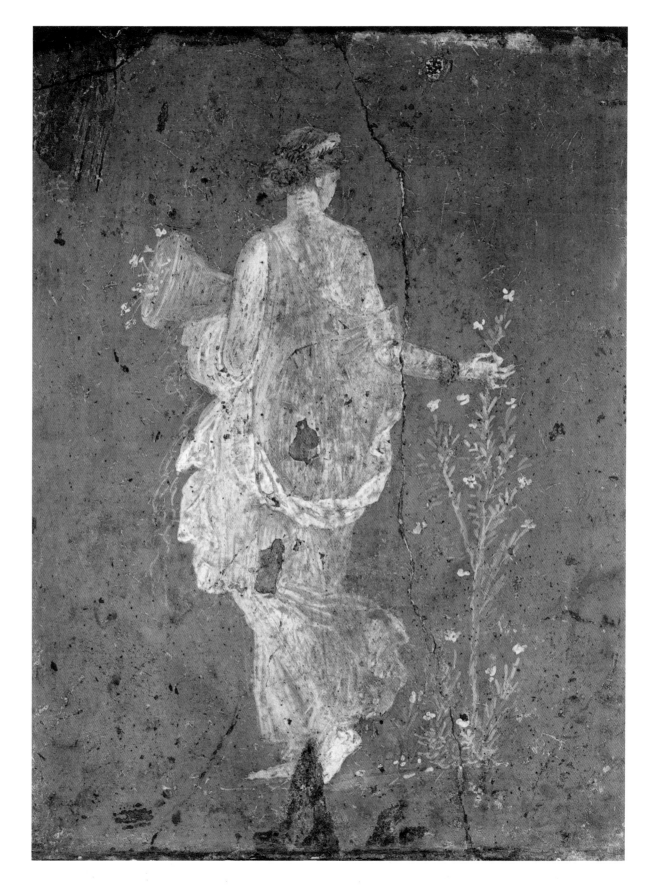

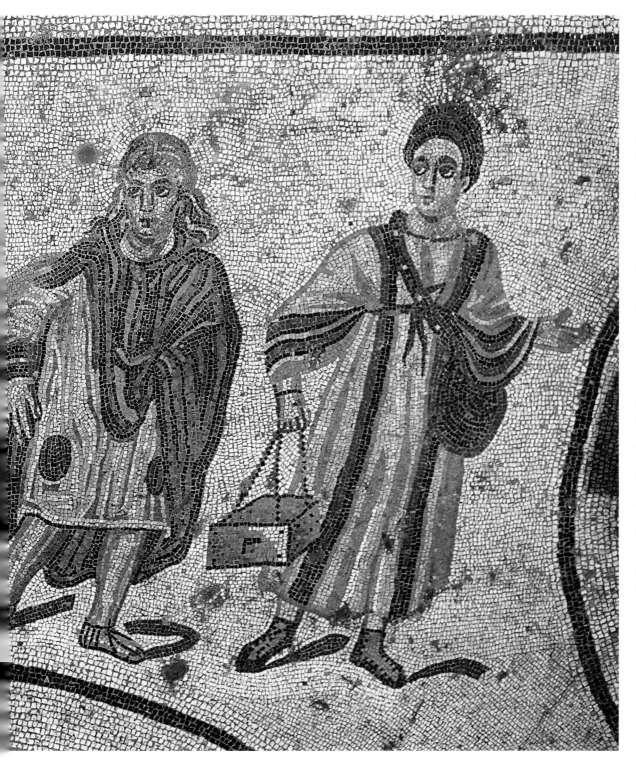

Elegance in Roman Dress

The colors worn by Roman matrons diversified greatly beginning in the first century, under the influence of Eastern and "barbarian" fashions. Colors hardly worn until then (green, blue, violet) became very popular henceforth. Later, men too began to wear such shades, formerly considered frivolous or immodest. This floor mosaic from a luxurious Sicilian villa attests to those changes and shows the mistress of the house going to thermal baths in bright and colorful clothing. She is accompanied by her two daughters dressed in green and yellow, and two servants who seem to be carrying pieces of cloth and a box with salves. Mosaic found in the vestibule of Villa Romana del Casale, near the town of Piazza Armerina, Sicily, first quarter of the 4th century.

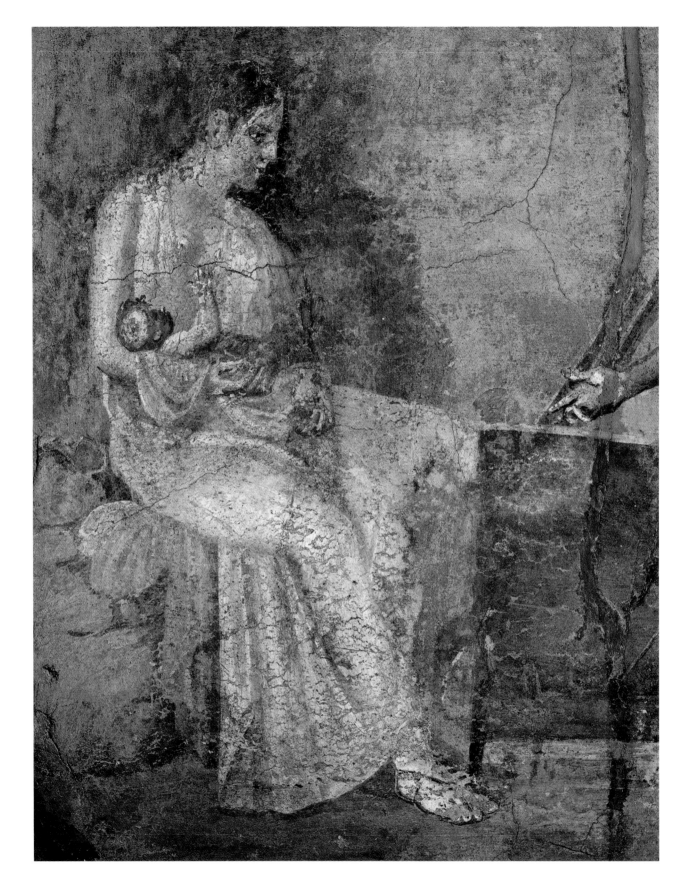

all moist with dew, she harnesses her shining horses. Here you can see the color of Pathos myrtle; there in the distance, that of purple amethyst or again the tender pink of certain feathers of Thracian cranes. Elsewhere you see the color of the chestnuts and almonds of Amaryllis, and that of the cloth to which wax has given its name. As many new flowers as the earth produces . . . , so many and even a greater variety of dyes does wool come in. Choose them with discretion because all colors do not suit all women. Black suits blonds . . . , white suits brunettes.[35]

Ovid was a socialite very familiar with the high society of his day and all its shortcomings, including those having to do with clothing. But he was also a poet, an expansive poet who delighted in presenting a multicolored palette more or less invented, allowing him to introduce into his lines many flowers, some fruits, precious stones, and various mythological allusions. Would such colors, in such varied and refined shades, have actually been worn during the reign of Augustus? There is reason for doubt, it seems a bit early, especially with regard to the splendid azure blue and the green that imitates the color of water. However, a few decades later, during the reign of Nero, this kind of diversity in shades may well have been observed in feminine dress, under the influence of Eastern fashions and thanks to dyers of Germanic origin establishing themselves in Rome, experts in the range of blues and greens. Moreover, the emperor himself set the example by frequently dressing in his favorite color, green, something his predecessors had never done.[36]

On the other hand, unlike green and blue, the two yellows that Ovid describes are completely plausible: the one imitating gold, that is, a particularly luminous yellow, and the one the color of saffron, a yellow tending toward orange. But they were more feminine than masculine colors. Free men, that is to say Roman citizens, wore togas, and they had to be as white as possible. They were made of wool, large, heavy, impractical, and easily soiled; in the form of a circle, moreover, they were draped according to complicated patterns. They were not dyed—dyeing in white was a feat that remained almost impossible until the eighteenth century—but lightened and bleached with the help of salts of tartar or plants in the saponin family. Through successive washings and whitenings, the wool was damaged and, prior to any civic ceremony, it had to be hastily dusted with chalk to hide the imperfections. In fact, togas were generally worn only in public. At home or in the country, the patrician wore a sort of shawl over his tunic (white or beige) or else a light cloak or even a second tunic (*pallium*, *lacerna*). These clothes, a part of private life, could be different colors, but the toga could only be white. Not until the third century did yellow, red, and brown togas appear, in addition to togas with two- or three-color patterns, and not until then were such togas no longer considered gaudy and eccentric. Nonetheless, during the empire, many Romans tried as often as possible to avoid wearing togas, men and women alike preferring lighter or more practical clothes.[37]

Women were subject to less rigid dress codes than men. Silk and cotton fabrics, imported from the East, sometimes replaced wool and linen and came in a wider variety

Yellow Fabric in a Pompeian House

In Rome, in the residences of the wealthy, chairs and beds were often covered with fabric and cushions. Their colors varied, but yellow was among the colors used most frequently, especially for chairs for women. For luxury fabrics, dyes were made from saffron; for ordinary cloth, weld or safflower, sometimes broom.

Woman nursing an infant. Mural painting, Pompeii, 1st century CE. Naples, Museo Archeologico Nazionale.

of shades. Yellow remained the most common color never-theless, especially for the *stola*, a long, pleated dress worn over the tunic, with or without a belt, taking on a variety of forms according to the decade and the current fashion. Over the *stola* was worn a shawl that covered the shoulders and descended almost to the knees; this *palla* was very expen-sive, often decorated and embroidered, and it included a panel to cover the head. Its colors were darker and more diverse. Beginning in the first century, wealthy women wore true dresses in private, lighter and more attractive than the austere *stola*. Their colors became increasingly less restrained over time; by the second century, in addition to a wide variety of yellows, there were pinks, violets, light blues, light greens, and even stripes, motley, and small col-ored patterns. Among the most unusual, those that enraged the traditionalists, we must mention the *plumatilis*, a fabric flecked with yellow, pink, gray, or brown evoking the plum-age of birds, and the *cumatilis*, a motley of greens, whites, and blues that seemed to ripple with each step, imitating the waves of the sea.[38]

These oddities come later, however. Before that time, a woman of good Roman society usually dressed in white, beige, or yellow. This last shade was the prime color for married women, with the wedding itself at the origin of this custom. During the Roman republic, the wedding cer-emony required that the couple be dressed in yellow and that they enter together a room painted or hung with this same color, symbolic of joy, happiness, fertility, and pros-perity. This ritual subsequently waned, leaving only the bride dressed in yellow.[39] But gradually, and somehow by extension, yellow became the color most often worn by matrons, not one specific shade of yellow but all yellows: bright, vivid, and saturated for the wealthiest, duller and more drab for others.

Although yellow was generally considered the color of women, it was also considered to be the color of effeminate men, like the Greeks whose morals had long shocked the Romans, or more repeatedly, the inhabitants of Phrygia (a

Yellow, the Color of Artemis

In this mural painting in the house of a wealthy Pompeiian banker, Iphigenia, having become a priestess of Artemis, sets free her brother Orestes and his friend Pylades who came to Tauris to seize a sacred statue. She is dressed entirely in white while the young girl who accompanies her, and who is holding a sword, wears blue, a color that may emphasize her lower rank. Around their necks, both wear long yellow scarves, the traditional color worn by women devoted to Artemis. Mural painting, 1st century CE. Pompeii, House of Caecilius Iucundus, triclinium.

region in Asia Minor where the city of Troy was located); they all supposedly felt a strong attraction for yellow and would frequently wear it. In Rome itself, it was particular individuals who, for one reason or another, usually polit-ical, were characterized as effeminate (*delicati*) by their enemies or by poets reveling in gossip and vicious slurs (Martial, for example).[40] The most famous case is that of Publius Clodius Pulcher, whose behavior caused a scan-dal in the time of Caesar and Cicero. The adjectives used for him, first by his political enemies, and later by histori-ans, convey valuable information about the status and lex-icon of yellows in ancient Rome. That is why this "Clodius affair" is worth recounting in detail.

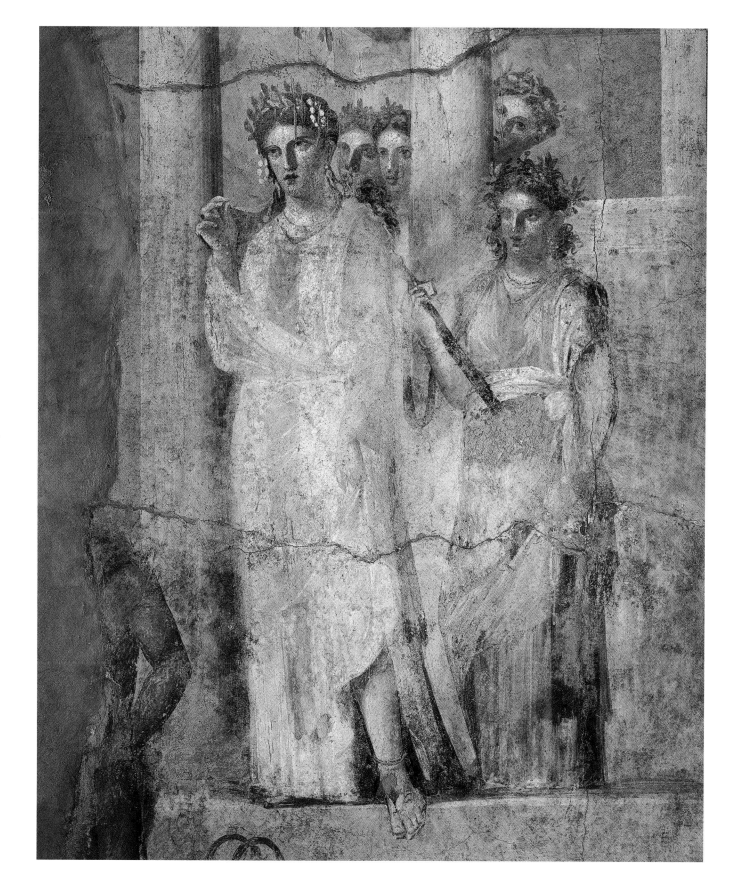

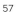

57

THE CLODIUS AFFAIR

Cicero (106-43 BCE)

In his discourses, Cicero hardly speaks of colors. As with all orators, rhetorical nuances are enough for him and help him to multiply the effects of style. Although there is one exception: each time he attacks his personal enemy, Publius Clodius Pulcher (92–52 BCE), he never fails to mention that when Clodius was young and attempting to seduce the wife of Caesar, he disguised himself as a woman. These attacks give him the opportunity to describe in detail the various pieces of clothing worn by the culprit, notably an elegant *stola crocota*, a long yellow dress dyed with saffron. As yellow was a color for women's clothing, Cicero demonstrates how Clodius was effeminate, debauched, and an imposter, unworthy of holding any sort of public office.

White marble bust, 1st century BCE. Florence, Uffizi Gallery.

P ublius Clodius Pulcher (92–52 BCE) was born into an illustrious family. After a troubled youth and brief military career, he entered politics and immediately attracted attention. On the one hand, he was a demagogue who supported the people and not the patricians, despite his birth, rank, and fortune. On the other hand, he was a kind of "dandy," a fop who loved playing seducer, attached great importance to his appearance, courted Rome's beautiful women, and became famous not so much for his political activities as for his escapades. At least that is what his enemies who wrote on this subject would have us believe, first and most famous among them, Cicero.

His most notorious escapade, the one that unleashed an enormous scandal and almost cost him his career, took place the evening of December 4, 62. In an attempt to seduce Pompeia Sulla, Caesar's first wife, with whom he was in love, Clodius disguised himself as a woman and entered Caesar's house. The residence was a sacred place because Caesar functioned as the great pontiff, the highest magistrate in the public religion of Rome. It was also the time for celebrations and rites to honor the deity of chastity, the goddess Bona Dea; only women were authorized to attend these rites. Despite his disguise as a kithara player, Clodius was betrayed by his deep voice and discovered; he managed to escape nevertheless. But a major scandal ensued: a man present at the rites of Bona Dea, that was unheard of! Brought before a court, Clodius defended himself by claiming that it must have been someone else, that he himself was far from Rome at the time of the events; he even produced a witness to corroborate his testimony. But Cicero testified that he had encountered Clodius in Rome that very afternoon, thus exposing his weak alibi. Clodius then found another means for escaping condemnation; he bribed the jurors. Acquitted, he was released to freedom but harbored a fierce and lasting hatred toward Cicero henceforth.

The affair caused quite a stir and led to Caesar's divorce from Pompeia Sulla. Clodius, however, managed to stay

out of the limelight for a while; he then relaunched his political career as if nothing had happened. In 59, he succeeded in getting elected tribune of the plebs, took demagogic measures, distributed free wheat, modified many laws partial to the magistrates, and regained wide popularity. He then took on Cicero, reproaching him for having unjustly accused alleged conspirators, and with the aid of the consul Piso, had him condemned to exile. Cicero's house on the Palatine was destroyed, and his belongings were confiscated and auctioned off. Thanks to a front man, Clodius was able to acquire them.

With Caesar away waging war in Gaul, Clodius gradually took control of Rome, maintaining various armed gangs charged with eliminating all his enemies. But his enemies had gangs of their own, notably Titus Annius Milo, head of the patricians' party. For three years, unrest and confrontations ensued, disrupting all the elections. Then, on January 18, 52, on the Appian Way, Clodius and his band unexpectedly encountered Milo's band. Milo was a candidate for the consulate. The skirmish was violent. Clodius was wounded, then taken to an inn and killed by one of Milo's slaves. This dishonorable death on the Appian Way unleashed the wrath of the people, which the Senate had a very hard time containing. Accused of murder and brought before a special court, Milo was defended by Cicero, quite clumsily, and the trial unfolded in a tense and hostile atmosphere for the great orator. Milo was spared capital punishment but was condemned to exile in Marseille. He died four years later, during the wars between Caesar and Pompey.[41]

Cicero's speech for the defense, the *Pro Milone*, has survived, not as he delivered it, in a rush, under threat, and trembling, but rewritten in the form of solidly constructed discourse, a model of the genre, studied in the author's lifetime in schools of rhetoric and still today in high school Latin classes. The argument is simple: Clodius was the aggressor, his death served as punishment for all his crimes at the same time as it rid Rome of a detestable tyrant. In this text and in many others that preceded it, Cicero uses all his eloquence to spew his bile against Clodius.[42] He reviews Clodius's youthful indiscretions, his licentiousness, depravity, and shamelessness, but he lingers especially on the Bona Dea affair, distorting the facts and inventing shocking details to render Clodius perfectly odious. Because he cross-dressed as a woman, he was debauched, effeminate, and homosexual, vices incompatible with holding public office. Cicero takes delight in describing Clodius's outfit during this scandalous episode: a yellow gown dyed with

59

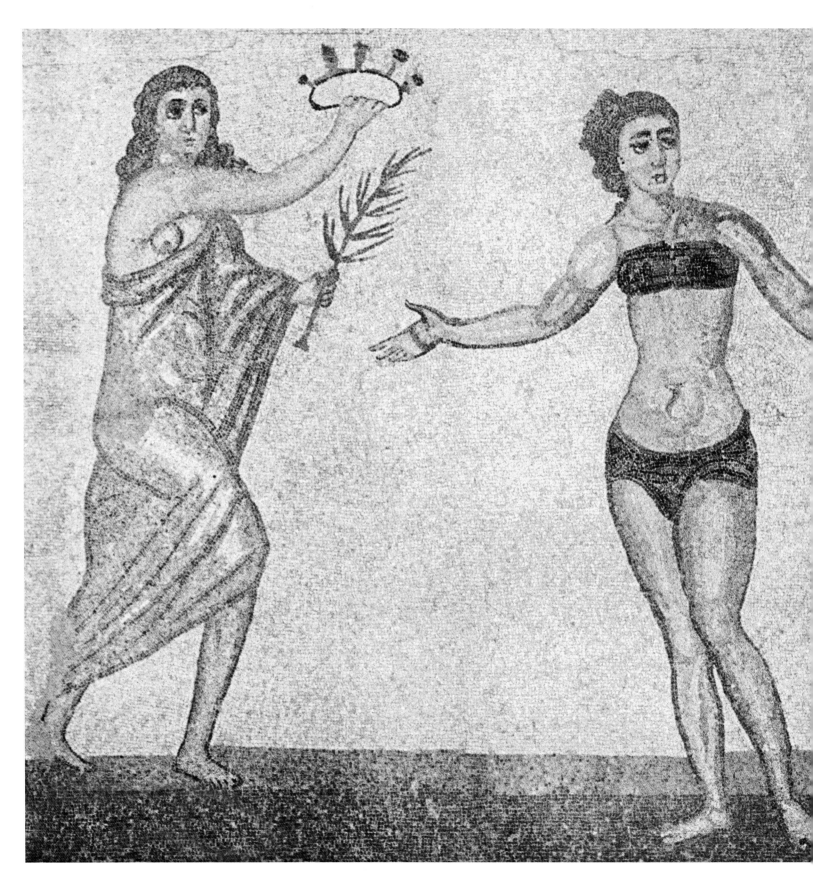

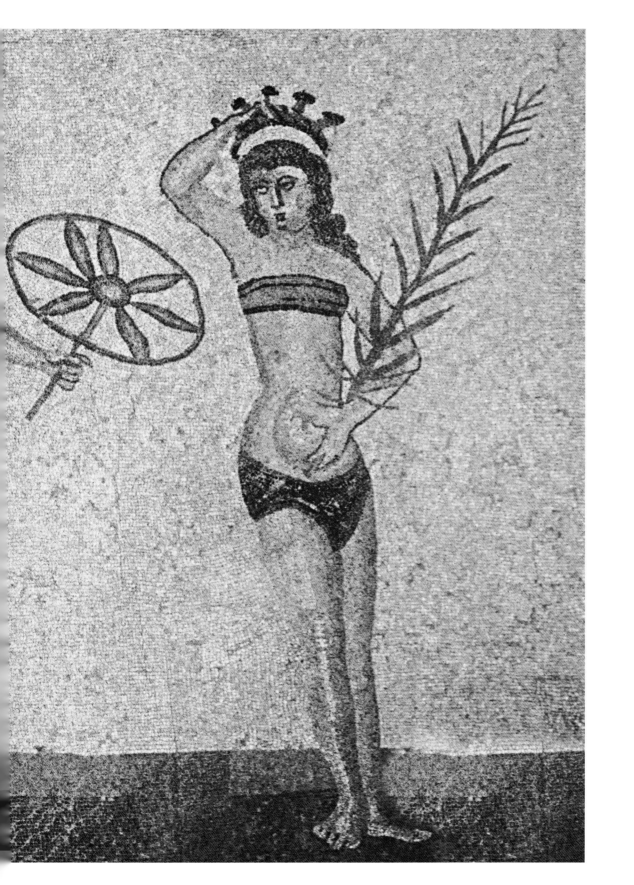

PREVIOUS SPREAD

The Underwear of Roman Women

This tile mosaic, one of the most famous and unexpected in Roman antiquity, presents ten young women practicing different athletic exercises. All of them wear a kind of two-piece bathing suit made up of a *strophium* (cloth band forming a bra) and surprising panties, not attested elsewhere.

One of them is being crowned the winner by a figure—man or woman?—dressed in a yellow toga. Tile mosaic found in the "chamber of young women in bikinis," Villa Romana del Casale, near the town of Piazza Armerina, Sicily, first quarter of the 4th century.

saffron (*crocata*), a long-sleeved tunic (*tunica manicata*), headdress in the form of turban (*mitra*), women's sandals (*soleae muliebres*), crimson ribbons and frills (*fascolae purpurae*), and even what we would now call a bra (*strophium*) meant to support a bosom that Clodius was apparently not lacking. To this typically feminine attire Clodius added a kithara to pass himself off as a female musician. To sacrilege was added shame, dishonor, and disgrace; not only had Clodius forced his way into Caesar's house, not only had he taken part in a ritual forbidden to men, but he had also cross-dressed as a woman, transformed his body, and made up his face (*effeminavit vultum*).[43]

In the long list of elements that constituted Clodius's disguise, the most interesting one in relation to our subject is that of the *crocata*, a long, elegant dress dyed with saffron. As yellow was the color reserved for female dress, any man who voluntarily wore it transgressed the social and moral order; he emasculated himself, abandoned his status as citizen, and could only be an imposter or debauchee, especially a debauchee or homosexual, if we are to believe a number of authors in the following centuries. That is

how Petronius in the *Satyricon* describes the participants at the famous Trimalchion banquet: the women and effeminates were dressed in yellow.[44] That is how Martial in two of his epigrams describes men who like to dress as women: one rents yellow *stolae* and violet *cingulae* (belts); the other rests on a bed draped with yellow.[45] That is how Juvenal, a few decades later, describes a reveler with feminine ways, reporting that he sometimes donned a sky-blue toga, sometimes a dress of pale yellow silk: this was a hypocrite and a homosexual.[46]

Only effeminate men or men disguised as women wore yellow. However, while Cicero employs a commonly used term, the adjective *croceus* (a beautiful bright orange yellow, like saffron), to describe Clodius's outfit, Petronius, Martial, and Juvenal all use a much rarer word, *galbinus*, hardly used in Cicero's time and still less frequently in the early empire. This is a derogatory adjective, describing a shade somewhere between pale yellow and greenish yellow, a sort of nasty yellow, as much on the chromatic as the social level.[47] Because despite its recent appearance, this word was not limited to the description of fabrics and clothing. Indeed Martial, in describing the *délicatus* who rented women's belts and dresses, wrote that he had *galbinos mores* (literally: yellow morals).[48] For Martial, the abstract as well as the concrete could be *galbinum*.

Whether referring to materials or morals, these notes are of great importance to us. They make us understand that in first-century Rome the various shades of yellow—from orange yellow to greenish yellow here—were considered part of a single family and could express the same idea, as in the case of femininity. Of course, between *croceus* and *galbinus* there is a wide range of shades, even a vast distance, but the color remains united conceptually in a single chromatic category: yellow. For red, black, and white, such a unity existed for a long time in Latin. But for yellow, that seems to be a novelty (unknown in Greek and other Near Eastern languages). And for green and blue, similar chromatic unities for each color's terms and shades had yet to

62

be established; for green, it would have to wait a few centuries, for blue, over a millennium.[49]

Another note, perhaps of even greater interest, involves the lexicons of our authors—from Cicero to Juvenal—in which the palette of yellows seems almost to be arranged as a spectrum, from orange to greenish tones, and not in the ancient color order generally attributed to Aristotle: white, yellow, orange, red, green, blue, violet, black. In this "Aristotelian" sequence, dominant in all areas of thinking and material life from the fourth century BCE until the seventeenth century CE, yellow and green are not adjacent; how could a shade of yellow tend toward green? Toward orange, perhaps, but never toward green. Not until the discovery of the spectrum in 1666 could certain shades of yellow finally be extended in the direction of green. But this spectral order of colors (violet, indigo, blue, green, yellow, orange, red) was unknown to the Greeks and Romans. Was it known to other ancient peoples? The Germans, for example? The adjective *galbinus*, which, for modern translators, seems to characterize a greenish yellow, in fact appeared quite late and probably derives from the most common word designating the color yellow in various Germanic dialects: *gelb* (a term that has survived in this form in modern and contemporary German).[50] Could the ancient Germans have been more attuned to the spectral order of colors than the Greeks or Romans? That is debatable. In this case, rather than an intermediary shade between yellow and green, did *galbinus* simply designate an ugly yellow, unpleasant to the Roman eye? That is an open question.

THE LESSONS OF THE LEXICON

Tiger Attacking a Calf

Latin authors knew little about the tiger, which they presented as an enormous lion with a striped coat. They made it into a symbol of swiftness and ferocity. Some stressed how the sound of a drum enraged tigers and how they were easily subject to drunkenness from the smallest drop of wine; this was a way of mollifying them. Under the Roman Empire, it was possible to see live tigers in circus acts. They were imported from India and more or less tamed in menageries. The name of the tiger (*tigris*) helped to create an adjective (*tigrinus*) to describe everything that is striped, speckled, or spotted yellow and black or brown. Colored marbles (*opus sectile*) from the basilica of Junius Bassus, first half of the 4th century. Rome, Capitoline Museums, Conservators Palace.

For the moment, let us see what various adjectives exist in Latin for describing the shades of yellow. There are many of them, but what is striking is the absence of one basic, reliable, recurrent term that takes precedence over all others, as is the case, for example, with red (*ruber*). This is all the more surprising because in Greek the term *xanthos*, describing bright, luminous yellows, does play such a role more or less, whereas other terms are employed more rarely and in more limited ways: *okros* (ocher yellow), *chloros* (greenish yellow), *chrysos* (golden yellow), *melinos* (honey yellow), *krokinos* (saffron yellow). Very often, moreover, the chromatic meaning of these words is relatively imprecise, conveying the effects of light or saturation more than a strictly material reality. According to Lucien Gernet's lovely expression, the Greek chromatic vocabulary provides the "feeling of the color" more than true color notations.[51] We must point out, however, that the terms used in the spoken language are practically unknown to us, and that, aside from medical texts, the texts where we can study the lexicon of colors in ancient Greek belong principally to the domain of poetry, literature, and history, not to daily life or material culture.[52] Hence the difficulties of translation and obvious anachronism when we try to convey through a modern color term a Greek word employed to render the play of light and matter, or even to create impressions. As it happens, these remarks may apply to Latin as well, but to a lesser degree, because the terms drawn from Latin encyclopedias and technical treatises came to enrich the abundant Latin poetic and literary lexicon more so than in Greek.

The most frequently used Latin adjective is *flavus*, but it is not in the least a basic term. Essentially it describes the yellows in nature when they are considered favorably (flowers, fruits, wheat, barley, honey, wax, sand, and the coats of certain animals, especially horses) as well as blond hair "like gold." It was hardly ever used for fabrics or man-made objects, and with regard to hair, it applied only to Greeks

and Romans. To describe the blond hair of Germans, Celts, or Slavs, the Latin lexicon purposely employed other adjectives, emphasizing the dull (*luridus*, *pallidus*) or reddish (*rutilus*, *russus*) tone of such blondness; flavus was much too honorific a term to be applied to such barbarians! That said, its etymology remains a matter of debate: does *flavus* belong to the large family of the word *flos*, "flower"? It could thus be a derivative of *florus*, which means not only "in blossom" but also "beautiful," "blond," and "rich." Or, as in its first usages, does *flavus* especially evoke the color of grains? If that is the case, it might be an ancient borrowing from the Gaulish *blavos* (yellow), itself derived from *blavo* (wheat), but this hypothesis remains tentative.

Fulvus conveys a darker yellow than *flavus* but still includes the idea of brightness or brilliance, even flashing or blazing. It is the color of the coats or plumage of certain wild creatures (lion, wolf, eagle), either admired or feared, but it is also the color of flames, lightning, stars, stormy weather, and syrupy wine. It must not be confused with the adjective *furvus*, which belongs to the range of browns and blacks and expresses the idea of physical or moral ugliness.

Moreover, dyeing provided the Latin lexicon of yellows with two commonly used words: *croceus* and *luteus*. The first describes a beautiful yellow tending toward orange, a yellow with a saffron (*croceus*) base or similar to saffron. It is a term that conveys value, expressing simultaneously beauty, brilliance, and prestige, and also, quite often, femininity. We have already defined the *stola crocota* as a long, elegant gown dyed with saffron and worn by matrons of the upper classes, and *infectores crocotarii* as dyers who specialized in saffron dye and formed their own guild early on, a powerful and respected one.

Luteus is a more generic adjective. It expresses no idea of beauty or prestige but is used to describe ordinary yellows, beginning with fabrics, whether or not they are dyed with weld (*lutum*), as well as plants and flowers, the complexion, the yolk of an egg, muddy water in rivers, the coats of cattle. Its palette seems expansive, from beige to orange and including all shades of the color yellow, from dull to luminous, pale to saturated. Thus *luteus* seems to confirm a certain unity among yellow tones in the eyes of the Romans, even though, as with *flavus*, it does not constitute a basic term.

Aureus speaks more of material than of color; its first meaning is "in gold," "covered with gold," or "gilded." By extension, it describes brilliant golds, like that of the sun, luxurious fabrics, or the most striking blond hair. But very often its meaning is more metaphoric than denotative, which is not the case with *croceus* or *flavus*, for which it sometimes serves as superlative. In medieval Latin, the use of *aureus* in a purely chromatic sense is more common and designates simply a beautiful yellow; in modern Latin, it sometimes is used to name the color yellow in an archetypal way and regardless of shade, notably in scientific works.

Luridus is the opposite of *aureus*; it is an impure yellow, vaguely muddy, dirty, or grayish. It describes the color of bile, diseased skin, withered plants, cheap fabrics, and sometimes the moon. *Pallidus*, always difficult to translate, is less negative; it applies especially to the color of a face drained of blood but can also evoke the pale yellow of a plant or mineral.

These are the principal adjectives signifying "yellow" in classical Latin. Other words exist, but are used rarely or in a specialized way. Let us mention: *ravus* (grayish yellow), *helvus* (yellowish like certain vegetables), *silaceus* (ocher yellow), *melleus* (the color of honey), *sulfureus* (the color of sulfur), *cereus* (the color of natural wax). To this list should be added *galbinus*, which we have already discussed and which probably does not designate a "greenish yellow"—as philologists and dictionary authors usually translate it— but rather a yellow that is disagreeable to the eye. A better translation would be "yellow in the German manner," clearly pejorative for a Roman in the classical period, especially with regard to cloth and clothing. Indeed, "barbarian" dyers did not use saffron or even weld to dye in yellow, but rather broom, gorse, nettle, fern, and even the leaves

of ash trees or the bark of alder, which, for lack of an effective mordant, penetrated textile fibers poorly and produced dull, washed-out tones. Could that be why the Romans were not very fond of German yellows?

In any case, there is no doubt about the origin of the word *galbinus*; its passage from the common Germanic *gelb* (yellow) to the Latin *galbinus* seems obvious, especially as an intermediary form *galbus* is attested very early.[53] It is this term, in conjunction with the derogatory diminutive *galbinus*, that designates a particularly vile yellow at the end of the first century BCE.[54] At first glance, borrowing this color term from a Germanic dialect hardly seems significant. Yet it would prove to be of great consequence to the history of the color yellow in Europe. Even though the use of *galbus* and *galbinus* remained limited in medieval Latin, these two words formed the basis for the term designating yellow in many Romance languages: the French *jaune*; the Italian *giallo*; the Romanian *galben*.[55] As with blue, the Latin lexicon of yellows was too weak and disorganized to resist the conquest of its chromatic field by a single, solid Germanic word: *gelb*.

Despite this weakness, the lexicon, through its diversity and referents, gives us a good idea of where Romans found yellow in their everyday environment and helps us to understand why they liked this color. Essentially, there were yellow plants, minerals, natural elements, and useful or noteworthy objects: magnificent flowers, delicious fruits, apicultural products, nourishing grains, precious stones and metals, hair like the rays of the sun, rich fabrics dyed with saffron. Roman yellows were most often beautiful, vivid, and saturated, closer to orange than to green: the yellow of gold, of course, but also the yellow of ripe grain (Ceres, goddess of the harvest and fertility, is blond, crowned with wheat, and often dressed in yellow); the yellow of numerous fruits (lemons were unknown, but citron served in its place, and quince was ubiquitous in cooking and medicine); the yellow of honey and wax (apiculture played a significant role in rural life), two gifts the gods offered to humans by way of bees. Bees were particularly venerated and possessed only virtues, at least if we are to believe the poets: modesty, chastity, courage, zeal, cooperation, solidarity, cleanliness, purity, wisdom, generosity, and devotion. Virgil dedicates an entire poem to them in his *Georgics*—perhaps the most beautiful Latin text in antiquity—and makes them the messengers of the gods, dispensers of divine essence on earth:

> There are in bees a part of the divine spirit, an emanation of the universal soul, dispersed in all living beings and then returned to the eternal principle once bodies have dissolved in death.[56]

The page is a full-page medieval manuscript illumination with surrounding Latin text that is largely illegible/handwritten and not reliably transcribable.

THE SILENCE OF THE BIBLE AND THE CHURCH FATHERS

The Golden Calf

The story of the Golden Calf destroyed by Moses is told in the book of Exodus (32:1–29). En route to the Promised Land, the Hebrew people, having recently left Egypt, asked Aaron for a god to guide them because they believed Moses to be dead (he had climbed Mount Sinai to receive the Ten Commandments). Aaron had all the golden jewelry worn by the women melted down to make a figure in the form of a calf, similar to the god Apis, a bull worshipped by the Egyptians.

The people immediately began to worship this new idol, thus provoking the anger of Moses when he descended from Sinai. Following God's command, he had the Golden Calf destroyed and all its worshippers killed. In medieval paintings that used neither gold nor gilding, the Golden Calf is simply represented by a yellow- or brown-colored bovine.
Mozarabic Bible, verse 960. León, Spain, Real Colegiata Basílica de San Isidoro, library ms 42, folio 46 r°.

Now let us leave Rome and the Romans and turn our attention to the peoples of the Bible. What does the holy book teach us about the place that yellow occupied in ancient Near Eastern cultures? Actually, nothing. Rich in terms for materials (gold, bronze, ivory, ebony, coral, and so on), the Hebrew Bible is remarkably poor in terms for color, and the Greek translation, the Septuagint, begun in Alexandria about 270 BCE, is hardly more colorful. All that changed, on the other hand, when the Bible passed into Latin. The first Latin translators tended to introduce chromatic adjectives where they had not appeared in Hebrew or Greek. And following this lead, Saint Jerome added a certain number at the turn of the fourth to fifth century, first when he revised the Latin text of the New Testament, and then when he retranslated the Old Testament directly from the Hebrew and Greek. In a general way, the biblical text has thus become more colorful over the course of centuries, versions, and translations, especially in the modern period with vernacular languages accentuating this phenomenon.

Let us consider a few examples. What the Hebrew terms "a magnificent cloth," Latin translates as *pannus rubeus* (a red cloth), and seventeenth-century French as *un tissu écarlate* (a scarlet cloth). Where the Greek says "sumptuous clothing," the Latin translation is *vestis purpurea* (a suit of crimson) and modern French, *un manteau cramoisi* (a crimson cloak). Moreover, red tones have no monopoly on this emphasis on color according to the translation. Adjectives in Hebrew or Greek meaning "pure," "clean," "new," and "bright" are translated into Latin as *candidus* (white), and others, like "dark," "disturbing," "obscure," "wicked," and "sinister" as *ater* or *niger* (black). This is why, beginning in the fourth century and until just after the year one thousand, the commentary written by the Church Fathers and their successors on biblical texts became increasingly rich in color notations. Thus they began to construct a symbolic color system hardly existent in antiquity. It continued

to be established during the early Middle Ages and would go on to exert its influence for more than a millennium in numerous areas of religious life (liturgy, dress), social practices (clothing, coats of arms, insignias, ceremonies), and artistic creation.[57]

These remarks, unfortunately, hardly concern the color yellow because it is practically absent from the biblical text, whether in Hebrew, Aramaic, Greek, Latin, or a vernacular language. Recent studies, first among them the ones by François Jacquesson, have shown that the red-white-black triad occupies 95 percent of the biblical palette, regardless of the language or version.[58] Red—all shades combined—represents by itself two-thirds of biblical color references; white, 20 percent; and black, 10 percent. That leaves only a handful for green, yellow, and brown. As for blue, gray, orange, and pink, they seem totally absent from the books of the Bible. At least as color terms, because there is obviously a mention, here or there, of sky, sea, ashes, coral, or sunrise, to cite a few examples. But their colors are not named.

Yellow and gold pose similar problems. While the color yellow is hardly mentioned in the Bible, the precious metal, on the other hand, appears abundantly. In certain books of the Old Testament, in fact, it occupies a significant place, as we have already noted. Must we henceforth assume that wherever gold is present, yellow is there as well? Nothing could be less certain. First of all, in biblical times, gold could take on all sorts of shades; furthermore, those shades

mattered less than gold's weight, purity, and brilliance. Ancient gold, whether actually real or totally metaphoric, was first material and light, well before being color.

Let us put gold aside then, and see if yellow is more directly connected with another mineral material of great worth: precious stones. In the Bible, these are mentioned individually on various occasions, but there are two lists that warrant our particular attention; the first occurs in the book of Exodus, the second in Revelations.

As the second book of the Old Testament, Exodus recounts the Hebrews' flight from Egypt and their journey led by Moses through the desert. Over the course of these events, the Hebrews made an alliance with a god who revealed to them his name ("I am the one who is") and promised them a land. There are many especially famous episodes: Moses on Mount Sinai, the ten commandments, the manna from heaven, the golden calf, the description of the tabernacle, the description of the high priest's garb. The description of the high priest's garb includes a pectoral (*hoshen*), that is, a large piece of orphrey covering the chest and inlaid with twelve precious stones, each representing one of the tribes of Israel (Exod. 28:15–21).[59] Here is a list of those stones: ruby, topaz, emerald, garnet, sapphire, diamond, opal, turquoise, crystal, aquamarine, onyx, jasper. Those are their modern names, but difficult questions of translation and identification arise for many of them. Moreover, associating them with precise colors is no easy

Morse Ivory

The Middle Ages left us a great number of ivory objects in a palette that goes from the milkiest white to a relatively dark chestnut, passing through the whole range of white, ecru, yellow, and brown tones, sometimes with pinkish, greenish, or grayish highlights. The shade depends on the nature of the ivory, conservation conditions, and the effects of time or lighting. On morse ivory, the patina is generally yellower and darker than on elephant ivory. That is the case with the famous chess pieces originating in Norway and discovered on the coast of the Isle of Lewis, northwest of Scotland. But those held in London, at the British Museum, have been cleaned many times and decolored, whereas those found in Edinburgh, at the National Museum of Scotland, have retained a beautiful dark patina, between yellow and brown.
Chess pieces from the Isle of Lewis, 12th century. Edinburgh, National Museum of Scotland.

Gold Clasp

Like the ancient fibula, the *fermail* (clasp) was an important accessory in medieval dress. It served to fasten together the two upper parts of a piece of clothing and to keep it closed at the neck, shoulder, or chest. Unlike the fibula, its perimeter (circle, oval, lozenge) was closed, and the surface fastened over the fabric was flat. When made of precious metal and decorated with stones, this brooch also served as an ornament and highlighted the rank or wealth of the one who wore it. In the late Middle Ages, it gave way to other kinds of fasteners, notably buttons and buttonholes.
Openwork clasp with eight granulations, 13th century. Paris, Musée de Cluny.

71

exercise. Some of them can take on many colorations, others change shades according to the light, and still others possessed a color in antiquity that is no longer generally associated with them today. That is the case with the opal and the topaz, whose colors vary greatly according to time period, description, and variety. Let us note nevertheless that in this first biblical list, yellow seems absent, unlike red, green, and even blue.

Is that also true in Revelations? In his final vision, John describes the place where the elect will go after the Last Judgment: the heavenly city of Jerusalem, luminous and bejeweled, resplendent with gold and silver, with chairs made of precious stones (Rev. 21:9–27). And here is the list: jasper, sapphire, agate, emerald, onyx, carnelian, chrysolite,

beryl, topaz, chrysoprase, jacinth, amethyst. The questions of translation, identification, and coloration are even more complex here than for the stones in Exodus, but yellow still does not seem to be involved. Only chrysolite and chrysoprase can present a few discrete yellow tones, but their coloration belongs more to the green range than the yellow range. And in addition to the difficulties posed by the lexicon are the varieties in coloration that any single stone may present.

Thus overall, we must recognize that yellow is absent from the rare biblical passages that are the least bit expansive about colors. When it is present, it is always indirectly so, by means of gold, wax, honey, saffron, or ripe wheat. The silence of the holy book explains the silence of the Church Fathers. They were hardly more forthcoming on yellow.[60] Their exegetic commentaries find no basis for discourse on this color, nor do they give it a place in Christian rituals and the liturgical practices associated with them. Even an "encyclopedist" like Isidore of Seville (560–637), who writes of dyes, pigments, inks, the color of clothing, and the colors used by painters, remains almost silent with regard

to yellow. As with his predecessors, red, white, and black are the colors that win his attention. Yellow is only mentioned in relation to the etymology of the adjective *croceus*, derived from the word "crocus," which refers to saffron.[61]

Among the Church Fathers, in the palette of yellows, gold occupies the entire field and early on became an object of debate. Was it light or matter? Was its presence in the church permissible? What role, for example, should be given to the precious plate in Christian worship? Was it not a useless luxury, a *vanitas*, an obstacle between the priest or the faithful and the divine? The responses to these questions vary widely, at least beginning with the Merovingian period. In the earliest Christian times, most authors were hostile to all that was precious and sumptuous. Subsequently, opinions became more nuanced, especially because some prelates were themselves goldsmiths—the famous Saint Eligius, for example, bishop of Noyen and adviser to King Dagobert—and as the influence of Byzantine practices grew

increasingly stronger. In Byzantium, in the interior of the church as well as on objects of worship, gold was omnipresent. That is why gold's presence increased in the great churches of the West, where it not only fulfilled liturgical and artistic functions (until the thirteenth century, the goldsmith's art remained exclusively for the church), but also played a political role.

Possessing gold was, in fact, a sign of great power. Hence the princes of the Church imitated secular princes and tended to hoard it in a great variety of forms: ingots, plates, rings, nuggets, and powders, as well as coins, jewelry, weapons, dishes, reliquaries, and objects of worship, not to mention fabrics and clothing enriched with gold thread. Over the course of time, the yellow metal maintained ever closer relations with the sacred and the powerful. It was not only hoarded but also displayed, transported (in processions, notably), offered, exchanged, received, coveted, stolen. Gold appeared to be "light materialized."[62] That God was "light" seemed to justify—even require—its abundant presence in the church, in the image of King Solomon's temple.

The first reactions against luxury and splendor in the great churches appeared at the end of the Carolingian period and became stronger during the eleventh century. We will discuss this further on. Let us emphasize here the complex connections that gold maintains with colors. Abundantly present in illuminations, enamel work and gold work, it seems to anchor colors (gold background), enclose them (frames, borders), control them, and stabilize them to make them more radiant. And since yellow was often absent from the palettes of painters and goldsmiths, it was gold that replaced it. Medieval gold was material and light, but it was also color.[63]

Reliquary of the True Cross

There are numerous Byzantine reliquaries that each claim to hold a fragment of the True Cross, the one on which Jesus was crucified and that Helena, the mother of Constantine, rediscovered during a pilgrimage to the Holy Land in 326. They bear the special name of staurothekes (from the Greek *staros*, cross, and *theke*, containing) and are generally made of richly ornamented precious metal. During and following the Crusades, many of these reliquaries were brought to the West and reworked, while other Western imitations were made in their likeness, thus multiplying the supposed relics of the True Cross. Reliquary from the church of Jaucourt, Aube, 12th and 14th centuries. Paris, Musée du Louvre.

Yellow in Insular Illumination

During the early Middle Ages, the palette of monastic illuminators working in the British Isles, notably Ireland and the Isle of Iona, differed a bit from that of their brothers at work on the continent: less gold, no black or white, hardly any blue and, on the other hand, much yellow. That is the case in *The Book of Durrow*, a book of the Gospels copied and painted toward the end of the twelfth century and long kept in the Durrow Abbey, located in the center of Ireland. Its famous "carpet pages," made from a complex network of interlacing, circles, crosses, and serpentine motifs, make abundant use of yellow, perhaps to replace gold. *The Book of Durrow*, Iona (?), late 7th century. Dublin, Trinity College Library, folio 125 v°.

73

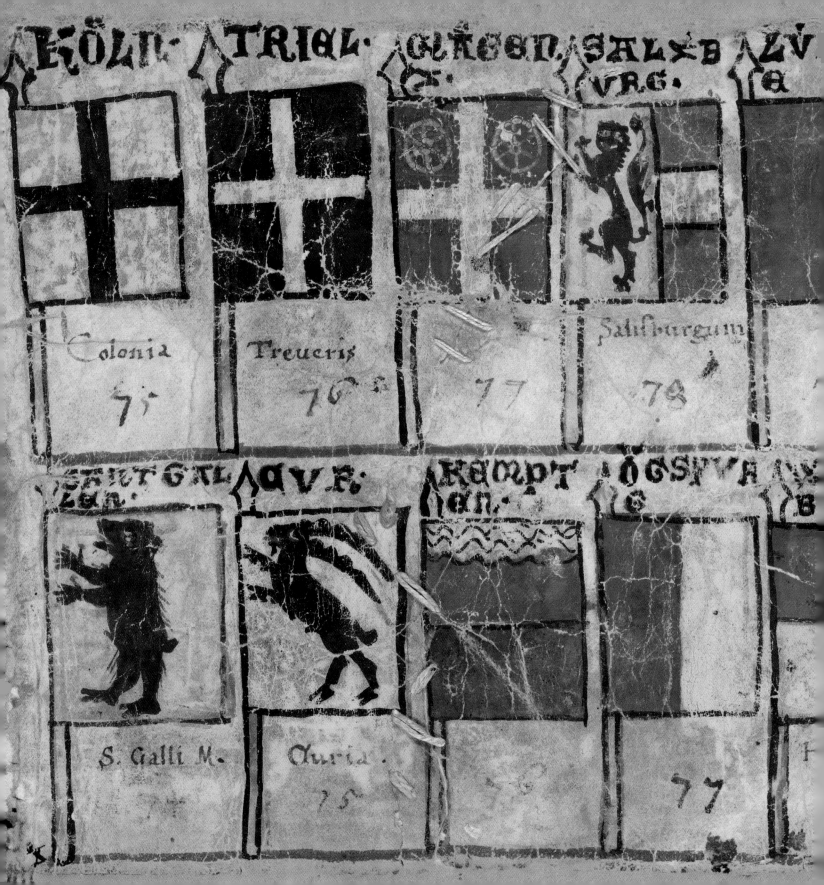

Colonia
75

Treueris
76

77

Salifburgum
78

S. GALL ZEN · AVR · KEMPT AN · AÓGSPVA N · B

S. Galli M.
74

Curia
75

76

77

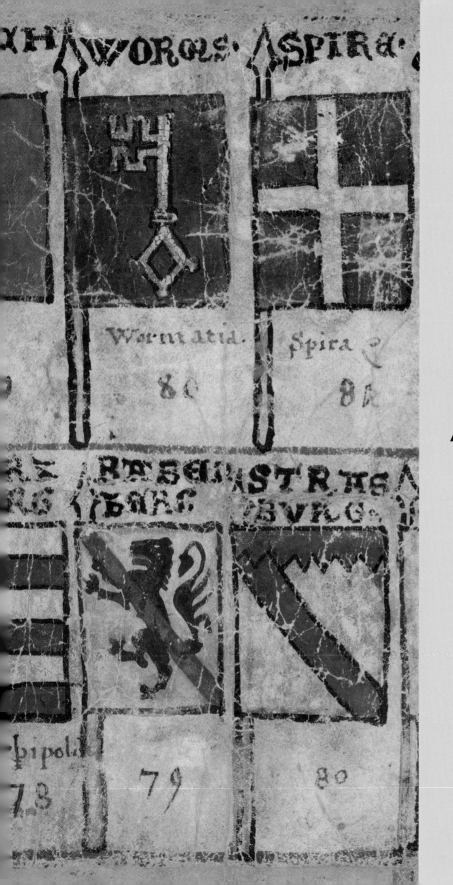

AN AMBIGUOUS COLOR

(SIXTH TO FIFTEENTH CENTURIES)

How and when in the West did color, long defined as matter, and then as matter and light, also become a concept, an abstraction, a thing in and of itself, distinct from its materiality and its medium: *the color* red, yellow, green, blue? Such chromatic entities, conceived in the absolute, removed from all context, seem hardly to have existed in antiquity. A Greek or Roman, for example, could say perfectly well, "I like red flowers," "I like yellow fabric," "I hate the blue clothing of Germans," but he would have had a hard time declaring, "I like red," or "I hate blue." Yet claiming to like or dislike one color or another posed no problem at the dawn of modernity. Thus it was over the course of the Middle Ages that the transformations took place that gave rise to what may be called "abstract colors," and by extension, to the symbolism of colors. This symbolism only truly and effectively comes into play once colors have become dematerialized and retain their meanings, regardless of the technique used to produce them or the medium in which they appear.

To study those necessarily slow, complex transformations, grammatical and lexical phenomena offer a rich area of inquiry, especially with regard to medieval Latin. How did color terms, which had long remained adjectives, slowly become standard nouns as well, not used to express a figurative or metaphorical meaning of the color as in classical Latin (*rubor, nigritia, viriditas*), but possessing a unique, literal meaning of *color*?[1] How did they replace the *color* + adjective syntagma (*color ruber, color croceus*), or the nominalized neuter adjective (*rubrum, croceum*) much less commonly used? That evolution seems to have occurred over the course of the twelfth century, a time when vernacular languages replaced Latin and began to use color terms as true nouns. They were first used to name colors—"Red is a beautiful color seen on…" "Yellow is a ugly color made through art…"—and then as common nouns, henceforth accompanied by the definite article: *the* (color) red, yellow, green, blue.

Two areas seem particularly fertile for examining these complex transformations and for attempting to trace their chronology and identify their various aspects: liturgy and heraldry.

PREVIOUS SPREAD
Heraldic Banners

The banner is a feudal emblem in rectangular form, the long side parallel to the pole. It often bears the same figures and colors as coats of arms. Yellow (*or* in heraldic terms) is not the most frequent color. Red (*gueules*) and white (*argent*) appear more often, especially in Germanic countries. *Wappenrolle von Zürich*, banners of bishops and abbeys (Germany, Switzerland, Austria, Alsace), c. 1335–40. Zurich, Musée National Suisse.

The Suicide of Judas

The Gospel of Matthew (27:5) recounts how Judas, seized with remorse, returned the thirty denarii, the reward for his betrayal, to the high priests of Jerusalem, admitting to having delivered an innocent man, and then went to hang himself. In images, this suicide does not strip him of his yellow robe, his most recurrent attribute. *Bible historiale moralisée*, Naples, c. 1350–55. Paris, Bibliothèque nationale de France, ms. français 9561, folio 174.

THE ABSENCE OF YELLOW IN CHRISTIAN WORSHIP

Byzantine Gold

Gold is everywhere in Christian Byzantine art, where it usually evokes divine light. That is the case with this mosaic representing Christ Pantocrator, his right hand raised in blessing, his left hand holding the Bible. Following tradition, he is dressed in dark blue. The gold mosaic pieces are made of molten glass embedded with thin pieces of gold leaf, which creates an intense effect of brilliance and light. *Mosaic of the Empress Zoe (detail)*, 11th century. Istanbul, Hagia Sophia Museum, south gallery.

The long, echoing silence of the Bible and the Church Fathers on yellow explains why it is absent from the liturgical color code, gradually established between the Carolingian period and the twelfth century. The theologians, prelates, and clerics who favored the color code's appearance and then its expansion could find nothing, no biblical text or patristic commentary, to justify the use of yellow in the rites associated with feast days, their importance, meanings, or the fabrics and clothing chosen to celebrate them. For red, they had at their disposal everything they needed; not so for yellow. In a more general fashion, the silence of the Bible and the Church Fathers also explains why in medieval culture—and the liturgy played an essential role in this matter—the symbolism of yellow developed much later than that of red, white, black, and even green, and why it was more a question of images than of texts.

Let us stay with the liturgical color code for the moment.[2] In earliest Christian times, officiants celebrated the worship service in their everyday clothes; hence, there was some variety and a predominance of white or undyed garments. Subsequently, white came to be reserved for Easter and highest holy days, with most authors agreeing to consider it the color endowed with the greatest dignity. For a long time, however, practices varied widely from one diocese to another, especially because, beginning in the ninth century, gold and brilliant, saturated colors made their appearance into the rich fabrics and garments used for worship. Along with this movement came the compilation of speculative treatises on color symbolism; the number of colors mentioned varied, but authors did their best to annotate them with reference to the Scriptures. Yellow—as we might expect—was not among them.

There is also the question of whether these first liturgical texts on colors—texts that were often anonymous, difficult to date, and sometimes difficult to understand—had any impact on actual worship practices. Neither archaeology nor iconography (where dark colors seem to dominate)

78

79

When Yellow Is Not Gold

In medieval illumination, yellow and gold are not one and the same. Each has its own status and produces its own effects. This painting representing the *Annunciation to the Shepherds*, in a lavish manuscript from the scriptorium of the Abbey of Reichenau on Lake Constance, offers a good example. Gold evokes divine light whereas yellow is used to paint the angel's garb and the wool of the sheep. Symbolically different, gold and yellow had to be chromatically different as well.

The Pericopes of Emperor Henry II, Abby of Reichenau, early 11th century. Munich, Bayerische Staatsbibliothek, Clm 4452, folio 8 v°.

confirms this. On the other hand, their words are echoed in the texts of the great twelfth-century liturgists (John of Avranches, Honorius of Autun, Rupert of Deutz, Jean Beleth), all more normative than descriptive. Nevertheless, beginning in this period, the practice of associating a color with a feast or a time in the liturgical calendar is already well attested in most of the dioceses of Roman Christendom, even if differences between the dioceses remained great.

Then came Cardinal Lotario, the future Pope Innocent III. In about 1195, when he was only a cardinal-deacon and Pope Celestine III, an enemy of his family, had briefly removed him from Church government, Lotario wrote many treatises, among them a treatise on the mass, *De sacro sancti altaris mysterio*. It was a youthful work, sometimes considered unworthy of the great Innocent III; as was his practice, the young scholastic included in it many citations and compilations. Although this marks it as a work of its time, its value for us is that Lotario summarizes what was written previously. Moreover, with regard to the colors of fabrics and clothing, the account is all the more valuable because it describes the practices of the Roman diocese on the eve of Lotario's own papacy. Until then, Roman practices might have served as a point of reference for liturgical matters, but they hardly had normative import throughout Christendom, as bishops and the faithful often remained attached to local traditions. Thanks to the immense prestige of Innocent III, things changed over the course of the thirteenth century. The idea took hold that what was done in Rome ought to have official standing. What is more, the writings of this pope, even youthful works, became "authoritative"; that was the case with the treatise on the mass. The long chapter on colors was not only echoed by all the liturgists of the thirteenth century, but it was also put into practice in numerous dioceses, some of them very far from Rome.[3]

We do not have space here to describe in detail the distribution and symbolism of colors throughout the liturgical year as Cardinal Lotario presented them. Let us summarize

PAGE 83

Innocent III and Francis of Assisi

Although not the subject of the scene, this mural painting by Giotto brings together two individuals with different ideas on color. Pope Innocent III (1160–1216), when he was still a cardinal, wrote a treatise on the mass containing an important chapter on liturgical colors, necessary for conducting Christian worship services. Saint Francis (1182–1226), on the other hand, was an enemy of color, or rather of dyeing; for the monastic order he had just founded, he wanted robes of only natural, undyed wool. *Giotto, Francis of Assisi receiving the approval of his first rule by Innocent III,* mural painting, c. 1297–99. Assisi, Basilica of Saint Francis, mother church.

Apostles Dressed in Yellow

In miniatures, Judas began appearing dressed in yellow in the twelfth century, but he has no monopoly on that color, far from it. In this full-page painting from a famous psalter, from the scriptorium of Saint Alban's Abbey in England (Hertfordshire), many apostles including Saint Peter himself (*left*), are wearing this color. Is Judas among them? If we consider the subject of the scene (taking place after the Resurrection), and if we count heads (eleven), it seems unlikely. *Saint Alban's Psalter,* Mary Magdalene announces the resurrection of Christ to the apostles, c. 1120–23. Hildesheim, Lower Saxony, Mariendom Cathedral library, HS 1.

the principal elements. White, the symbol of purity, was used for the feasts of the angels, virgins, and confessors, for Christmas and Epiphany, for Maundy Thursday and Easter Sunday, for the Ascension and All Saints' Day. Red, which recalls the blood spilled by and for Christ as well as the fire of the Holy Spirit, was used for the feasts of the apostles and the martyrs, for those of the Cross and for Pentecost. Black, linked to mourning and penitence, was used for masses for the dead as well as during the time of Advent, for the feast of the Holy Innocents, and for the Septuagesima at Easter. And green, finally, was called on for days when neither white, red, nor black was suitable, because—and this is a most interesting note—green was an intermediary color between white, black, and red.[4] In this code, simultaneously liturgical and chromatic, there is no question of either blue or yellow. At the end of the twelfth century, blue had yet to experience its great social and symbolic promotion. That would take place over the following century, but it would then be too late for blue to find a place in the Christian color order, henceforth determined. As for yellow, as we have said, it left all the liturgists and theologians perplexed. On the one hand, the Bible and the Church Fathers did not speak of it, and thus its symbolism was almost nil; on the other hand, gold was omnipresent and played the role of a color when it came to completing the liturgical palette constructed around red, white, black, and green. Nowhere, either on the scriptural or material level, did yellow find its place.

Although more descriptive than normative, Cardinal Lotario's text moved in the direction of unifying the liturgy. Its renown continued, thanks to the famous *Rationale divernorum officiorum*, compiled by Guillaume Durand, Bishop of Mende, about 1285–86. This work in eight books, constituting the largest medieval encyclopedia of objects, signs, and symbols tied to the celebration of divine worship, actually repeats Lotario's chapter on colors, develops allegorical considerations and symbolism, completes the cycle of feasts, and establishes a system belonging to all of Christianity based on what was originally only a description of Roman practices. Because we know that many hundreds of *Rationale* manuscripts have survived, that it was the third book printed, after the Bible and the Psalter, and that there were forty-three incunabulum editions of it, we can appreciate the influence such normative and symbolic discourse on colors could have had in the West. Once again, sadly for us, yellow never found its place there.[5]

This gradual expansion of the liturgical color system between the Carolingian period and the thirteenth century was not an isolated phenomenon. It was part of a vast color movement involving the decor of churches (polychromatic architecture and sculpture, historiated murals, stained-glass windows, furniture) that requires us to consider archaeology and liturgy together in order to study it. Within a building, all the colors, whether permanent or ephemeral, whether on stone or parchment, glass or fabric, speak and respond to one another. In the church, color articulates space and time, distinguishes actors and places, expresses tensions, rhythms, accents; it is necessary to the theatricality of worship. But, to complete the picture, we must go further and consider archaeology and liturgy in relationship to another discipline: heraldry.

Historians recognize that the first effective attempts to establish a color code for liturgical fabrics and clothing were contemporary with the beginning of heraldry. The two codes resemble each other. As with the colors in coats of arms, liturgical colors existed in a limited number and could not be combined indiscriminately. As in heraldry, these were abstract, conceptual, single colors, and their shades did not count. That is why the theologian, like the herald, could attribute a strong symbolic dimension to them. Nevertheless, unlike the liturgy, heraldry recognized yellow and even made wide and double use of it.

Von Stain. Schwaben

YELLOW IN HERALDRY

Yellow of Heraldry

In the French language of heraldry, the color yellow is *or*, and has been since heraldry's beginnings in the twelfth century. But in representations of coats of arms, artists and artisans long used yellow rather than gold. We can still see this in an illumination from the mid-fifteenth century showing the coats of arms of the von Stein family (Swabia): *d'or à trois crochets à loup de sable*. In the modern period, however, gold gradually came to be used more frequently than yellow and greatly transformed heraldic art. *Scheiblersches Wappenbuch,* c. 1450–55. Munich, Bayerische Staatsbibliothek, Cod. icon. 312 c.

The appearance of coats of arms over the course of the twelfth century constitutes an essential turning point for the color yellow, indeed almost a second birth. For the first time in Europe, a system of signs constructed largely on color granted yellow a primary place. What the liturgy had never succeeded in doing, heraldry achieved in a few decades: moving from three (white, red, black) to six basic colors (white, red, black, green, yellow, blue). For the first time as well, yellow was granted symbolic meaning all its own, independent of its materiality or medium. Henceforth there is "the (color) yellow," an abstraction, no longer just some yellows varying according to pigment, dyestuff, light, and technique. Now, after a long delay, this color could quickly catch up to red, white, and black in the area of emblems and symbols. Still tentative in the twelfth century, yellow's symbolism grew richer in the centuries that followed and then expanded into domains beyond heraldry.

As they appeared on battle and tournament fields and then as they spread rapidly throughout society to establish identity and mark property, coats of arms were composed of two elements: figures and colors, showing up on a shield defined by a perimeter whose form had no significance. The triangular form, inherited from medieval shields, was not at all obligatory, it was simply the most common. Within the form of the shield however, colors and forms could not be used or combined indifferently. They obeyed rules of composition, limited in number but restrictive, and mainly concerned with the use of colors. There were six of these, which gradually—and largely thanks to the influence of heraldry—became the six basic colors of Western culture: white, yellow, red, blue, black, and green.[6]

The six colors of heraldry were absolute, conceptual, and almost abstract; their shades did not count. Yellow, for example, could be light, bright, saturated, diluted, closer to orange, or closer to beige; it could be conveyed by gold or gilding, take on a shade of lemon, straw, honey, mustard, and so on. This had no importance or meaning; what

counted was the idea of yellow, not its material expression. One practice is consistent throughout medieval documents presenting painted coats of arms, however; heraldic colors are most often clean and luminous. Red is a true red; blue and green are bright and clear; as for yellow and white, until the end of the twelfth century, they were generally represented by yellow and white, but after that they could be conveyed by gold or silver, which is quite unpleasant to the eye (at least to our eyes today).

In the modern period, this absolute, almost abstract nature of heraldic colors was adopted by the code for flags; here as well, shades had no importance. That is still the case today. No constitutional text, for example, defines the blue and red of the French flag, nor the yellow and red of the Belgian flag, the green of the Italian or Irish flag, the blue of the Greek or Swedish flag; these are emblematic and thus abstract colors. They can also be manifested in all sorts of shades—which change with the weather when they are flown outdoors—without affecting the flag's power in the least. That is one of the many legacies of medieval heraldry.[7]

Their shades do not matter, but the way the six colors are combined in coats of arms obeys strict rules; some combinations are permitted and others are forbidden. Heraldry divides its six colors into two groups: in the first group are white and yellow; in the second are red, black, blue, and green. The fundamental rule for using these colors forbids juxtaposing or superimposing two colors that belong to the same group. Let us take the case of a shield with the figure of a lion. If the field is red, the lion could be white or yellow, but not blue, black, or green, because these last three colors belong to the same group as red. Conversely, if the field of the shield is yellow, the lion could be red, blue, black, or green, but not white. This fundamental rule existed from the beginning of heraldry and was always respected everywhere (in the Middle Ages, violations rarely exceed 1 percent of cases in any given group of coats of arms). It is possible that it was borrowed from banners and first linked to issues of visibility since the first coats of arms, nearly all

dichromatic, were visual signs made to be seen from a distance in the heat of battle.

In heraldry, colors constitute an essential element, because there are many coats of arms without figures, but no coats of arms without colors.[8] The repertoire of figures is obviously much larger than the one of colors. In truth, it is limitless; any animal, plant, object, or geometrical form may become a figure on coats of arms. Over the centuries, new figures continually enriched this repertoire; from about forty figures commonly used in the Middle Ages, the number grew to more than two hundred in the eighteenth century.

Everything explained thus far is relatively easy to comprehend. What makes understanding heraldry more complicated for nonspecialists is the existence of a heraldic language all its own, particularly effective (with few elements, it conveys much information) but often far removed

Frequency of Yellow (*Or*) in Coats of Arms

The great number of medieval coats of arms with colors that are known to us (about 250,000 for the period extending from the mid-twelfth century to the late fifteenth century) can provide us with various statistics on the frequency of colors: according to time, place, class, and social category. Overall for the period, red (*gueules* in the language of heraldry) is the color used most often, followed by white (*argent*), and yellow (*or*). Blue (*azur*) and black (*sable*) lag far behind, and green (*sinople*), even farther. In Normandy (here is a page of Normand shields), the *or/gueules* combination is by far the most frequent, as in England, southern France, and northern Spain. *Grand Armorial équestre de la Toison d'or*, c. 1435–38. Paris, Bibliothèque de l'Arsenal, ms. 4790, folio 65 v°.

87

The First Franc

On September 13, 1356, King John the Good of France was defeated and taken prisoner at the Battle of Poitiers. He was first taken to Bordeaux and then to London. In the Treaty of Brittany (1360), an enormous ransom was demanded for his release. Upon returning to France, he created a coin with a high gold content (3.88 grams of fine gold) of great liberating value: it served in part to pay his ransom. The name *franc* that it was given is difficult to interpret. Was it because the coin had set the king free? Was it an honest (*frank*) coin, that is to say, of sound quality and not to be devalued? Or was it simply a borrowing from a word in the legend: . . . REX FRANC/ORUM?

Franc à cheval du Dauphiné coin, 1364. Cabinet des médailles, Monnaies royales II, 774.

from ordinary language. According to country or tongue, it is more or less intelligible by the nonspecialist. It is in French and English that the discrepancy is greatest. Someone who knows nothing about heraldry will understand almost nothing in a description of coats of arms in armorial terms, especially in English texts where, even today, heraldry uses the Anglo-Normand in which it was written in the thirteenth century. In Italian and Spanish, the gap is smaller; in German, Dutch, and Scandinavian languages, it is minimal, the color terms and syntactical turns being closer to those of the standard language. Moreover, both in French and in English, the discrepancies developed only gradually. In the thirteenth century, heralds describing the coats of arms of tournament participants to the spectators were still understood by the public; their language was more or less that of literary texts. By the fifteenth century, in the time of the first treatises on heraldry, heralds complicated it on purpose to make themselves indispensable. Later, seventeenth-century scholars added many useless distinctions to it, falling into the trap of pedantry and finally making heraldic descriptions entirely unintelligible to the layman.

In the French language of heraldry, the most widely used in the Middle Ages and sometimes very far from the French realm, the six colors bore specific names: *gueules* (red), *argent* (white), *or* (yellow), *azur* (blue), *sable* (noir), and *sinople* (green), the colors cited here in the order of frequency. These terms did not all appear at the same time; *or*, *argent*, *azur*, and *gueules* (the etymology of this last term is obscure[9]) existed from the beginning, that is, as early as the second half of the twelfth century. *Sable* (the name of sable fur) is more recent, and *sinople* began to be used as a synonym for green only in the mid-fourteenth century. Before then, one simply said *noir* (black) or *vert* (green).[10] Similarly, at the beginning of heraldry, to name the color yellow in Old French, *or* or *jaulne* could be used interchangeably. Then over the course of the thirteenth century, the word *or* definitively emerged as dominant even though the heraldic color most often remained yellow. This was not without consequence for the prestige and significance of this color, which heraldic treatises at the end of the Middle Ages sometimes likened to ordinary yellow, sometimes to the precious metal.[11] That is how its symbolism became double.

89

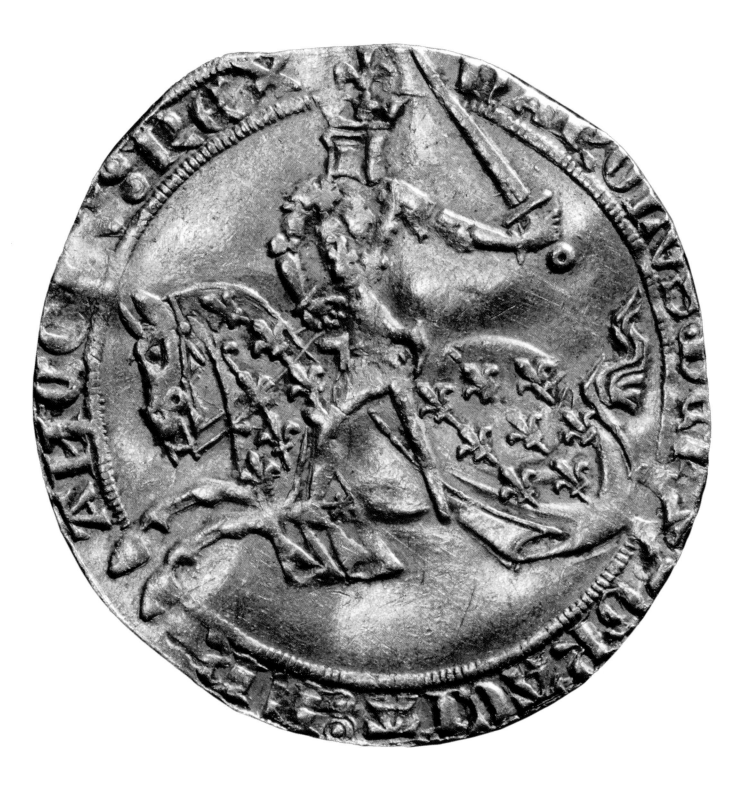

AN AMBIVALENT SYMBOLISM

Horses' Quarter Sheets

Not used in war, the quarter sheets worn by horses made their appearance in the second half of the twelfth century in tournaments, where they gradually became an essential element. Subsequently, they were seen as well at jousts, passages of arms, displays, and parades of all kinds. They could be in the colors of coats of arms or could even reproduce them in their entirety (seen here for the Capodilista family of Padua: *d'or au cerf de gueules*). But they could also be monochrome, sometimes in accordance with a chromatic code decided in advance. By the late Middle Ages, they were usually decorative. *Codex Capodilista,* c. 1438–40. Padua, Biblioteca civica, folio 22.

We are offered an early example of this ambivalence by way of a narrative motif recurring in Arthurian romances in the twelfth and thirteenth centuries, in verse as well as prose: the sudden appearance in the story of an unknown knight bearing a monochromatic shield—*plaines* as in Old French. Moreover, it is often not only his shield that is monochrome, but also his banner, coat of arms, and his horse's quarter sheet; from head to toe, the knight and his mount are entirely dressed in the same color. In general, such a knight appeared on the occasion of a tournament, or he appeared on the hero's path, challenged him, and led him into new adventures. This episode often constitutes a foreshadowing: the color attributed to the unknown knight is a way for the author to let the reader sense what is going to happen. In this type of literature, the color code is consistent and meaningful. A black knight, for example, is not in the least a bad or perfidious knight, but only an individual of the highest order (Tristan, Lancelot) who seeks to hide his identity for the moment; in general, he is on the hero's side and ready to display all his valor, especially in a joust or tournament. A red knight, on the contrary, is often hostile; this is a cruel, violent, or wicked knight, sometimes a demonic being from the Other World. More discreet, the white knight is generally seen as good; this is an older character, a friend or protector of the hero, who gives him wise council. Conversely, a green knight is a young knight, recently dubbed, whose audacious or insolent behavior will be the cause of disorder.[12]

Two facts of note regarding this literary topos: first, the absence of a blue knight, a color clearly still too weak on the symbolic level to play a significant role in such a context; second, the ambivalence of the yellow knights—sometimes they are viewed favorably, sometimes unfavorably. In the first case, they are kings or princes whose aid, protection, and friendship are going to prove invaluable to the hero. In the second case, they are treacherous knights, traitors to

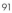

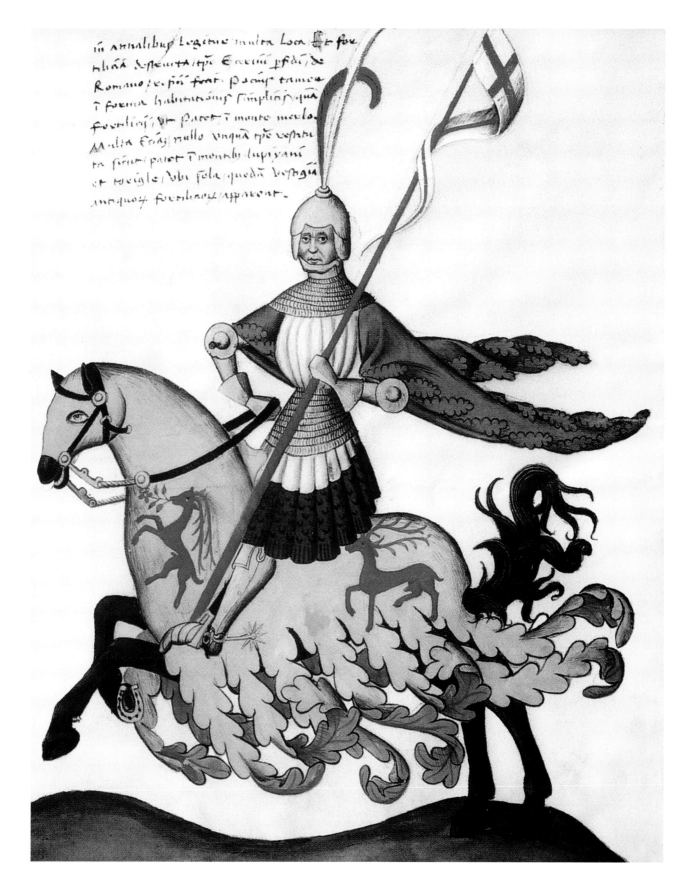

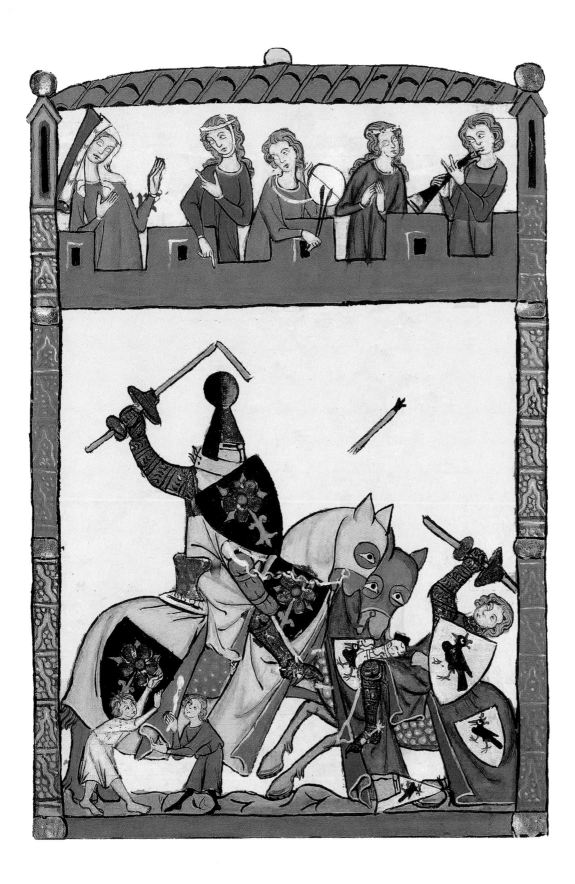

The Yellow Knight

In thirteen-century French and Anglo-Normand chivalric romances, there was a color code for the monochrome shields that knights carried and the matching quarter sheets worn by their horses. Most often, a red knight was a bad knight, driven by dark intentions. A black knight could be good or bad but sought to hide his identity. A green knight (*right*) was a young knight whose impetuous behavior would lead to disorder. On the contrary, a yellow knight was often calm and wise, sometimes of high rank. In this literary code, more or less respected in romances in Middle High German, there was no blue knight.

Codex Manesse, Zurich, c. 1300–1305. Heidelberg, Universitätsbibliothek, Cod. Pal. germ. 848, folio 192 v°.

92

OPPOSITE

Man-of-Arms with Armorial Tabard and Banner

These armorial bearings belong to a member of the Courtenay family, English earls of Devon (Powderham branch?). In heraldic terms, they can be described as *d'or à trois tourteaux de gueules, au lambel d'azur.*

Sir Thomas Holmes's Book of Arms, part 3, c. 1490–1510. London, The British Library, ms. Harley 4205, folio 59.

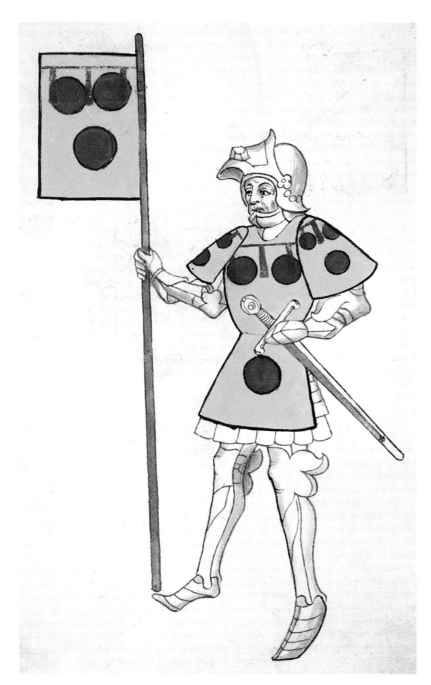

their lords and motivated by very bad intentions. We will discuss this further on.[13]

This double meaning for yellow in the world of the chivalric blazon appears abundantly in the manuals and treatises on heraldry from the late Middle Ages. Mostly written by heralds, these relatively numerous texts go on at length about colors, their nature, hierarchy, and meanings, not only in the domain of heraldry itself but also on a more general level, thereby constituting a rich source for identifying the value systems underlying the chromatic codes of the late Middle Ages, especially regarding customs of dress. For these authors, the discourse changes and the color hierarchy is reversed, according to whether yellow is considered to be ordinary yellow or gold.

Classifying colors in the order of "nobility" was one of the favorite preoccupations of the heralds. If yellow was considered as gold—*or* was its very name in the language of heraldry—it came first, followed by white, red, blue, green, and black. But if it was only ordinary yellow, it ranked lower, and the hierarchal order was then as follows: red, blue, white, yellow, green, and black. Some heralds in service to the king of France or to princes of the house of France preferred to place blue, the field of royal blazons, before red; others, more enamored with religious symbolism, made white the most virtuous of colors. Those cases were rare, however.

PAGE 95

Lancelot Wearing Yellow

In the romance *La Mort le roi Artu*, which had emerged by 1215–20, the Lady of Escalot dies of unrequited love for Lancelot. But it would be a mistake to see the color yellow, worn by Lancelot in this late fourteenth-century miniature, as symbolic of lying or treason. Lancelot did not betray her, just as he did not betray Queen Guinevere. Here, he is simply dressed as great lords dressed at the courts of Milan dukes in about 1380. *Lancelot du Lac* and *Queste del Saint Graal* (compilation), Milan, c. 1380–85. Paris, Bibliothèque nationale de France, ms. français 343, folio 106.

Here, in slightly modernized language, is what an anonymous herald, probably a Norman or Picard, wrote sometime around the 1440s. He likens yellow to gold and makes it the noblest of colors:

The first color in heraldry is yellow, which is called *or* in coats of arms. The reason is that by its nature, gold is bright, strong, and shining, as a beautiful color must be. It is full of virtues and comfort, to the point that master physicians (doctors) advise showing this color to a man who is very weak, near death; it will give him back his strength. Yellow is compared to the sun, the most noble of lights. Among stones, it resembles the topaz and beryl, stones very fine and precious. Among the four elements, it is associated with fire, as is the color *gueules*, but in the Zodiac, it is the lion that it represents, and in the days of the week, Sunday. Among virtues, it signifies nobility, courage, and honor. That is why no one must bear this color in his arms if he is not of noble lineage, a powerful lord, and very valiant knight in battle.[14]

It is difficult to praise gold more highly, and, by extension, the color yellow. But half a century later, an anonymous author, perhaps from Lille or Brussels, had something very different to say when he compiled the second part of a work destined to become famous: *Le blason des couleurs en armes, livrées et devises*. To the discourse of his predecessors he added a few points on the symbolism of dress; these are rather unfavorable toward yellow:

Yellow, said Aristotle, is located halfway between white and red, but closer to red; and thus we can see that it is more in accordance with red than with white by reason of its strong light, similar to that of fire. . . . This color is made by nature and by art and is of three types: the first is medium yellow which is a common color; the second is lighter and thus is a beautiful color; the third tends toward red and is an ugly color that we call yellow-orange. In urine, this yellow is a sign of bad humors, as that which is seen for jaundice. Among virtues, yellow signifies well-tempered strength and richness; but it is more often a bad color and then signifies craving and pleasure at possessing, lying and pretense, and even perfidy. In livery, it is a color that is worn by those of low condition, pages, footmen, and valets. Nowadays it is a color of mediocre reputation; that is why it is often worn with another color. With gray, it means many worries, but with black, constancy in all things, and with violet, joy in love.[15]

In most surviving manuscripts and printed copies, this *Blason des couleurs* follows a small manual on heraldry attributed to a famous herald named Jean Courtois and known as the Sicily Herald. It enjoyed considerable success. Printed in Paris in 1495, it was reprinted in 1501, and then six more times until 1614.[16] Meanwhile, it was translated or adapted into various languages (first Italian, then German, Dutch, and Castilian). It had great influence in various domains, notably literary and artistic ones. Rabelais alludes to it several times in his *Gargantua*.[17] Many sixteenth-century Venetian painters borrowed from its codes to dress in one color or another the figures they presented. Those dressed in yellow are more negative than positive.

On the other hand, those with blond hair are almost always seen in a positive light. This was already the case in Roman antiquity and the feudal period; it was still true in Venice in the sixteenth century. It is worth pausing here because blondness represents one of the rare positive aspects of the color yellow.

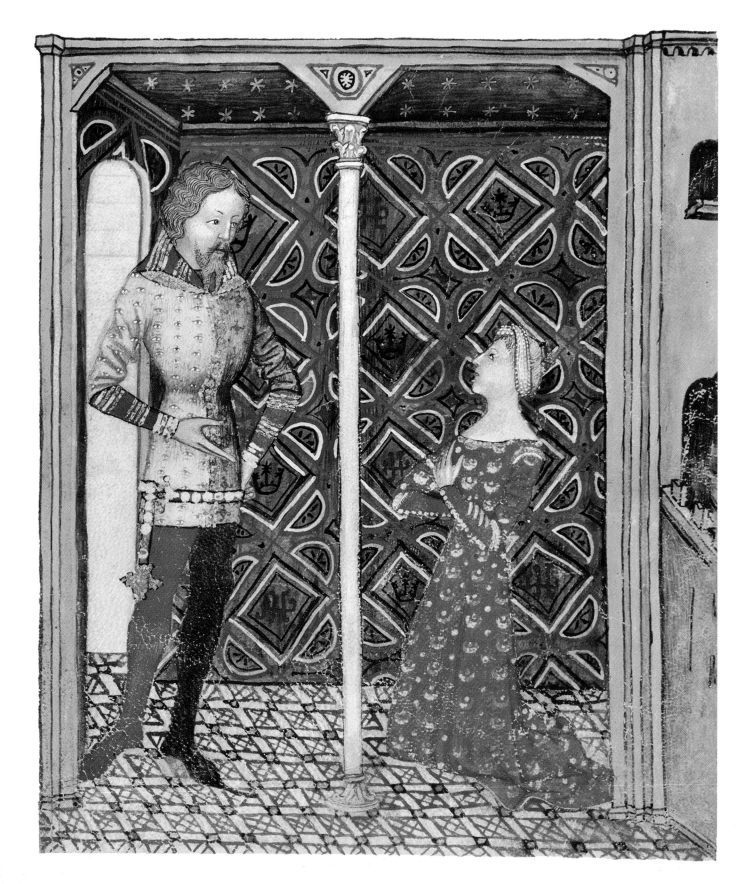

THE PRESTIGE OF BLOND HAIR

A Saint Dressed in Yellow

Attributed to the young Pietro Lorenzetti, this panel, from an altarpiece now dismantled, has not yet revealed all its mysteries. Who is this saint who originally accompanied a *Virgin with Child*? Saint Agatha and Saint Margaret are the names most often proposed. But Agatha, a virgin and martyr, is often represented holding a palm leaf or a candle, or even bearing on a platter her two cut-off breasts. As for Margaret, although she often holds a cross, recalling the one that allowed her to escape the belly of a dragon, she is generally dressed in green, not yellow. The patron saint of pregnant women, she wears the color of hope. Pietro Lorenzetti, *Sainte Marguerite* (?), c. 1320. Le Mans, Musée de Tessé.

L et us go back three centuries to the period of chivalry and courtly love, when blond hair very often signified nobility, honor, love, and beauty. Of course the Middle Ages had invented nothing in this regard; many Greek deities had already been endowed with blond hair, beginning with Apollo and Aphrodite, and Roman matrons had various strategies for making themselves more beautiful by lightening their hair, dyeing it blond, or wearing blond wigs. But the feudal period raised this value system to new heights. Chivalric romances, long-winded on hair, as much for men as for women, provide us with much evidence.[18] In fact, for all authors, describing hair was a required exercise because it was an essential component of any portrait, not only physical but also social and moral. Hair spoke simultaneously of physical beauty, nobility of birth, politeness of manners, and qualities of the soul. It could be different colors: a variety of blonds, chestnuts, browns, reds, grays, or blacks, with the lightest shades being the most admired. But it could also be *luisans* or *reluisans* (shining), *sords* (dull), *deliés* (thin and fine), *gros* (thick), *ondoiants* (wavy), *recercelés* (loosely curled), *crespés* (tightly curled), *eshevelés* (uncombed), or *tors* (shaggy).[19] Each of these adjectives located the character within a system of values, and none is truly synonymous with any other. Similarly, with regard to color, all blond hair was considered to be positive, but genuinely blond hair was more highly valued than *blois* (pale blond) or *sors* (between dark blond and light chestnut) or *jaulnes* (duller blond). The vernacular adjective *blond*, of Germanic origin but the subject of much etymological debate, is much more expressive than the Latin *flavus*.[20] Not only does it emphasize the luminous, attractive quality of hair this shade, like strands of gold, but it also adds the idea of youth, seduction, nobility, and courtesy. In Arthurian romances, most of the queens and heroines are blond, as are the valiant knights that they set on the paths of romance and adventure. Only Queen Guinevere, wife of King Arthur, is the exception; she is a brunette, not

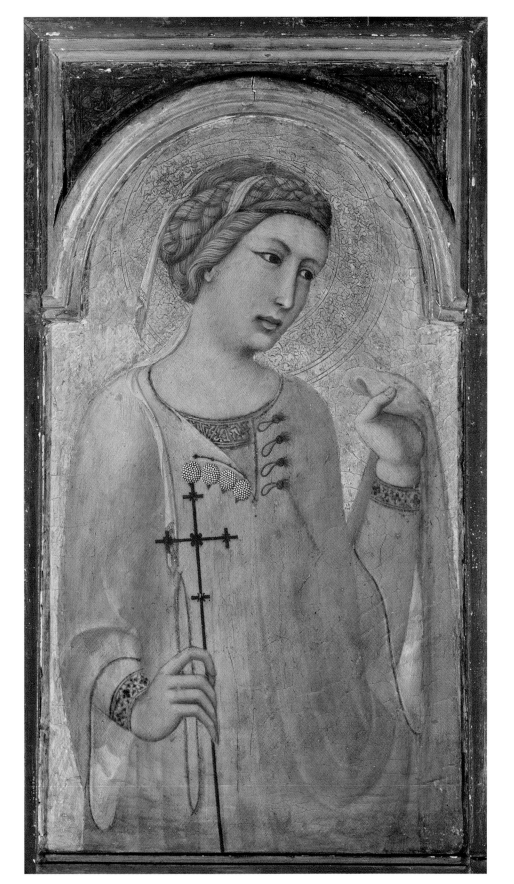

because she is an older woman (she is still very beautiful), but because she is capable of adultery and treachery, and thereby unpopular with the medieval public.[21]

The archetype of feminine blondness and beauty is Queen Iseult, wife of King Mark of Cornwall. It is to her blond hair that she owes her marriage; Mark, slow to marry, is urged by his barons to do so in order to produce an heir. One day when two swallows enter the great hall of his castle, each bearing in its beak a strand of golden hair, he proclaims that he will marry the woman to whom that hair belongs. It is finally learned that the woman is Iseult the Blond, daughter of the king of Ireland, famous for her incomparable beauty. Mark sends his nephew Tristan to ask for her hand in his name, to which Iseult's father agrees. Unfortunately, on the boat returning them to Cornwall, the two young people accidentally drink a love potion that was not meant for them. Henceforth they are linked by a violent, uncontrollable, almost inhuman love, against which they have no power to fight. What follows is a long series of adventures, misunderstandings, conflicts, and tragedies ending in the death of the two heroes.[22]

Very early on, Queen Iseult's blondness became legendary and constituted a topos, so much so that, in order to emphasize their heroines' splendid hair, many authors of courtly romances gave up the rather banal comparison of "hair like gold" in favor of "hair more blond than Iseult the Blond's." That is what Chrétien de Troyes does in his romance *Erec et Enide*, composed about 1165–70. To emphasize the magnificence of Enide's hair (the most beautiful woman in Logres, King Arthur's realm), he proclaims:

Por voir vous di qu'Isolz la Blonde
N'ot les crins tant sors ne luisantz
Que a cesti ne fut neanz.

I tell you, Iseult the Blond
Had hair not so blond nor shining
There was no comparison.[23]

This image is echoed a few years later in Chrétien de Troyes's romance *Cligès*, to describe the light radiating from the blond hair of Soredamors, Gawain's sister and Arthur's niece:

Car li chevoz Isot le Blonde
Dont on parla per tot le monde
Furent oscur envers les siens

Because the hair of Iseult the Blond
Of which people talk throughout the world
Was dark compared to hers[24]

More than any other author, Chrétien de Troyes knew what he was talking about in making such comparisons. In his youth, he himself had written a *Roman du roi Marc et Iseut la Blonde*, unfortunately lost today. And in *Cligès*, he explains to us the etymology of Soredamors, the name of the mother of his hero and sister of Gawain. It breaks down into two parts: *sore* (blondness) and *d'amors* (of love).[25]

This almost obligatory link between blond hair and love is not exclusive to ladies. It also involves the heroes of the Round Table, not only the most important ones like Gawain, Lancelot, Tristan, Yvain, and Percival, but also those very minor figures who appear in only one episode or even in

Marriage of King Mark and Iseult the Blond

In medieval literature, Iseult is the archetypal blond queen, with hair like strands of gold. Moreover, that is why King Mark wanted to marry her without ever having seen her. Fate determined that this marriage would be unhappy, even tragic, but Mark was not at all responsible for that, although iconography often represents him as a negative, or even sinister figure.
Roman de Tristan en prose, Bourges or Tours, c. 1465–70. Paris, Bibliothèque nationale de France, ms. français 102, folio 58 v°.

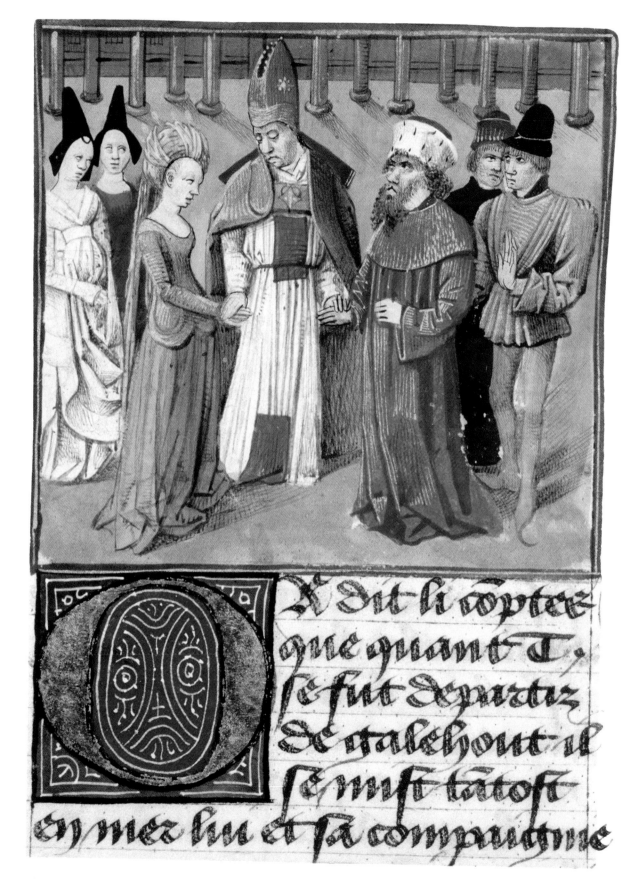

Et dit li comptes que quant T. se fut departiz de Galehout il se mist tantost en mer lui et sa compaignie

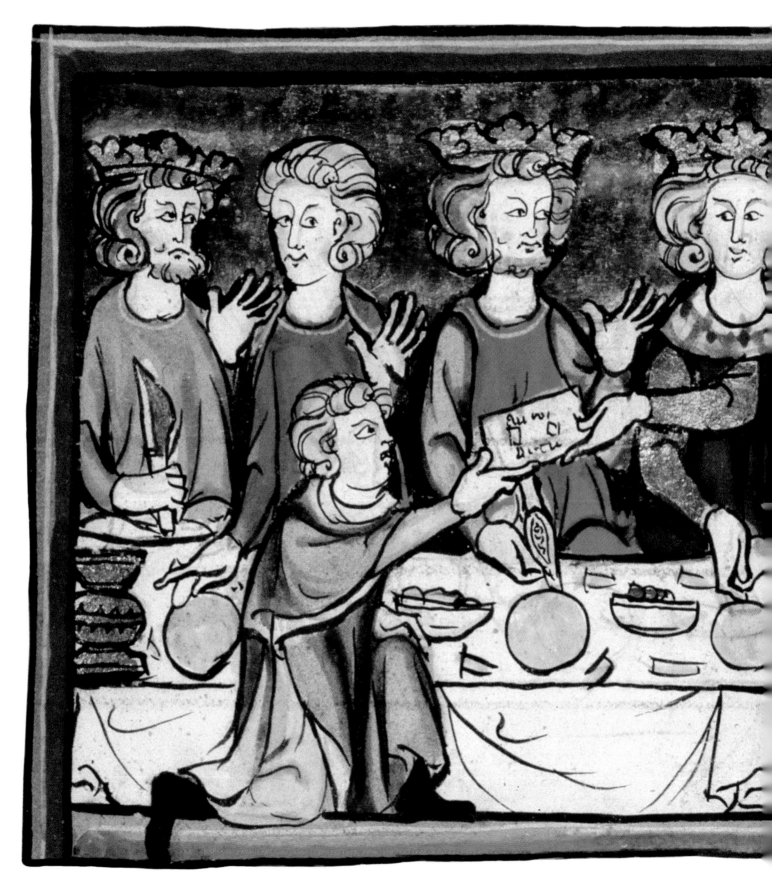

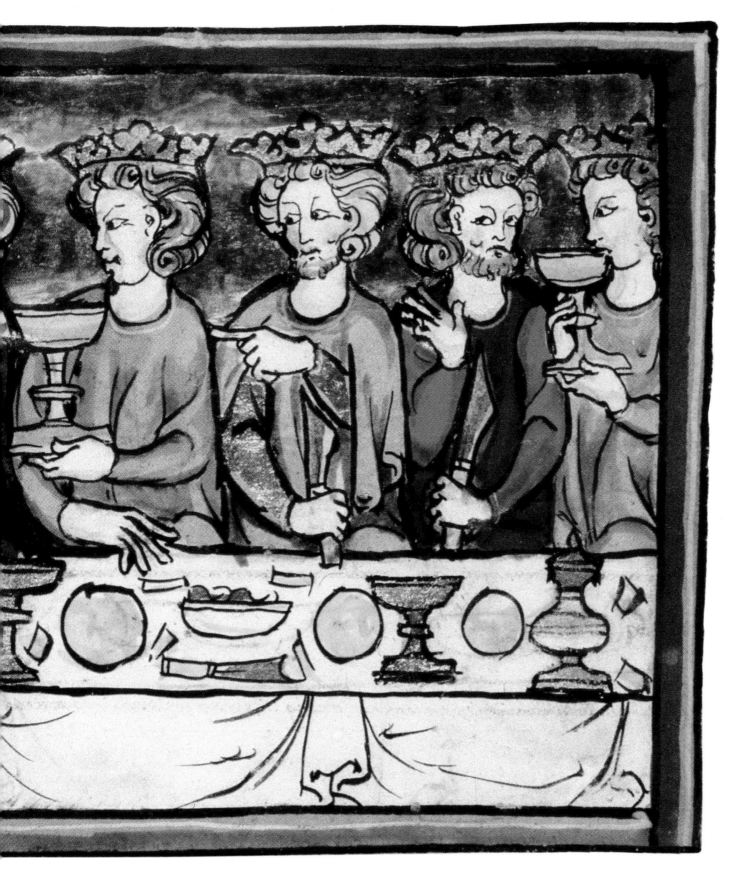

PREVIOUS SPREAD

A Banquet at King Arthur's Court

Seated at dinner, surrounded by lords, ladies, and knights, Arthur, represented as a young man, receives a messenger. The illuminator took great care to distinguish the gold of the crowns and precious dishes from that of the miniature's background. As for the loaves of bread on the table, they are simply painted a light yellow. *Lancelot-Graal,* Thérouanne (?) detail, c. 1290. Paris, Bibliothèque nationale de France, ms. français 95, folio 326.

a simple list of tournament participants or seekers of the Grail. One of them is named *"Le Blond Amoureux."* The reader knows nothing about him except that he is a seducer, a fop; he is not the hero of a single noteworthy adventure but he pleases the ladies and knows how to make them fall in love with him. His coat of arms is a shield *de sable au peigne d'argent, chevelé d'or* with this devise: "Amoureux suis."[26]

Long-winded on hair and the love rituals connected to it—offering a lock or curl to one's beloved, jealously guarding a comb or ribbon that has touched one's lady's hair— these same chivalric romances also have much to say about other parts of the body. Even if this subject diverts us a bit from the color yellow, it is worth mentioning here. Their descriptions are both reflections of and models for the aristocratic society of their time. Thanks to them, we know the criteria for feminine beauty in the late twelfth and early thirteenth centuries. In addition to blond hair, a beautiful woman had to have an oblong face, rather long neck, light complexion, white and "well-planted" teeth, small mouth, slightly turned-up nose, blue or gray eyes (definitely not green, the color of witches' eyes), smooth, wide brow, and plucked, arching eyebrows. Moreover, the female body had to be thin and slender, with a small, high bust, narrow hips, long legs, and small, delicate feet. The ideal was the "virgin," a young woman, reserved and well behaved, lacking any apparent sensuality or seductiveness. Subsequently, in the romances of the late thirteenth and early fourteenth centuries, the preference was for fuller, more generous bodies

and figures, *por mieulx soffrir le jeu del lit* ("to better suffer bed play"). Courtly love tended to become more carnal.[27]

The stereotypes for masculine beauty were not very different. Unlike the chansons de geste, courtly romances praise thin, delicate bodies, physical ease, restrained gestures, polite manners, and elegant dress. Gawain, nephew of King Arthur, chivalrous model of distinction and courtesy, is the archetype here. A beautiful body usually meant a beautiful soul and high birth.[28] Male and female villains presented in these same Arthurian texts are clearly the opposite of the knights. They have big heads, red or black hair, gigantic ears, dark sunken eyes, thick lips, and short, flat or long, hooked noses. Above all, their teeth are crooked and a dirty, unhealthy, foul yellow. Moreover, their bodies are misshapen: too big or too fat, stooped and sometimes hunchbacked, with short arms, crooked fingers, spindly legs, and enormous flat feet, sometimes webbed like those of geese.[29]

By the end of the Middle Ages, in princely and royal circles, these value systems would change somewhat. For men, light shades would go out of fashion and excessively blond hair would become a curiosity from another age. The lavish Count of Foix and Viscount of Béarn, Gaston III Phoebus (1331–1391), a cruel, ambitious lord, earned his Apollonian nickname due to his strange and splendid blond hair, like the color of the sun. But he would be one of the last medieval princes to be admired and celebrated by the chroniclers for their light complexion and golden locks.[30] In the fifteenth century, powerful dynasties or fashionable princes had to be less fair, with brown or even black hair, as in the image of the dukes of Burgundy, Philip the Good and Charles the Bold, or the great Italian lords that reigned over Milan and Florence. For women, on the other hand, the decline of blondness was less clear, especially as new hair dyes and devices of all kinds now allowed for an infinite variety of shades of blond, chestnut, auburn, red, and brown, each with their own golden, copper, and even gray versions. That would remain the case throughout the sixteenth century, at least in aristocratic circles.[31]

103

Gaston III Phoebus, Count of Foix and Viscount of Béarn

Nicknamed "Phoebus" in his lifetime because of his blond hair, supposedly resembling the locks of Apollo himself, Gaston III, Count of Foix (1331–1391), lord over much of the Pyrenees, was an enlightened despot, lavish prince, and passionate hunter. At the end of his life, he had transcribed a *Livre de chasse*, of which he was the author, and of which many magnificent illuminated manuscripts survive. The work conveys a vast knowledge of wild animals, dogs, and hunting practices.

Gaston Phoebus, *Livre de chasse*, c. 1400–1410. Paris, Bibliothèque nationale de France, ms. français 616, folio 51 v°.

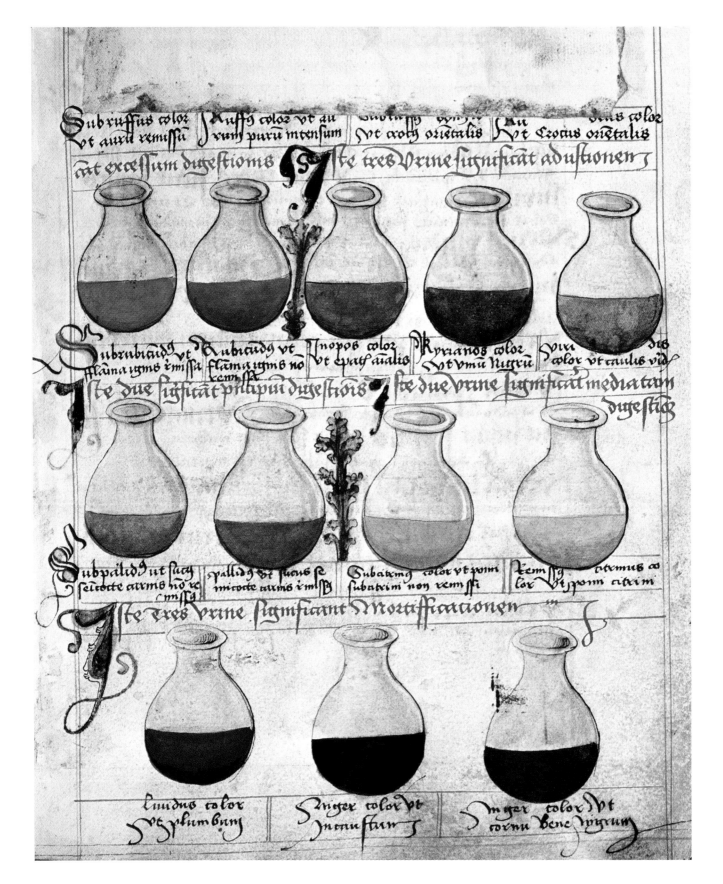

BILE AND URINE

Naming the Colors of Urine

In some manuscripts, the color chart is not a wheel, but a series of receptacles (*matulae*) lined up beside one another. The text accompanying each of them attempts to name the shade as precisely as possible by varying the basic terms by means of different prefixes and suffixes. This was only possible in Latin, because until the eighteenth century vernacular languages did not offer sufficiently precise and expansive lexicons for such an exercise. Sigismond Albik, *Tractatus de pestilentia*, mid-15th century. Prague, National University Library.

Like coats of arms and banners, the blond hair of fair ladies and gallant knights is proof that yellow could be considered positively in the feudal period; it evoked not only gold and the sun but also honor, courtesy, beauty, and love. Nevertheless, as with all colors, it was ambivalent and had its negative aspects as well. And the closer we get to the end of the Middle Ages, the more numerous and diverse they seem to be. Beginning from the late thirteenth century, the symbolism of yellow declined dramatically and in turn evoked envy, jealousy, lying, dishonor, and treason. That is a heavy burden for a color that had long remained obscure, in the shadow of gold. In attempting to understand why, let us turn our attention from blond hair but remain in the domain of the body, and let us consider two yellowish fluids secreted by the organism: bile and urine. We have come a long way from seduction and courtesy, in the direction of disease and defilement, to the heart of medical practices.

Like Greek and Arabic medicine, medieval medicine had a global vision of the universe. Everything, including the human body, depended on the combination of four basic elements—water, air, earth, and fire—as well as on the balance of four essential qualities—warm, cold, dry, and humid. To those four qualities corresponded four bodily "humors": blood (warm and humid), phlegm (cold and humid), yellow bile (warm and dry), and black bile (cold and dry). Most diseases were considered a result of an imbalance among these humors, an imbalance that doctors had to try to correct by eliminating what was excessive and increasing what was lacking, either in the entire body or in a particular organ. To do so, doctors relied on the pharmacopoeia and diet. Sometimes they made patients absorb, in variable degrees (generally from one to four), foods or substances that would help to increase the amounts of warmth, coldness, dryness, or humidity they lacked; sometimes, conversely, doctors put patients on diets and, also in variable degrees, restricted their intake of those qualities they had in too great excess.

Before treatment, doctors had to establish a diagnosis, relying essentially on examinations of the pulse and urine. They also had to consider different factors: season, climate, location, diet, lifestyle, and age of patients, and especially their "complexion" or temperament. Every healthy patient possessed a dominant humor that defined the broad outlines of his/her health, character, and behavior. Blood predominated among the sanguine, lymph among the phlegmatic, bile among the choleric, and atrabile (black bile) among the melancholic. Each of these temperaments was associated with different elements, notably a principal color: red for sanguine, white for phlegmatic, yellow for choleric, and black for melancholic. Hence, red was warm and humid, white was cold and humid, yellow was warm and dry, and black was cold and dry. Seeing, touching, drinking, or eating one of those four colors, in one form or another, could help reestablish to some degree the balance of humors. Eating quince, for instance, yellow fruit par excellence, could help warm the organism again and rid it of excess humidity.[32]

Of course, this brief account greatly simplifies the theory of humors as ancient and medieval medicine conceived of and practiced it. But it offers some valuable information to historians of colors. It teaches us, for example, that yellow was a warm and dry color, that it was associated with a rather negative humor, bile, and a choleric temperament, rarely considered in a positive light. Indeed, in the Middle Ages, there existed a hierarchy of temperaments, more moral and social than strictly physiological. The sanguine temperament—active, strong, courageous, and willing—was the most highly valued; the choleric temperament—violent, unstable, rancorous, and hypocritical—the most despised. Bile itself, an organic fluid produced by the liver, had nothing seductive or virtuous about it; it was yellowish, thick, bitter, viscous, foul, and secreted excessively not only by those who were choleric but also by those who were jealous, envious, and traitorous. Many doctors, unaware that it helped to break down fats and keep food from rotting in the intestines, likened it to gall in animals, also yellowish

in color. Clearly, this color held nothing of value for medieval medicine.

And urine did nothing to enhance its value either, quite the opposite. Urine was a vile, repugnant fluid, a foul excretion that doctors only examined carefully because it helped them establish diagnoses. In the West, over the very long span of time from Greek antiquity to the twentieth century, taking the pulse and examining urine were the two methods most favored by doctors to assess a patient's health and organ functions in order to provide care. Urine was the principal evidence of a patient's condition because it was the result of all the concoctions taking place within the body, which itself was likened to a cauldron or boiler.[33]

Numerous medieval treatises, mostly adapted or translated from Greek or Arabic, explain the medical procedure for establishing a diagnosis based on urine. Let us trace the steps described by Gilles de Corbeil, canon of Notre Dame in Paris, doctor to King Philip Augustus, and author of *De urinis*, a famous scholarly poem composed in the years 1200–1210.[34] The doctor began by collecting urine in a specific container (the *matula*); then he evaluated that sample by inhaling its odor—mild or strong, pungent or fetid—and sometimes by tasting it to identify the flavor and add to his information. Then came the actual uroscopy, a scene often represented in illustrations.[35] The doctor "candled the urine" by raising the receptacle to eye level and holding it close to a source of light in order to examine the general appearance of the fluid (clear, cloudy, dark), its consistency (liquid, thick, viscous), its color, and any possible sediment found in it. According to a few later treatises, for example, one by the Byzantine physician Zacharias (Johannes Actuarius), compiled about 1300–1310, the doctor continued his investigations by filtering the urine and adding various products to it in order to see how it reacted, notably by changing or not changing color. This was already a kind of chemical analysis, similar to those practiced beginning in the nineteenth century. According to Actuarius, it let the doctor choose the

106

The various labels around and within the wheel include (reading the vessels and text):

Rufus · Subrubeus · Rubeus · Subrubius · Rubicundus · Ciorinus · Subcitrinus · ...

107

Urine Wheel

Since Greece antiquity, examining urine and taking the pulse have been medicine's principal means of establishing diagnoses. After smelling and sometimes tasting it, a doctor studied urine's appearance, consistency, fluidity, and especially its color. This last step was the most important and most delicate. That is why color charts existed to help the doctor determine the exact shade of the liquid under scrutiny. These color charts—among the oldest ever constructed—were often in the form of a wheel. The closer we approach to the modern period, the greater the number of shades included there.

Urine table, end of the fourteenth century. Leipzig, Bibliothèque de l'Université, ms. 1177, folio 28.

precise remedies needed, assess patients' chances of recovery, and even predict their life expectancy.[36]

For many authors, the most important of all these procedures was the examination of color. This explains the existence of "urine wheels" (*rotae urinarum*), a kind of color chart in a circular form that served as a reference tool to determine with precision the shade of the liquid present in the *matula*. Identifying this shade as precisely as possible helped in accurately assessing the imbalance of humors. That is why over the course of decades, these urine wheels were broken down into increasingly greater numbers of shades: about twenty in Gilles de Corbeil's time, at the beginning of the thirteenth century; forty-two three centuries later, as the modern era began. These shades ranged from white to black (an extremely serious case!), passing through the entire span of whites, pinks, yellows, oranges, reds, bronzes, greens, grays, browns, and even purples. Only blues were absent; in this domain, blue could not have had significance as a color.

Fortunately, many representations of these wheels have survived, true chromatic scales meant not for painters or dyers but very much for doctors. The rainbow aside, these are the oldest known color wheels and thus very important documents for the color historian. They teach us how in the Middle Ages colors were classified not in the order of the spectrum (it is much too early for that) but in an order that tradition attributes to Aristotle: white, yellow, orange, red, green, violet, black. They teach us as well how colors were broken down into different shades and how yellow—as we would expect—is represented by the most shades here. Sometimes these wheels not only represented the shades, they gave them precise names as well. Thus these color charts are just as important for the history of chromatic vocabulary. Everything was written in Latin, of course, the basic terms being reinforced by a subtle play of prefixes and suffixes and accompanied by different adjectives: light/dark, clear/cloudy, pale/saturated, dull/bright, and so on. A urine named *percrocea calida et surda* was a

Mercury and Argus

In his *Metamorphoses*, Ovid recounts how Argus, endowed with a hundred eyes and nicknamed "the one who sees everything," was charged by Juno to keep watch over Io, with whom Jupiter, Juno's unfaithful husband, had fallen in love. Jupiter asks his son Mercury to kill Argus. Mercury does so through trickery. The god is easy to recognize here by his attributes: winged cap and heels, staff, rooster. His yellow clothing may emphasize his treachery (he uses a magic wand to put Argus to sleep before killing him), but most importantly makes him an executioner. Executioners dressed in yellow appear very frequently in iconography of the late Middle Ages.
Évrart de Conty, *Le Livre des échecs amoureux moralisés*, c. 1495–98. Paris, Bibliothèque nationale de France, ms. français 143, folio 112 v°.

warm, saturated orange color; another named *subpallida leviter turbida* was whitish and slightly cloudy. At the end of the Middle Ages and the beginning of the modern period, Latin could convey a considerable number of color shades; vernacular languages had much greater difficulty doing so before the eighteenth century.

Bile and urine are strong indicators of the ties between yellow and dirt and disease.[37] It was not a color indicating strength and good health, as red could be, or youth and vigor, as green often did. Nor was it a color linked to death, as were black and sometimes white. No, yellow conveyed decline, desiccation, aging.[38] In the systems of "correspondences," so important to heraldic treatises, encyclopedias, and allegorical poetry in the late Middle Ages, the six ages of life were sometimes each associated with a color: white for childhood, blue for early adolescence, green for youth, red for prime of life, yellow for early decline, and black for old age. This chromatic scale appeared again in a shortened form with regard to the seasons: green for spring, red for summer, yellow for autumn, black for winter. For this type of literature, which delighted in associations and long exerted considerable influence over the symbolism of colors, not only in art and literature but also in daily life, yellow was the color of autumn, in nature as in a human life. It was a barren, dull, withered, and more or less faded color. There was no freshness to it, it had lost its strength and light, in fact, it seemed to have become the opposite of gold. Thus its symbolism could only be negative.[39]

ENVY, LYING, AND TREACHERY

Fauvel and His Courtesans

A literary and allegorical creature, Fauvel is a horse embodying the favorite vices of the king of France and his entourage in the early fourteenth century. These vices can be seen in the color of his fauve coat, perfect symbol of hypocrisy, and in the six letters that form his name: Flattery, Avarice, Villainy, Vanity, Envy, Lowness. Gervais du Bus and Chaillou du Pesstain, *Le Roman de Fauvel*, c. 1310–16. Paris, Bibliothèque nationale de France, ms. français 146, folio 2 v°.

In fact, at the end of the Middle Ages, the number of vices associated with yellow continued to grow. When we study the tables of correspondences just discussed—sometimes extensive tables that present colors in relationship to various objects or elements (planets, metals, precious stones, ages of life, signs of the zodiac, seasons, days of the week) but also and especially to vices and virtues—the column of vices for yellow is particularly full. Of course all the colors are ambivalent and each possesses its good and bad aspects, but no other color, not even black, presents such an imbalance. Only when yellow is likened to gold is it considered positively; when considered alone, simply for itself, it is always negative.[40]

The first vice associated with yellow is envy. When over the course of the thirteenth century the list of the seven deadly sins had finally stabilized, each was symbolically assigned a color.[41] Pride and lust were red, avarice was green, sloth was white, and envy was yellow. For gluttony (*gula*), the authors wavered between red and violet; and for anger, between red, black, and yellow. But for this last color, a host of other vices were quickly added to envy and anger: jealousy (cousin to envy), lying and hypocrisy (which result from it), then cowardice, deceit, dishonor, and even treachery. All these vices tend more or less in the same direction: yellow is a false, duplicitous color that cannot be trusted; it cheats, deceives, and betrays. What reasons can there be for such discredit, which did not exist in ancient societies but would long endure, from the late Middle Ages until the contemporary period?[42]

The chemistry of colorants provides few clues for answering this question, at least for the Middle Ages. Neither in painting nor in dyeing was yellow an untrustworthy color that betrayed the one who used it, as green frequently did, for example. Chemically unstable, both as dyestuff and pigment, medieval green was eventually associated symbolically with everything unstable: youth, love, luck, fortune, hope.[43] That was not at all the case with yellow. Of course, some yellow pigments were less stable than others, but for

111

The Colors of the Deadly Sins

Beginning in the late thirteenth century, texts and images attributed colors to the seven deadly sins: red for pride, lust, and sometimes anger and gluttony; green for avarice; yellow for envy; white or blue for sloth. This miniature shows a pilgrim assailed by four of the seven sins, recognizable by the color of their clothing and represented as women. *From left to right*: pride, envy, lust (or anger), and avarice. Guillaume de Digulleville, *Le Pèlerinage de vie humaine*, late 14th century. Aix-en-Provence, Bibliothèque Méjanes, ms. 110, folio 127.

the period that interests us, yellow was not yet a color that betrayed painters (this would be less true later).[44] Thus we must search elsewhere. Perhaps within the lexicon? The history of words and wordplay (figurative meanings, metaphors, phonic affinities, various analogies) can often help the historian understand the origins of beliefs and superstitions, and thus those of emblems and symbols as well. Could that be the case here? Can we trace the roots of yellow's association with envy and treachery to lexical phenomena?

One lead is offered to us by the homonymy that exists between the Latin word *fel*,[45] which means the gall or venom of animals as well as human bile—thus returning us to the color yellow—and the vernacular word *fel* (objective case: *felon*),[46] which is an Old French term for a vassal who has rebelled against his lord. It is a strong term, Germanic in origin (it comes from the Frankish *fillo*: wicked, deceitful), and played an important role in the legal vocabulary of the feudal period. Subsequently, its use expanded, the subjective case disappeared, and the objective case *felon* in Middle French came to describe a traitor of any kind. Thus the phonic echo between *fel* and *felon* could explain the transition of yellow, the natural color of gall, to a yellow symbolic of treachery and betrayal, a transition facilitated by

the fact that in medieval Latin, the word *fel* is sometimes used figuratively to mean anger or rancor.

Of course these are only hypotheses, but the phonic and semantic play between Latin and the vernacular language seems sufficiently solid to explain why yellow, the color of bile, ended up becoming the color of *felonie*—treachery and lying. Especially since medicine explained that the choleric temperament was produced by an excess of bile, and since moral theology taught that anger, one of the seven deadly sins, engendered a great number of vices: violence,

Renart with the Dyer

Always in search of mischief, Renart decides to disguise himself to trick people better. He enters a dyer's workshop but accidentally falls into a vat of yellow dye. Furious, the artisan threatens to kill him, but Renart explains to him that he is a dyer as well and that he can teach him a remarkable new technique in the art of dyeing. Thus the artisan helps the fox out of the vat, but as soon as he is free,

Renart makes fun of the dyer, reveals that he is not one, but congratulates him on the quality of his dye that "has turned him from red to bright yellow," thus making him unrecognizable. He can keep making trouble without being discovered.
Roman de Renart, c. 1300–1305. Paris, Bibliothèque nationale de France, ms. français 12594, folio 20 v°.

114

duplicity, deceit, hypocrisy, treachery. These were all finally associated with the color yellow, as much in the world of symbols and representations as in actual practice. Let us pause to consider a few remarkable examples of this link between yellow and fraud, ruse, and trickery.

The first one comes from a literary text, *Le Roman de Renart*, which constitutes for the historian an immense repertoire of signs and symbols involving animals and also colors. The earliest parts date to the last quarter of the twelfth century, and the episode that concerns us here took shape about 1180.[47] Renart, always in search of food and mischief, tries to disguise himself to deceive his enemies more effectively and to escape the legal proceedings that King Noble (the lion) has instituted against him. Thus he enters a dyer's workshop but accidentally falls into a vat of yellow. Furious, the artisan threatens to kill him, but Renart explains to him that he is a dyer as well and that he will teach him a new technique in the art of dyeing, a technique "very fashionable in Paris," which consists of mixing ashes with the colorant. This is a perfectly common formula, since it is a matter of simply adding a mordant, but the artisan is intrigued. Thus he helps the animal out of the vat, a feat Renart would never have been able to accomplish alone. But as soon as he is free, Renart reveals that he is not really a dyer himself. He mocks the dyer and congratulates him on the quality of his dye that "has turned him from red to bright yellow," thus making him difficult to recognize:

Ta teinture est mold bien prenanz:
Jaunez en sui, et toz luisanz
Ja ne serai mes coneüz
En lue ou j'ai esté veüz.[48]

Your dye takes very well:
It's made me all yellow and shining,
No one will ever recognize me
Anywhere I've been before.

Thus disguised, Renart can continue on his way, performing his misdeeds with complete impunity. Encountering Ysengrin the wolf, he passes himself off as a "Breton" minstrel. Then he steals a hurdy-gurdy and returns home where his wife Hermeline, believing him dead, is preparing to marry a second husband, her distant cousin Poncet. Still unrecognizable in his yellow coat, Renart offers to play the hurdy-gurdy for the wedding ceremony; this gives him a chance to fool everyone, disrupt the wedding, punish his supposed widow, and take vengeance on Poncet by getting him killed by a farmer's watchdogs.[49]

Modern critics have tried to explain the choice and significance of the color yellow in this episode where Renart is by turn dyer and then minstrel. But they have gone a bit astray, either by detecting the traces of a distant Eastern origin there—an Indian tale, the *Panchatantra*, often revised and transmitted to the West through Islam—or by seeing

in it an allusion to the "heraldic" color of the English coat of arms, since in a twelfth-century text, a Breton minstrel could only be of English origin.[50] In fact, there is no need to look toward heraldry; the color yellow was chosen here simply to highlight the fox's disguise and duplicity. Moreover, this same color appears on Renart's shield during his legal battle with Ysengrin, recounted in the sixth branch of *Le Roman*, compiled a few years later (about 1190–95). The wolf bears a red shield and the fox, a yellow shield. It is a contest that pits violence against ruse:

> Et Ysengrins tot ensement
> Reporchasce arms belement. . . .
> Son escu est vermeuls trestoz
> Et la cote roge de soz. . . .
> Renars qui meint a escarnis
> Ne restoit mie piz garniz:
> Asés avoit de buens amis
> Qui de lui se sont entremis.
> Escu roont a sa maniere
> A conmandé que l'en li quere:
> Un l'en ont quis fu tot gaunes.[51]

> Ysengrin as well
> procures arms for himself. . . .
> his shield is entirely vermilion
> and his coat underneath, all red. . . .
> Renart, who had mocked everyone,
> is no less well-equipped:
> he had many friends
> who looked after him.
> He ordered them to find him
> a round shield his size:
> they found him one that was all yellow.

In medieval literary texts, yellow—as well as its superlative form, russet—was frequently associated with lying, trickery, and hypocrisy, three vices that define Renart's

very nature and that his temporary transformation into a false dyer reveals to its fullest. Every dyer is a trickster, but a false dyer is all the more deceitful. And when it is a matter of a fox, trickster animal par excellence, the vice is somehow compounded exponentially: the professional trickery of the dyer is amplified by the natural trickery of the fox.

It is a short step from trickery to treachery, especially since the color remains the same. Chivalric romances and chronicles provide many examples for us: the treacherous vassal is dressed in yellow or carries a yellow shield and banner, like the traitor Ganelon in the prose revision of *The Song of Roland* from the 1450s.[52] Sometimes the code is more subtle. In a passage from his *Mémoires*, Olivier de La Marche, an important chronicler of the fifteenth-century Burgundy court, tells how in 1474, Henry of Württemberg, Count of Montbéliard, considering himself betrayed by Duke Charles the Bold, came before him with his entire retinue dressed in yellow.[53]

This link between yellow and treason is further highlighted by a spectacular practice that lasted from the late Middle Ages until the early modern period and consisted of painting yellow the houses of prominent figures if they were guilty of high treason, heresy, or a crime of lèse-majesté. In Paris, the most famous example is that of Charles III, Duke of Bourbon et Auvergne (1490–1527), Constable of France and a great captain. Following a dispute of inheritance with the mother of King Francis I, Louise of Savoy, and an unjust verdict rendered against him by the Paris Parliament, the constable fled France in 1523, joined forces with the enemy, and began serving Charles V. Immediately a new ruling by the Parliament ordered his goods to be confiscated and the doors and windows of his splendid Paris mansion near the Louvre to be painted yellow, "the color of infamy." Two years later, as head of the Imperial Armies, the constable got his revenge by winning the Battle of Pavia and taking an illustrious prisoner: Francis I himself. But thwarted by Charles V who refused to take up his cause, he acted on his own henceforth, tried

116

to carve out a principality in Italy, and died in 1527 while laying siege to Rome.[54]

In 1572, the Paris residence of Admiral Gaspard de Coligny experienced a similar fate. During the Saint Bartholomew's Day massacre (August 24, 1572) the admiral was assassinated in his bed; his body was tortured, eviscerated, castrated, decapitated, and then hung by the feet on the Montfaucon gallows. But that was not enough; Coligny was tried postmortem and accused of the crime of lèse-majesté and betrayal of the realm. All his goods were sequestered, and the doors and windows of his mansion on rue de Béthisy, not far from the Louvre, were painted yellow "to make known the enormity of his crimes and just sentence."[55]

In this period, such defamatory practices were far from new. They appeared in Italy toward the end of the thirteenth century and then expanded into southern Germany and neighboring regions in the decades that followed. At first, the guilty one's coat of arms was painted backward or hung from a gallows in a public space for all to see; then the culprit himself was depicted on the walls of his own residence in humiliating positions or scenes; finally the residence itself was painted, partially or totally in yellow. This last ritual, initially reserved for counterfeiters or forgers, gradually expanded to heretics, relapsed heretics, and those guilty of crimes against the prince or the public peace. Of course it was far from systematic, but by about 1500, this practice was quite widespread throughout much of Europe.[56]

Once simply the color of falsehood and lying, yellow became the color of heresy and treason as well.

117

Admiral Gaspard de Coligny and His Brothers

As principal leaders of the Huguenots, the three Coligny brothers were not all victims of the Saint Bartholomew's Day massacre. Only Gaspard suffered a horrible death that day (August 24, 1572). His two brothers, Odet de Châtillon (1517–1571), former prelate turned reformer, and François d'Andelot (1521–1569), very active military leader, were already dead at the time of the massacre. In this drawing that postdates the events, the yellow clothing must not be interpreted as a deprecatory color, the color of treason, but rather as simple ornamentation. Anonymous drawing with watercolors, late 16th or early 17th century. Chantilly, Musée Condé.

THE ROBES OF JAN HUS AND OF JUDAS

Judas Receiving Payment for His Betrayal

The Gospels say nothing about the physical appearance of Judas, but as early as the twelfth century, images give him two recurring attributes: red hair and a yellow robe. Other attributes were added later to complete his iconographic repertoire, especially awkwardness. That is what Giotto shows here: Judas holds the purse with the thirty silver coins, the price of his betrayal, in his left hand. Giotto, *Judas Receiving Payment for His Betrayal*, 1305. Padua, Scrovegni Chapel.

O ne famous case of heresy, ending with the accused being led to the stake dressed entirely in yellow, is that of Jan Hus of Constance in 1415. Born in southern Bohemia in about 1370, Jan Hus was a brilliant student of theology at the University of Prague, then the most prestigious academic institution in Europe. As professor, then dean, and finally rector, he stood up against the emperor and the supremacy of the German language. He then took on the pope, prelates, and the ecclesiastical hierarchy and called for a general reform of the Roman Catholic Church. As a priest himself, he preached this message in Prague and throughout Bohemia, finding receptive audiences among the nobility as well as commoners. In fact, he not only called for mass to be held in the Czech language and communion under both kinds to be offered to the laity but also for the end of the sale of indulgences, the confiscation of goods from the clergy, and the departure of the German Holy Roman Empire from Bohemia. Having become a kind of national hero, he inspired popular movements that frightened the imperial and papal authorities alike. Accused of heresy by his detractors, condemned repeatedly by King Wenceslas of Bohemia, excommunicated by Pope Gregory XII (1411), Jan Hus appealed "to the Judgment of Christ" and demanded to be heard by the General Council of the Church then assembled in Constance to quell the crisis of the Great Schism. He was granted safe conduct but was arrested and imprisoned immediately on arrival, in late November 1414. His trial began a few weeks later before an assembly of formidable inquisitors and theologians and canonists of great renown. His writings were condemned and he himself, having refused to submit, was declared a heretic and delivered to secular authorities. Condemned to be burned at the stake, he was led to his execution on July 6, 1415, dressed in a long yellow robe and wearing a sort of miter decorated with two demons. He was burned alive, and his remains were thrown into the Rhine.[57]

Jan Hus Burnt Alive

Most accounts relate how Jan Hus (1370–1415) was led to the stake dressed in a long yellow tunic and wearing a tall miter decorated with black devils. In images, the miter is always represented this way, but the color of the tunic varies greatly: yellow, red, brown, black, and even white. Ulrich von Richental, *Chronicle*, 15th century. Prague, National University Library.

This yellow symbolic of heresy echoes another yellow, also enemy to Christ and his church: the yellow of betrayal. Here the symbolic figure is not a rebel priest and theologian prefiguring Luther but a companion of Jesus, a treacherous apostle who occupied a most important place in medieval iconography: Judas. I have discussed at length his red hair in my preceding book on the history of the color red.[58] His hair constitutes an attribute recurring in images to emphasize his false and perfidious nature.[59] I will return to this presently but would like to pause here to consider another of Judas's iconographic attributes, equally negative: his yellow robe, a symbol of treachery and an emblem of Jewishness.

No canonical text from the New Testament nor even from the Apocrypha tells us of Judas's physical appearance or what he was wearing at the time of Jesus's arrest. That is why in early Christian art and art of the early Middle Ages, his image is not characterized by any specific trait or attribute. In representations of the Last Supper however, efforts were made to distinguish him from the other apostles, setting him apart somehow by means of his place, height, or attitude. A few centuries later, in the Ottonian period, an attribute reserved for him alone appeared and then slowly spread: red hair. Originating in the countries of the Rhine and Meuse, this iconographic trait gradually took hold in much of western Europe, first in miniatures and then in other visual mediums. Beginning in the twelfth century, this red hair, henceforth combined with a beard of the same color, was the most commonly recurring of Judas's attributes in iconography.

The Executioner of Saint John the Baptist

Medieval iconography features many executioners. Among their various attributes (ugly or convulsed expressions, red hair, bare knees, violent gestures, instruments of torture in their hands), the most visible is the color of their clothing: yellow, red, yellow and red, yellow and green, stripes in two or three colors. *John the Baptist thrown into prison on the order of Antipas.* Mural painting in the Gallieri chapel, Chieri Cathedral (Piedmont), c. 1418–20.

These attributes continued to increase in number, however, over the course of time: short in height, low brow, brutish features, dark skin, hooked nose, thick mouth, black lips (because of the kiss of betrayal), halo absent or else black in color, yellow robe, awkward gestures, hand holding the purse with thirty silver pieces, demon or toad entering the mouth; later, in the modern period, a dog appeared at his side. Like Christ, Judas had to be unmistakable. As centuries passed, he acquired a host of attributes that artists were free to choose from, according to their aesthetic ambitions, iconographic constraints, and symbolic intentions. Two attributes dominated nevertheless: the red hair and the yellow robe.[60]

However, Judas had no monopoly on either trait. In art from the late Middle Ages, a certain number of traitors, scoundrels, and rebels are often redheads. That is the case with Delilah, the great traitress of the Bible, as well as Cain, who in the symbolic typology drawing parallels between the two Testaments, is nearly always presented as a prefiguration of Judas. There is also Ganelon, the traitor in *The Song of Roland*, who, out of vengeance and jealousy, does not hesitate to send Roland (his own relative) and his companions to their deaths. Again, there are the rebel lords of the courtly romances, the disloyal stewards, sons revolting against their fathers, traitorous brothers, usurping uncles, and adulterous wives. And finally, there are all those who engaged in dishonest or dangerous activities and in doing so violated to some extent the established order: prostitutes, usurers, moneychangers, counterfeiters, musicians, jugglers, and even executioners and clowns.[61] Incidentally, the last of these were not only redheads, they were also dressed in yellow, as if their red hair represented their bad nature and the color yellow, their social status as inferior outcasts, the cause of disorder or transgression.[62]

In images beginning in the thirteenth century, Judas is also dressed in yellow, a color emblematic of his betrayal but also his Jewishness, as we will see shortly. Sometimes a touch of green was added to emphasize his greed, since

122

Amulius, Great-Uncle of Romulus and Remus

Numitor, king of Alba, had only one daughter, Rhea Silvia, a Vestal Virgin. But she was impregnated by the god Mars and gave birth to twins: Romulus and Remus. Amulius, Numitor's brother and would-be successor then began plotting against him. Amulius usurped his brother's throne, put his niece to death, and had her twins thrown in the Tiber river. The yellow of his lavish clothing emphasizes his triple nature: traitor, usurper, and executioner.
Gentile da Fabriano (workshop), *Condemnation and Execution of Rhea Silvia* (detail), c. 1405–12. Foligno (Umbria), Palazzo Trinci, loggia fresco.

123

green in the Middle Ages was the color of avarice (a vice that the purse with the thirty silver coins also highlighted). These colors were then combined in the form of striped or parti-colored clothing, or sometimes a yellow robe and green cloak. But that was rare. Usually the perfidious apostle was dressed in a long monochrome yellow robe, and in many miniatures, stained-glass windows, and painted panels, he is the only one wearing this color, thereby devaluing it even further.

For the historian, the problem is discerning the relationship between iconographical and actual practices. Is the image the reflection of or model for reality? Or something else entirely? And regarding the subject that interests us, what influence might dressing a traitor in yellow have on the popularity of that color in society? These are difficult questions to answer, but it does seem that at the end of the Middle Ages and beginning of the modern period, yellow appeared less frequently in clothing than it had in the feudal period or even in the mid-fourteenth century. A document like the famous Florentine *Prammatica del vestire* from 1343 to 1345—an extraordinary document in many respects—teaches us that in Tuscany at that time, yellow was a color happily worn as part of the feminine

wardrobe, and the iconography fully confirms this.[63] But that was no longer the case two centuries later, in Florence or anywhere else in Europe. Among Catholics, the image of Judas and the image of the synagogue, both clad in yellow, had greatly devalued this color; among Protestants, it was considered too gaudy and "dishonest," as were red and green: a good Christian had to avoid them.[64]

Before studying the link between yellow and the synagogue, let us consider for a moment this *Prammatica del vestire* from mid-fourteenth-century Florence. What was it? A kind of general inventory of the wardrobes of Florentine women, or at least of those belonging to nobility, the patrician class, and the *popolo grasso*; an inventory carried out by many lawyers in order to implement recent sumptuary laws and to tax all those who had to be taxed. The authorities' aim was to reduce luxury expenditures (clothing, fabrics, jewels, dishes, furniture, equipment) because they considered these to be unproductive investments. With regard to clothing they also wanted to combat the new fashions, which they deemed indecent or outlandish (brightly colored dresses with low necklines, especially those that were too tight fitting). And finally, they wanted to maintain boundaries between the various social classes and categories; each should remain in its place and dress according to its condition, rank, fortune, and reputation. As always, these sumptuary laws were moralizing, reactionary, segregationist, misogynistic, and anti-youth.

From autumn 1343 until spring 1345, all upper-class women had to present their trousseaux before the lawyer of their district, who counted, named, and described the various items found there. In their faltering, tortured Latin, these authorities tried to provide as much detail as possible for each garment: type of fabric (wool, silk, samite, velvet, cotton, canvas), style, cut, dimensions, colors, decorations, linings, accessories. This information was transcribed into various notebooks, now gathered into a single volume, in handwriting that was not very neat, full of abbreviations, and difficult to read. In total, 3,257 entries inventoried 6,874

The Yellow of Clowns

Representations of court jesters or fools are quite numerous in illuminated manuscripts of the late Middle Ages. The attributes they were given include the marotte, the fool's cap with two or more "horns," bells, and bichrome striped, checked, or quartered clothing (as here). One of the two colors is almost always yellow; the other is often green, sometimes red or blue. Breeches frequently add a third color, transforming the clown into a multicolored actor. *Bible historiale*, psalm 51 (52), dating from 1411. London, The British Library, ms. Royal 19, D III, folio 266.

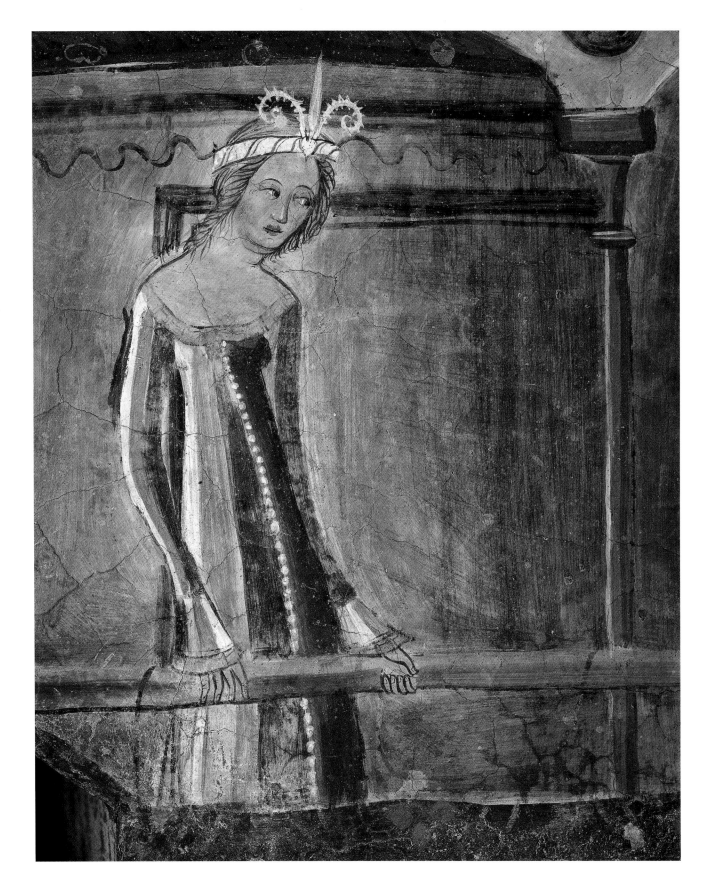

An Elegant Dress in the Italian Style

After the Great Plague of the mid-fourteenth century, clothing styles diversified and reflected a certain rediscovered joie de vivre. Striped and multicolored clothing was popular especially for women in northern Italy. Gradually these flashy and colorful new styles crossed the Alps and won over the southern Germanic world.
Noble woman on the balcony watching a tournament (detail), late 14th century. Castel Roncolo (near Bolzano), Sala del Torneo fresco.

127

Young Woman Dressed in Yellow

Amazingly, it is the straw yellow color of the dress, followed by analysis of the pigments used (massicot and weld lacquer) that led to attributing this painting to Alessio Baldovinetti (1425–1499), a Florentine painter who used similar yellows elsewhere with smooth, dull, and dry aspects. Formerly the painting was attributed to Piero della Francesca. The identity of the model remains unknown; the emblem with three palm leaves represented on the sleeve of her elegant dress has provided no solid leads.
Alessio Baldovinetti, *Portrait of a Woman in Yellow,* c. 1465. London, National Gallery.

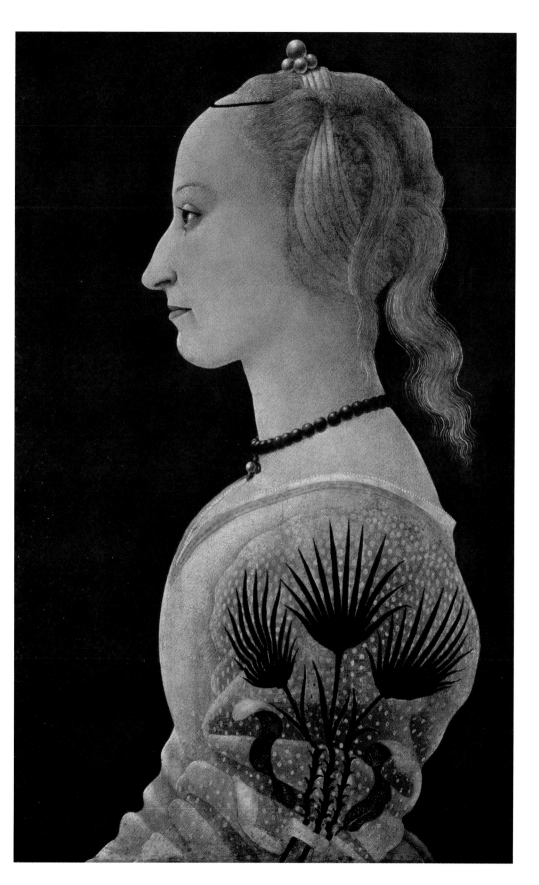

Francis of Assisi Rendering His Clothes to His Father

For the monks and friars of the Middle Ages, as later for the Protestants, clothing recalled original sin. Adam and Eve were naked in earthly paradise; then they disobeyed God, were expelled, and donned clothing again as a sign of their sin. Echoing this sin, all clothing had to be humble and dignified. Wearing lavish or eccentric outfits was offensive to God. Having taken a vow of poverty, Francis returns to his father, a rich cloth merchant, the clothes that he had given him. Dressed in yellow, his father expresses his anger. Giotto, *Scenes from the Life of Saint Francis*, c. 1290-95. Assisi, Basilica of Saint Francis, mother church.

dresses and coats, 276 headpieces, and a large number of accessories of all kinds, all of which belonged to more than 2,420 women, some of whom appeared multiple times. The whole thing constitutes a document unique in every way, not only for the history of clothing and society but also for the history of vocabulary and description.[65] With regard to color, red tones dominated (67 percent of all inventoried items), but yellows came in second (41 percent). Moreover, these two colors were often combined as stripes, checks, dots, or vertical halves. Greens (27 percent) and blues (19 percent) were rarer, and browns, grays, and whites rarer still. As for the great taste for blacks, then emerging in Milan, it would not reach Tuscany until the end of the century.[66]

Thus the beautiful ladies of Florence still liked to dress in yellow in the 1340s, on the eve of the Black Death, as did those in the other great cities of Italy, France, Germany, and England, and as their ancestors had done, almost daily, in ancient Greece and Rome. But the mid-fourteenth century marked the end of yellow's popularity. Subsequently, it would never again be a fashionable color, a color sought after by elegant women, not even in the eighteenth century.

Reserved for women in the peasant classes, it would gradually disappear from the cities and, beginning in the late nineteenth century, from clothing in general, whether for men or women, in the town or country. To this day, it has still not made a comeback, far from it. We will consider the reasons for that further on.

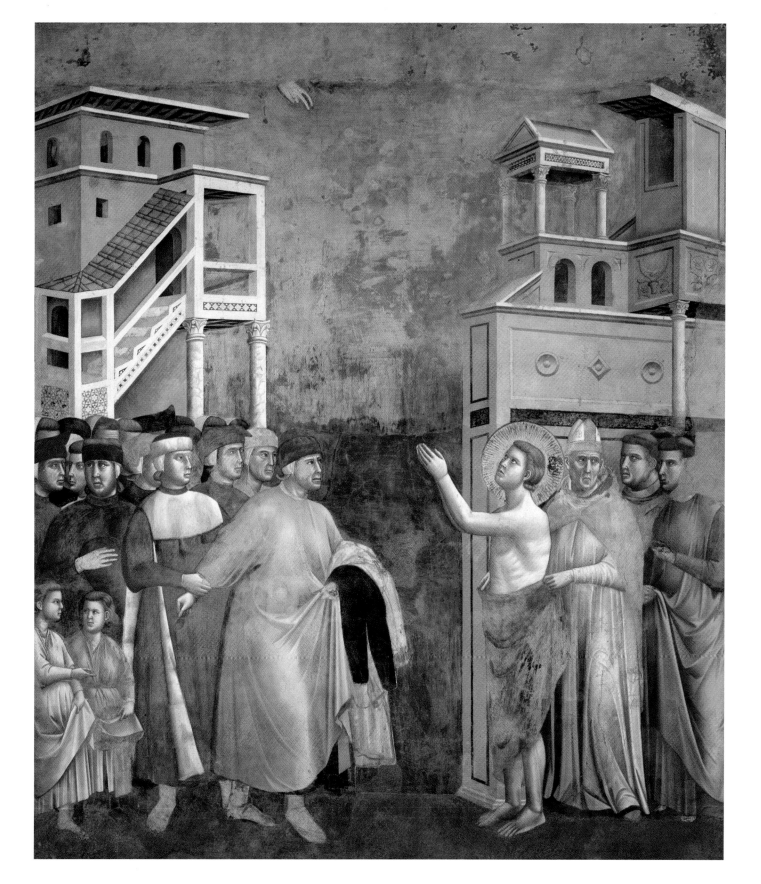

THE ORIGINS OF THE YELLOW STAR?

The Synagogue

In medieval iconography, the yellow robe is an attribute of Judas and of the Synagogue. The Synagogue is represented here with eyes blindfolded or closed because she has not recognized the divinity of Jesus or the New Law of Christ.

Often in her left hand she holds, with dignity, a broken lance as a symbol of her defeat. Konrad Witz, *The Synagogue*, detached panel from the Mirror of Salvation altarpiece, c. 1435. Basel, Kunstmuseum.

For the moment, let us stay with Judas and the images from the late Middle Ages. The traitorous apostle's robe certainly speaks of his perfidious nature, but it also emphasizes his Jewishness. In the art and images from the end of the Middle Ages, yellow tended to become the color of the Jews and the synagogue. Let us cite as a splendid example the painted panel by Conrad Witz, part of a reredos now dismantled, but dating to the years 1434–35. The synagogue is personified there as a young woman dressed in an immense robe of brilliant yellow; she is wearing a light veil over her eyes and holds in one hand the Tables of the Law, in the other a broken lance. Elsewhere, in miniatures and stained-glass windows from the same period, the Jews—and sometimes the Hebrews of the Old Testament—are often portrayed wearing clothing or a piece of clothing in this color (robe, cloak, belt, sleeves, gloves, breeches) and, more often still, a hat or cone-shaped cap, also painted yellow. This headgear has long appeared in images, sometimes as early as the eleventh century, and constitutes the most common iconographical attribute for the Jewish people, but it could be any color, and most frequently was white. In the mid-thirteenth century, it increasingly appeared as yellow, notably in Germany, England, and Italy.[67]

Here again, what is the link between image and reality with regard to dress? In everyday life in Western cities where they were present, did Jews always dress, totally or partially, in yellow? Of course not. But the images echo dress regulations imposed on Jews beginning in the early thirteenth century: the wearing of cloth insignias, often in the color yellow, so as to distinguish them from Christians. Images exaggerated this practice, taking the part for the whole, and transformed the discriminatory, defamatory mark into a veritable iconographical code. That code survived into the Middle Ages and is encountered in painting until well into the modern period.

It was in 1215 that the Fourth Council of the Lateran, in its canon, required that Jews and Muslims be distinguished

130

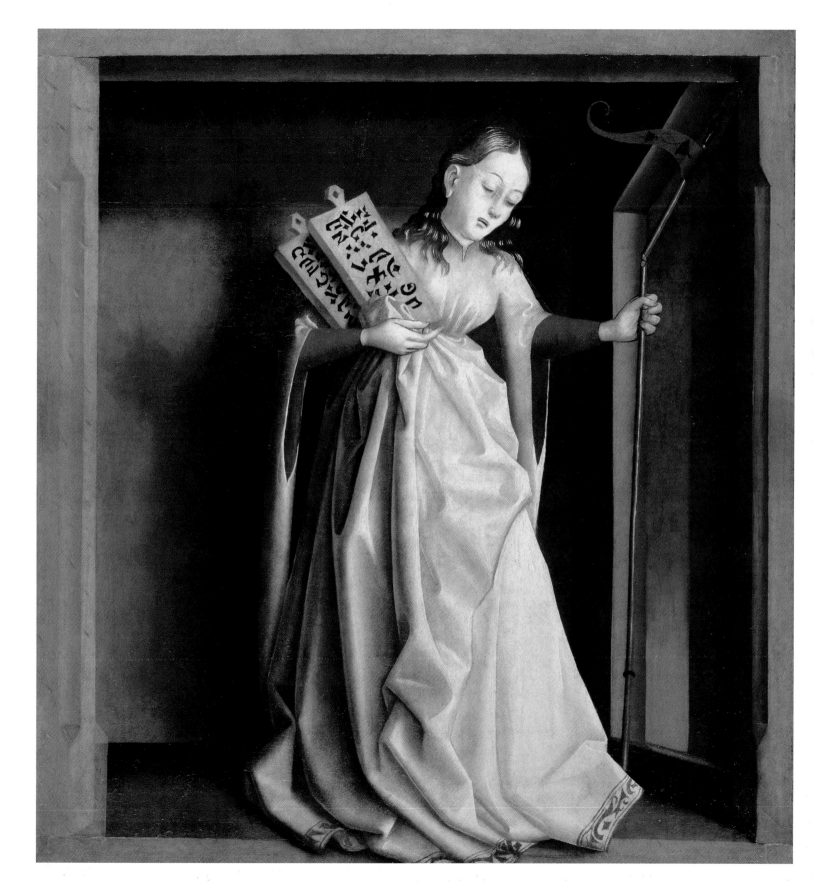

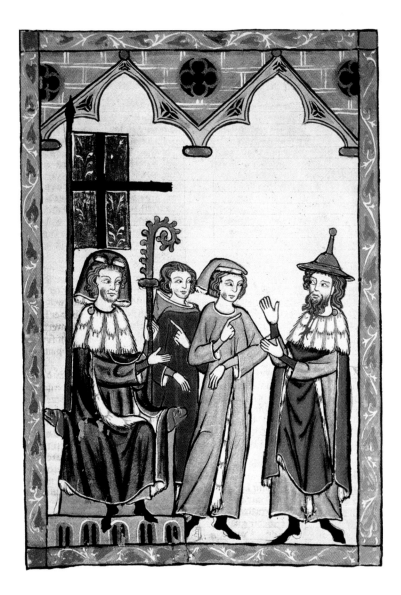

Jewish Hat

The Jewish hat in the form of a cap, sometimes conical, sometimes pointed, was not only an iconographical attribute. It was actually worn by men in certain towns or regions of western Europe, sometimes freely chosen, sometimes imposed as a mark of exclusion. It was most frequently yellow, but that was far from the only color. *Codex Manesse*, the Jewish poet Süsskind von Trimberg before the Bishop of Constance, c. 1300–1310. Heidelberg, Universitätsbibliothek, Cod. Pal. germ. 848, folio 355.

Thereafter the provincial councils and diocesan synods took up the charge, so effectively that gradually throughout the thirteenth century in a certain number of Catholic cities, dioceses, and provinces, distinctive clothing marks appeared (or reappeared) for Jews and more rarely for Muslims. The phenomenon was most widespread in England, the Rhine valley, northern Italy, southern France, and the entire Christian Iberian Peninsula. Elsewhere it was less pronounced or more strictly local, but it would only increase over the course of the next century.[68]

The yellow star, of grim and recent memory, seems to find some of its origins here. Nevertheless, we must be cautious because, despite a vast bibliography, the signs and marks imposed on Jews in medieval societies remain difficult to study as a whole. Contrary to what certain authors have too readily believed, there were not common practices throughout Christendom, or even consistent practices within one realm, diocese, or city. Of course, the color yellow—which, as we have seen, was often associated with Jews in images—appears more frequently than other colors, but for a long time municipal and royal authorities also prescribed wearing marks of red, white, green, black, or, more rarely, vertical halves or quarters of yellow and

from Christians by a specific article of clothing, leaving to secular authorities in each town or realm the task of determining what that should be, its form, color, and placement. Certainly this was not the first time the wearing of a particular sign was imposed on non-Christians living in Christian lands, but it was the first time a general council of the Church legislated on the matter. In the following year, shortly before his death, Pope Innocent III wrote to all the bishops of the dioceses of Western realm to remind them of the council's decision and call for its broad application.

The Persecution of Jews

In England, it was not the *rotella* but an insignia in the form of the Tables of the Law that was most frequently imposed on Jewish communities as a mark of exclusion. In Germany, it was often a star. In Italy, rather than a specific insignia sewn onto clothing, a conical hat or yellow belt was required.
Expulsion of the Jews from England, anonymous miniature, 14th century. London, The British Library, ms. Cotton Nero D.II, folio 183 v°.

red, yellow and green, red and white, and white and black. Until the sixteenth century, chromatic rules remained varied, as did the nature or form of the mark. The most common form was a *rotella*, that is, a plain round piece of cloth, but it could also be a diamond, star, ring, a stylized figure of the Tables of the Law, or even a cross or cap sometimes combined with a scarf or belt. In the case of insignias sewn onto clothing, they might appear on the shoulder, chest, back, head covering, or several places at once. Here again, broad generalizations are almost impossible.[69]

It was an edict in 1269, from a prestigious king—Saint Louis—that long led to the belief that the yellow circle was the (almost) universal insignia imposed on the Jews. It was nothing of the kind. In the French realm itself, practices varied widely until the end of the fourteenth century. Nevertheless, here is the text of that famous edict, translated and slightly abridged, that was sent by Saint Louis to all bailiffs and seneschals on the eve of his departure for his Second Crusade, in the specific context of putting the realm into order and exalting the Christian faith:

Because we want Jews to be recognized and distinguished from Christians, we are ordering you . . . to impose insignias on each Jew of both sexes: that is, a wheel of felt or wool in the color yellow, sewn high on the clothing, on the breast and back, so as to constitute a sign of recognition. The diameter of the wheel will be four fingers and its surface large enough to contain the palm of a hand. Following this measure, if a Jew is found without this insignia, the upper part of his clothing will belong to the one who encountered and discovered him thus.[70]

Must this mark, imposed on all Jews in the French realm, be seen as a more or less direct precursor to the yellow star? Some historians say so, but that seems a bit risky, not so much because in following decades, the form and color of this mark varied widely, but because from the thirteenth to the sixteenth century, throughout Europe, similar discriminatory signs—including the yellow circle—were required for many other categories of outcasts and reprobates, Christian and non-Christian alike. In this regard, aside from the stylized image of the Tables of the Law, found especially in England, nothing was exclusively reserved for the Jews. Other outcasts wore the same marks and insignias at one time or another in their history.[71]

Our principal sources for this information are the clothing decrees that multiplied at the end of the Middle Ages

YELLOW THE HISTORY OF A COLOR

and the beginning of the modern period in large cities in the West. They accompanied sumptuary laws or were an extension of them. Going on at length about the colors forbidden to particular social categories, they are also and even more expansive about required colors and marks. The reasons invoked are always the same: to maintain the established order, ensure good morals, follow ancestral traditions, avoid confusing honest folk with those whose status set them apart or located them on the margins or even outside of society.

There is a long list of all those affected by these dictates who had to wear particular clothing, colors, or insignias. First were men and women who practiced dangerous, dishonest, or simply suspect occupations: surgeons, hangmen, prostitutes, usurers, jugglers, musicians, beggars, vagabonds, and all types of poor. Following them were those condemned for one thing or another, from simple drunks causing public disorder to false witnesses, traitors, thieves, and blasphemers. Then came various categories of the disabled, as infirmity—physical or mental—was always the sign of great sin in medieval value systems: the lame, cripples, lepers, Cagots, those "poor of body and cretinous of mind." Finally there were the non-Christians, first among them the Jews. But let us repeat, for none of these social categories, not even for Jews and Muslims, did there exist a system of marks or colors that was shared throughout Christendom. On the contrary, practices varied widely from one region to another, one city to another, and within the same city, from one time period to another. In Milan and Nuremberg, for example, cities where regulatory texts became numerous and detailed in the fifteenth century, the marks and colors dictated—for prostitutes, lepers, and Jews—changed from one generation to the next, almost from one decade to the next. Nevertheless, we can observe, here as elsewhere, a certain number of consistencies, from which it is worth drawing a general outline.

Only five colors are involved in these discriminatory marks: white, black, red, green, and yellow. As for blue, it was almost never used, which says much about its growing prestige in the last three centuries of the Middle Ages.[72] Those five colors could appear in various ways: alone, so that the mark was monochrome, or in combination, with bichrome marks appearing most frequently. All combinations took place, but those recurring most often were red and white, red and yellow, white and black, yellow and green. The two colors were thus combined as in the geometric figures of heraldry (*parti, coupé, écartelé, fascé, palé*).[73] If we attempt a study by category of the excluded and outcast, we can observe—by slightly oversimplifying—that white and black were used especially for the impoverished and infirm (especially lepers); red for executioners and prostitutes; yellow for forgers, heretics, and Jews; green, either alone or combined with yellow, for musicians, jugglers, clowns, and the mad. But for Jews as for the others, so many counterexamples exist that it is impossible to find a general code here or even the beginning of a system.[74]

134

135

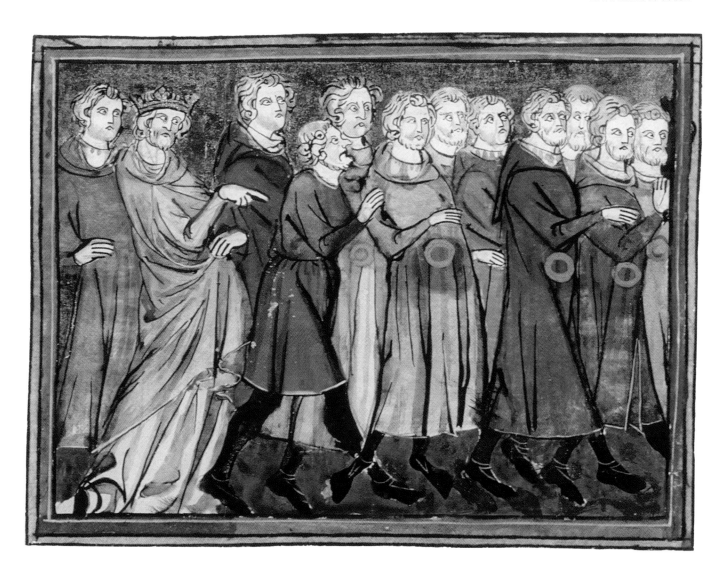

The Rouelle Imposed on the Jews

Beginning in the thirteenth century, in certain realms, states, or cities in the West, Jews were required to wear a distinctive insignia. The form and color of that insignia varied widely according to time and place. Nevertheless, in France, the most common form was that of a ring or a wheel (hence the name *rotella* or *rouelle*) and the most common color was yellow.
Expulsion of the Jews from France in 1182. Miniature from a manuscript of the *Grandes Chroniques de France*, c. 1320–25. Brussels, Bibliothèque royale de Belgique, ms. 5, folio 265.

AN UNPOPULAR COLOR

(FOURTEENTH TO TWENTY-FIRST CENTURIES)

At the end of the Middle Ages, yellow appeared in the world of symbols and the imagination as a greatly devalued color associated with many vices: envy, jealousy, duplicity, lying, treachery, and madness. It remained very much present nonetheless in everyday life and material culture, especially in fabrics and clothing. In the fifteenth century, all social classes still dressed in yellow; women in particular liked to wear this color, whether they were nobility or commoners, city dwellers or peasants. In the century that followed, that was no longer entirely true. Yellow became rarer in aristocratic circles and ceased to be a fashionable color, sought after by stylish dressers. It would never really become popular again, not even in the eighteenth century, the Age of Enlightenment, a time of when colors were profuse and multiplied into countless shades. In fact, although it did not disappear completely, yellow began a long period of decline in the early modern period that gradually touched all society. This decline accelerated beginning in the mid-nineteenth century, and its effects are still felt today; it does not take great powers of observation to notice that in our everyday world, yellow remains quite inconspicuous, and that is true throughout Europe.

It is not easy to identify all the causes for this gradual disappearance. No doubt yellow's bad reputation worked against its use in clothing. Wearing a color associated with traitors does not enhance one's esteem or pleasure. Moreover, unless dyed with saffron, an expensive colorant, cloth dyed in yellow, with either weld or broom, often made the one wearing it look wan. No doubt too the instability of most yellow tones, both in dyeing and in painting, did not serve the color well. It was not that yellows were chemically unstable, as were nearly all greens, but they soiled easily, lost their brilliance in certain lights, suffered from the negative influence of neighboring shades, and were quickly altered by even modest blending. Goethe summarized yellow's handicap well, as it was used by either painters or dyers: "Yellow is a gay, soft, and joyous color, but in poor light it quickly becomes unpleasant, and the slightest mixing makes it dirty, ugly, and uninteresting."[1] That is probably why, with regard to clothing, yellow became an unpopular color in the modern period, relegated to peasants, artisans, and domestics. That is also why in artistic creation, especially in the baroque period, it often had to yield its place to gold.

PREVIOUS SPREAD

Identifying Judas, an Easy Exercise

As early as the thirteenth century, in representations of the Last Supper, Judas is distinguished from the other apostles and can be recognized by various attributes that will increase in number over the course of time: position, attitude and special gestures, brutish or contorted expression, absent halo, awkwardness, incriminating mouth, purse with the thirty denarii, dog at his feet, and especially his yellow robe and red hair.
Philippe de Champaigne, *The Last Supper*, c. 1652. Paris, Musée du Louvre.

138

Portrait of a Young Venetian Woman Dressed in Yellow

In Venice, the European capital of color, yellow tones were in fashion at the beginning of the sixteenth century. Not sharp, aggressive yellows tending toward green, but yellows that were warmer, softer, and more golden, that harmonized with women's blond hair.
Pietro degli Ingannati, *Portrait of a Young Woman*, c. 1515–20. Berlin, Gemäldegalerie.

However, there is another way to explain the disappearance of yellow in daily life: Protestant morals. As an extension of the sumptuary laws and dress decrees of the late Middle Ages, the Reformation declared war on colors they deemed too vivid or gaudy. Gradually, priority in all domains was given to the black-gray-white axis, more dignified than "papist polychromy" and more in keeping with the culture of engraving and the printed book, then coming into its own. I have examined the "chromophobia" of the great Protestant reformers at length elsewhere, notably in my work, *Noir: Histoire d'une couleur*.[2] I will direct the reader there and simply summarize here the broad outlines, emphasizing the fate in store for yellow, which, along with red, was the principal victim of this new war against colors.

Protestant chromoclasm, whether Lutheran or Calvinist, involved the church and the worship service first of all. For the great reformers, the presence of color was excessive there; it had to be reduced or eliminated. In their sermons, they repeated the biblical words of the prophet Jeremiah railing against the luxury displayed by King Joachim and against "the princes who construct magnificent temples like palaces, cutting windows into them, paneling the walls with cedar and painting them with vermillion."[3] Red—the richest color for the Bible and, in the sixteenth century, the one that epitomized the luxury of the Roman Catholic Church—was the chief target, but yellow and green were targeted as well; they needed to be expelled from the temple.[4] Hence the violent destruction—of stained glass in particular—and strategies for removing color from walls, such as stripping or whitewashing them, and using monochrome black or gray hangings to hide paintings and images. Chromoclasm went hand in hand here with iconoclasm.[5]

Nevertheless, as churches gradually became as stark as synagogues, it was probably in customs of dress that Protestant chromophobia exerted its most severe and lasting influence. For the Reformation, clothing was always a sign of sin and shame because it recalled the Fall. Adam and Eve lived naked in earthly paradise but, having disobeyed God, they were expelled. They were then given clothing to hide their nudity. That clothing was the symbol of their sin, and its first function was to remind man of his fall from grace. That was why all clothing had to be somber, simple, modest, and adapted to climate and occupation. To draw attention to oneself through one's clothing

141

was a grave sin. Protestant morals had the deepest aversion to luxurious clothing, makeup, jewelry, costumes, and inconstant or outlandish fashions. This resulted in extreme austerity in dress and appearance and the abolition of useless accessories and artifices. The great reformers set the example, both in their personal lives and in the painted or engraved representations they left of themselves. They are all portrayed in severe, monochromatic dark or black clothing.[6]

Bright colors, considered immodest, were absent from the Protestant wardrobe: red and yellow primarily, but also pinks, oranges, greens, and even purples. Conversely, dark tones were recommended: blacks, grays, and browns most prominently. As a pure color, white was advised for children's and sometimes women's clothing. Blue was tolerated insofar as it remained drab and modest. Multicolored clothing that dressed "men like peacocks"—the expression Melanchthon used in a famous sermon in 1527—was severely condemned.[7] Yellow and red were particularly targeted.

In the seventeenth century, the war waged against these two colors was no longer limited to Protestant Europe because on several counts, the Catholic Counter-Reformation tended to adopt some part of Protestant values. Throughout Europe, yellow—like red—became increasingly less conspicuous for moral reasons, both in everyday clothing and decor. Thus it also appeared less often in texts and images. It was not absent, of course, but with documents on it becoming rarer and less expansive, its true popularity becomes harder to trace and its history harder to reconstruct, compared to those of other colors. During the ancien régime, yellow seems to play hide-and-seek with the historian.

NEXT SPREAD

Yellow, Sign of Joy in the English Court of Henry VIII

Accounting documents, chronicles, and portraits attest to the pronounced taste for yellow of King Henry VIII of England. For him, it was a sign of joy, victory, and happiness. He wore it notably each time he remarried (he had six wives) and demanded that the new queen and all the court wear it as well. *The Family of Henry VIII*, anonymous painting, c. 1545. London, Hampton Court Palace, Haunted Gallery.

DIEV ET MON DROIT

THE YELLOW OF PAINTERS

An Illuminator at Work

Most of the time, medieval illuminators ground their pigments and prepared their colors themselves. In large workshops, assistants were responsible for some part of those operations and facilitated the work of the painters. In general, two pigments were not ground together to obtain a third one. The principal yellow pigments were made with bases of ocher, orpiment, tin, lead, and weld lacquer. Illustrated letter in a manuscript of the *Omne bonum* encyclopedia, c. 1360–70. London, The British Library, ms. Royal 6E VI, folio 329.

Painting constitutes a good example of this elusiveness that throws the historian off yellow's track. In late medieval miniatures, as in panel paintings, yellow was relatively abundant and presented true yellow tones, often bright and saturated. That was the case for stained glass as well, thanks to the invention in the early fourteenth century of silver stain, which diversified the palette of shades and multiplied yellow tones.[8] That was still partially the case for the paintings of the early sixteenth century, but afterward, from the 1560s until the impressionist revolution, that is, for more than three centuries, yellow made itself scarce and often took on shades far removed from the pure color: tending toward browns, greens, grays, ochers, pinks, straw or ivory tones, and sometimes even outright beige, as with Caravaggio, or golden, as with many of the apostle painters of the baroque period. It is nevertheless possible that time has done its work and transformed or darkened one pigment or another. When yellow is truly yellow, it covers only a small surface and constitutes a kind of chromatic accent. Of course exceptions do exist, notably in seventeenth-century Dutch painting. But even with Vermeer, the grand colorist and painter of yellow, his yellows serve more to harmonize—in an almost musical way—the other colors than to play a strictly iconographic role. Moreover, the "little patch of yellow wall" in his *View of Delft*, so admired by the writer Bergotte that it prompts his death, seems more or less white and pink today.[9] Was that already the case in 1921? Marcel Proust does not seem to have noticed it:

The circumstances of his death were as follows. A fairly mild attack of uraemia had led to his being ordered to rest. But an art critic having written somewhere that in Vermeer's *View of Delft* (lent by the Gallery at The Hague for an Exhibition of Dutch painting), a picture which he adored and imagined that he knew by heart, a little patch of yellow wall (which he could not remember) was so well painted that it was, if one looked at it by itself, like some priceless specimen of Chinese art, of a beauty that

144

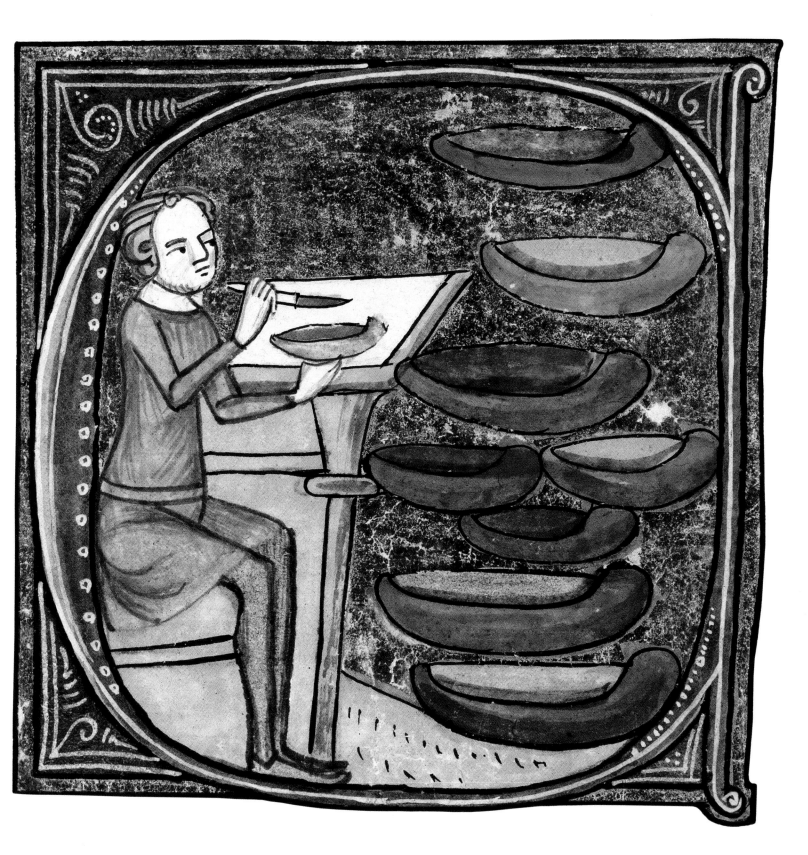

Silver Stain

In the early fourteenth century, the invention of silver stain transformed stained glass colors and techniques. This yellow pigment with a silver compound base was applied to the exterior surface of the glass and fixed there. During the firing, it penetrated the glass and altered the color: if the glass was white, it became yellow; if it was already blue or red, it became green or orange. This new technique, accompanied by progress in painting in grisaille, made it possible to obtain many colors on a single piece of glass without enclosing each color in a network of lead. Chess game and courtly love. Stained glass window from the l'hôtel de la Bessée, in Villefranche-sur-Saône, c. 1430-40. Paris, Musée de Cluny, inv. Cl 24322.

was sufficient in itself, Bergotte ate a few potatoes, left the house, and went to the exhibition. At the first few steps that he had to climb, he was overcome by an attack of dizziness. He walked past several pictures. . . . At last he came to the Vermeer which he remembered as more striking, more different from anything else that he knew, but in which, thanks to the critic's article, he noticed for the first time some small figures in blue, that the sand was pink, and, finally, the precious substance of the tiny patch of yellow wall. His dizziness increased; he fixed his gaze, like a child upon a yellow butterfly that it wants to catch, on the precious little patch of wall. "That's how I ought to have written," he said. "My last books are too dry, I ought to have gone over them with a few layers of colour, made my language precious in itself, like this little patch of yellow wall."[10]

There is no need whatsoever to read this famous passage from *The Captive*, the fifth volume of *Remembrance of Things Past*, in order to recognize that Vermeer was a great painter of yellows, as were his contemporaries, Samuel van Hoogstraten and Pieter de Hooch. We need only to look at their paintings. For that same period, outside the Netherlands, there are no names worth mentioning. Only two among the great masters seem to be exceptions: Simon Vouet (1590–1649), whose saturated yellows tend toward orange, and Claude Gelée (about 1600–1682), called Le Lorrain, whose violent yellows radiate from many of his canvases seeking to capture the light of a rising or setting sun. But in a more general manner, the great painters of yellow

Extracting Orpiment

Already used by painters in ancient Egypt and Greece, orpiment is a natural pigment with an arsenic trisulfide base. It provides very beautiful yellow tones, similar to those of gold, and despite its high price and toxicity, illuminators often resorted to it to replace that precious metal. In frescoes, on the other hand, it was not used because it darkens badly when exposed to air and tends to contaminate the colors around it. Miniature from a manuscript of the *Livre des simples médecines*, c. 1465-70. Paris, Bibliothèque nationale de France, ms. français 12319, folio 64.

147

are more recent: Turner, Gauguin, Van Gogh, most of the fauvists, Schiele, Kupka. We will discuss them further on.

Like the painters of the Middle Ages, modern painters had at their disposal a palette of relatively abundant pigments for expressing all the shades of yellow. If they used them only sparingly, unlike their predecessors, it was not for lack of chemical or technical means, but very much because of the color's disfavor and its modest place in the material culture of their time. They used it more for mixing or glazing than as a color in its own right.

The oldest yellow pigments were the ochers, that is, clays rich in iron hydroxide, already used by Paleolithic painters. They were solid and very stable in light but did not cover well. If an ocher contained manganese oxide in addition to iron, the color obtained tended toward brown and took the name "terre d'ombre." Many sixteenth- and seventeenth-century painters preferred it to ordinary ochers, especially since it could be charred to take on a "burnt" aspect with very beautiful effects.

Orpiment has been used by painters almost as long as ochers have. A natural arsenic sulfide, it combined easily

The Little Patch of Yellow Wall

Marcel Proust immortalized Vermeer's *View of Delft* by making it play a decisive role in one of the most famous episodes in *Remembrance of Things Past*: the death of the writer Bergotte, who collapses while looking at the painting, a victim of both an attack of uremia and too violent emotion. It is likely that even without Proust or Bergotte, the *View*

of Delft would be considered one of the most beautiful urban landscapes in the whole history of painting. But who would have noticed the "little patch of yellow wall"? Looking carefully, we can clearly see that it is not a wall but a small roof, and that it seems more pink than yellow. Johannes Vermeer, *View of Delft*, 1660–61. The Hague, Mauritshuis.

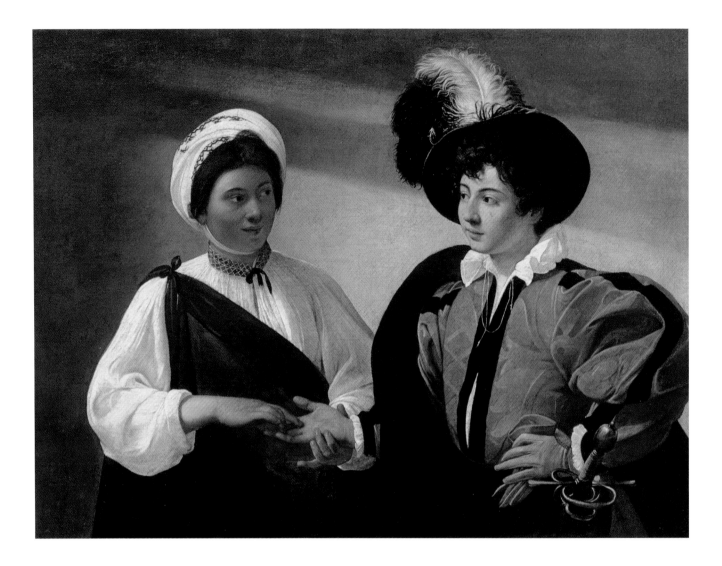

with clays but not at all with metallic pigments. A compound of sulfur and arsenic, it was an extremely toxic product that had to be handled with care and could only be used on small surfaces. However, it produced very beautiful yellow tones, clear and bright if there was more sulfur, tending toward orange if there was more arsenic. Painters used it to replace gold and knew how to create it artificially by fusing sulfur and realgar, but artificial orpiment darkened more quickly than natural orpiment. Hence painters sometimes resorted to mosaic gold, a false gold, more or less red in color, obtained from sulfur, tin, mercury, and sal ammoniac.

However, in fifteenth- and sixteenth-century painting, the most frequently used yellow pigments were neither ochers nor orpiment, but pigments with a lead and tin base. The Romans were already familiar with them, but in the late Middle Ages, formulas for making them multiplied, varying the proportions of the two metals and the temperature of their fusion. If the proportion of tin was low, the temperature could remain moderate (between 300 and

OPPOSITE

From Yellow to Brown

In the second half of the sixteenth century, true yellows appeared less often in Italian painting, yielding their place to tones of ivory, beige, straw, russet, and light brown, all often ochered or bronzed. They permitted more accentuated contrasts than yellow did and more subtle plays of light. In Rome, in the early years of his career, Caravaggio proved very adept at creating original effects from this new palette.
Caravaggio, *The Fortune Teller*, c. 1595–98. Paris, Musée du Louvre.

Yellow in Everyday Life

In the seventeenth century, in northern Europe, accounting documents, postmortem inventories, and easel paintings attest to a still relatively significant presence of yellow tones in domestic interiors: fabrics, hangings, furniture. In southern Europe, it tended to be rarer.
Samuel van Hoogstraten, *View of an Interior* or *The Slippers*, 1654–62. Paris, Musée du Louvre.

Drawing and Color

For the painter, which is fundamental, drawing or color? This question was posed constantly from the end of the fifteenth century until the beginning of the twentieth century and prompted many debates, quarrels, and controversies. Most of the time, drawing prevailed: it is masculine and addresses the mind, whereas color, which submits to it, is feminine and addresses only the senses.

Guido Reni, *The Union of Drawing and Color* (workshop copy?), c. 1630. Versailles, Palaces of Versailles et Trianon.

153

Simon Vouet, Painter of Yellows

In eighteenth-century France, there were few great painters of yellow. In addition to Claude Géllee (Le Lorrain), we must especially cite Simon Vouet (1590–1649). Following a very long stay in Italy (fifteen years), he adopted the habit of using a pigment much prized on the peninsula, Naples yellow, alongside pigments previously used in France (orpiment, yellow from tin and lead, weld lacquer), thereby creating lavish and luminous effects.

Simon Vouet, *Allegory of Wealth*, c. 1640. Paris, Musée du Louvre.

600 degrees). Thus one obtained massicot, a golden yellow, often described in texts as a "beautiful yellow." It was indeed splendid, but it was an unstable pigment, not resistant to light, with a tendency to darken or turn green over time. If the lead and tin were combined in roughly equal proportions, the temperature had to be raised to 850 or 900 degrees; for this reason, the pigment was often produced by master glassmakers who added sand to it. This yellow was more solid than massicot but just as toxic. Moreover, the two pigments are difficult to distinguish in texts because the recipes are so varied and the vocabulary so uncertain.[11] In this regard, as always, the Latin is more precise and easier to understand than the vernacular languages used, notably the Italian dialects. For example, what was the *giallorina* that appeared as early as the early fifteenth century in *Libro dell'arte* by the Florentine painter Cennino Cennini and was still mentioned frequently in treatises in the eighteenth century?[12] A lead-tin yellow? A simple massicot? A Naples yellow?

Naples yellow was a very different pigment from the other two, although just as toxic. Made up mainly of antimony and lead, it existed in the natural state in the form of a residue from volcanic rock, abundant on the slopes of certain volcanoes. The Egyptians and the Romans were already familiar with it, but it was in the mid-sixteenth century especially that the great modern European masters began to adopt it. They gave it the name "Naples yellow" because it generally came from the slopes surrounding Mount Vesuvius. This pigment was solid, covered well, and provided beautiful, saturated yellows although they were often a bit pink or off-white. It could be produced artificially by combining lead and antimony with potash or lime sulfate, but the synthesis was complex and difficult to obtain.

For their palette of yellows, painters also used exotic tree resins (like gambage, which provided solid, bright, but unsaturated tones) and lacquers. Lacquers were plant extracts precipitated chemically with a metallic base, usually aluminum. The most commonly used was from weld, a

The Colors of the Rising Sun

Well before Turner and Monet, Claude Gellée, called Le Lorrain (about 1600–1682) knew how to create remarkable pictorial effects by capturing the changeable light of the sun playing across the surface of water. To do this, a wide palette of yellow tones was employed, from very pale ones that merge with white to much more saturated ones that take orange tones, and including ocher, pinkish, grayish, and even slightly blue yellows. Le Lorrain, *Morning in the Harbour*, c. 1640–45. Saint Petersburg, Hermitage Museum.

very solid pigment that provided yellows tending slightly toward green. Stil de grain was also a plant-based lacquer, made from buckthorn berries or chestnut leaves. It also provided solid but slightly green, dull yellows. Painters used them especially for creating shadows and applying glazes.

As with all the colors, every painter and every workshop possessed its own "recipes" for yellows, as current laboratory analyses show. The same pigment would provide very different hues depending on how it was ground, the nature of the binder, or the addition of one charge rather than another. And depending on the blends as well; an ocher clay would react differently if a bit of lead yellow was added rather than a bit of orpiment. Beginning in the 1600s, some workshops where scholars collaborated with painters became expert in matters of blending and the chemistry of pigments. That was the case in Anvers, for example, in Rubens's studio, where painters and their many assistants worked side by side, each specializing in a specific task, but also in collaboration with scientists, Jesuit teachers, philosophers, engravers, and even dyers.

A Protestant Palette

With the Reformation's harsh condemnation of colors, it is possible, as early as the seventeenth century, to distinguish a Catholic palette from a Protestant palette among the painters. Rubens (1577–1640) was a Catholic painter and immense colorist; Rembrandt (1606–1669) was a Calvinist painter who preferred the play of monochromes and shimmering effects of light to the use of lively colors.
Rembrandt, *Philosopher in Meditation*, 1632. Paris, Musée du Louvre.

THE YELLOW OF SCHOLARS

On the scientific level, the seventeenth century constituted an important period of change for yellow—as for colors as a whole. Intellectual curiosity evolved, experiments multiplied, new theories came to light, along with new classifications and reclassifications. That was the case first of all in the physical sciences, especially optics, which had hardly progressed since the thirteenth century. Beginning in the 1600s, there were numerous new speculations on light and consequently on colors, their nature, perception, and classification. At that time, however, the normal order for colors arranged along an axis was still the Aristotelian order (as it was called) that I have mentioned several times: white, yellow, red, green, blue, purple, black. White and black remained full-fledged colors. As for yellow, it fell between white and red, so that green, located farther away, was never the intermediary between yellow and blue. Hence, there were very few painters or dyers who mixed yellow and blue to make green. The spectral order of colors discovered by Newton in 1666 was still far away, it seems, although many scholars were beginning to question the Aristotelian classification.

158

A few proposed replacing the axis with a circle or half circle in order to show how colors could engender one another; others imagined branching patterns of remarkable complexity. One of the most audacious of these was reproduced by the famous Jesuit Athanasius Kircher (1601–1680)—a prolific writer interested in everything, including colors—in his great work on light, *Ars magna lucis et umbrae*, published in Rome in 1646. This ingenious diagram attempted to convey as image the entire system of genealogical relationships that seemed to unite colors to one another. Yellow (*flavus*) was presented there as one of the five basic colors; it helped to produce orange (*aureus*) when combined with red, green (*viridis*) when combined with blue, brown (*fuscus*) when combined with black, and even an off-white tone described as *sulalbus* (cream, ivory, eggshell) when combined with white.[13]

Classifying Colors in the Seventeenth Century

In the first half of the seventeenth century, numerous systems were proposed for classifying colors and showing how they can engender one another. One of the most audacious and accomplished of these was proposed in 1646 by the learned Jesuit writer Athanasius Kircher (1601–1680). Yellow (*flavus*) clearly appears here as one of the five "basic" colors. Athanasius Kircher, *Ars magna lucis et umbrae*, Rome, 1646, page 12.

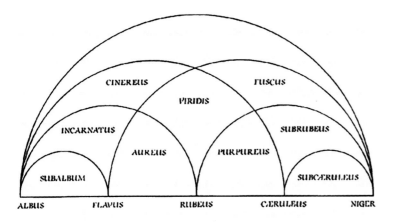

159

More pragmatically, other men of science observed and theorized about the know-how of artists and artisans. That was true of the Paris doctor Louis Savot, who questioned dyers and glass artists and then constructed his chromatic classifications based on their practices. There was also the Flemish naturalist Anselme de Boodt, frequent visitor to Emperor Rudolph II's court and his cabinets of curiosities. His studies centered on gray, and he showed, for perhaps the first time, how it could be produced by simply mixing black and white, as previously it had been considered a blend of all the colors. But most important was François d'Aguilon, prolific Jesuit writer and friend of Rubens, who formulated the clearest theories as early as 1613, those with the greatest influence on authors in the following decades. He distinguished between "extreme" colors (black and white), "medium" colors (red, blue, yellow), and "mixed" colors (green, purple, orange). In an elegant diagram similar to those of musical harmony, he showed how colors could be combined to create other colors. As later with Kircher, yellow was already a "mother color."[14]

In the same period, some painters were proceeding similarly with their palettes. They were trying to obtain empirically a great number of tones and shades by simply mixing a small number of "first" colors, either by mixing them before applying them, superimposing them directly on wood or canvas, creating glazes, or resorting to a colored medium. Actually, this was hardly new, but in the first half of the seventeenth century, inquiries, experiments, hypotheses, and debates took on an intensity they had never known before. Throughout Europe, artists, doctors, pharmacists, physicists, chemists, and dyers were all asking the same questions: how many "basic" colors were necessary for creating all the others? How to classify, combine, and mix them? And even, what to call them? On this last point, the vocabulary proposed was extremely varied, no matter what the language in question. These "basic" colors were by turn characterized as "first," "principal," "simple," "elementary," "natural," "pure," or "capital." In Latin, the expressions *colores simplices* and *colores principales* were most often used. In French, the lexicon was less consistent and more ambiguous. An expression like "pure color," for example, was equivocal and could designate a basic color, a natural color, or even a color to which neither white nor black was added. As for the adjective "primary," used as early as the late seventeenth century and still today, it did not really take hold until the nineteenth century.

And how many basic colors were there? Three? Four? Five? Here opinions varied widely. Some authors looked back very far to ancient traditions, notably to the opinion of Pliny who cites only four of them in his famous *Natural History*, book 35: white, red, black, and the enigmatic *sil* (*silaceus*), usually identified as yellow, but sometimes as blue. Understanding this term, extremely rare in classical Latin, is all the more difficult because Pliny was speaking more of colorants than of the colors obtained.[15] That was why many seventeenth-century authors did not use his *Natural History* or classical antiquity as a reference but rather the experiments of their contemporaries, affirming that there were five "first" colors: white, black, red, yellow, and blue. Later, when Newton had scientifically eliminated black and white from the color order, most scientists would only accept three colors: red, blue, and yellow. This was not yet the theory of primary and complementary colors,

The Invention of Color Engraving

Newton's discovery of the spectrum opened the door to many speculations and inventions. Hence the invention of color engraving by Jakob Christoffel Le Blon about 1720, further refined by Gautier d'Agoty a few years later. The process consists of engraving a design on an initial plate, then exactly reproducing it on three other plates superimposable on the first; each of the plates is then inked with a different color (blue, red, yellow, black), and then used successively to print a single sheet of paper. Jakob Christoffel Le Blon, *Le Cardinal de Fleury*, successive prints for a color engraving, 1737. Paris, Bibliothèque nationale de France, Cabinet des estampes et de la photographie.

but it was already the modern subtractive triad that would allow Jakob Christoffel Le Blon to invent color engraving in 1720–40, and then allow other experimenters over the following decades to make considerable progress in the areas of printing and reproduction.[16]

Let us remain for the moment with the seventeenth century. Whether there were three primary colors or five, yellow was among them. This was something very new: this color that had become so inconspicuous in material culture, decor, and everyday life, was now given equal standing with red and blue by certain men of science! That novel idea was adopted by a portion of the learned world, and then gradually by some artists and even some artisans, notably dyers.

In a general work on colors, *Experiments and Considerations Touching Colours*, Robert Boyle (1621–1691), the Irish chemist with many varied interests, expressed it very clearly in 1664, less than two years before Isaac Newton's discovery of the spectrum:

There are very few simple or "primary" colors, the various combinations of which somehow produce all the others. Because even though painters can imitate the shades—but not always the beauty—of the countless colors one encounters in nature, I do not believe that they need to use colors other than white, black, red, blue, and yellow to bring out this extraordinary variety. Those five, variously combined—and also, if I may say so, uncombined—are

sufficient for creating a considerable number of colors, a number that those unfamiliar with the painters' palette cannot even imagine.[17]

The perspective of Robert Doyle, a widely read author, came to be generally accepted among chemists and then among painters. Only five basic colors existed, and yellow was one of them. In chromatic genealogy, it ranked among the first, along with white, black, red, and blue.

Yellow maintained this primary position in the spectral order of colors discovered by Isaac Newton two years later, in 1666—an order that has remained to the present day the basic scientific classification for arranging the colors. For Newton, colors constituted "objective" phenomena. That was why questions regarding vision, too bound up with the eye ("uncertain and deceiving"), had to be put aside, as well as those involving perception, too subject to different cultural contexts. One had to concentrate on questions of physics alone. That was what Newton did by returning to earlier experiments involving light passing through a glass prism. Indeed the young English scientist thought that color was nothing other than light subjected to various physical changes as it moved or encountered matter, changes that had to be observed, defined, studied, and measured. By doing multiple experiments, he discovered that the white light of the sun neither dimmed nor darkened as it passed through a glass prism; on the contrary, it created a colored, elongated strip as it exited, within which it was dispersed into many colored rays of unequal lengths. Those rays formed a chromatic sequence that was always the same: violet, blue, green, yellow, orange, red. Newton first distinguished six rays but later added a seventh one (deep blue or "indigo") in order to form a set of seven. Henceforth, the colors that made up light were identifiable, reproducible, controllable, and even measurable.[18]

Newtonian Optics

It was not until 1704 that Isaac Newton (1642–1727) published his great treatise on optics, comprising the synthesis of his earlier works on light and color, works begun in 1666 when he was a student at Cambridge. The first edition in English created less of a stir than the second one, published in Latin three years later. In the early eighteenth century, Latin remained the language of scholars.
Isaac Newton, Opticks: or, a Treatise of the Reflexions, Refractions, Inflexions and Colours of Light, London, 1704.

YELLOW IN DAILY LIFE

Yellow, a Feminine Color

In the seventeenth century, postmortem inventories teach us that in northern Europe, yellow was a color essentially worn by women, in town and country alike.

This is confirmed by the abundant genre paintings by Flemish and Dutch painters. Jan Steen, *A Peasant Family at Mealtime*, c. 1660. London, National Gallery.

One might think that the new scientific status of yellow would contribute to its promotion in material culture and the world of symbols. That was not the case. In the second half of the seventeenth century and the first half of the eighteenth century, yellow remained what it had previously been: a shade largely absent from clothing and everyday life, a color whose enduring negative reputation proved very difficult to rehabilitate. Obviously we do not have opinion polls from this period on favorite or unpopular colors. But if we did, it is likely that yellow would come last among the six basic colors of European culture, with red and blue contending for first place, white and black coming next, and green and yellow bringing up the rear.

Of course such calculations are a bit anachronous, but postmortem inventories, increasingly common over the decades, give an accurate image of yellow's modest place in everyday life during the ancien régime, not only in France but also, to varying degrees, in neighboring countries. Compiled by lawyers, the purpose of these inventories was to list the goods owned by an individual at time of death and assign each an estimated value. These documents are invaluable for historians of everyday life because estate items (dishes and cooking utensils, professional tools, clothing, linens, sheets, engravings, various papers, merchandise, and so on) were generally inventoried one by one. For textiles, for example, wardrobes and chests of drawers were opened, the pieces of cloth and clothing meticulously counted and described in detail, notably by color, which constituted an essential identifying element. The same was true for hangings, rugs, furniture coverings, leather objects, blankets, and book bindings. Lawyers and their assistants always specified color because, here as elsewhere, color often was a way to classify. Their information is reliable and gives a certain idea of the universe of colors in which the different seventeenth- and eighteenth-century social classes lived. Yellow is not absent, of course, but it is far from being the color

162

163

most often listed, especially since it was more common among the less affluent classes than the wealthier ones.[19]

These postmortem inventories are difficult documents to read and interpret. Beyond the usual paleographic problems presented by old handwriting—especially that of lawyers—they are rife with technical, local, and dialectal terms that no longer exist. This is especially true with regard to textiles, that is, the principal mediums for color. Let us consider, for example, a town like Argenteuil, a large agricultural and wine-growing village on the banks of the Seine, northwest of Paris. Postmortem inventories were numerous there in the seventeenth and early eighteenth centuries.[20] The affluent middle class and artisans comprised a significant part of the population, so much so that most of the surviving inventories involve them.[21] These inventories tell us that for most textiles, the predominant colors were brown, gray, black, and white. Red and green were rarer, purple and blue rarer still. As for yellow, it was hardly present: only about forty occurrences for all of the seventeenth century. They involve, in particular, wool blankets and various articles of clothing: petticoats, headdresses, *escursoirs* (aprons). A

Brown Tones for Everyday Objects

Painter of country life, Frans Rijckhals (1609–1647) left us many canvases showing the interiors of barns and farms where objects and animals are arranged and fixed in place as in a still life. The play of light takes precedence over the palette of colors, reduced essentially to browns, beiges, grays, and whites. Frans Rijckhals, *Interior of a Barn*, c. 1640. Tourcoing, Musée des Beaux-Arts.

ABOVE

Lemon Yellow

Lemons abound in still lifes from the seventeenth century. The fruit was long known but it was slow to replace the citron in cooking and to lend its name to a shade of yellow. About 1650, it became standard in all European languages, henceforth opposing yellow orange to lemon yellow. Giovanna Garzoni, *Still Life with Citrons and Lemons*, c. 1640–45. Los Angeles, J. Paul Getty Museum.

OPPOSITE

The Color of Fruits

Beginning in the sixteenth century, the abundance of fruit in still lifes helped to increase the place of yellow, red, and orange in painting. Apples and lemons had long appeared more frequently than pears, but beginning in the 1720s and 1730s, pears benefited from an astonishing popularity, not only in art but also in everyday life. The eighteenth century was the great century of pears; in good society, neighbors competed to produce in their gardens the most beautiful fruits to share with one another. Justus Juncker, *Still Life with Pear and Insects*, 1765. Frankfurt am Main, Städel Museum.

few chairs covered with yellow fabric, a few serge or taffeta linings, and some canvas cloth complete this short list.[22]

It must be noted that, for these few examples, the shades of yellow are never specified, although they sometimes are for other colors: gray can be *cler* or *noirci*; red, *cramosy* or *vermeil*; green, *gay* or *perdu*. Perhaps such precision regarding yellow provided no useful information, with all yellows having more or less equal value? Moreover, what could those shades have been? In paintings from the seventeenth century and the first decades of the eighteenth century that show us interiors, yellows do not seem truly yellow; they are quite dull and tend more toward beige, brown, or golden than toward green. The shades we call "lemon yellow" or "canary yellow" are seen only in still lifes and used only for painting a few kinds of fruit (quinces, apples, pears). These shades appear to have been absent from clothing and furnishings, at least if we are to believe the paintings, which—we must always remember—do not at all constitute "photography" of colored reality and are never in their original state; their pigments have been transformed over time, and different layers of varnish have gotten covered over or entirely altered. Thus for the historian of everyday

colors, paintings are a resource that must be exploited with caution; there is always a large gap not only between their original state and what we see today but also between that original state and the colored reality of the beings, places, and objects represented.[23]

Let us remain in the domain of painting and consult the manuals and recipe collections meant for painters that were printed in the seventeenth and eighteenth centuries. They are relatively numerous (notably in Italy and Spain), very varied in their aims, but necessarily expansive on colors, pigments, and formulas. That is why it is tempting to compare the number of lines, pages, or chapters devoted to each of the great colors. The most verbose technical chapters, those that explain how to make and use pigments, are for reds and blues: reds come before blues in the seventeenth century, blues before reds in the eighteenth century (a change that, in itself, constitutes important evidence).[24] Next come greens and blacks, then purples, browns, and golds. According to such a classification, which can be surprising on a methodological level but often proves to be instructive, yellows generally follow behind the rest, as if this were a marginal color of little interest to painters.[25]

These same ratios are found in the many collections that remained unpublished and in the color charts that sometimes accompanied them. One of the most astonishing, compiled and completed in 1692 in Delft, is attributed to a practically unknown Dutch painter, A. Boogaert. It comprises 732 pages and reproduces more than five thousand shades meant to serve as model references for water-based painting (gouache and watercolor). Now held at the Bibliothèque Méjanes d'Aix-en-Provence, it warrants further attention from researchers, notably historians of painting, because this color chart is the most extensive one ever created before the late nineteenth century.[26] Moreover, it is a valuable *unicum*, entirely copied and painted by hand. A facsimile would be welcome, if only in order to safeguard it, as an online version cannot serve this function and misrepresents to some degree most of the shades.[27]

An Exceptional Color Chart

In the last years of the seventeenth century and the first years of the eighteenth century, color charts began to multiply on a very large scale, notably those intended for painters. For decades, the one proposed by the Dutch artist A. Boogaert in 1692 for watercolor painting would remain the most expansive ever produced: more than five thousand shades! A. Boogaert, *Klaer lightende spiegel der verfkonst, waer in tesien is alder handen kleuren van water verfen . . .*, 1692. Aix-en-Provence, Bibliothèque Méjanes, ms. 1389.

Regarding the subject at hand, this exceptional document confirms the lack of interest yellow held for painters. If the 5,045 shades presented are categorized by large color groups—no easy task since the color chart is not organized according to either the spectrum or the old Aristotelian order (white, yellow, red, green, blue, purple, black)—the breakdown would be roughly as follows: blue: 23 percent; red: 21 percent; green: 15 percent; yellow: 14 percent; gray, brown, and black: 10 percent; white: 7 percent; purple: 5 percent; orange: 5 percent. Nevertheless, this breakdown must be treated with caution because a large number of shades seem to fall between two or even three colors, and moreover, the words and figures inscribed below each shade to identify it add more to the confusion than the order.

Painters were not the only ones to neglect the range of yellows; dyers did as well. If we study similar breakdowns regarding dyestuffs in dyeing treatises and manuals, the results are almost the same as for painting. Not only does the chapter on yellows never come first (the chapter on blues always does), but it often comprises the smallest portion. That is the case with one of the most famous eighteenth-century treatises, *De la teinture des laines et des étoffes de laine en grand et petit teint* by Jean Hellot, published in Paris "by the widow Pissot" in 1750. Jean Hellot (1685–1766), renowned chemist, member of the Academy of Sciences, was appointed inspector general of the dyeing workshops in the French realm in 1740. In his treatise, he compiled the results of ten years of inquiries and observations, color by color, dyestuff by dyestuff, mordant by mordant. The work was greatly influential throughout Europe. Despite its small size (it is a simple twelvemo), it comprises 632 pages.[28] They are divided as follows: about 140 pages of general remarks on wools and various ways of approaching dyes, 192 pages devoted to blues, 155 to reds, 23 to blacks, 15 to fauve tones (something very new), 11 to greens, 9 to yellows, and about 60 to mordants and various blends for obtaining purples, oranges, grays, pinks, and browns. These proportions reflect both the traditions of European dyeing (absolute predominance of blues and reds) and color trends in the mid-eighteenth century (emergence of a taste for pastel tones, multiplying henceforth into all sorts of shades). Almost two hundred pages for blues, nine for yellows! The numbers speak for themselves; clearly, the Age of Enlightenment was an age of blue, not yellow.[29]

Venice, the European Capital of Color

From the fourteenth century until the late eighteenth century, Venice was the uncontested capital of color in Europe, as much for painting as for dyeing. Precious dyestuffs imported from the East arrived in its ports. In their studios, its painters proved themselves to be incomparable colorists, while its dyers in their workshops perfected processes for dyeing luxury fabrics adopted throughout Europe. And Venetian presses published works that discussed at length the nature, use, beauty, and harmony of colors. *Dyeing and drying textile fibers*, detail of a painted wooden sign for the dyers' guild of Venice, c. 1740. Venice, Museo Correr.

171

DICTIONARIES AND ENCYCLOPEDIAS

The Natural Sciences and Color

In book printing and engraving, certain subjects need color more than others: heraldry, cartography, anatomy, botany, and zoology. Color serves here to classify, contrast, distinguish, and hierarchize. For the natural sciences, the invention and then proliferation of color engraving in the eighteenth century constituted important progress. Edme-Louis Daubenton and François-Nicolas Martinet, "Yellow Parrot of Cayenne," *Planches enluminées d'Histoire naturelle*, 1765.

Let us now leave the specialized works and turn to a few dictionaries and encyclopedias. Is the place of yellow any greater in them? Was the color any more highly regarded there? What can the reader learn on this subject?

To answer these questions, I examined several French indexes from the seventeenth and eighteenth centuries, mainly: the *Dictionnaire français contenant les mots et les choses* by Pierre Richelet (1680); the *Dictionnaire universel* by Antoine Furetière (1690) and its various revised and expanded editions through 1727; the first four editions of the *Dictionnaire* by the Académie Française (1694, 1718, 1740, 1762); the *Dictionnaire de Trévoux* published by the Jesuits in 1704 and expanded in four subsequent editions until 1771; and finally, the *Dictionnaire critique de la langue française* by Father Jean François Faraud (1787–88). This reading was long and a bit tedious, and the results disappointing, in part because these works all copied one another. Or rather, they all copied what Antoine Furetière had written in his dictionary that appeared in 1690, a project that cost him his seat in the Académie Française a few years earlier.[30] And also in part because the entries devoted to yellow, without being completely barren, offer the historian nothing very original or relevant; moreover, they are much less expansive than those devoted in these same works to the colors red, white, black, blue, and even green. This imbalance undoubtedly reveals the most important information: in the modern period, among the basic colors, yellow remained the poor cousin, the unpopular relative, as much in everyday life as in texts.[31]

Regarding grammar and language events, all these dictionaries emphasize that the word *yellow* can be an adjective or noun. When it is an adjective, they offer the following definition: "said of what is the color of gold, lemon, saffron." This is not really a definition, but it is interesting because, once again as ever, it associates yellow with gold; moreover, it tells us indirectly that the lemon had become a common fruit, well known in France during the ancien régime (which

was not the case in the Middle Ages). When the word *yellow* is a noun, the definition offered by our dictionaries is particularly lacking and disappointing: "the color of what is yellow." Similar tautologies can be found for the other colors as well. But really, what else is there to say? Even today, what definition can be offered for this word? Stating that yellow is the color in the spectrum located between one wavelength or another is not false but it is a statement that only satisfies the physicist. What can the human sciences make of such a definition? Absolutely nothing, as I stressed at the beginning of this book.

At the beginning of his entry on *jaune* (yellow) in his *Dictionnaire universel*, Antoine Furetière makes an interesting remark, repeated by nearly all his successors: "Yellow is a brilliant color, the one that reflects the most light after white. . . . That is why painters paint the rays of the sun yellow."[32] He adds that five shades of yellow can be distinguished: *naissant, pâle, citron, paillé, doré* (nascent, pale, lemon, straw, golden). But the Newtonian spectrum seems unknown to him because never does he note that yellow can tend toward green on the one hand and toward orange on the other. Later, however, such a notation would be found in a few eighteenth-century indexes. Generally speaking, the further we advance into the Age of Enlightenment, the more physics and chemistry occupy a significant place in the discourse on colors. This is true for dyeing as well; the authors of these dictionaries are happy to list the principal dyestuffs in use at the time. On the other hand, for reasons difficult to grasp, painting and pigments are hardly mentioned. Only "Naples yellow" is sometimes the subject of a short discourse. Why that pigment and only that pigment? It is hard to know. Was it considered to be the one that produced the most beautiful yellows, those containing a slight touch of white or ivory? Or was it the most expensive or most exceptional, being made from residues of volcanic rock, especially from Mount Vesuvius? Or, on the contrary, despite its high toxicity, had it become the pigment most commonly used by the great masters in the Age of Enlightenment?

In the dictionaries "of words" as well as in the dictionaries "of words and things"—such as Furetière's—a certain number of expressions, adages, and proverbs are cited. Among the ones recurring most often: a *yellow cloth* (a large cleaning cloth, more or less beige); *to be yellow as a quince* (to be sick, especially with jaundice); *to make up yellow tales* (to relate implausible stories; blue can be used in a similar way: *to tell blue tales*); *to make someone see his yellow beak* (to make someone understand he has made a mistake, or that he is naive and says stupid things). Furetière explains that this last expression comes from the language of falconry, as young falcons that do not yet know how to hunt have yellow beaks.[33] On the other hand, although no mention is made of a yellow race, yellow fever, or yellow laughter, most of the authors note the custom of painting the doors and windows of someone's house yellow if he has "gone bankrupt." We have seen that this practice already existed in the late Middles Ages and the sixteenth century, but it involved traitors to king or country, like the famous Bourbon constable. Apparently, during the ancien régime, bankruptcy had become more serious than high treason, and henceforth it was denounced with yellow.

In addition to the adjective-noun *jaune* and its diminutive *jaunastre* (a term less belittling than tentative: "that which tends toward yellow"), our dictionaries mention the verb *jaunir*. For its literal meaning, they limit themselves to a banal definition: "to render yellow" or "to dye yellow." But for its figurative meanings, they propose a list of particularly disparaging synonyms: to age, to soil, to sully, to fade, to mold, to rot. We are very far here from gold, from the sun and the benefits of its rays! The verbal form of yellow emphasizes, on the contrary, how negative this color can be, and how closely related not only to lying and treachery—a distant medieval legacy still alive in the eighteenth century—but also to disease, aging, dirt, mold, and rot. Its meaning has hardly changed even to the present day.

Among the nouns derived from the word *jaune*, the only one to appear in our dictionaries is the word *jaunisse*:

174

JAUNE. adj. de tout genre. Qui est de couleur d'or, de citron, de saffran. *Drap jaune. couleur jaune. fleur jaune. cela est jaune. il a le teint jaune. cela est jaune comme saffran, comme de l'or.*

On dit, *d'Un homme qui a le teint jaune, qu'Il est jaune comme un coing, jaune comme un escu, comme soucy, comme saffran.*

On dit, *qu'Un homme fait des contes jaunes,* quand il dit des choses incroyables.

Jaune, est aussi substantif & signifie, *La couleur de ce qui est jaune. Jaune pasle. jaune doré, jaune couleur de citron, &c. quelle couleur est-ce là? c'est du jaune, de beau jaune.*

Jaune d'œuf, ou le moyeu de l'œuf, est la partie de l'œuf qui est jaune.

On dit en parlant de quelqu'un qu'on pretend s'estre trompé par ignorance, *qu'On luy fait voir son bec jaune.*

JAUNASTRE. adj. de tout genre. *Qui tire sur le jaune. Cela est jaunastre. de couleur jaunastre.*

JAUNET. s. m. *Espece de petite fleur jaune qui croist dans les prez.*

On appelle aussi fig. mais bassement, des pieces d'or, *Des jaunets.*

JAUNIR. v. a. Rendre jaune, teindre en jaune. *Il faut jaunir cette toile. jaunir un plancher. on a jauni ses armes pour marque d'ignominie.*

Jaunir, est aussi neutre. *Devenir jaune. Ces fruits commencent à jaunir. les bleds jaunissent. toute la campagne jaunissoit. cet homme-là a un grand desgorgement de bile, il jaunit à veuë d'œil.*

JAUNI, IE. part. Il a les significations de son verbe.

JAUNISSE. s. f. *Maladie causée par une bile respanduë qui jaunit la peau. Cette fille a la jaunisse. cela guerit de la jaunisse.*

Defining Yellow

Since the seventeenth century, language dictionaries have experienced great difficulty in defining color, and perhaps even more difficulty in defining each color adjective. To say that yellow is the color of "what is the color of gold, lemon, saffron," is not false, but it is not truly a definition. These difficulties have not disappeared even today; defining color and color terms remains an almost impossible exercise. *Dictionnaire de l'Académie française*, second edition, Paris, 1695.

jaundice. Moreover, this disease seems to be well known and is defined as "an excess of bile that spreads throughout the body and yellows the skin."[34] On the other hand, although we find the terms for whiteness, blackness, redness, and greenness, the term for "yellowness" does not exist. This is still true today, and this absence is, in itself, revealing. Why did the French language reject the terms *bleueur* and *jauneur*, while *blancheur*, *noirceur*, *rougeur*, and *verdeur* posed no problem for it? Undoubtedly because blue and yellow acquired their status as full-fledged colors later than the other four, and therefore Latin had rarely made them into nouns.[35]

There is not space here for extending our inquiries and discussing the dictionaries published in Europe in the seventeenth and eighteenth centuries in other countries and in other languages. The entries devoted to yellow in them are more or less detailed, but they offer almost the same meanings and ideas as those found in French. The most curious ones, it seems to me, are found in the fourth edition of the *Vocabulario* published in 1729–38 in Florence by the Accademia della Crusca (*giallo*), and in the celebrated, singular *Dictionary of the English Language* published in London in 1755 by Samuel Johnson (*yellow*). These two indexes attribute unexpected figurative meanings to the word, all of them pejorative: tense, denigrator, in debt, foul smelling.

Instead of turning to other dictionaries to end this section, let us open a few encyclopedias from the Age of Enlightenment, works that are often more voluminous because they are more concerned with things than with words. The pioneering model for this is the *Cyclopedia or Universal Dictionary of the Arts and Sciences* by the freemason Ephraïm Chambers, published in London in 1727. It enjoyed considerable success and was rapidly followed by similar publications in other countries and languages. The place of color was often significant in them, distributed among various chapters and elaborated in more or less detail, but always considering the latest discoveries. In general, it is Newtonian and post-Newtonian physics

that get the most attention. Nevertheless, chemistry and dyeing are equally represented with more detailed scientific discourse on colors for them than for painting, perhaps because painting had recourse to its own dictionaries, manuals, treatises, and indexes.[36]

Regarding yellow, let us consider the example of the French *Encyclopédie*, commonly attributed to Diderot and Alembert, and heavily influenced by the *Cyclopedia* by Chambers. The title announces its aim: *Encyclopédie ou dictionnaire raisonné des arts et métiers, par une société de gens de lettres*. Indeed, the work set out not only to give a complete inventory of knowledge but also to classify it, to highlight the progress of the human intellect "enlightened by reason," and to attack certain doctrines deemed outdated or "belonging to the world of superstition." This publication was not spared its difficulties (editorial, financial, legal) and prompted deep hostility, especially from the Jesuits. The first volume appeared in 1751, the last and seventeenth in 1765 (followed until 1772 with eleven volumes of plates).[37]

The color yellow earns a "principal" entry, but it is short and not instructive.[38] It is necessary to search elsewhere, in various parts of more important entries, some written by recognized scholars, others by regular contributors to the project, as well as in a few entries considered of less scholarly or intellectual significance, relegated to "shop boys" (Alembert's expression). All of these involve major fields of knowledge: botany and natural history (Daubenton), medicine, physics, and chemistry (Jaucourt), history (Diderot), painting, dyeing, law, and grammar. An ingenious cross-reference system allows the reader to go from one entry to the another and avoid missing anything. In total, entries involving yellow are found scattered throughout eleven of the seventeen volumes of the *Encyclopédie*, whereas red is found in fourteen volumes and blue in sixteen.

That said, on our color, the *Encyclopédie* is hardly innovative. Whether it is a matter of pigments, colorants, fabrics, dress, grammar, botany, or ornithology, it says little more than the previously mentioned dictionaries do. On the other hand, regarding the sciences, it emphasizes repeatedly that yellow is a "primary color" in the same way as blue and red are, and that it finds its place in the spectrum between green and orange. Two powerful ideas, relatively recent in the world of knowledge and not yet universally accepted by all scholars in the mid-eighteenth century, but these two ideas would endure and remain fully relevant even today.

A Tinctorial Plant: Weld

Numerous plants have tinctorial properties in the range of yellows, but in western Europe, only a few were actually used on a large scale. Among them was weld (also called reseda), already in use in the late Neolithic period and still widely employed in the mid-nineteenth century. Weld is a tall herbaceous biannual plant that grows well in many areas. All parts of it contain a principal yellow colorant: luteolin.
Le Livre des simples médecines, c. 1520. Paris, Bibliothèque nationale de France, ms. français 12322, folio 150 (weld, asprella, vine, cytinus, arum lily, hyssop).

Indacus

Ipzium

Inantes

Ipoquistidos

Iarus

Isope

177

THE EAST COMES INTO FASHION

The Yellow of Imperial Power in China

In China, over the course of dynasties, yellow gradually became the color of the emperor and supreme power. Emperors wore yellow robes, their carriages were called "the yellow carriage," even the paths they walked on were called "the yellow path." Their flags, the cloths used to wrap their seals, and the glazed tiles of their palaces were yellow as well. Only the imperial family was authorized to wear clothing in this color. *The Emperor Qianlong who reigned from 1735 to 1796. Chinese print, c. 1775. Private collection.*

The East long fascinated Europeans, but for centuries it was an East more imagined than visited, the source of all riches, marvels, and wonders. The accounts of Marco Polo (1254–1324) and travelers like him, who went to China and stayed there for some amount of time, did little to correct this illusion of a fabulous, distant Orient, an image inherited from ancient encyclopedias and medieval bestiaries. It would not be until the seventeenth century and the creation of various East Indian trade companies that the accounts of merchants and sailors began to revise and qualify these far too imaginary descriptions and stories.[39] New travel writings, like those of French travelers Jean-Baptiste Tavernier (1605–1689),[40] François Bernier (1620–1688),[41] Jean Chardin (1643–1713),[42] and English travelers Peter Mundy (1600–1667)[43] and Robert Knox (1640–1720), and Venetian traveler Niccolo Manucci (1638–1715),[44] corroborated to some extent the accounts of merchants and sailors. More than their predecessors, they enjoyed offering their readers a few notes on color in these faraway countries. Whether in Persia, India, at the court of the Great Mughal, in China, or Insular Asia, the omnipresence of yellow was always emphasized in the material culture and everyday life, a presence much more pronounced than in Christian Europe and primarily involving fabric and clothing.

At the same time, many Asian products were arriving in the West: silks, cotton fabrics, lacquers, ceramics, spices, ivory, precious stones, dyestuffs, gold, silver, copper, and other metals. The color yellow played a role here, an important role reflected in the countless "chinoiseries," so popular in the Age of Enlightenment despite being imitations: hangings, false lacquerware, porcelain cabinets, Chinese motifs in furniture and dishes, pagodas in formal gardens. Until the 1780s, China was the fashion in everything, sustained by a strong wave of sinophilia: this was an ideal country, a country of tolerance where men of letters held a place of honor.[45] Hence the extravagant praise from the great philosophers, first among them Voltaire.[46] Only Montesquieu

178

appeared critical and saw in the Chinese Empire the very symbol of despotism.

Thus China was featured in novels, plays, festivals, balls, and more simply, in dress. That was why the writings of various missionaries who had journeyed to the Far East were consulted, especially the enormous book by Jean-Baptiste Du Halde, *Description géographique, historique, chronologique, politique et physique de l'empire de la Chine et de la Tartarie chinoise*, based on the writings of Jesuit priests.[47] This encyclopedic work repeatedly lingers over the symbolism of colors, and we learn that, in China, yellow represented the earth and the center of the universe, that it was a beneficial color, the most noble color of all, and that it was worn by emperors since the earliest times: their robes were yellow, their carriages were yellow, their flags were yellow, their seals were gold and wrapped in yellow cloth; moreover only the emperor and his family were permitted to live in palaces with walls of red brick and roofs of glazed yellow tiles.[48] Thus, in the eyes of Europe, over the course of the eighteenth century, China became a country associated with the color yellow.

180

Chinoiseries

In European furniture, the taste for chinoiseries, already very present for many decades, reached its height with the rococo style beginning in the 1730s. It was not a matter of furniture originating in China but of European furniture taking its inspiration from Chinese models, either real or, more often, imaginary. Venetian chest of drawers, mid-eighteenth century. Private collection.

Chinese Motifs

What was true of furniture was also true for decorative objects. Chinoiseries abounded in decor and motifs: mountain landscapes, lush vegetation, bamboo constructions, unusual bridges, junks, parasols, fans, mandarins, phoenixes, dragons, monkeys. Meissen porcelain vase, mid-eighteenth century. Florence, Palazzo Pitti.

An Influential Work

In the late seventeenth and early eighteenth centuries, the writings of Jesuit missionaries who had made the journey to the Far East generally met with much success. But that was even more true for the enormous book by Jean-Baptiste Du Halde who tried to synthesize those writings in his *Description géographique, historique, chronologique, politique et physique de l'empire de la* *Chine et de la Tartarie chinoise* (Paris, 1735, 4 volumes). This encyclopedic work sometimes lingers over the symbolism of colors and we learn than in China, yellow represented the earth and the center of the universe, that it was a beneficial color, and that it was reserved for the emperor and his family. For Europeans, China became a country increasingly associated with the color yellow.

Beginning in the 1720s and 1730s, yellow enjoyed a popularity in the West unlike anything it had experienced in preceding decades, not only because of chinoiseries and oriental fashions but also due to a general lightening of all tones. The eighteenth century represented a sort of colorful, luminous interlude between the often dirty, wretched seventeenth century and the sometimes extremely somber nineteenth century.[49] The Enlightenment did not only illuminate the domain of the mind, it was equally present in daily life: doors and windows expanded in size, lighting improved and became less expensive. Henceforth, colors were easier to see and more attention was paid to them, especially since the chemistry of colorants was making rapid and decisive progress, promoting advances in dyeing and textile production. All of society benefited, especially the middle classes, now that they had access to bright, bold colors, formerly available only to the aristocracy. Dark, dull tones were everywhere in decline; this marked the end of the drab browns, dark greens, and purplish crimsons of the preceding century. In clothing and furnishings for the wealthiest classes, the fashion was for light shades, "pastel" tones, subtle colors, principally in the range of blues, yellows, pinks, and grays. At the same time, the vocabulary expanded and attempted to name precisely these new shades, sometimes resorting to highly imaginative expressions. Thus, in French in the middle of the century we find: "*soupir étouffé*," "*gorge de pigeon*," "*cuisse de nymphe émue*," "*pluie de roses*," "*poire du matin*," "*boue de Paris*," "*ventre de carmélite*," "*caca-dauphin*" (muffled sigh, pigeon's throat, excited nymph's thigh, rain of roses, morning pear, Paris mud, Carmelite's belly, dauphin's poop).[50]

For fabric, especially silk and cotton, many shades were now described as "Nankin yellow" and were supposedly obtained from a very precious dyestuff imported from the capital of China. In fact, this catchy name was only a marketing device that applied to various dyes, some actually of Asian origin, some very much French or European. Visually, this "Nankin yellow," highly prized from the 1740s to the 1770s, covered a wide palette, ranging from light yellow to nearly orange, by way of blond, straw, buff, and even beige tones. Their common characteristic was to be luminous without being saturated.

At the end of the century and in the first decades of the following one, the rage for yellows subsided a bit. The East remained fashionable, but henceforth it was Egypt

The Princely Yellow of Hunting

The liveries of hunting parties at the end of the ancien régime frequently displayed bright colors, notably in princely houses: green for the Orléans; yellow for the Contis; red for the Condés, all passionate hunters.

Auguste de Chatillon, *Louis-François-Joseph de Bourbon-Conti in Hunting Attire*, 19th century. Versailles, Palaces of Versailles et Trianon. (Copy of an eighteenth-century painting.)

and the Near East that prompted interest and no longer faraway China or inaccessible Japan. The Romantics were fascinated by the ruins of Asia Minor and the Holy Land, whereas politics turned toward North Africa. Egyptomania, ancient and "return to Egypt" styles, abandoned yellow for gold, which was combined with deep greens and strong, saturated reds described as "Pompeiian." Later, Orientalist painters (Eugène Delacroix, Eugène Fromentin) and writers who visited North Africa or Palestine were struck by the intense light that dominated there, but they saw little yellow in wall hangings or clothing. Contrary to the generally accepted idea, women wore no yellow. It is true that in the Muslim world, yellow was not considered favorably. As in the West, it was the color of lying and treachery; moreover, it was the color of disease and aging; and finally, it was attributed to the Jews in the Ottoman Empire, while blue, cold and evil, was the color attributed to Christian minorities. For Islam, white was the symbol of purity, green the color of paradise, black the sign of high rank, and red the color of life and strength; yellow was clearly less valued than any of these. The only admired shades were those of certain flowers and saffron or the sun. But the Arabic language speaks more of "gold" than of "yellow."[51] Rather than a Muslim color, the yellow of North Africa thus appeared to the European eye as an "ancient" color. When Gustave Flaubert's "Carthaginian" novel *Salammbô* was published in 1862, after Flaubert had gone to Tunisia to better educate himself on Carthage and to steep himself "in the light and colors of the place," he wrote to his friend Louis Bouilhet that he had formed the definitive plan for *Salammbô* following that journey: to give his readers "the idea of the color yellow." This is a slightly surprising claim, considering that the dominant color in the novel is red.[52]

Let us return to Asia. When was the expression "the yellow race" first used to describe the populations of Central Asia and the Far East? Hardly before the late eighteenth century, it seems. One of the first authors to formulate it was the German doctor and anthropologist Johann Friedrich

182

Rococo Yellow

The French rococo style embraced light and delicate colors: white, yellow, pink, and gold, sometimes with a bit of very pale blue, green, or gray. Yellows were not saturated, but nevertheless fresh and luminous; they were often mixed with a bit of white.

Paneling from the hôtel Stuart d'Aubigny (the yellow room), c. 1745. Paris, Musée Carnavalet.

PAGE 185

Fragonard, Painter of Yellow

A few eighteenth-century French painters proved to be very skilled colorists in the range of yellows, pinks, and oranges. Jean-Honoré Fragonard (1732–1806) is among them. A box of pigments that once belonged to him and is now held in Grasse (Villa-Musée Fragonard) teaches us that for yellows, the painter used mostly golden ocher and Naples yellow, which he treated in a special way to make it more brilliant.

Jean-Honoré Fragonard, *The Reader*, c. 1770–72. Washington, DC, National Gallery of Art.

Blumenbach (1752–1840), author of various treatises on anatomy and natural history but also and especially of a work on humankind and the diversity of "races," published in Göttingen in 1795: *De generis humani varietate nativa*.[53] Even while firmly proclaiming the unity of the human species, Blumenbach distinguished five races (*varietates*) according to skin color: Ethiopian (black), Caucasian (white), Mongolian (yellow), Malaysian (brown), and Amerindian (red). Nevertheless, he recognized that these different skin colors formed a chromatic *continuum* and that numerous intermediary shades existed, difficult to classify. Moreover, he posited no racist or racial theory, in the sense that we understand those words today. The idea of a race's superiority over one or many others was foreign to him, and the explanation he proposed for understanding differences in skin color and physical type was geographic and climatic in nature: the more one lived in a country with a hot, dry climate, the darker the skin.[54] That was nothing very new, since such explanations can be found already among authors of antiquity and the Middle Ages. Its originality lay only in making skin color a characteristic subject to change. Blumenbach aptly recalled that in ancient Greece, the word that designated color, *khrōma*, had its etymological source in the idea of skin. Otherwise, Blumenbach supported the theory of monogenesis (all humans descending from a single ancestor) and emphasized the existence of an absolutely impermeable border between the human species and animals, even those considered "superior."

Blumenbach has often, wrongly, been made into one of the first theoreticians of racism. The product of colonialism and capitalism, racism predates him. Nevertheless, we must note that classifying human groups according to skin color as Blumenbach proposed was rapidly adopted by other authors with more pernicious ideas (let us think of Gobineau, for example), and that in the first half of the nineteenth century, many European languages began to use the expressions "white race," "black race," and "yellow race" quite commonly.[55] Racial theories henceforth made their appearance and tainted these words with more or less pejorative connotations. That was undeniably so at the end of the nineteenth century when Asians were spoken of as "the Yellows," or "a yellow," or especially "the yellow peril." In this period, many Europeans began to fear that Asian populations would surpass "the Whites," and eventually rule the world. The expression was first applied to China, then in the process of revitalization in many domains, and subsequently to Japan, which had become fervently militaristic during its violent conflict with Russia in 1904–5. Certain politicians even feared a China-Japan alliance that would be a formidable "yellow peril." Later, in 1931–32, an expression like "*croisière jaune*" (yellow cruise), used to describe the much publicized automobile expedition from Beirut to Peking through Central Asia, was not exempt from certain derogatory, or at least ambiguous, connotations. That is no doubt why, unlike the press and the general public, official authorities preferred to call it the "Central Asian mission."[56]

Today in French, "*les jaunes*" is no longer used to refer to Asian populations, nor "*un jaune*" or "*une jaune*" to describe a man or woman of Asian origin. They are simply called "Asian." But the continent remains associated with the color yellow in the area of sports; on the Olympic flag, created in 1912 but flown only since the Anvers games in 1920, it is represented by a yellow circle.[57] This choice came from outside Asia (the Western authorities of the Olympic movement based in Paris, then in Lausanne) but seems to be accepted today.

DISCRETION, TRANSGRESSION, AND MODERNITY

Yellow Rehabilitated by the Painters

Before World War I, yellow experienced a dramatic comeback in painting. By turn, the nabis, fauvists, cubists, futurists, and expressionists granted it a significant place in their paintings, a place it had long ago lost and that neither the Orientalists nor the impressionists had been able to fully restore. Frantisek Kupka, *Second Study for the Yellow Scale*, 1907. Houston, Museum of Fine Arts.

From the 1850s until World War I, the place of yellow in everyday life not only failed to grow—its place was already quite minimal in the century's early decades—but it even experienced a certain decline. There were various reasons for this, the principal ones probably rooted in the social moral codes that accompanied the second industrial revolution. As much in Europe as in the United States, most of the revolution's financiers and great industrialists were Protestant. Thus it was Protestant values that spread with the ever-expanding production of objects of mass consumption. In the domain of color, that translated into a rejection of bright shades, with priority given to white, black, gray, and brown. Yellow, like red, was one of the first victims of these Protestant morals that appeared in the sixteenth century and were still very present in the nineteenth century.[58] Although rapid and significant progress had been made in the chemistry of colorants, making new, bright, and varied colors possible without increased cost for many products, dull, neutral shades remained dominant. Similarly, in furnishings and decoration in the urban apartments and country homes of the wealthy, only small touches of yellow were present, and more or less burnished bronzes henceforth replaced the gold and gilding of earlier times. With regard to clothing, yellow was rejected, scarcely worn by women (and then only by brunettes) and absent from the masculine wardrobe.[59] A man would never wear yellow unless he wanted to draw attention to himself or deliberately transgress social codes. Such a rejection helped to promote beige, a relatively new shade that would gain considerable popularity in the dress of both sexes beginning in the 1920s and 1930s.

Another reason for this decline of yellow in daily life stemmed from its continued disrepute in value systems and aesthetic trends. As in the late Middle Ages and throughout the modern period, yellow remained an unpopular color in the nineteenth century. Opinion polls on favorite colors and their symbolism offer proof. These polls emerged

186

Yellow, the Color of Trickery

In the second half of the nineteenth century, the theater, public notices, political cartoons, and caricatures made yellow the color of both the deceivers and the deceived. It also stood for the workers' unions linked to employers as well as cuckolded husbands and citizens deceived by their elected officials and duped by those in power.
Hector Moloch, *The Cuckold, French Citizen*, cartoon engraving, 1882. Private collection.

Les Syndicats Jaunes

Founded in 1902, the Féderation Nationale des Jaunes de France tried to federate all the *syndicats jaunes*, that is, the unions that opposed the socialist and communist *syndicats rouges*, and that rejected strikes and confrontations with employers as methods of protest. Describing themselves as the "proletariat right," this federation had for its motto, *Famille, Patrie, Travail* (family, country, work), which would be adopted, in a different order, by the Vichy regime.
Propaganda postcard, c. 1905. Private collection.

188

in Germany in the 1880s; they all demonstrated how yellow was unpopular and associated with negative ideas. It came in last among the six basic colors—less than 3 percent of individuals asked cited it as their favorite color (whereas almost 50 percent of respondents cited blue, and 18 to 20 percent cited green)—and continued, as ever, to be considered the color of lying, jealousy, and deception.[60] Thus in the theater, yellow appeared on stage in the costumes of cuckolded husbands and unfaithful wives; in politics it was completely spurned for being too closely associated with ideas of treachery and disloyalty. In the world of unions, the "*syndicats jaunes*" that appeared in France in 1899–1900 during the huge strikes affecting the Creusot mines claimed to defend the workers even though they were conning them

for the owners (at least that was the accusation of their adversaries, the "*syndicats rouges*"). They opposed the strike, presenting themselves as the right-wing proletariat, even as a revolutionary "anti-red" movement, that is, opposed to socialism and later to communism.[61]

Thus yellow appears as the color of deception in all its aspects: the deceivers on one side, the deceived on the other! But that is not its only negative connotation, far from it.

Yellow gets bad press everywhere, as language events and the lexicon demonstrate. In French and in Italian, a "yellow" (*jaune, giallo*) is a traitor; in English slang, a "yellow dog" refers to a cowardly person, a "chicken," and since the 1900s, "yellow journalism" describes newspapers disseminating gossip and scandal ("scandal sheets"). Similar ideas are found in other languages: in German, *gelber Laune sein* means "to be sour-tempered," and in Dutch, *gele verhalen vertellen* means "to tell lies." As for the French verb *jaunir*, as in neighboring languages (*vergilben, ingiallire, to yellow*), it is derogatory. Of course, literally it means "to become yellow," "to turn yellow," but its figurative meanings are more frequently used and remain deprecatory, as in the seventeenth and eighteenth centuries: "to become soiled," "to wither," "to wear out," "to age," "to mold," "to rot," and so on. Whether ancient or contemporary, language is not kind to this color, often beautiful at first, but so quick to soil or fade.

189

A certain number of social practices attest to similar discredit, for example, the "yellow ticket," or yellow identity card required for prostitutes in the Russian and the Austro-Hungarian Empires.[62] Or the yellow passports that were granted in France to convicts who had served their sentences and were released: in *Les Misérables*, Victor Hugo explains repeatedly why Jean Valjean, a former convict (he had spent nineteen long years in Toulon prison) carries a *passeport jaune*, a document that discredits him in the eyes of his employers, the government, and even society at large.[63]

In a general fashion, and almost throughout Europe, yellow is a color more or less closely associated with all those who find themselves on the margins of the social order. That was the case with the mentally ill, sometimes dressed in yellow camisoles or tunics, like the fools and clowns of medieval iconography. Sometimes lunatic asylums were similarly painted yellow or called "yellow houses" in some central European countries, especially Hungary and Russia (*zeltyi dom*), as recently as the 1920s.[64] That was the case

PREVIOUS PAGE

The Colors of Degenerate Art?

The art of Karl Hofer (1878–1955), painter and engraver close to the expressionists, was described as "degenerate" by the Nazi regime in 1934. The artist lost his position as professor at the Kunstschule of Berlin, witnessed many of his canvases burned, and was forbidden from exhibiting or even creating art. This painting in yellow and green is perhaps an ironic cry against the injustices done to him. Karl Hofer, *The Green Flag*, 1934. Private collection.

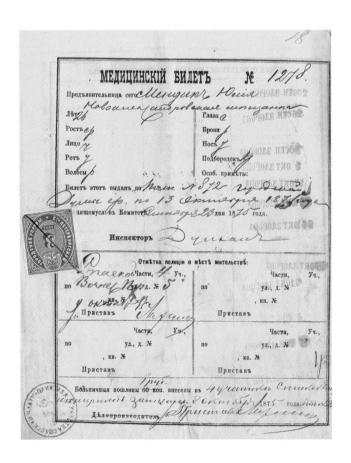

again with prostitutes, who were certainly not still required in the nineteenth century to wear an item of brightly colored clothing to distinguish them from honest women, but who themselves, in big cities, willingly donned yellow clothing, hats, ribbons, or gold-colored accessories in order to be spotted by possible clients in the dim light of street lamps. This was not the legendary golden belt of the trollops of the late Middle Ages—a belt that probably never existed—but it was quite often a yellow shawl, imitating those worn in the winter by upper-middle-class women.[65] In a short story in his collection *Les Diaboliques*, published in 1874, Jules Barbey d'Aurevilly presents a woman on a street in a disreputable part of Paris who draws attention not only by the "swagger in her walk" but also and especially by her very garish attire: "a dress of saffron satin with golden tones" and a "magnificent Turkish shawl" with red and yellow stripes. The reader learns a few pages further on that the woman is a duchess who is trying to pass herself off as streetwalker to ruin the name of the man she married and has begun to detest.[66]

In fact, in many towns, municipal authorities were long divided on the approach to take regarding prostitutes. Should they impose distinguishing marks on them so as to make them easily recognizable or, on the contrary, require that they be very discreet, even confined to brothels

190

Administrative Yellow for Russian Prostitutes

Until 1917 in the Russian Empire, certain Jewish women, restricted like all Jews to one residential zone (in the west, near the central European powers), deliberately asked for "yellow passports," that is, official prostitution cards, in order to move about more freely like the prostitutes, and especially to go to Moscow or Saint Petersburg. This card was the color yellow. Medical card for Russian prostitutes, 1875. Private collection.

The Colors of Prostitution

In Europe from the fourteenth to twentieth centuries, prostitution was represented by two colors especially: red and yellow. These were colors that could be seen and that were imposed by authorities to mark a brothel (a sign or lantern) or a professional prostitute (a dress or article of clothing). These were also the colors generally chosen by painters to portray bought love (Vermeer, Toulouse-Lautrec, Kupka).

Frantisek Kupka, *The Yellow Shop II*, 1906. Prague, Narodni Galeri v Praze.

NEXT PAGE

The Impressionist Disciples of Chevreul

Certain theories of chemist Michel-Eugène Chevreul contributed to the growing presence of yellow in impressionist painting. That was the case with optical mixing: no need to mix two colors to obtain a third (for example, yellow and blue to make green); juxtaposing them in small touches on the canvas was enough because the eye itself would mix them. Such a discovery captivated many painters, notably Pissarro and Seurat.

Pissarro, *The Church at Éragny-sur-Epte*, 1889. Private collection.

with the doors and shutters closed, simply marked with a sober red lantern? In 1827, a Montpellier doctor addressed a long report to the mayor and prefect in which, to curb the disorders of prostitution and limit the cases of syphilis, he suggested that all streetwalkers wear a very visible sign, especially at night. He recommended the choice of a "canary yellow hat, trimmed with a ribbon and veil of the same color," and an "equally yellow belt, with a more or less embellished badge displaying the number under which the girl is registered." But such advice was increasingly uncommon as the decades passed. Very much to the contrary, after 1850, legislators often required prostitutes to adopt decent attire, with shoulders and head covered, and not to attract attention with colors that were too garish, notably yellow.[67]

Yellow is indeed a color that is seen, a color that stands out. That is why it is frequently reserved for clothing or objects that must attract the eye, surprise the viewer, enliven the view. Some examples are theater costumes, disguises, the outfits of jesters or clowns, and later, athletic uniforms. Similarly, yellow is omnipresent on specific objects for parlor games or children's toys; it is visible, stands out from ordinary implements, adds a pleasant, playful, sometimes comic, and always cheerful dimension.[68]

Nonetheless, it was not children or performers who contributed to the tentative rehabilitation of yellow in the late nineteenth and early twentieth centuries; that credit goes to painters, even if they were not all champions of the color. For example, in about 1850, Eugène Delacroix wrote, "Everyone knows that yellow and orange are beautiful colors, signs

From Color to Form

This painting, one of Paul Cézanne's most famous still lifes, earned this commentary from Maurice Denis (1870–1943), one of its great admirers: "The fruits are the best example of Cézanne's working method, perhaps renewed by Chardin. A few square touches indicate, through the gentle proximity of shades, the rounded form; the contour comes only at the end, like an angry accent, which emphasizes and isolates the form, already made perceptible by the gradation and contrast of colors."
Paul Cézanne, *Straw-Trimmed Vase, Sugar Bowl and Apples*, c. 1890–93. Paris, Musée de l'Orangerie.

YELLOW THE HISTORY OF A COLOR

of joy and pleasure." A generation later, Vincent van Gogh made a similar proclamation, having arrived in southern France and immediately writing to his brother Théo: "The sun dazzles me and goes to my head, a sun, a light that I can only call yellow, sulfur yellow, lemon yellow, golden yellow. How lovely yellow is!"[69] On the eve of World War I, Wassily Kandinsky was of another opinion: "Bright yellow wounds the eyes, the eye cannot bear it: one thinks of the ear-splitting sound of a trumpet. It irritates, stings, excites. . . . Yellow torments man, it imposes itself on him like a constraint, intruding with a kind of unbearable brutality."[70] Kandinsky did not like yellow, as likewise he did not like green, which he compared to "a fat, healthy cow, resting, rooted, capable only of ruminating and contemplating the world through its stupid, inexpressive eyes."[71] Such assertions—as unfair to colors as to cows—are specific to Kandinsky. Most painters from the beginning of modernity, from the impressionists to the fauvists, liked yellow, a warm and luminous color, and made much greater use of it than all their predecessors.

Actually the change began quite early; in the mid-nineteenth century, with the invention and then distribution of pliable metal tubes with screw-on caps, transporting and conserving paints became easier, thus promoting plein air painting. Henceforth, few painters continued to make their own pigments; most of them used industrial products, ready to apply, but not always reliable. In the range of yellows, two synthetic pigments were very much the rage then: first, chrome yellow, relatively inexpensive but very unstable, and then cadmium yellow, more reliable but more expensive. A painter with little money, like Van Gogh, a great lover of yellows as we have just seen, was often betrayed by his chrome yellows, which turned brown or beige (as in his sunflower series) or even greenish. But cadmium yellow, which cost four or five times as much, was not an option for him.[72]

In a general way, plein air painting brought with it a lightening of all tones and a new relationship to light, much to

the profit of yellow. But there was another reason for the more plentiful use of yellow in paintings: its status as a primary color and the acceptance by painters of recent scientific theories, notably those of Michel-Eugène Chevreul regarding the perception of colors, the law of simultaneous contrast, and the principle of optical mixing.[73] This last theory explained that it was not necessary to mix two colors materially to make a third; juxtaposing them on the canvas was sufficient because the eye would mix them. Such a discovery appealed to a great number of artists: impressionists, postimpressionists, divisionists, pointillists. Henceforth, to make green, some painters merely applied a touch of blue and a touch of yellow side by side; the eye drew them together and blended them to the point of producing the illusion of green. But a few painters who exploited this far too modern process were betrayed, like Van Gogh, by their yellows. That was the case with Pissarro and Sisley. That was the case especially with Seurat and his well-known, enormous painting *A Sunday Afternoon on the Island of La Grande Jatte* (1884–85). To create greens, in many places he juxtaposed small points of Prussian blue and chrome yellow, two particularly unstable pigments that turned gray and brown. Despite numerous restorations, more or less successful, the painting still bears the marks of such a practice.[74] Like so many others, Seurat was the victim of science, or rather of science misunderstood and poorly applied. In fact no painters actually read Chevreul's book *De la loi contraste simultané des couleurs* (1839), a dense, fat, and overscholarly work. They all settled for abridged or summarized versions of it, notably the very succinct one that Charles Blanc offered in his *Grammaire des arts du dessin* (1867), a work that became an enormous best seller.[75]

However, the greatest champions of yellow tones were not the impressionists or their successors, but the young fauvists of the years 1905–10: Derain, Matisse, Marquet, Van Dongen, Manguin, Vlaminck, and a few others. Influenced by Gauguin and Van Gogh and struck with a veritable "colorist fever," they set out to exalt pure color and free it from

The Palette of Pointillism

Even more than the impressionists, Seurat (1859–1891) sought to establish a pictorial link between art and science. To do this, he created pointillism: seen as a whole from a certain distance, juxtaposed and differently colored points give the impression of tonal unity. For example, yellow points and red points create for the eye an impression of orange, red points and white points, an impression of pink.

Georges Seurat, *The Circus*, 1891. Paris, Musée d'Orsay.

all the constraints that held it within the norms and had enslaved it to drawing since the Renaissance. Hence their rejections of perspective, naturalism, classical values, and above all, local color; as in medieval illumination, anything could be any color for the fauvists, in the name of what they championed as "the poetic arbitrariness of color."[76] Hence, too, the speed of execution, the violence of brushwork, and the search for resonant, sensual contrasts.[77] All of that benefited yellow, which the fauvists used abundantly and to which they gave warm, bright, saturated tones that often tended toward orange.

A House Painted Yellow

All houses painted yellow were not brothels or insane asylums. They could be ordinary houses with no particular significance. That was true of the house in Arles on the Place Lamartine, in the Cavalerie neighborhood where Van Gogh rented four rooms in May 1888, two of which were on the ground floor and served as his studio. It was in this house (which no longer exists today) that he roomed with Gauguin the following autumn.
Vincent van Gogh, *The Yellow House*, 1888. Amsterdam, Van Gogh Museum.

ON THE MARGIN OF YELLOW: ORANGE

Gauguin's Yellows and Oranges

Gauguin was a great painter of yellows. It is the color in which he excelled, as much when he was in Brittany at Pont-Aven, or in Arles with Van Gogh, as when he was traveling in Polynesia. These are certainly not all the same yellows, but they are always more symbolic than realistic, painted flat and shadowed with a darker stroke. At Pont-Aven, they are heightened by the proximity of orange, in Tahiti, by the proximity of brown.
Paul Gauguin, *The Yellow Christ*, 1889. Buffalo (USA), Albright-Knox Art Gallery.

B efore bringing our long history of yellow to a close, let us say a few words about the history of orange, a color we have encountered many times without ever pausing to consider it. Actually, orange has not always existed, at least not in the theories and discourse on color. Neither ancient nor medieval authors made it a chromatic category all its own. And hardly any words can be found in the lexicon for naming the orange tones that we see in nature. For a long time, one had to draw on the vocabulary of yellows, browns, and reds to name the flowers and fruits that come in this shade.[78] Often orange was confused with *rufus* (*roux* in French), a pejorative term for a russet color that seems to combine the worst of yellow and the worst of red and add a more or less dark dimension to this mix. I discussed *roux* at length in my last book, devoted to the history of the color red.[79]

At the end of the Middle Ages, however, orange began to distinguish itself from russet, then to brighten and assert itself as an autonomous color. In doing so, its value undeniably increased. There were various reasons for this somewhat surprising gain in stature, but the principal ones seem related to fruits and dyes. The sweet orange's arrival in Europe, coming from East Asia and replacing the bitter orange, the only one known until then, helped to increase the value of the fruit and its color. This new citrus variety, with its delightful taste, look, and aroma, henceforth appeared on the tables of the wealthy, then made its way into the pharmacopoeia and began to be cultivated in special gardens, well protected from wind and cold: orangeries, which gradually became a mark of nobility and wealth (moreover, that is the reason why French revolutionaries declared war on them beginning in the summer of 1789). In the iconography of the Renaissance, the fruit itself became the symbol of beauty, love, pleasure, fruitfulness, and prosperity.

This promotion of the fruit benefited the color, used widely for fabric and clothing with the arrival of new

198

199

dyestuffs. Orange, a nascent shade, came into fashion in the 1400s and remained fashionable for some decades, at least in princely society. Of course dyers had experienced little difficulty prior to that date dyeing in orange; they only had to immerse fabric in a vat of red and then in a vat of yellow, and use a strong mordant. The vats for these two colors were found in the same workshops, so that posed no problem. But there was little demand for that color range, and the opportunities for dyeing in orange were rare. Moreover, as dyeing had hardly progressed since Roman antiquity in the range of yellows and fauves, the oranges produced by medieval dyers remained dull, drab, and slightly brown.

Everything changed at the end of the fourteenth century when Europe began to import from the Indies new species of tropical trees belonging to the family now named *Caesalpiniaceae*. These trees provide a hard, heavy, very dry wood (it burns without releasing smoke) that is particularly red, like embers, a natural and very powerful dyestuff. It was already known in Roman antiquity, but the wood was not extensively imported because dyers did not know how to use it very well and had at their disposal all the dyes they needed in the range of reds (madder, kermes, orcein, not to mention the various Mediterranean mollusks for producing purple). However, toward the end of the fourteenth century, dyers noticed that new tree species growing in the South Indies as well as in Ceylon and Sumatra produced better dyes than the old ones. They thus decided to import this wood in large quantities, and because of its similarity to the red of live coals (*braises*), the dyestuff extracted from it was given the name "brazil" (*brasileum*); the wood itself became "brazilwood." In two generations, dyers—in Venice, Florence, Bruges, and Nuremberg—learned how to work with it and to draw from it bright, saturated, new tones: pinks if they used alkaline mordants (alum, tin); oranges if they used acid mordants (vinegar, urine).

These two colors, formerly neglected for being too dull and drab, became fashionable. Duke Jean de Berry (1340–1416), great patron enamored with novelty in the arts as in

The Fauvist Palette

The young "fauvists" in the years 1905–10 (Derain, Matisse, Marquet, Van Dongen, Manguin, Vlaminck) seem to have been stricken with true "colorist fever." They favored pure, warm, luminous colors that they set out to liberate from all constraints that had enslaved them to drawing since the Renaissance. For the fauvists, any element in a painting could be any color, in the name of what they called "the poetic arbitrariness of color." In this intense palette, yellow and orange occupied a major place. André Derain, *View of Collioure*, 1905. Essen, Folkwang Museum.

clothing, was among the first to delight in dressing both himself and his entourage in them. But he was not the only one, especially not for orange; throughout Europe beginning in the 1400s, princely society showed a pronounced taste for this new color and sought a vernacular name for it. In the end they borrowed the name from the fruit itself, then abundant on tables and in orchards. Thus, in the fifteenth century, orange was born, at least with regard to dyeing, fashion, and the lexicon.[80]

After a short lull in the 1460s, orange returned to the forefront at the beginning of the following century, when Europeans discovered in the New World other species of tropical woods in the same family as those of the Indies and Insulindia, but with even more impressive dyeing properties: campeche wood in Central America, pernambuco wood in South America. Infatuation with the latter was so great that the country that provided most of it was given the name of the dye extracted from it: Brazil. Brazil replaced the Indies as the chief exporter of the dyestuff to Europe. Despite the long and perilous crossing of the Atlantic, the cost of the American product was in fact lower than that of the Asian one, because in Portuguese and Spanish colonies in the New World, slaves cut and prepared the wood.

From then on, the rage for orange hues never diminished. Of course in fashionable society, it never truly competed with reds, blues, and especially blacks, but it was used for small touches and in this way outstripped yellow, an unpopular color due to its negative symbolism. Painting in the sixteenth and seventeenth centuries attests to the subtle presence of orange in the dress practices of high society, as much for men as for women. Sometimes it was accompanied by a political or dynastic dimension. In the second half of the sixteenth century, orange became the symbolic, militant color of the princes of the House of Orange, ardent defenders of the Reformation and northern Netherlands' independence, struggling against the Spanish crown.[81] In addition, in a more general manner as the modern period began, the color orange acquired an increasingly rich stock of symbols, those belonging to the fruit bearing that name: light, pleasure, beauty, health, fertility, richness.

The enhanced value of orange even extended into the world of science. In the seventeenth century, scientific curiosity evolved, experiments multiplied, new theories came to light, and new classification systems as well. A few scientists proposed replacing the old Aristotelian axis (white, yellow, red, green, blue, black) with diagrams showing the "genealogy" of colors. That was the case with François d'Aguilon, Jesuit friend of Rubens, whom we have already encountered. In his treatise on optics (*Opticorum libri sex*) published in Anvers in 1613, he made hierarchical distinctions between "extreme" colors (black and white), "medium" colors (red, blue, yellow), and "mixed" colors (green, purple, orange). Two generations later, as we have seen, Newton discovered the spectrum and proposed to the scientific world a new order of colors constructed according to a hitherto unknown sequence: violet, indigo, blue, green, yellow, orange, red. The traditional chromatic axis inherited from Aristotle was overturned: black and white were no longer included; red was not at the center of the axis anymore but at one extreme; green was now situated between yellow and blue; and most importantly, orange and violet had been added, having become true colors. Thanks to Newton, orange had finally established its chromatic pedigree.

In the mid-eighteenth century, orange benefited from advances in chemistry regarding dyestuffs and the new fabric and dress fashions that followed from them. This was especially true since yellow had become timidly fashionable and red was much in decline; there was a place open for orange. Henceforth, yellows tending toward orange were featured in dress and furnishings, not in vivid, saturated shades but in subtle, discreet ones, often with dawn or rose tones. Later, beginning in the 1770s and 1780s, darker oranges appeared, tending a bit toward brown to make orange-beige, ocher, sorrel, reddish, and russet tones. This color that Newton had promoted scientifically and the Age of Enlightenment had embraced aesthetically, could now be broken down

202

Modigliani, Painter of Russet

Redheaded women abound in the paintings by Amedeo Modigliani (1884–1920), and children with red hair, girls and boys, are not uncommon either. Most often these red tones are pure and violent oranges, which the artist used as well, softening them only a little, to paint nude women with brown or black hair and body hair.

Amedeo Modigliani, *Red-Haired Boy*, 1919. Paris, Musée National d'Art Moderne.

into multiple shades. Their use, however, remained limited throughout the nineteenth and twentieth centuries, and that is more or less the case still today.

In our modern Western societies, orange has indeed occupied a small place, less significant than elsewhere in the world. In India and all of Southeast Asia, for example, it plays a part in daily life, and has done so for a very long time. Not only is it the sacred color of Hinduism and Buddhism, the symbol of purity, wisdom, and freedom, but it is also, more simply, a color believed to bring good luck. That is why it is seen in many fabrics and clothing, especially for women, side by side with other colors just as unusual in our latitudes. This is true to such an extent that in our imaginations, when we think of orange, we think of Hindu spirituality, Tibetan monks, or even the Buddha's saffron robe, which traditions claim was originally a simple death shroud.[82]

Western symbolism for orange is more pragmatic. First of all, it is a color that is noticed, that stands apart from the others, that can be seen at night and in fog. Hence its wide use for signaling, notably at sea (life jackets, lifeboats, life buoys) as well as places considered dangerous. That is why orange is present on building sites, fuse boxes, labels of toxic products: it signals danger, advises caution. It plays the same role in traffic lights; between red that requires drivers to stop, and green that allows them to go, yellow-orange asks them to slow down and be careful. This link with danger and rescue explains why, over the past two decades, orange has become a political color in certain countries, the color of new parties that propose to save a divided nation or a state in peril. The most spectacular case is that of Ukraine where, following the fraudulent presidential election in November 2004, an "orange revolution" broke out. The color was ubiquitous in public demonstrations, as if announcing the dawn of a new time, like a rising sun.[83]

In western Europe, political orange continues as ever to represent the dynastic color of the royal House of Orange-Nassau. As such, it is present on the national flag (but not the state or government flag) of the Netherlands and on the jerseys of athletes who represent that country on athletic fields throughout the world. Through a complicated historical legacy, it is equally present on the flag of Ireland where it represents the Protestant community, whereas green represents the Catholic community; white plays the role of a peacekeeping link between them.

As a color that can be seen and stands out from other colors, orange is frequently used by advertising these days; it attracts the eye and seems to enliven everything that it covers.[84] But it can quickly become flashy, violent, and loud if too much present. Hence a certain vulgarity is associated with it, notably in matters of dress and furnishings. In the 1970s, under the pretext of "making life more cheerful," architects, decorators, stylists, and designers used orange everywhere, often in combination with sharp (apple green) or incongruous (chestnut, violet) colors. At the time, that seemed amusing, inventive, joyous, original. Today many creators and consumers wonder how they could have done that. In fact, the idea that a color or color combination can "brighten up life" is very naive, and most of the creations from the 1970s—whether a matter of objects, places, clothes, or buildings—strike our eye today as aggressively ugly. Moreover, in the same period, in many disadvantaged neighborhoods in large cities, inhabitants circulated petitions to get rid of the large surfaces of orange, apple green, pink, and violet with which naive and well-intentioned town planners had covered the flaking walls of certain buildings in order to "restore the neighborhood." After a few weeks, all the inhabitants demanded a return to white or gray.[85]

Orange is not a good solution for "brightening up life," far from it. Better to use it sparingly, as for the packaging of health products where, through a kind of tacit code, it signals tonics, energy boosters, and all products rich in vitamin C. The orange, that fun and fortifying fruit, is the necessary referent for the color and seems to bestow all its

204

virtues on it. Formerly the fruit of the wealthy, a gift that poor children received on Christmas or Saint Nicolas Day, a treat brought to prisoners, the orange has clearly become more common, but it remains a sensory pleasure, a delight to taste, touch, see, and smell. Although no longer costly, it retains something precious and luminous about it, something reminiscent of the golden apples.

205

Orange to Brighten Life

In the 1960s and 1970s, with the laudable intention of "making life brighter," decorators and designers introduced much orange into everyday life, sometimes in combination with sharp (apple green) or incongruous colors (chestnut, silver). What seemed amusing, inventive, even jubilant at the time strikes us as vulgar or difficult to bear today. And the idea that a color or color combination can "brighten up life" seems very naive.
Giancarlo Mattiolo, office lamp, Nesso, 1961.
Private collection.

ON THE
ATHLETIC FIELDS

Yellow Jersey

Introduced during the 1919 Tour de France to better distinguish the leader of the general class amid the pack of cyclists, the yellow jersey has contributed enormously to the mythology of the Tour and the rehabilitation of the color yellow. Gradually, the expression, "to have the yellow jersey" has expanded beyond the world of cycling and sports to that of economics, politics, and even the sciences and the arts. Poster for the film recounting the mythic 1949 Tour de France, the most famous race in the history of cycling.

The painters of the late nineteenth and early twentieth centuries were the first to see yellow in a new light, that of modernity. Nevertheless, in the decades that followed, it was sports that worked most efficiently to reclaim for yellow a bit of its dignity and a larger place in color practices. Yellow's comeback began with the club jerseys for various sports teams. Of course, at the very beginning of modern sports—originating in English and Scottish high schools in the second half of the nineteenth century—the choices were much more narrow: only two colors initially, white and black. That number rapidly doubled: white, black, red, blue. By the early twentieth century, the number had increased to seven, as green, yellow, and purple came to be added slowly to the four preceding colors. Nevertheless, after World War I, black became less common on athletic fields, and the three new colors had not yet gained full acceptance. Thus, until 1920 to 1925, despite a diversified palette for sports uniforms, the dominant combinations remained white/red and white/blue. Although far from absent, yellow's presence long remained quite minimal in the world of European sports. In soccer, it was not until after the first World Cup in Uruguay in 1930 that a few European clubs adopted South American styles and chose colors rarely used until then, notably green and yellow.[86] In track and field, the first Olympic sport, yellow's promotion began even later, not until the 1950s and 1960s with the first achievements of Jamaican and then African athletes.[87]

That said, it was neither soccer nor track and field that sealed yellow's fate in the world of sports. It was cycling, and in particular the Tour de France, that witnessed the creation of the "yellow jersey" in 1919. The reasons and circumstances of its origins and lasting success have been recounted many times; I will summarize them here.[88] The jersey emerged on July 19, 1919, at the beginning of a stage taking the cyclists from Grenoble to Geneva, and the first cyclist to have worn it was the legendary Eugène Christophe (who would never win the Tour de France and owed

his immense popularity to his bad luck).[89] It was a matter of an advertising campaign, yellow being the color of paper used for printing the newspaper *L'Auto*, sponsor of the race. It was one of those pale, dull yellows then used to dye newsprint, meant for large runs of short-lived publications. Henri Desgranges, the director of *L'Auto* and of the Tour, had the idea of asking the provisional leader of the general classification to wear this color to make him more visible among the pack of cyclists. This was a double win for Desgranges because it associated the emblematic color of his newspaper with his champion. What is surprising is that the idea occurred to him mid-race and he was able to implement it immediately. But what finally matters is that, once created, the yellow jersey became a huge success. The magic of the Tour de France, first raced in 1903 but already immensely popular in 1919, took hold immediately and has never slackened. The yellow jersey became a mythic object,

and what began as a simple advertising campaign was transformed into a true social and language event.

In fact, very quickly this glorious new yellow jersey would give rise to a catchy phrase—*maillot jaune*—which the press and advertising picked up and which has been used well beyond the domain of cycling and sports. As early as the 1930s, there were "*maillots jaunes*" firms in industry, then later in economy and finance, and later still in the domain of scientific or technical laboratories and teams. To be *maillot jaune* meant henceforth—and even today—to be leading the pack, whatever the type of competition or classification involved. The expression even found a place in many other languages, including Italian (*maglia gialla*), even though, since 1923, the cyclist leading the famous *Giro*, the Italian Tour raced in the spring, wears a pink jersey (*maglia rosa*)![90] The Tour de France has undeniably contributed to the comeback of yellow.

In another sport, the adoption of yellow has also constituted an important promotion for this color, but more recently and without taking on a mythological dimension comparable to that of the yellow jersey: tennis. Toward the end of the 1970s, the white rubber tennis ball became yellow, essentially for reasons of visibility. First of all, umpires and players were increasingly complaining about the difficulty

Borg and the Little Yellow Ball

Originally tennis balls were not yellow, but white. When color television made its appearance, white balls were easy to confuse with the white lines of the court on screen. In 1972, to offer television audiences greater visibility, the International Federation of Tennis decided to introduce yellow felt tennis balls, a very visible and more or less fluorescent yellow. But white balls were not forbidden, and many players, Borg among them, protested against this scandalous change that gave priority to the spectacle over the sport.
Bjorn Borg during the Masters Grand Prix, December 2, 1975, Stockholm.

of telling whether or not a ball had touched the line: both were white. Second, color television had made its appearance and now broadcast important tennis tournaments. But on small television screens, white balls were hard to see and easy to confuse, here as well, with the white lines. For the comfort of players and television audiences, the decision was made to go from white to yellow, a very visible yellow that was more or less fluorescent (*optic yellow*). The ball remained rubber and felt-covered (which sometimes makes children call it "hairy"), kept its weight of fifty-seven or fifty-eight grams, and its diameter of between 6.3 and 6.5 centimeters, but it changed color. It is not easy to assign an exact date to this change. Not only was there much initial trial and error (even including a brief interlude of using orange balls, which were almost successfully imposed), but also and most importantly, yellow never became obligatory; even today, white balls are accepted in most tournaments. Nevertheless, the yellow ball quickly won over players, umpires, and the public; beginning in 1978, it became the emblem of modern tennis.

Before that date, yellow had appeared on other playing fields. That was the case in soccer in the form of a small yellow card (10 × 7.5 cm) used by referees to signal a warning given to a player and to replace any discussion that could be misunderstood. The first official "yellow card" was shown on May 31, 1970, by the referee of the opening match of the World Cup, Mexico-USSR. Subsequently, the use of such cards extended to rugby (temporary expulsion), handball, and table tennis. For the color historian, the most interesting aspect of this new practice is the existence of a superlative form of the yellow card: the "red card," signaling a serious infraction punished by expulsion from the field. In soccer, two successive yellow cards, that is to say, two warnings, are transformed into a red card. Yellow thus appears to be half a red, the two colors pairing up to signify the infraction and then the punishment.

These two small pieces of different colored cardboard rapidly gained favor with referees and spectators and became

The Yellow Card

During the 1966 Soccer World Cup, it was the referees themselves who suggested using pieces of cardboard in different colors to make their decisions more comprehensible to players who spoke very different languages. The system was implemented for the first time during the following World Cup in 1970: a yellow card to give a warning, a red card to signify an expulsion (two successive yellow cards immediately convert into a red card). Lisbon-Bastia match, UEFA Cup. Lisbon, September 28, 1977.

so popular that, as with "yellow jersey," the expressions "yellow card" and "red card" entered into the spoken language beyond the context of sports. Today in French, as in neighboring languages, they have even become a form of freely and commonly used interjections.

YELLOW FOR
THE PRESENT DAY

The Yellow of Heraldry in Painting

After his suprematist period that helped him to attain a minimal degree of form, Kasimir Malevich (1878–1935) began to make figurative painting again but reminiscent of his works from the preceding period: severe compositions, simplified forms, clean and vivid colors, very much like heraldry. Yellow plays an important part in them, as in coats of arms and athletic jerseys. Kasimir Malevich, *Complex Presentiment*, 1932. Saint Petersburg, Hermitage Museum.

Let us leave the playing fields and turn to the streets to view scenes of everyday life. There is no denying that in large European cities, yellow is hardly present. Rare on storefronts and buildings, rare in clothing worn by most people, rare on cars, it is used mostly as a means of signalization, especially to signify danger (in combination with black), something forbidden, or a distinctive feature. Here again, its role stems from its (real or imagined) visibility being greater than that of any other color. Yellow is visible, stands out, attracts attention. A text written in black is easier to see on a yellow background than a white one, especially from a distance. Hence the long-standing frequent use of this color combination on certain official signs. And hence, also, the rejection of this same pair by advertising; together, black and yellow connote something disturbing, dangerous, or repulsive in nature.[91]

We must mention here the painful memory of the yellow star, the degrading and discriminatory mark imposed on Jews by Nazi Germany. This was first done in the Reich beginning September 1, 1941, and then in annexed regions and conquered countries over the course of the following years. In France, all Jews over the age of six were required to wear it in the Occupied Zone beginning in June 1942; three stars were allotted each Jew, to be claimed at the police station. The insignia consisted of a piece of cloth in the form of a star of David, with the word "*Juif*" at its center ("*Jude*" in Germany and Austria; "*Jood*" in the Netherlands; "*J*" in Belgium; "*HZ*" in Slovakia) written in characters crudely imitating Hebrew script. The color of the star was most often yellow and the letters, black, but there were also orange stars with green letters. The star had to be sewn onto exterior clothing in a very visible manner, its placement determined by local authorities. Requiring that such an insignia be worn was a flagrant display of policies of discrimination and persecution practiced for many years by the National-Socialist regime. Acting in this manner, the Nazis revived with a vengeance the infamous practices of the late Middle

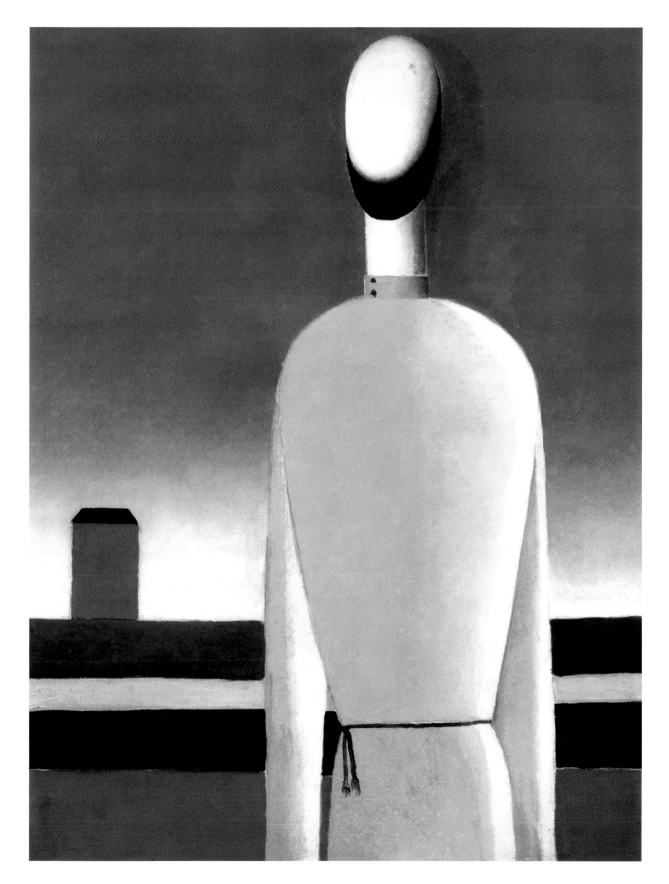

The Yellow Star

Demeaning and discriminatory mark imposed on the Jews by Nazi Germany, the yellow star was used in the Reich beginning September 1, 1941, and then in annexed regions and conquered countries over the course of the following years. The insignia consisted of a piece of cloth in the form of a star of David, with the word "Juif" at its center ("Jude" in Germany and Austria; "Jood" in the Netherlands; "J" in Belgium; "HZ" in Slovakia) written in characters crudely imitating Hebrew script. The color of the star was most often yellow and the letters, black, but there were also orange stars with green letters.

Yellow star on the cover of an anti-Semitic booklet from 1942.

Ages and early modern period, as the aggressive choice of the color yellow emphasized, meant to echo the medieval circles and the robe of Judas. But by the end of the war, after the discovery of the death camps, this yellow of defilement and death saw its symbolism transmuted to become a testament to history.[92]

In the present day, more mundanely, we might think that yellow's singular quality of visibility explains its use for mailboxes, mail service vehicles, and taxis in many European countries. Nothing is less certain. Yellow in these cases seems to be the legacy of a long history that has hardly anything to do with signals or visibility; it is the heraldic and symbolic color of the Thurn and Taxis family, minor Lombard lords who became German barons, and then princes in the Holy Roman Empire, and who founded and organized the European postal system in the fifteenth and sixteenth centuries. Later in Germany, they invented the horse-drawn ancestors of our modern "taxis." The dynastic yellow of this family—today one of the richest in the world—thus became the trademark color of its postal enterprises and then its vehicle transportation companies.[93] Despite many changes, yellow has remained the color of the postal service and taxis in several European countries. Elsewhere, yellow is also often the very visible color of taxis, but it is undoubtedly the smoke, grime, and fog of big cities that accounts for this choice.[94]

In the beginning of this twenty-first century, in houses and apartments, yellow is hardly more present than in the streets. It is mostly used for small touches, constituting in home decor an accent or ornament. Only in children's rooms and sometimes in kitchens is it used on a larger scale. But clearly it is impossible to generalize here with fashions being so changeable and difference being so great between social classes, types of housing, the size of cities, and especially between countries and regions. In northern Europe, for example, notably in Scandinavia, one sees more yellow buildings, houses, vehicles, furniture, gear, and objects than in Mediterranean Europe. Someone should try to draw up

Postal Service Yellow

Why are mailboxes yellow in many European countries? To be more easily spotted, of course. But also and especially because in Europe, the postal system was created and organized beginning in the fifteenth and sixteenth centuries by the great German-Italian Thurn and Taxis family, whose emblematic color was yellow.
Mailboxes of the Imperial Post, Germany, late 19th century.

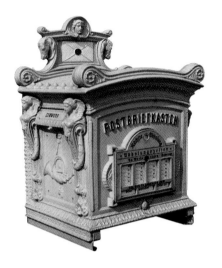

Yellow, the Color of Taxis

The same is true for taxis as for mailboxes: in many countries, they are yellow. But that is not just to be able to spot them in the flood of cars and urban smog. It is also because before being automobiles, they were horse-drawn carriages, and again, it was the great Thurn and Taxis family that introduced them. Yellow was the color of their livery.
Ad Meskens, *Yellow Cabs on Fifth Avenue*. New York, 2009.

a geography of the contemporary uses of color in everyday life, but in this time of European, or even global, standardization, that exercise seems increasingly difficult.[95] In a general way, the shorter the days, the scarcer the natural light, and the colder it is, the more yellow is featured in the environment, beginning with official buildings and means of transportation. Yellow, like a few other bright colors (orange and red notably), is supposed to brighten the daily routine and enliven existence. Moreover, electric lighting itself has now sometimes become yellow again, as it was originally; it seems to warm rooms at the same time as it lightens hearts.

This cheerful and fortifying dimension of the color yellow also explains its presence not only on athletic fields, as we have seen, but also at beach, skiing, and vacation resorts. Here there is no need to dress as in the office, and loud colors are not met with disapproval, far from it. Bright, saturated yellows replace beige, which represents a kind of

substitute yellow in daily and professional life, an elegant, reserved substitute, of course, but sometimes insipid and sad. Moreover, the growing use of beige in the clothing of Western societies beginning in the 1930s seems to constitute good evidence of the moroseness that increasingly affects those same societies. So, from moroseness to decline, then from decline to decrepitude . . .

It is not only in the office or professional life that yellow is a neglected, if not shunned, color. The same is true in political life, where its strongly negative symbolism has long curbed its use. Why choose for one's emblem a color associated with the ideas of lying and treachery? In fact, since the mid-nineteenth century in Europe, few political parties, social movements, or public opinion trends have broken this taboo. And when they have done so, as with the *syndicats jaunes* of the 1900s that we have already discussed, it has caused considerable harm. Nevertheless, it seems that in this area, things may be in the process of evolving, and the political palette may be on the point of trying something new. Already in Germany, directly following World War II, the liberal-democratic party FDP (Freie Demokratische Partei) took the color yellow for its emblem.[96] Beginning in the 1970s, it has sometimes allied itself with the conservative CDU and sometimes with the social-democratic SPD, thus earning the reputation of a party less centrist than versatile, ready to flip sides easily. Thus some political observers have considered it unreliable, like its color. More recently, the Five Star Movement (Movimento 5 Stelle) in Italy, founded in 2009 and which refuses to call itself a political party (which is complicated further by its very widely scattered electorate), also chose yellow for its emblematic color. That choice was not so much because yellow was the only color available (in fact, in Italy as elsewhere, no one wanted it due to its negative symbolism) but because it was a color "that stood outside the system." And even more recently, the French movement called the "Gilets jaunes" (yellow vests) did the same; yellow, the color that is visible and that, like the vest, signals

PREVIOUS SPREAD
The Color of the Beach

Beach sand is never really yellow, of course, but since the late eighteenth century, seashore beaches have conventionally been painted in the range of yellows, tending more or less toward ochers, tans, or grays depending on the period and the artist. In twentieth-century art, those tones became brighter and clearer, as with this Breton beach painted by Félix Vallotton (1865-1925) during World War I, the horrors of which he represented elsewhere through engravings and in an entirely different palette. Félix Vallotton, *The Bay of Trégastel*, 1917. Private collection.

Distress and Loneliness

Some yellows are fortifying and joyous, but others are not. It is enough to apply them lightly over green or beige, to surround them with somber or pallid colors, or to employ them in a more or less empty space to convey a feeling of anguish, sadness, or abandonment. The famous painting by Edward Hopper (1882-1957) titled *Automat*, portraying a woman in a yellow hat, sitting alone with her cup of coffee in a dingy, deserted cafeteria, is a perfect example. Edward Hopper, *The Automat*, 1927. Des Moines, Des Moines Art Center.

danger, clothes the "Republic's forgotten ones," subject to social and fiscal peril. As I write these lines (April 2019), it is difficult to say what will become of this movement.

Thus in politics, the long rejected yellow seems to be experiencing a revival. Fleeting bursts of activity or a true groundswell? It is too early to say. Nevertheless, we must note that in the most recent opinion polls on color preferences, yellow remains—still and as always—in last place among the basic colors, throughout western Europe. The order of responses remains the same as it was at the end of the nineteenth century. In answer to the question, "what is your favorite color," blue comes in first, at 45 to 50 percent; green second, at 15 to 18 percent; red at about 12 percent; black at between 8 and 10 percent, and yellow at less than 5 percent; the other colors share what percentage remains.[97] For the historian, the most important information these studies offer is that results have remained the same since these polls began, that is, since the 1880s.

Such studies spread throughout Europe and then the United States after World War I and multiplied after 1950 under the influence of marketing and advertising.[98] Despite the appearance of new materials and new lighting, despite all the changes in society and sensibility that have taken place since the late nineteenth century, the results have hardly varied from one generation to another. Whether it is 1890, 1930, 1970, or 2010, blue always comes first by a wide margin, yellow always decidedly last. Moreover, not only do results remain consistent from one decade to another,

Les Gilet Jaunes

Appearing in France in October 2019, the "yellow vests" movement was first a protest against higher gasoline prices and lower speed limits. Hence the choice of the emblem of the yellow vest, which all drivers are required to carry. This is a safety jacket, very visible, that must be donned by anyone who needs to venture into the road. Subsequently, the movement has expanded its protests to include many other issues, but the *gilet jaune* has remained its symbol. Valentina Camu, Silent protest in honor of wounded *gilets jaunes*. Paris, February 2, 2019.

but also they hardly vary across the European continent.[99] Neither climate nor amount of sunshine, not history, religion, or cultural traditions, much less political regimes or levels of economic development seem to affect what colors are in or out of favor.[100]

What will happen in the decades to come, following the vast and raucous enterprise of globalization now well underway? Will blue remain the favorite color of Europeans and yellow, the least favorite, forever the victim of a symbolic past too heavy to bear? Little hints of movement seem to announce some changes, not only in political symbolism and everyday uses, but also and especially in value systems and trends in sensibility. If I were not a historian but rather a creator—painter, designer, graphic artist, advertiser—I would make the most of this and wager on yellow. I would begin by restoring its place in the color world, the place it deserves and that it held in Greek and Roman antiquity, lost in the Middle Ages, and has never regained since.

Is yellow a color of the future?

Yellow and Red, "Colors of the South"

In summer 1953, while traveling in Sicily, Nicolas de Staël finally discovered the "pure colors of the South" that he had so long sought. This was for him a true aesthetic and chromatic shock, which he translated on his return into a series of landscapes, many of which number among his masterpieces.
Nicolas de Staël, *Agrigente* (detail), 1953–54. Private collection.

NOTES

Introduction

1. Beginning in the eighteenth century this new spectral order of colors was even applied to the rainbow, which has always been perceived strictly culturally. While ancient societies saw only three or four colors in the rainbow, our modern eye tends to distinguish seven: those of the spectrum. It is not that we always see these seven colors. But as early as elementary school, we learn that there are seven colors in the rainbow; hence, we see them. Or at least we believe we see them.

A BENEFICIAL COLOR

1. B. Berlin and P. Kay, *Basic Color Terms: Their Universality and Evolution* (Berkeley, 1969), 14–44.

2. M. Pastoureau, *Rouge: Histoire d'une couleur* (Paris, 2016), 14–17. See also the English edition: M. Pastoureau, *Red: The History of a Color*, trans. Jody Gladding (Princeton, 2017).

3. L. Gerschel, "Couleurs et teintures chez divers peuples indo-européens," *Annales ESC* 21 (1966): 608–63.

4. M. Pastoureau, *Bleu: Histoire d'une couleur* (Paris, 2000), 49–84. See also the English edition: M. Pastoureau, *Blue: The History of a Color*, trans. Markus I. Cruse (Princeton, 2001).

5. On the ochers of the Paleolithic period, there are numerous analyses and an abundant literature. For an overview and assessment, see especially E. Wreschner, *Studies in Prehistoric Ochre Painting* (Jerusalem, 1983); E. Chalmin, M. Menu, and C. Vignaud, "Analysis of Rock Art Paintings and Technology of Paleolithic Painters," *Measurement Science and Technology* 14 (2003): 1590–97; E. Hovers et al., "An Early Case of Color Symbolism," *Current Anthropology* 44 (2003): 491–522. In ancient Greek, the word *ōkhros*, from which comes the French *ocre*, designates a pale color, most often in the range of yellows but also sometimes an indistinct color: whitish, grayish, or brownish.

6. The oldest fragments of cloth that have come down to us date back no further than the early third millennium BCE. Of course, much earlier iconography shows figures wearing different colored clothing, but to what extent do these images convey the realities of color? Just because a representational document shows us a king or hero dressed in yellow does not mean that figure really wore those colors. Nor does it mean that he did not. But the problems of documentation are not considered in this way, no matter the document or era in question.

7. A. Varichon, *Couleurs: Pigments et teintures dans les mains des peuples*, 2nd ed. (Paris, 2005), 59.

8. F. Delamare and B. Guineau, *Les matériaux de la couleur* (Paris, 1999), 20; J. Wiethold, "La gaude: Une plante tinctoriale importante de l'époque médiévale et du début de la période moderne," *Les nouvelles de l'archéologie* 114 (2008): 52–58.

9. In an extensive bibliography, see especially E. Babelon, *Les origines de la monnaie considérées au pointe de vue économique et historique* (Paris, 1897); M. Agliette and A. Orléan, *La Violence de la monnaie* (Paris, 1984); G. Le Rider, *La naissance de la monnaie: Pratiques monétaires de l'Orient ancien* (Paris, 2001); A. Testart, ed., *Aux origines de la monnaie* (Paris, 2001).

10. R. Halleux, *Le problème des métaux dans la science antique* (Paris, 1974).

11. I. Ivanov and M. Avramova, *Varna Necropolis: The Dawn of European Civilisation* (Sofia, 2000); R. Treuil, "La nécropole de Varna," *Dossiers d'archéologie* 259 (2001): 120–23; T. Higham et al., "New Perspectives on the Varna Cemetery: Dates and Social Implications," *Antiquity* (Cambridge) 81, no. 313 (2007): 640–54.

12. F. Tiradritti, *Peintures murales égyptiennes* (Paris, 2007); A. Mekhitarian, *La peinture égyptienne* (Paris, 2008).

13. F. Daumas, "La valeur de l'or dans la pensée égyptienne," *Revue de l'histoire des religions* 149, no. 1 (1956): 1–17.

14. Hesiod, *Works and Days*, lines 106–201.

15. Catullus, *Poems*, lines 384–422; Virgil, *Georgics* I, lines 125–59; Tibullus, *Elegies* I, 3, lines 35–48; Horace, *Epodes* XVI; Ovid, *Metamorphoses* I, lines 89–150.

16. See J.-P. Vernant, *Mythe et pensée chez les Grecs: Étude de psychologie historique*, 2nd ed. (Paris, 1996), 19–106; P. and A. Sauzeau, "Le symbolisme des métaux et le mythe des races métalliques," *Revue de l'histoire des religions* 219, no. 3 (2002): 259–97.

17. Paris, BNF, ms fr. 14357, fol. 16v°–17 (speech by a herald regarding a passage from Genesis (Genesis 2:8–10).

18. Ovid, *Metamorphosis* I, lines 89 and passim.

19. On the golden apples in the garden of the Hesperides, the most verbose and most useful ancient authors to consult are Apollodorus, *Bibliotheca* II, 5, 11; Apollonius of Rhodes, *Argonautica* IV; Pausanias, *Description of Greece* IX, 35; Diodorus Sicilus, *Bibliothea historica* IV, 27–37.

20. On the story of Jason, the Argonauts, and the Golden Fleece, see Apollodorus, *Bibliotheca* I, 9, 1; Apollonius of Rhodes, *Argonautica* IV, 177. See also the fine book by A. Moreau, *Le mythe de Jason et de Médée: Le va-nu-pied et la sorcière*, 2nd ed. (Paris, 2006).

21. On the legend of Midas, among other ancient authors, see especially Herodotus, *Histories* I, 14; Hyginus, *Fables* CXCI; Ovid, *Metamorphoses* XI, 90; Virgil, *Bucolics* VI, 13.

22. On this theme, see J.-P. Allard, "De l'or des Sythes à l'or du Rhin," *Études indo-européennes* (1999): 67–118.

23. The Rhinegold legend as well as the legend of Siegfried and the legend of the Nibelungs have engendered much scholarly literature. To navigate it, consult the recent bibliography by F. Krage, *Nibelungen und Nibelungensage: Kommentiere Bibliographie, 1945–2010* (Berlin, 2014).

24. Genesis 1:16; Psalms 74 (73):16. God commands the sun on many occasions; for example, Job 9:7; Baruch 6:59. In the Bible, the frequent expression "under the sun" means "on earth" and "those who see the sun" means "living beings": Ecclesiastes 7:12; 11:7. Worship of the sun and the stars in general is forbidden: Deuteronomy 4:16–19; 17:3–5; Job 31:26–28.

25. On the worship of Heliogabalus and Sol Invictus in the Late Empire see R. Turcan, *Héliogabale ou le sacre du soleil* (Paris, 1985); J.-P. Martin, "Sol Invictus: Des Sévères à la tétrachie d'après les monnaies," *Cahiers du Centre Gustave Glotz* 11 (2000): 297–307.

26. Pliny, *Historia naturalis*, bk. 2, chaps. 16 and 27.

27. Until the twelfth century, blue is often absent in such a sequence. See M. Pastoureau, *Bleu: Histoire d'une couleur* (Paris, 2000), 30–40.

28. Plato, *Symposium*, 211e; *Georgias*, 465b. See the fine study by Angelo Baj, "Faut-il se fier aux couleurs? Approches platoniciennes et aristotéliciennes des couleurs," in *L'Antiquité en couleurs: Catégories, pratiques, représentations*, ed. M. Carastro (Grenoble, 2009), 131–52.

29. Plato, *Lysis*, 217c–d; *Timaeus*, 67c–68d; *Republic*, bk. 10, 596d–598d. See P. M. Schuhl, *Platon et l'art de son temps*, 2nd ed. (Paris, 1952); E. Keus, *Plato and Greek Painting* (Leiden, 1978); K. Ierodiakonou, "Plato's Theory on Colours in Timaeus," *Rhizai: A Journal for Ancient Philosophy and Science* 2 (2005): 219–33. See also the thesis by Adeline Grand-Clément, *La fabrique des couleurs: Histoire du paysage sensible des Grecs anciens* (Paris, 2011).

30. On Roman dyeing and dyestuffs, the literature is sparse except with regard to purple (for which, on the contrary, it is considerable). See especially F. Brunello, *The Art of Dyeing in the History of Mankind* (Vicenza, 1973), 103–16; A. Rouveret, S. Dubel, and V. Naas, eds., *Couleurs et matières dans l'Antiquité: Textes, techniques et pratiques* (Paris, 2006), passim.

31. Pliny, *Historia naturalis*, bk. 21, chap. 17. See also, for a history of saffron, J. Humphries, *The Essential Saffron Companion* (Amsterdam, 1998) (first part); P. Willard, *Secrets of Saffron: The Vagabond Life of the Most Seductive Spice* (Toronto, 2001), 24–37.

32. The noun *lutum*, designating *weld*, must not be confused with a homonymous term designating *mud* or *clay*. The two words, however, may have a shared etymology, linked to yellow: a bright color with regard to weld, a dull color with regard to clay. Moreover, *lutum* was sometimes used as an offensive term in imperial Rome, more or less corresponding to our modern French *espèce d'ordure* (piece of rubbish).

33. J. André, *Étude sur les termes de couleurs dans la langue latine* (Paris, 1949), 112, 115, 139–45.

34. On yellow dyes in the modern period: C. Viel, "Colorants naturels et teintures du xviie siècle à la naissance des colorants de synthèse," *Revue d'histoire de la pharmacie* 347 (2005): 327–48; A. Varichon, *Couleurs: Pigments et teintures dans les mains des peuples*, 2nd ed. (Paris, 2005), 50–81; D. Cardon, *Mémoires de teinture: Voyage dans le temps chez un maître des couleurs* (Paris, 2013); D. Cardon, *Le monde des teintures naturelles* (Paris, 1994), translation M. Pastoureau.

35. Ovid, *The Art of Love*, bk. 3, lines 169–92.

36. M. Pastoureau, *Vert: Histoire d'une couleur* (Paris, 2013), 26–35. See also the English edition: M. Pastoureau, *Green: The History of a Color*, trans. Jody Gladding (Princeton, 2014).

37. On the Roman toga and its place within the vestimentary system: L. M. Wilson, *The Roman Toga* (Baltimore, 1924); J. L. Sebasta and L. Bonfante, eds., *The World of Roman Costume* (Madison, 1994); C. Vout, "The Myth of the Toga: Understanding the History of Roman Dress," in *Greece and Rome*, vol. 43 (Cambridge, 1996), 204–20; F. Chausson and H. Inglebert, eds., *Costume et société dans l'Antiquité et le haut Moyen Âge* (Paris, 2003); F. Baratte, "Le vêtement dans l'Antiquité tardive: rupture ou continuité?" *Antiquité tardive* 12 (2004): 121–35. See also P. Cordier, *Nudités romaines: Un problème d'histoire et d'anthropologie* (Paris, 2005), passim.

38. On women's clothing and fashions, in addition to the works cited in the previous note, see R. MacMullen, "Women in Public in the Roman Empire," *Historia* (Yale University) 29, no. 2 (1980): 208–18; J. M. Robert, *Les modes à Rome* (Paris, 1988); A. T. Croon, *Roman Clothing and Fashion* (Charleston, 2000); P. Moreau, ed., *Corps romains* (Grenoble, 2002).

39. On marriage, the color yellow, and saffron dye: C. Zaitoun, "Vêtement et safran dans le rituel: L'importance de la parure dans la société égéenne," in *Costume et société dans l'Antiquité et le haut Moyen Âge*, ed. F. Chausson and H. Inglebert (Paris, 2003), 7–25; F. Cherchanoc, "Le voile de mariage: le cas des *anakalupteria*," *Mutis*, n.s., 4 (2006): 239–67.

40. Martial, *Epigrams*, bk. 6, chap. 28, lines 6–7, and chap. 29, lines 5–7; Statius, *Silvae*, bk. 2, chap. 1; and so on. See J. Boswell, *Christianity, Social Tolerance and Homosexuality* (Chicago, 1980), 61–87; P. Veyne, "L'homosexualité à Rome," *Communications* 35 (1982): 26–33; F. Dupont and T. Eloi, *L'érotisme masculin dans la Rome antique* (Paris, 2001); C. Baroin, "La beauté du corps masculin dans le monde romain: État de la recherche récente et pistes de réflexion," *Dialogues d'histoire ancienne*, supplement 14 (2015): 31–51.

41. F. Dupont, *L'Affaire Milon: Meurtre sur la voie Appienne* (Paris, 1987); J. Cels Saint-Hilaire, "P. Clodius, ses amis, ses partisans, sous le regard de Cicéron," *Dialogues d'histoire ancienne*, supplement 1 (2005): 69–90.

42. See the three vehement discourses by Cicero against Clodius: *De domo sua; Oratio haruspicum responso in P. Clodium in senatu habita; In P. Clodium et Curionem.*

43. Cicero, *De haruspicum responso*, chap. 21, sec. 44.

44. Petronius, *Satyricon*, bk. 2 (Trimalchion), chap. 67, line 4.

45. Martial, *Epigrams*, bk. 1, no. 96 and bk. 2, no. 82.

46. Juvenal, *Satires*, bk. 2, line 97.

47. André, *Étude sur les terms de couleur*, 148–50.

48. Martial, *Epigrams*, bk. 1, no. 96, lines 8–9.

49. M. Pastoureau, *Bleu: Histoire d'une couleur* (Paris, 2000), 49–84.

50. A hypothesis further supported by the fact that *galbinus* was undoubtedly first accepted in the form *galbus*. See André, *Étude sur les couleurs*, 148–49.

51. L. Gernet, "Dénomination et perception des couleurs chez les Grecs," in *Problèmes de la couleur*, ed. I. Meyerson (Paris, 1957), 313–24.

52. For the color yellow, the medical texts offer many examples linked to the color of urine. See summaries of ancient urology (Galen's in particular) in C. Vieillard, *L'urologie et les médicins urologues dans la médecine ancienne* (Paris, 1903); and in L. Moulinier, *L'uroscopie au Moyen Âge: Lire dans un verre la nature de l'homme* (Paris, 2012).

53. Although *galbus* is found only in glosses, which makes any dating difficult. André, *Étude sur les couleurs*, 148–49.

54. On the roots of the Germanic term *gelb* (*ghel, *gwhel): B. Lehmann, "Die deutschen Farbwörter: Eine linguistische Analyse und ihre literatur-wissenschaftliche Anwendung," in *Festschrift for Eric Lowson Marson* (Frankfurt am Main, 1997), 97–120; W. J. Jervis Jones, *German Colour Terms: A Study of Their Evolution from Earliest Times to the Present* (Amsterdam, 2013), 274–345, especially 297–98 and 311.

55. On the Indo-European origin of the words signifying "yellow" in Germanic and Romance languages, see A. M. Kristol, *Les langues romanes devant le phénomène de la couleur* (Bern, 1978).

56. Virgil, *Georgics*, bk. 4, lines 220–23.

57. On the questions of the lexicon and translation, see the two studies by François Jacquesson cited in the following note. See also M. Pastoureau, *Vert: Histoire d'une couleur* (Paris, 2013), 36–40, and *Rouge: Histoire d'une couleur* (Paris, 2016), 58–63.

58. F. Jacquesson, *Les mots de couleurs dans les textes bibliques* (Paris, 2008), online version at the LACITO (CNRS) research site: http://lacito.vjf.cnrs.fr/partenariat/pdf/Couleurs-bibliques2.pdf; in conjunction with the article by the same author, "Les mots de la couleur en hébreu ancien," in *Histoire et géographie de la couleur*, ed. P. Dollfus, F. Jacquesson, and M. Pastoureau (Paris, 2013), 67–130 (*Cahiers du Léopard d'or*, vol. 13).

59. On the pectoral of the high priest, see C. Nihan, "Le pectoral d'Aaron et la figure du grand prêtre dans les traditions sacerdotales du Pentateuque," *Vetus Testamentum Supplements* (Leiden) 177 (2017): 24–40.

60. On the Church Fathers and the symbolism of colors, see C. Meier-Staubach and R. Stuntrup, *Handbuch der Farbenbedeutung im Mittelalter*, 2 vols. (vol. 2 on CD) (Cologne and Vienna, 2014).

61. Isidore of Seville, *Etymologies*, bk. 17, chap. 9, sec. 5–6. See J. André, *Lexique des terms de botanique en latin* (Paris, 1956).

62. *Lux incorporata* writes Isidore of Seville in his *Etymologies*, bk. 16, chap. 18, sec. 4–5; and *luces incorporatae* writes Honorius Augustodunensis in his *Exposito in cantica*, 5, 10 (*Patrologia latina*, vol. 172, col. 440).

63. M. Pastoureau, "L'Église et la couleur des origines à la Réforme," *Bibliothèque de l'École des chartes*, vol. 147 (1989): 203–30, especially 214–16.

AN AMBIGUOUS COLOR

1. In classical Latin, these terms do not designate the colors red, black, and green so much as modesty, wickedness, and vigor. The most common meaning—that is to say, almost the only meaning—is not the etymological but the figurative one.

2. On the origin and early expansion of liturgical colors, the bibliography is sparse. Allow me to cite two of my own studies: "Le temps mis en couleurs: Des couleurs liturgiques aux modes vestimentaires (XIIᵉ–XIIIᵉ siècles)," *Bibliothèque de l'École des chartes* 157 (1999): 111–35; "Classer les couleurs au xii siècle: Liturgie et héraldique," *Comptes rendus des seances de l'Académie des inscriptions et belles-lettres*, no. 2 (forthcoming).

3. Lotario of Segni (the future Pope Innocent III), *De sacro sancti altaris mysterio*, bk. 2, chap. 60, published in the *Patrologia latina*, vol. 217, col. 774–916 (the part devoted to liturgical colors is found in columns 799–802; a partial translation of it appears in my article cited in the preceding note, "Les temps mis en couleur . . .").

4. "Viridis color medius est inter albedinem et nigritiam et ruborem," Lotario of Segni (the future Pope Innocent III), *De sacro sancti altaris mysterio*, bk. 2, chap. 60, published in the *Patrologia latina*, vol. 217, col. 801.

5. This influence was nevertheless more theoretical and didactic than truly practical. In the fourteenth and fifteenth centuries, the establishment of the papacy in Avignon, the schism, and general crisis in the Church reversed this movement toward a more unified liturgy that had gotten a strong start in the thirteenth century. Many dioceses far removed from Rome returned to their individual practices and retained them well into the modern period. The decisions of the Council of Trent and the establishment of the Roman Missal by Pope Pius V (1570), which made Roman practices obligatory, did not actually take hold for a long time. While all the dioceses in Christendom gradually adopted the five principal liturgical colors imposed by Rome (white, red, black, green, and violet), many local particularities survived until the mid-twentieth century.

6. Beginning in the late thirteenth century, we encounter a seventh color in heraldry: *pourpre* (violet); its use is the exception and it does not truly constitute a heraldic color in its own right, at least not in the Middle Ages. Subsequently, its frequency increased a bit but never attained 1 percent usage. Its appearance was intended mostly to complete a septet of heraldic colors so correspondences could be established with the seven planets, seven metals, seven deadly sins, and so on. See M. Pastoureau, *L'art héraldique au Moyen Âge* (Paris, 2009), 80–82.

7. The abstract nature of heraldic colors is found again in another sign system, the modern heir to medieval heraldry: road signs, encoded like true coats of arms. Coats of arms developed in about the middle of the twelfth century in a few small regions located between the Loire and the Meuse; today they are present on five continents, thanks to road signs.

8. Color is the very essence of the heraldic code, even though we recognize many coats of arms without their colors. That is the case with seals, coins, tokens, medals, sculpture that has lost its color, wood engravings without color, and so on.

9. K. Nyrop, "*Gueles*, histoire d'un mot," *Romania*, vol. 68 (1922): 559–70. Today, one of the least fanciful hypotheses links the vernacular word *gueules* to the classical Latin word *tegulatus* (red like tile), which may have become *gulatus* in medieval Latin, but this last form has not been attested.

10. A. G. Ott, *Étude sur les couleurs en vieux français* (Paris, 1899), 31–32; A. Tobler and E. Lommatzsch, *Altfranzösisches Wörterbuch*, vol. 9 (1973), col. 9–10. In the fourteenth century, Jean Corbechon, translating and adapting Bartholomeus Anglicus's *De proprietatibus rerum*, a vast encyclopedia compiled some 130 years earlier, repeats this still relevant etymology of the word *sinople*: "Synop is a red color that was first found in the sea near the city of Sinop." See M. Salvat, "Le traité des couleurs de Barthélemy l'Anglais," *Senefiance*, vol. 24 (*Les couleurs au Moyen Âge*) (Aix-en-Provence) (1988): 359–85 (see p. 381).

11. C. Boudreau, *L'héritage des hérauts d'armes: Dictionnaire encyclopédique de l'enseignement du blason ancien*, vol. 2 (Paris, 2006), 924–48.

12. G. J. Brault, *Early Blazon: Heraldic Terminology in the XIIth and XIIIth Centuries with Special Reference to Arthurian Literature* (Oxford, 1972), 31–35.

13. Below, pp. 111–17.

14. Boudreau, *L'héritage des hérauts d'armes*, 816–17, translation M. Pastoureau.

15. H. Cocheris, ed., *Le Blason des couleurs en armes, livrées et devises* (Paris, 1860), 82–83, translation M. Pastoureau.

16. See the twenty or so editions inventoried in the very scholarly bibliography by G. Saffroy, *Bibliographie généalogique et nobiliare de la France*, vol. 1 (Paris, 1968), no. 1999–2021.

17. F. Rabelais, *La vie inestimable du grand Gargantua, père de Pantagruel* (Paris, 1535), chap. 1:

Gargantua's colors were white and blue. I know very well that reading these words, you say white is said to signify faith, and blue constancy. . . . But who told you that white signifies faith, and blue constancy? A book, you say, very little read, sold at the book stalls, entitled *The Blason of Colours*. Who made it? Whoever he was, he was wise not to not set his name to it.

18. C. Connichie-Bourgne, ed., *La chevelure dans la littérature et l'art du Moyen Âge* (Aix-en-Provence, 2004); M. Rolland-Perrin, *Blonde comme l'or: La chevelure féminine au Moyen Âge* (Aix-en-Provence, 2010).

19. Rolland-Perrin, *Blonde comme l'or: La chevelure féminine au Moyen Âge*, 19–73.

20. A. Ott, *Étude sur les couleurs en vieux français* (Paris, 1899), 79–81; J. Bruch, "*Balai, blond*," in *Neuphilologische Mitteilungen*, vol. 23 (1922), 93–94; M. Rat, "Le *blond* et le *brun*," *Vie et langage* (1967): 318–24; G. Tilander, "Origin de l'adjectif blond," in *Festschrift H. Meier* (Munich, 1971), 545–48.

21. On Guinevere: J. Marx, "La vie et les aventures de la reine Guenièvre et la transformation de son personnage," *Journals des savants* 1 (1965): 332–42; P. Noble, *The Character of Guinevere in Arthurian Romances . . . : A Casebook* (New York, 1996); D. Rieger, *Guenièvre reine de Logres, dame courtoise, femme adultère* (Paris, 2009); D. Rieger, "Guenièvre littéraire, femme multiforme, entre sexualité, pouvoir et sagesse," *Cahiers de recherches médiévales et humanistes* 23 (2012): 259–72.

22. On the various medieval versions of the story of Tristan and Iseult, there is a considerable bibliography for the list of scholarly and of popular editions and translations alike. As an introduction, one can still read with pleasure and interest the modern French version offered to educated readers more than a century ago by Joseph Bédier: *Le Roman de Tristan et Iseut* (Paris, 1900), and to complement it, a slightly different one by René Louis, *Tristan et Iseult* (Paris, 1972). On Iseult's blondness, see F. Plet, "Yseut est-elle une vraie blonde?" in Connochie-Bourgne, ed., *La chevelure dans la littérature*, 309–24.

23. Chrétien de Troyes, *Erec et Enide*, lines 424–26.

24. Chrétien de Troyes, *Cligès*, lines 5311–13. See also three almost identical lines repeated by Robert de Blois, *Floris et Lyriopé*, lines 223–25.

25. Chrétien de Troyes, *Cligès*, lines 965–82.

26. M. Pastoureau, *Armorial des chevaliers de la Table Ronde: Étude sur l'héraldique imaginaire à la fin de Moyen Âge* (Paris, 2006), 106, no. 33.

27. On feminine beauty in courtly romances: M. Lot-Borodine, *La femme et l'amour au XIIᵉ siècle d'après les romans de Chrétien de Troyes* (Paris, 1909), passim; A. Colby, *The Portrait in Twelfth Century French Literature* (Geneva, 1965); J. M. Ferrante, *Woman as Image in Medieval Literature, from the Twelfth Century to Dante* (New York, 1975); J. Verdon, *La femme au Moyen Âge* (Paris, 1999), 9–15; M. Camille, *The Medieval Art of Love-Objects and Subjects of Desire* (London, 1998); M. Milland-Bove, *La demoiselle arthurienne: Écriture du personnage et art du récit dans les romans en prose du XIIIᵉ siècle* (Paris, 2006).

28. Let us note, however, that over the decades, the figure of Gawain loses stature in romances. By the end of the thirteenth century, he is hardly the gallant knight he was a century earlier, wise and courteous, the model of chivalry. See K. Busby, *Gauvain in Old French Literature* (Amsterdam, 1980); P. Walter, *Gauvain le chevalier solaire* (Paris, 2013).

29. There are many descriptions of loutish, ugly, deformed peasants in chivalric romances from the twelfth and thirteenth centuries. A few examples can be found in P. Ménard, *Le rire et le sourire dans le roman courtois en France au Moyen Âge (1150-1250)* (Geneva, 1969), 529–44. They can be compared to those describing masculine beauty in H. Loubier, *Das Ideal der männlichen Schönheit bei dem altfranzösischen Dichtern des XII. und XIII. Jahrhunderts* (Halle, 1890).

30. On Gaston Phoebus: B. Narbonne, *Gaston Phébus, seigneur du Béarn (1331-1391)* (Paris, 1936); P. Tucoo-Chala, *Gaston Fébus, prince des Pyrénées (1331-1391)* (Bordeaux, 1991); C. Pailhès, *Gaston Phébus: Le prince et le diable* (Paris, 2007); *Gaston Phébus, prince Soleil (1331-1391)* exhibition (Paris, Musée de Cluny, 2011–12).

31. R. Rambaud, *Les fugitives: Histoire anecdotique et historique de la coiffure féminine à travers les âges*, 2nd ed. (Paris, 1955); C. Lebas and A. Jacques, *La coiffure en France du Moyen Âge à nos jours* (Paris, 1979); G. Vigarello, *Histoire de la beauté: Le corps et l'art d'embellir de la Renaissance à nos jours* (Paris, 2004). See also the works cited in note 18 above.

32. The literature on medieval medicine is vast. As an introduction, notably on the theory of humors and the four temperaments, see B. Gordon, *Medieval and Renaissance Medicine* (New York, 1959); M. J. Imbault-Huart, B. Merlette, and L. Dubief, *La médecine médiévale à travers les manuscrits de la Bibliothèque nationale*, exhibition catalog (Paris, Bibliothèque nationale, 1982); M. Grmek, *Histoire de la pensée médicale en Occident*, vol. 1: *Antiquité et Moyen Âge* (Paris, 1995); D. Jacquart and F. Micheau, *La médecine arabe et l'Occident médiéval*, 2nd ed. (Paris, 1997); M. Nicoud, *Les régimes de santé au Moyen Âge* (Rome, 2007), 2 vols.

33. L. Moulinier, *"Lire dans un verre la nature de l'homme": Petite histoire de l'uroscopie médiévale* (Paris, 2012).

34. Gilles de Corbeil, *Liber de urinis (Aegidii Corboliensis Liber de urinis)*, in *Carmina medica*, ed. L. Choulant (Leipzig, 1826), 25–86. See C. Vieillard, *Gilles de Corbeil, médecin de Philippe Auguste et chanoine de Notre Dame (1140-1224): Essai sur la société médicale et religieuse du XIIᵉ siècle* (Paris, 1908); M. Ausécache, "Gilles de Corbeil ou le médecin pédagogue au tournant des XIIᵉ et XIIIᵉ siècle," *Early Science and Medicine* 3, no. 3 (1998): 187–215.

35. A doctor candling urine is frequently represented in miniatures from the late Middle Ages. In some publications meant for the general public, photographic reproductions of this scene are sometimes absurdly captioned: "Priest raising the host during mass"!

36. Moulinier, *"Lire dans une verre,"* 148–66.

37. In the Middle Ages, jaundice was considered more a matter of excess bile production than of blocked flow. Hence the "bilious" or "choleric" temperament of men and women whose bodies produced too much bile. Since bile was considered warm and dry, their therapy most often consisted of ingesting foods and products reputed to be cold and humid, such as pulpy fruits.

38. There are strong ties between the color yellow and dryness. Hence in Old and Middle French, the double sense of the word *saur*, sometimes meaning "yellow," sometimes "dry." The adjective survives in modern French in the phrase *hareng saur* (dried smoked herring). There is debate over the word's etymology: the Dutch *soor* or the Latin *superaureus*? See H. J. Arndt, "Beiträge zur Etymologie des altfranzösischen *saur*," in *Neue Beiträge zur romanischen Etymologie*, ed. Harri Meier (Heidelberg, 1975), 59–62.

39. V. Frandon, "Iconographie des saisons dans l'Occident médiéval," *Revue de la Bibliothèque nationale* 50 (1993): 3–8.

40. Briefly summarized here are the "correspondences" proposed for the color yellow, as can be found abundantly in heraldic treatises and encyclopedias from the late Middle Ages. Planet: the sun; metal: gold; precious stones: diamond, topaz, beryl; virtues: strength, nobility, honor; vices: envy, jealousy, lying, hypocrisy, treachery; day of the week: Sunday; signs of the zodiac: Leo and Cancer; age of life: middle age; element: fire. Yellow shares some of these correspondences with other colors. Red, for example, is also associated with fire and strength; blue with honor, green with envy, and so on.

41. See the fine book by C. Casagranda and S. Vecchio, *Histoire des péchés capitaux au Moyen Âge* (Paris, 2009).

42. On the *syndicats jaunes* of the late twentieth and early twenty-first centuries, see p. 188.

43. On the medieval symbolism of green at the end of the Middle Ages, see M. Pastoureau, *Vert: Histoire d'une couleur* (Paris, 2013), 87–135.

44. Notably in the second half of the nineteenth century when certain painters (Van Gogh and Seurat, for example) misused chrome yellow and cadmium yellow. See pp. 194–97.

45. In medieval Latin, the word *bilis* is a scholarly term, reserved for medicine; it was

226

rarer than the word *fel* in standard usage. Moreover, for doctors, it designated not only human bile but also the choleric temperament as well as jaundice.

46. The objective case designates the declined form in Old French taken by a noun, adjective, article, or pronoun when it functions as a complement. Thus this form is more frequent than that of the subjective case and therefore found at the origin of almost all current forms of nouns, adjectives, and articles in modern French.

47. In fact it was around this time (1180) that the episodes of *Renart teinturier* and *Renart jongleur* seem to have been added to the other episodes in the first "branch." See R. Bossuat, *Le Roman de Renart*, 2nd ed. (Paris, 1971), 31–43.

48. *Le Roman de Renart*, branch 1, vol. 1, ed. J. Dufornet and A. Méline (Paris, 1985), 160–61, lines 2313–16, translation M. Pastoureau.

49. *Le Roman de Renart*, branch 1, vol. 1, ed. J. Dufornet and A. Méline, 182–207, lines 2743–3212.

50. Such hypotheses do not stand up to analysis. Yellow does not, by itself, constitute the heraldic or emblematic color of either the English realm or the Plantagenet dynasty (it is, of course, the combination of yellow and red—*or et gueules*—that fulfills this role), and in medieval literature and traditions, yellow does not particularly evoke England. It is red that plays this role and that opposes the blue of France.

51. *Le Roman de Renart*, branch 6, vol. 1, ed. J. Dufornet and A. Méline (Paris, 1985), 446–47, lines 862–79, translation M. Pastoureau.

52. Brussels, Bibliothèque royale, ms. 9067, folio 131.

53. Cited by J. Huizinga, *L'automne du Moyen Âge* (Paris, 1975), 331.

54. D. Crouzet, *Charles de Bourbon, connétable de France* (Paris, 2003), 246 and following. In the seventeenth century, all that remained of the constable's mansion was a door, called the Door of the Petit-Bourbon, facing the Seine (to the extreme south of the Louvre's present

colonnade). The memoirist Tallemant des Réaux maintains that in about 1660, traces of yellow paint could still be seen on it. See *Les historiettes de Tallemand des Réaux: Mémoires pour servir à l'histoire du XVIIᵉ siècle*, vol. 1, 2nd ed., ed. M. Monmerqué (Paris, 1840), 127 (*La princesse de Conti*).

55. M. de Waele, "Le cadavre du conspirateur: Peur, colère et défense de la communauté à l'époque de la Saint-Barthélemy," *Revue d'histoire moderne et contemporaine* 64, no. 1 (2017): 97–115. See also, more generally, D. Crouzet, *Les guerriers de Dieu: La violence au temps des troubles de religion (vers 1525-vers 1610)*, 2 vols. (Seyssel, 1990).

56. G. Ortalli, *La peintura infamante del XIIIᵉ au XVIᵉ siècle* (Brionne, 1994).

57. J. Boulier, *Jan Hus* (Brussels, 1958); J. Puyo, *Jan Hus: Un drame au coeur de l'Église* (Brussels, 1999); A. Richardt, *Jean Huss précurseur de Luther* (Geneva, 2015).

58. M. Pastoureau, *Rouge: Histoire d'une couleur* (Paris, 2016), 102–8.

59. R. Mellinkoff, "Judas' Red Hair and the Jews," *Journal of Jewish Art* 9 (1983): 31–46; M. Pastoureau, "L'homme roux: Iconographie médiévale de Judas," in *Une histoire symbolique du Moyen Âge occidental* (Paris, 2004), 221–36.

60. R. Mellinkoff, *Outcasts: Signs of Otherness in Northern European Art of the Late Middle Ages*, 2 vols. (Berkeley and Oxford, 1993), passim; M. Pastoureau, "Tous les gauchers sont roux," *Le Genre humain* 16/17 (1988): 343–54.

61. Pastoureau, "Tous les gauchers sont roux," 350–51.

62. M. Pastoureau, "Formes et couleurs du désordre: le jaune avec le vert," in *Médievales* (1983): 62–73.

63. L. Gérard-Marchand, et al., eds., *Draghi rossi e querce azzure: Elenchi descrittivi di abit di lusso, Firenze 1343-1345* (Florence, 2013).

64. M. Pastoureau, "La Réforme et la couleur," *Bulletin de la Société de l'histoire du protestantisme français* 138 (1992): 323–42.

65. Gérard-Marchand, *Draghi rossi e querce azzure*. See also L. Gérard-Marchant, "Compter

et nommer l'étoffe à Florence au Trecento," *Médiévales* 29 (1995): 87–104.

66. M. Pastoureau, "Du bleu au noir: Ethiques et pratiques de la couleur à la fin du Moyen Âge," *Médiévales* 14 (1988): 9–21.

67. R. Straus, "The *Jewish Hat* as an Aspect of Social History," *Jewish Social Studies* 4 (1942): 59–72; B. Ravid, "From Yellow to Red: On the Distinguishing Head-Covering of the Jews of Venice," *Jewish History* 6, no. 1/2 (1992): 179–210; D. Sansy, "Chapeau juif ou chapeau pointu: Esquisse d'un signe d'infamie," in *Symbole des Alltags, Alltag der Symbole: Festschrift für Harry Kühnel* (Graz, 1992), 349–75.

68. U. Robert, "Les signes d'infamie au Moyen Âge: Juifs, Sarrasins, hérétiques, lépreux, cagots et filles publiques," *Mémoires de la Société nationale des Antiquaires de France* 49 (1888): 57–172; G. Kisch, "The Yellow Badge in History," *Historia Judaica* 19 (1957): 89–146; D. Sansy, "Marquer la différence: L'imposition de la rouelle aux xiiie et xive siècles," *Médiévales* 41 (2001): 15–36.

69. The impossibility of generalizing and identifying a common system for the marks of infamy imposed on Jews throughout the entire medieval Christian West allows us some perspective on the theses advanced by B. Blumenkranz, *Le Juif médiéval au regard de l'art chrétien* (Paris, 1966) and all those that followed. These studies deserve to be reconsidered and refined.

70. Latin text in *Ordonnances des rois de France de la troisième race*, vol. 1 (Paris, 1723), 294. See G. Nahon, "Les ordonnances de saint Louis sur les Juifs," *Les nouveaux cahiers* 23 (1970), 23–42. See also J. Le Goff, *Saint Louis* (Paris, 1966), 793–814.

71. See the works of Ulysse Robert and Danièle Sansy cited above in notes 67 and 68.

72. In fact, beginning in the thirteenth century, blue became an admired and sought-after color; its prestige would grow until the Age of Enlightenment, when it became the favorite color of Europeans. To make it a mark of exclusion or infamy was nearly impossible. At least that is true in the Christian world. In

227

the Islamic world where blue is more or less scorned, it is a different story; there, blue was often imposed on Christian minorities by Muslim authorities. M. Pastoureau, *Bleu: Histoire d'une couleur* (Paris, 2000), 86–113.

73. Moreover, these geometric figures, borrowed from the heraldic repertoire, usually respected the rules for combining colors imposed by heraldry: yellow and white could not be juxtaposed or superimposed; neither could red and blue, red and black, blue and green, green and black, red and green, blue and black. See above, p. 86.

74. M. Pastoureau, *Jésus chez le teinturier: Couleurs et teintures dans l'Occident médiéval* (Paris, 1997), 126–52.

AN UNPOPULAR COLOR

1. J. Goethe, *Zur Farbenlehre: Didaktischer Teil*, vol. 1 (Tübingen, 1810), 76.

2. M. Pastoureau, *Noir: Histoire d'une couleur* (Paris, 2008), 124–33. See also the English edition: M. Pastoureau, *Black: The History of a Color*, trans. Jody Gladding (Princeton, 2009).

3. Jer. 22:13–14; see also the stating of the sins of Jerusalem, notably excessive luxury in decor, finery, and colors, in Ezek. 8:10–13.

4. Just as drastic was the attitude of the Protestant Reformation toward liturgical colors. In the Catholic mass, color played an essential role. Objects and vestments were not only coded according to the calendric system of colors, but they were also combined with lighting, architectural and sculpted polychromy, painted images in holy books, and all precious ornamentation to create a veritable theater of color. Red, for example, was especially showcased during feasts of the Holy Spirit (Pentecost is one immense red holiday), the Holy Cross, and the martyrs. In the eyes of the great reformers, all that had to be banished: "the temple is not a theater" (Luther); "pastors are not performers" (Melanchthon); "gaudy and excessive rituals falsify the sincerity of worship" (Zwingli); "the most beautiful ornament in the temple is the word of God" (Calvin). The palette and code of liturgical colors were thus abolished, giving way to white, black, and gray. See M. Pastoureau, "La Réforme et la couleur," *Bulletin de la Société de l'histoire du protestantisme français* 138 (1992): 323–42.

5. On Protestant iconoclasm, many works exist: J. Philips, *The Reformation of Images: Destruction of Art in England (1553-1660)* (Berkeley, 1973); M. Warnke, *Bildersturm: Die Zerstörung des Kunstwerks* (Munich, 1973); M. Stirm, *Die Bilderfrage in der Reformation* (Gütersloh, 1977) (*Forschungen zur Reformationsgeschichte*, 45); C. Christensen, *Art and the Reformation in Germany* (Athens, GA, 1979); S. Deyon and P. Lottin, *Les casseurs de l'été 1566: L'iconoclasme dans le Nord* (Paris, 1981); G. Scavizzi, *Arte e architettura sacra: Cronache e documenti sulla controversia tra rifomati e cattolici (1500-1550)* (Rome, 1981); H. D. Altendorf and P. Jezler, eds., *Bilderstreit: Kulturwandel in Zwinglis Reformation* (Zurich, 1984); D. Freedberg, *Iconoclasts and Their Motives* (Maarsden, Holland, 1985); C. M. Eire, *War against the Idols: The Reformation of Worship from Erasmus to Calvin* (Cambridge, MA, 1986); D. Crouzet, *Les guerriers de Dieu: La violence au temps des guerres de Religion*, 2 vols. (Paris, 1990); O. Christin, *Une révolution symbolique: L'iconoclasme huguenot et la reconstruction catholique* (Paris, 1991). To these individual and collective works must be added the scholarly, voluminous catalog of the *Iconoclasme* exhibition (Berne and Strasbourg, 2001).

6. M. Pastoureau, "Naissance d'un monde en noir et blanc: L'Église et la couleur des origines à la Réforme" in *Une histoire symbolique du Moyen Âge occidental* (Paris, 2004), 135–71.

7. The violent sermon *Oratio contra affectationem novitatis in vestitu* (1527), in which Melanchthon recommended that all honest Christians wear sober, somber clothing and not *distinctum a variis coloribus velut in pavonem* (be adorned with varied colors like a peacock). This important sermon for the history of clothing and colors was published in *Corpus reformatorum*, vol. 11, 139–49.

8. On the revolution in stained glass introduced by silver stain, see C. Lautier, "Les débuts du jaune d'argent dans l'art du vitrail, ou le jaune d'argent à la manière d'Antoine de Pise," *Bulletin monumental* 158, no. 2 (2000): 89–107. On stained-glass techniques more generally, see J. Lafond, *Le vitrail: Origines, techniques, destinées*, 2nd ed. (Lyon, 1988), 39–70.

9. Furthermore, this famous "little patch of wall" really seems to be a patch of roof, not wall.

10. M. Proust, *La Prisonnière* (Paris, 1923); here, *Remembrance of Things Past*, vol. 3, *The Captive*, trans. C.K.S. Moncrieff, T. Kilmartin, and A. Mayor (New York, 1981), 184–85.

11. E. Martin and A. R. Duval, "Les deux variétés de jaune de plomb et d'étain: Étude chronologique," *Studies in Conservation* 35, no. 3 (1990): 117–36.

12. C. Cennini, *Il libro dell'arte* (1437?), ed. F. Brunello (Vicenza, 1993), chap. 72, sec. 1.

13. A. Kircher, *Ars magna lucis et umbrae* (Rome, 1646), chap. 2.

14. F. d'Aguilon, *Opticorm libri sex* (Anvers, 1613), 8.

15. Pliny, *Historia naturalis*, bk. 33, chap. 56, sec. 158. See J. Gage, *Couleur et culture* (Paris, 2010), 35.

16. J. C. Le Blon, *Colorito, or the Harmony of Colouring in Painting Reduced to Mechanical Practice* (London, 1725). Le Blon acknowledges his debt to Newton and affirms the primacy of three basic colors: red, blue, and yellow. On the invention of color engraving, see the scholarly catalog from the exhibition, *Anatomie de la couleur* (Paris, Bibliothèque nationale de France, 1995), ed. F. Rodari and M. Préaud. On the history of color engraving, considered from a long-term perspective, see the study by J. M. Friedman, *Color Printing in England, 1486-1870* (New Haven, 1978).

17. R. Boyle, *Experiments and Considerations Touching Colours* (London, 1664), 219–20, translation M. Pastoureau.

228

229

18. I. Newton first published his great treatise on optics in English (1704), but it received little attention. He then had it translated into Latin (1707) and was thus able to reach the whole European scientific community. *Opticks, or a Treatise of the Reflexions, Refractions, Inflexions, and Colours of Light…* (London, 1704); *Optice sive de reflectionibus, refractionibus et inflectionibus et coloribus lucis…* Latin translation S. Clarke (London, 1707, reprinted Geneva, 1740). On Newton's discoveries and the importance of the spectrum, see especially M. Blay, *La conception newtonienne des phénomènes de la couleur* (Paris, 1983).

19. For how the study of postmortem inventories benefits historians, see, for example, the impressive survey by A. Pardailhé-Galabrun, *La naissance de l'intime: 3000 foyers parisiens, XVII–XVIII^e siècles* (Paris, 1988). See also B. Garnot, *La Culture matérielle en France aux XVI^e, XVII^e et XVIII^e siècles* (Paris, 1995); B. Garnot, *Société, cultures et genres de vie dans la France moderne (XVI^e–XVIII^e siècle)*, 9th ed., (Paris, 2008).

20. I owe thanks to the friendship and knowledge of Eliane Hartmann, historian of Argenteuil and remarkable specialist in legal documents, for the list of specific examples drawn from postmortem inventories compiled in the seventeenth century in this town outside of Paris. Yellow is mentioned more often in them (fabrics, clothing, furniture, hangings) than in the inventories of the Paris bourgeoisie from the same period, which is, in itself, valuable sociological information with regard to this color.

21. E. Hartmann, "Argenteuil au XVIII^e siècle: Les biens matériels des habitants d'un bourg de l'Ile-de-France à travers les inventaires après-décès," *Mémoires de la Société historique et archéologique de Pontoise, du Val d'Oise et du Vexin* 49 and 50 (2017, 2018).

22. Here again I thank Eliane Hartmann for all this detailed information.

23. On these issues, permit me to cite M. Pastoureau, "Quant les carottes étaient blanches: Les pièges de l'anachronisme dans l'étude des couleurs médiévales," in *L'image en questions: Pour Jean Wirth*, ed. F. Elsig et al. (Geneva, 2013), 263–87.

24. M. Pastoureau, *Bleu: Histoire d'une couleur* (Paris, 2000), 114–19.

25. Rigorous studies with figures on the principal treatises and manuals for painters and dyers printed in the sixteenth, seventeenth, and eighteenth centuries would be most welcome here.

26. Aix-en-Provence, Bibliothèque Méjanes, ms. 1389 (old classification number 1328). The manuscript is dated 1692 and its title reads: *Klaer lightende spiegel der verjkonst, waer in tesein is alder handen kleuren van water verfen…* (The enlightened reflection of painting in which all sorts of watercolors are treated …). It contains 370 leaves and measures 160 × 95 mm. The author, A. Boogaert of Delft, whose name is inscribed on the first leaf, is otherwise unknown.

27. Although, fortunately, an online version does exist: http://bibliotheque-numerique.citedulivre-aix.com/idurl/1/35315.

28. The color chart adds another 108 pages of introduction and various texts to these constituent 632 pages.

29. On blue in the Age of Enlightenment, see Pastoureau, *Bleu*, 123–40.

30. A. Furetière, *Dictionnaire universel contenant généralement tous les mots françois, tant vieux que modernes, et les terms de toutes les sciences et les arts…* (Amsterdam, 1690). On this author, a pioneer in many respects because he was not content to inventory just words but included "things" as well, see A. Rey, *Antoine Furetiére (1619-1688): Un précurseur des Lumières sous Louis XIV* (Paris, 2006).

31. Despite a short interlude, the period 1740–80, when "Nankin" yellow (yellow containing a bit of white) was fashionable for furnishings and women's clothing among the wealthier social classes.

32. Furetière, *Dictionnaire universel*, vol. 1, 301.

33. Furetière, *Dictionnaire universel*, vol. 1, 302.

34. Académie française, *Dictionnaire (Dictionnaire de l'Académie françoise dédié au Roy)*, 1st ed. (Paris, 1694), 218.

35. The terms *rubor, viriditas, nigritia, candor, albedo* exist in classical Latin as well as in medieval Latin; their figurative meanings appear there more frequently than their proper meanings (the color red, green, black …). The word *flavor* is rare in classical Latin (it is found only in poetry) and only designates the scent of flowers, not the color yellow; it is unknown in medieval Latin. On these questions, see A. M. Kristol, *Color: Les langues romanes devant le phénomène de la couleur* (Berne, 1978); L. de Saussure, *Des mots et des couleurs: Essai de linguistique* (Paris, 2017).

36. See, for example, several works in French reprinted or reissued many times throughout the eighteenth century: C. A. Dufresnoy, *L'Art de peinture*, ed. and trans. R. de Piles (Paris, 1673); J. B. Corneille, *Les premiers éléments de la peinture pratique…* (Paris, 1684); R. de Piles, *Cours de peinture par principes* (Paris, 1708); M. F. Dandré-Bardon, *Traité de peinture, suivi d'un Essai sur la sculpture* (Paris, 1765); R. H. Lucien, *L'art du peintre, doreur, vernisseur…* (Paris, 1773); P. R. Chaperon, *Traité de la peinture au pastel…* (Paris, 1788).

37. On the *Encyclopédie*, amid an abundant and often high-quality bibliography, for a good introduction, see R. Darnton, *L'aventure de l'Encyclopédie: Un best seller au XVIII^e siècle* (Paris, 1982); J. Proust, *Diderot et l'Encyclopédie*, 2nd ed. (Paris, 2001); M. Groult, *L'encyclopédie ou la création des disciplines* (Paris, 2003).

38. Vol. 7 (Paris, 1757), 156, cols. a, b.

39. England: 1600; Netherlands: 1602; France: 1664; later, Sweden: 1731. See M. Morineau, *Les grandes compagnies des Indes orientales* (Paris, 1999); R. Favier, *Les Européens et les Indes orientales au XVIII^e siècle: Aspects maritimes et commerciaux* (Paris, 2000); P. Haudrère, *Les compagnies des Indes orientales: Trois siècles de rencontres entre Orientaux et Occidentaux* (Paris, 2005).

40. *Les six voyages de Jean-Baptiste Tavernier, écuyer, baron d'Aubonne…* (Paris, 1676); new ed., by G. Monfert (Paris, 2004).

41. F. Tinguely, ed., *Un libertin dans l'Inde moghole: Les voyages de François Bernier*

(1656-1669), Édition intégrale (Paris, 2008). François Bernier seems to be the first author who, following his travels, established a classification of "human races" according to skin color. See P. H. Boulle, *Race et esclavage dans France d'Ancien Régime* (Paris, 2007).

42. *Journal du voyage du chevalier Chardin en Perse* (Amsterdam, 1686). On Jean Chardin (1643-1713), see D. Van der Cruysse, *Chardin le Persan* (Paris, 1998).

43. Peter Mundy made many trips to India, China, and Japan. His journals and abundant travel notes are now held in London in the collections of the British Library (ms. Harleian 2286 and Add. 19278-19280). The many color notations found there are particularly instructive.

44. R. Knox, *An Historical Relation of the Island Ceylon in the Oriental Indies* (London, 1681); N. Manucci, *Storia do Mogor*, memoir written between 1698 and 1708 and not published until the twentieth century. Most recent edition by Piero Falchetta (Milan, 1986).

45. J. D. Spence, *La Chine imaginaire: Les Chinois vu par les Occidentaux de Marco Polo à nos jours* (Montreal, 2001), 97-115.

46. That is the case with many articles in the *Dictionnaire philosophique* (1764), or even earlier in *L'Orphelin de la Chine* (1755), as well as in *L'Épître au roi de la Chine sur son recueil de vers qu'il a fait imprimer* (1771).

47. Four vols. (Paris, 1735).

48. Four vols. (Paris, 1735), passim. On the Jesuits in China: G. Soulié de Morant, *L'épopée des Jésuites français en Chine* (Paris, 1928); C. E. Ronan et al., *East Meets West: The Jesuits in China, 1582-1773* (Chicago, 1988).

49. The expression *Grande Siècle* is a particularly poor choice for describing the seventeenth century. There was, in fact, a dark, dirty, and wretched underside to the gilded splendor of life at court, and this was true throughout Europe, from the beginning of the Thirty Years' War until just about 1715. See the pioneering work by F. Gaiffe, *L'envers du Grand Siècle: Étude historique et anecdotique* (Paris, 1924).

50. On these expressions and a few others from the 1780s, see the catalog of the exhibition, *Modes et révolutions, 1780-1804* (Paris, Palais Galliera, February–May 1989); M. Sapori, *Rose Bertin: La couterière de Marie-Antoinette* (Paris, 2003); C. Guennec, *La modiste de la reine* (Paris, 2004).

51. A. Bouhdiba, "Les Arabes et la couleur," *Cahiers de la Méditerranée* 20-21 (1980): 63-77.

52. A. Bieler, "Les couleurs dans *Salammbô*," *Les Amis de Flaubert* 21 (1962): 18-26; R. Dugan, "La couleur et le faux dynamisme dans Salammbô de Gustave Flaubert," in *Essai sur Flaubert en l'honneur du professeur Don Demorest* (Paris, 1979), 331-44.

53. The work was translated into French by Frédéric-Charles Chardel in 1804, under the title *De l'unité du genre humain et de ses variétés*. It responds to many questions on the human races published by Emmanuel Kant between 1775 and 1788.

54. A few controversial works claim that originally Blumenbach thought that the Caucasian race was superior to the others and the Ethiopian race inferior; supposedly, it was a love affair that he had with "a beautiful black woman" that convinced him otherwise. This is a matter of legend.

55. A. de Gobineau, *Essai sur l'inégalité des races humaines*, 4 vols. (Paris, 1853-55). Among the many critics of Gobineau's book, which claimed "to enter history into the natural sciences," see J. A. Firmin, *De l'égalité des races humaines: Anthropologie positive* (Paris, 1885).

56. On the first "*croisière jaune*" automobile expedition in 1931-32, see E. Deschamps, *La croisière jaune: Chroniques, 1929-1933* (Paris, 2003); P. Gourlay, *Regards sur la croisière jaune* (Brest, 2004); J. Reynolds, *André Citroën, ingénieur, entrepreneur, explorateur* (Paris, 2006).

57. Each ring represents one continent and possesses its color: red for America, yellow for Asia, black for Africa, blue for Europe, and green for Oceania. The first three colors seem to have been chosen (by whom?) according to more or less ethnic considerations (and also perhaps slightly racist ones): red for the continent of the redskins, yellow for that of the yellow peoples, and black for that of the blacks. The other two colors, though, are trickier to interpret. Blue, associated with Europe, appears to be an old cultural legacy; blue has been Europe's favorite color since the eighteenth century, and it is also the color other non-European cultures use to symbolize it. Moreover, in 1912-13, white was not available for the European ring because it was already reserved for the background color of the future Olympic flag. Thus, blue for Europe. But where does the green for Oceania come from? Why this association? What was it meant to signify? Oceania has no special relationship, either natural or cultural, to this color. There are not abundant forests there, and neither indigenous nor later colonial traditions attribute special value to green. Subsequently, of course, attempts have been made to rationalize this association of green with Oceania through various explanations, but, as with all *a posteriori* explanations, these are flimsy if not fallacious.

58. M. Pastoureau, "La Réforme et la couleur," article cited (note 4).

59. In French fashion, an adage dating from the Second Empire would not disappear until a century later: "Yellow is the make-up of brunettes." Conversely, in fashionable society of the Belle Époque, the worst treachery or vengeance a brunette could take on a rival blond was to dress in yellow and sit beside her.

60. E. Heller, *Psychologie de la couleur: Effets et symbolique* (Paris, 2009), 4 and passim.

61. J.-P. Rioux, "Prolétaires de droite: Les syndicats jaunes," *L'Histoire* 4 (1978): 77-82; M. Tournier, "Les "Jaunes": Un mot-fantasme à la fin du XIX siècles," *Mot* 8 (March 1984): 125-46; M. Agulhon, "Les couleurs dans la politique française," *Ethnologie française* 20, no. 4 (1990): 391-98; C. Maillard, *Un syndicalisme impossible? L'aventure oubliée des Jaunes* (Paris, 2016).

62. Until 1917 in the Russian Empire, certain Jewish women, confined, as all Jews were, to one

231

residential zone (in the west, near the central European powers), deliberately requested "yellow passports," the ones reserved for prostitutes, in order to circulate more freely and especially to go to Moscow or Saint Petersburg.

63. J. Dubois, "Le crime de Jean Valjean et le châtiment de Javert," in *Crime et châtiment dans le roman populaire de langue française du XIX^e siècle*, ed. E. Constans and J.-C. Vareille (Limoge, 1994), 321–34.

64. Heller, *Psychologie de la couleur*, 76. The expression "yellow house" to refer to an insane asylum was still in use in the twentieth century in certain countries and languages. Thus in 1989 (the year it was released in France), the film by Joao Cesar Monteiro, *Souvenirs de la maison jaune*, told the story of a man who, following a vague attempt at indecent assault, spent time in a lunatic asylum in Lisbon. On the other hand, the famous "Yellow House" painted by Vincent van Gogh in Arles (Place Lamartine) in 1888 was not an insane asylum, as has sometimes been claimed, but simply a house where he rented a four-room apartment in the autumn of that year. Paul Gauguin lived there with him for part of that time. The painting is found today at the Van Gogh Museum in Amsterdam.

65. See the fine study by Véronique Bui, "Le châle jaune des prostituées au xixe siècle: Signe d'appartenance ou signe de reconnaissance?" *Fabula: Les colloques*, online: http://www.fabula .org/colloques/document939.php.

66. J. Barbey d'Aurevilly, *Les Diaboliques*, ed. J.-P. Seguin (Paris, 1967), 283–85 ("La vengeance d'une femme").

67. A. Parent-Duchâtelet, *De la Prostitution dans la ville de Paris considérée sous le rappart de l'hygiène publique, de la morale et de l'administration*, vol. 1 (Paris, 1995), 341–42. See also G. Sabatier, *Histoire de la législation sur les femmes publiques et les lieux débauche*, 2nd ed. (Paris 1830); A. Corbin, *Les filles de noce: Misère sexuelle et prostitution au XIX^e siècle* (Paris, 1982).

68. For example, the Yellow Dwarf parlor game that appeared in the eighteenth century and for which the first rules were published in the weekly review *L'Avantcoureur* 41, on Monday, October 27, 1760.

69. Heller, *Psychologie de la couleur*, 72 (letter from Vincent to Théo from March 1888).

70. Heller, *Psychologie de la couleur*, 78.

71. See M. Pastoureau, *Vert: Histoire d'une couleur* (Paris, 2013), 200–203.

72. P. Ball, *Histoire vivantes des couleurs: 5000 ans de peinture racontées par les pigments* (Paris, 2000), 364–66.

73. See G. Rogue, *Art et science de la couleur: Chevreul et les peintres, de Delacroix à l'abstraction*, 2nd ed. (Paris, 2009), passim.

74. This pointillist painting of huge dimensions (more than 2 × 3 m) was painted partially en plein air on the Grande Jatte island itself (located in the Seine between Courbevoie, Levallois, and Neuilly) between May 1884 and October 1885. It was first shown at the eighth impressionist exhibition in 1886. It is now held at the Chicago Art Institute.

75. C. Blanc, *Grammaire des arts du dessin: Architecture, sculpture, peinture, jardins, gravure en pierres fines, gravure en médailles, gravures en taille-douce…* (Paris, 1867), 601–16. In 1882, the year of the author's death, the work was already in its sixth edition.

76. This phrase is attributed to Pierre Francastel, quoted in a letter from André Derain to Max Jacob, but I have not found the exact reference for it.

77. On the fauvists and color: J.-L. Chalumeau, *Fauvisme* (Paris, 1996); S. Pagé et al., *Le fauvisme ou l'épreuve du feu* (Paris and Arles, 1999); R. Labrusse and J. Munck, *Matisse-Derain: La vérité du fauvisme* (Paris, 2005); C. Jeancolas, *L'art fauve* (Paris, 2006).

78. In classical and medieval Latin, to name a shade that corresponds to our orange, one had to be content with a few approximations: *croceus* (saffron yellow), *aureus* (the color of gold), *flammeus* (yellow or red like fire), *russus* (between red and yellow, but closer to red), *rufus* (between red, yellow, and brown). In vernacular languages, this was an even more difficult exercise until the beginning of modern times.

79. M. Pastoureau, *Rouge: Histoire d'une couleur* (Paris, 2016), 102–7 and passim.

80. The French adjective *orangé* made its appearance in the sixteenth century and did not become a noun until the following century. It obviously derives from the name of the fruit, which, until the late Middle Ages, existed only as the phrase *pomme d'orenge*. The name *orenge*, used alone, became common in about the mid-sixteenth century, but it designated the fruit, not yet the color. Let us note that no shared etymology exists between *or* (gold) and *orange*. The French *or* (the metal) comes directly from the Latin *aurum*; the word *orange* has a much more convoluted history. In the first place, the expression *pomme d'orenge*, attested as early as the thirteenth century, was copied from the Tuscan *melarancia*, which may itself have come from the Arabic *narandja*. This term was used for the bitter orange, the only one known in the West, more decorative than edible. But in the fifteenth century, the Portuguese and then the Spanish introduced the sweet orange into western Europe, which was sometimes called a "Chinese apple," since it came from Asia. To designate this new sweeter and mellower fruit, French finally dropped the "apple" (*pomme*) and kept only the "orange" (*orange*) with an "a." This new spelling was perhaps based on the Spanish *naranja*.

81. The term *orange*, either for the fruit or the color, bears no etymological relationship to the proper noun Orange (Latin: *Arausio*), a town now located in Vaucluse. In addition to that town, this name has also belonged to a principality and a dynasty—the House of Orange—which played an important role in the political history of the United Provinces and which still reigns today in the Netherlands. Because the name of the color and the dynasty are homonyms, the dynasty was compelled to adopt orange as its emblematic and political color beginning in the second half of the sixteenth century.

82. P. Cournu, *Dictionnaire encyclopédique du bouddhisme* (Paris, 2006), 235–36.

83. Among the studies in French on the 2004 Ukrainian revolution, let us cite: A. Guillemoles, *Même la neige était orange: La révolution ukrainienne* (Lyon, 2005); E. Thévenin, *L'enjeu ukrainien: Ce que révèle la révolution orange* (Paris, 2005); B. Cadène, *L'Ukraine en révolution* (Paris, 2005).

84. In French today, when we speak of the color, should we say *orange* or *orangé*? The opinions of lexicologists and grammarians are divided here. The most extreme lexicologists and grammarians caution never to use the word *orange* to mean the color, whether as an adjective or a noun, in order to avoid any confusion; according to this view, it should be reserved for the fruit. Others allow the use of the word *orange* when it is a matter of the color, but only as an (invariable) adjective, never as a noun. Thus, writing "*elle possédait dans sa garde-robe plusieurs chemisiers orange*" ("her wardrobe included many orange blouses") would be correct. But saying "*le peintre employait trois couleurs seulement: le rouge, le jaune et l'orange*" (the painter used only three colors: red, yellow, and orange") would not be correct; you would have to say, "*le rouge, le jaune et l'orangé.*" A few language specialists are more tolerant and permit both *orange* and *orangé* as color terms, either as adjective or noun. Only *orangé*, however, when it is an adjective, agrees in gender and number with the noun it modifies; *orange* is always invariable. Such grammatical and orthographical questions are that much harder to avoid since these color terms have no true synonyms. What if, instead of saying simply "*orangé*," I said "apricot," "pumpkin," "saffron," "tan"? In doing so, I would open such an expanded field of connotation that the color would shift to another level.

85. M. Pastoureau, "Couleur et design: Histoire d'un rendez-vous manqué," in *Design, miroir du siècle*, ed. J. Noblet, exhibition catalog (Paris, Grand Palais, May–July 1993), 207–16.

86. In France, for example, the Saint-Étienne and Nantes soccer clubs were founded more recently than other major professional clubs: Saint-Étienne in 1933, Nantes in 1943. That is probably why their teams wear green and yellow jerseys, respectively, and not blue or white like many others.

87. Restricting ourselves to track and field, let us mention here Jamaica's extraordinary victory in the Men's 400 Meter Relay Race at the Helsinki Olympics in 1952. The exceptional time achieved by the four runners (Arthur Wint, Leslie Laing, Herb McKenley, and George Rhoden) was considered at the time one of the greatest feats in sports history: 3 minutes, 3.9 seconds, shattering the previous record set in 1932. Their jerseys were yellow, worn with black shorts lined with yellow.

88. Amid an overabundant bibliography, see especially B. and C. McGann, *The Story of the Tour de France*, vol. 1: *How a Newspaper Promotion Became the Greatest Sporting Event in the World* (Glasgow, 2006), 47–56; P. Chany, *La fabuleuse histoire du cyclisme*, vol. 1: *Des origines à 1955* (Paris, 1988), 123 and following; J.-P. Ollivier, *Maillot jaune* (Paris, 2004), passim; J.-P. Bourgier, *1919: Le Tour renaît de l'enfer; De Paris-Roubaix au premier maillot jaune* (Toulouse, 1994).

89. J.-P. Rey, *Eugène Christophe, le damné de la route* (Pau, 2013); J. Seray and R. Jessic, *Eugène Christophe: De la forge de Sainte-Marie de Campan au maillot jaune* (Betpouey, 2014).

90. C. O'Brien, *Il Giro d'Italia: Una storia di passione, eroismo et fatica* (Milan, 2017); P. Colombo and G. Lanotte, *La corsa di secolo* (Milan, 2017).

91. Heller, *Psychologie de la couleur*, 71–86.

92. The yellow star has generated a considerable bibliography but has rarely been studied for itself, as object and insignia of exclusion and infamy. See especially G. Kisch, "The Yellow Badge in History," *Historia Judaica* 19 (1957): 89–144; J. J. Scheiner, *Vom gelben Flicken zum Judenstern? Genese und Applikation von Judenabzeichen im Islam und christlichen Europa (841-1941)* (Frankfurt am Main, 2004); G. Schönberner, *Das gelbe Stern: Die Judenverfolgung in Europa, 1933-1945*, 2nd ed. (Stuttgart, 1998); L. Poliakov, *L'étoile jaune* (Paris, 1999).

93. On the Thurn and Taxis family, creators of the modern taxi and postal service: J. Rübsam, *Johann Baptista von Taxis* (Freiburg im Breisgau, 1889); F. Ohmann, *Die Anfänge des Postwesens und die Taxis* (Leipzig, 1909); M. Dallmeier, *Quellen zur Geschichte des europäischen Postwesens* (Kallmünz, 1977); W. Behringer, *Thurn und Taxis: Die Geschichte ihrer Post und ihrer Unternehmen* (Munich and Zurich, 1990).

94. Let us note that in the United States, with regard to modern taxis, the color yellow was chosen by many companies (in Chicago in 1915, in New York in the 1920s) not as an allusion or homage to the old horse-drawn taxis of the Thurn and Taxis family, but with the idea that it was the color that could best be seen from a distance in the dirty, dense smog of urban streets. Other cities and other countries gradually imitated the American example, to the point that now, in much of the world, a taxi is a yellow vehicle. Most etymological dictionaries explain the origin of the word "taxi" by the fact that this vehicle is equipped with a "taximeter," a device to calculate the "tax" that the client who has been transported must pay. An ingenious explanation, based on the ancient Greek *taxis* (arrangement, disposition), but leaving out the Thurn and Taxis family, indisputable creators of the original horse-drawn "taxis." That link between the proper name and common noun seems obvious to me. In the family name, the second term, *Taxis*, was originally a toponym, sometimes written *Tassis* and probably constructed from the name of the yew tree (Latin *taxus*; Italian *tasso*). The family's oldest castle was indeed built in Lombardy, near Bergamo, on Mount Tasso (meaning "the hill of yew trees").

95. Nevertheless, see the works of Jean-Philippe Lenclos: *Couleurs du monde* (Paris, 1999); *Fenêtres du monde* (Paris, 2001); *Colors of the World* (New York, 2004); *Doors of the World* (London, 2005).

96. Originally, the FDP sometimes combined yellow and blue, and even green. Created

232

in 1948, this is a liberal party whose electoral importance remains modest though it plays something of a secondary role in the subtle games of government alliances; it defends free trade and fundamental liberties, but at the same time, it is not the enemy of certain reasonable intervention by the welfare state.

97. See the figures published recently by Eva Heller and discussed color by color in the work cited above: Heller, *Psychologie de la couleur*, 4 and passim. For figures from older studies, see the various editions (with statistics in each new edition) of the books by Faber Birren, *Selling Color to People* (first edition: New York, 1956) and *Selling with Color* (latest edition: New York, 2017).

98. The methods used to conduct such polls have hardly changed over the decades: stopping passers-by in the street and simply asking them, "What is your favorite color?" In order to be valid and included in the count, the answer must be clear and spontaneous; one true color name, not two or three, no adjectives describing the shade, absolutely no quibbling or hairsplitting about whether the question involves clothing, furnishings, paint, and so on. It is a simple, direct question and must be answered in a simple, direct manner. What counts is not some practical experience of the color or its material aspect, but how it exists in the imagination, the idea of the color, as it were.

99. European results largely reflect those in most countries of the Western world: United States, Canada, Australia, and New Zealand. Elsewhere, on the other hand, they are entirely different. In Japan, for example, white is first, followed by red, black, and pink; in China, red come first, followed by yellow and blue; in the Indies and Indo-Chinese peninsula, pink and orange are more popular than in Europe, whereas blue is not much liked. As for the populations of Africa and central Asia, they sometimes have difficulty accepting the parameters of color as defined by Western culture (tone, value, saturation). For a given color, it is sometimes more important to know if it is dry or moist, soft or hard, smooth or rough, than to decide if it is part of the range of reds, blues, or yellows. Color is not really something in itself, much less a phenomenon relevant only to vision. It is perceived in conjunction with other sensory parameters, and, accordingly, "European" studies on the notions of favorite or unpopular colors have little significance. On this important issue, see S. Torney, ed., *Voir et nommer les couleurs* (Nanterre, 1979). These differences between societies are fundamental because they highlight the strictly cultural nature of all aspects of color. They undermine the absolute nature of the so-called truths expounded by Western science (the spectrum, the chromatic wheel, primary colors, complementary colors, the law of simultaneous contrast, and so on) and invite great caution in matters of comparative studies. Like ethnologists, historians and sociologists must take them into account.

100. More surprising still in the results provided by such studies: they are the same for men and women, for all age groups, and for most socio-professional categories. Only young children show some diversity in exhibiting a greater preference for red, almost as popular as blue, and for yellow, much less unpopular than among adults. See M. Pastoureau, *Les Couleurs de nos souvenirs* (Paris, 2010), 204–9.

233

BIBLIOGRAPHY

GENERAL WORKS

Berlin, Brent, and Paul Kay. *Basic Color Terms: Their Universality and Evolution.* Berkeley, CA, 1969.

Birren, Faber. *Color: A Survey in Words and Pictures.* New York, 1961.

Brusatin, Manlio. *Storia dei colori.* 2nd ed. Turin, 1983. Translated as *Histoire des couleurs*, Paris, 1986.

Conklin, Harold C. "Color Categorization." *American Anthropologist* 75, no. 4 (1973): 931–42.

Eco, Renate, ed. "Colore: Divietti, decreti, discute." Special number of *Rassegna* (Milan) 23 (September 1985).

Gage, John. *Colour and Culture: Practice and Meaning from Antiquity to Abstraction.* London, 1993.

Heller, Eva. *Wie Farben wirken: Farbpsychologie, Farbsymbolik, Kreative Farbgestaltung.* 2nd ed. Hamburg, 2004.

Indergand, Michel, and Philippe Fagot. *Bibliographie de la couleur.* 2 vols. Paris, 1984–88.

Meyerson, Ignace, ed. *Problèmes de la couleur.* Paris, 1957.

Pastoureau, Michel. *Bleu: Histoire d'une couleur.* Paris, 2000.

———. *Noir: Histoire d'une couleur.* Paris, 2007.

———. *Dictionnaire des couleurs de notre temps: Symbolique et société.* 4th ed. Paris, 2007.

———. *Vert: Histoire d'une couleur.* Paris, 2013.

———. *Rouge: Histoire d'une couleur.* Paris, 2016.

Portmann, Adolf, and Rudolf Ritsema, eds. *The Realms of Colour: Die Welt der Farben.* Leiden, 1974. (*Eranos Yearbook*, 1972).

Pouchelle, Marie-Christine, ed. "Paradoxes de la couleur." Special number of *Ethnologie française* (Paris) 20, no. 4 (October–December, 1990).

Rzepinska, Maria. *Historia coloru u dziejach malatstwa europejskiego.* 3rd ed. Warsaw, 1989.

Tornay, Serge, ed. *Voir et nommer les couleurs.* Nanterre, 1978.

Valeur, Bernard. *La Couleur dans tous ses états.* Paris, 2011.

Vogt, Hans Heinrich. *Farben und ihre Geschichte.* Stuttgart, 1973.

Zahan, Dominique. "L'homme et la couleur." In *Histoire des mœurs*, ed. Jean Poirier, vol. 1, *Les Coordonnées de l'homme et la culture matérielle*, 115–80. Paris, 1990.

Zuppiroli, Libero, ed. *Traité des couleurs.* Lausanne, 2001.

Antiquity and the Middle Ages

Beta, Simone, and Maria Michela Sassi, eds. *I colori nel mondo antiquo: Esperienze linguistiche e quadri simbolici.* Siena, 2003.

Bradley, Mark. *Colour and Meaning in Ancient Rome.* Cambridge, 2009.

Brinkmann, Vinzenz, and Raimund Wünsche, eds. *Bunte Götter: Die Farbigkeit antiker Skulptur.* Munich, 2003.

Brüggen, Elke. *Kleidung und Mode in der höfischen Epik.* Heidelberg, 1989.

Carastro, Marcello, ed. *L'Antiquité en couleurs: Catégories, pratiques, représentations*, 187–205. Grenoble, 2008.

Cechetti, Bartolomeo. *La vita dei Veneziani nel 1300: Le veste.* Venice, 1886.

Centre Universitaire d'Études et de Recherches Médiévales d'Aix-en-Provence. *Les Couleurs au Moyen Âge. Senefiance*, vol. 24. Aix-en-Provence, France, 1988.

Ceppari Ridolfi, Maria A., and Patrizia Turrini. *Il mulino delle vanità: Lusso e cerimonie nella Siena medievale.* Siena, 1996.

Descamps-Lequime, Sophie, ed. *Couleur et peinture dans le monde grec antique.* Paris, 2004.

Dumézil, Georges. "*Albati, russati, virides.*" In *Rituels indoeuropéens à Rome*, 45–61. Paris, 1954.

Frodl-Kraft, Eva. "Die Farbsprache der gotischen Malerei: Ein Entwurf." *Wiener Jahrbuch für Kunstgeschichte* 30–31 (1977–78): 89–178.

Grand-Clément, Adeline. *La Fabrique des couleurs: Histoire du paysage sensible des Grecs anciens.* Paris, 2011.

Haupt, Gottfried. *Die Farbensymbolik in der sakralen Kunst des abendländischen Mittelalters.* Leipzig, 1941.

Istituto Sorico Lucchese. *Il colore nel Medioevo: Arte, simbolo, tecnica; Atti delle Giornate di studi.* 2 vols. Lucca, 1996–98.

Luzzatto, Lia, and Renata Pompas. *Il significato dei colori nelle civiltà antiche.* Milan, 1988.

Pastoureau, Michel. *Figures et couleurs: Études sur la symbolique et la sensibilité médiévales.* Paris, 1986.

———. "L'Église et la couleur des origines à la Réforme." *Bibliothèque de l'École des chartes* 147 (1989): 203–30.

———. "Voir les couleurs au xiiie siècle." In *View and Vision in the Middle Ages*, 2: 147–65. *Micrologus: Nature, Science and Medieval Societies*, vol. 6. Florence, 1998.

234

Rouveret, Agnès. *Histoire et imaginaire de la peinture ancienne*. Paris, 1989.

Rouveret, Agnès, Sandrine Dubel, and Valérie Naas, eds. *Couleurs et matières dans l'Antiquité: Textes, techniques et pratiques*. Paris, 2006.

Sicile, héraut d'armes du xve siècle. *Le Blason des couleurs en armes, livrées et devises*. Ed. H. Cocheris. Paris, 1857.

Tiverios, Michales A., and Despoina Tsiafakis, eds. *The Role of Color in Ancient Greek Art and Architecture (700–31 B.C.)*. Thessaloniki, 2002.

Villard, Laurence, ed. *Couleur et vision dans l'Antiquité classique*. Rouen, 2002.

Modern and Contemporary Times

Batchelor, David. *La Peur de la couleur*. Paris, 2001.

Birren, Faber. *Selling Color to People*. New York, 1956.

Brino, Giovanni, and Franco Rosso. *Colore e città: Il piano del colore di Torino, 1800–1850*. Milan, 1980.

Laufer, Otto. *Farbensymbolik im deutschen Volksbrauch*. Hamburg, 1948.

Lenclos, Jean-Philippe, and Dominique Lenclos. *Les Couleurs de la France: Maisons et paysage*. Paris, 1982.

———. *Les Couleurs de l'Europe: Géographie de la couleur*. Paris, 1995.

Noël, Benoît. *L'Histoire du cinéma couleur*. Croissy-sur-Seine, 1995.

Pastoureau, Michel. "La Réforme et la couleur." *Bulletin de la Société d'histoire du Protestantisme français* 138 (July–September 1992): 323–42.

———. "La couleur en noir et blanc (XVe–XVIIIe siècle)." In *Le Livre et l'Historien: Études offertes en l'honneur du Professeur Henri-Jean Martin*, 197–213. Geneva, 1997.

———. *Les Couleurs de nos souvenirs*. Paris, 2010.

PROBLEMS OF PHILOLOGY AND TERMINOLOGY

André, Jacques. *Étude sur les termes de couleurs dans la langue latine*. Paris, 1949.

Brault, Gerard J. *Early Blazon: Heraldic Terminology in the XIIth and XIIIth Centuries, with Special Reference to Arthurian Literature*. Oxford, 1972.

Crosland, Maurice P. *Historical Studies in the Language of Chemistry*. London, 1962.

Giacolone Ramat, Anna. "Colori germanici nel mondo romanzo." *Atti e memorie dell'Academia toscana di scienze e lettere La Colombaria* (Florence) 32 (1967): 105–211.

Gloth, Walther. *Das Spiel von den sieben Farben*. Königsberg, 1902.

Grossmann, Maria. *Colori e lessico: Studi sulla struttura semantica degli aggettivi di colore in catalano, castigliano, italiano, romano, latino ed ungherese*. Tübingen, 1988.

Irwin, Eleanor. *Colour Terms in Greek Poetry*. Toronto, 1974.

Jacobson-Widding, Anita. *Red-White-Black, as a Mode of Thought*. Stockholm, 1979.

Jacquesson, François. "Les mots de la couleur en hébreu ancien." In *Histoire et géographie de la couleur*, edited by P. Dollfus, F. Jacquesson, and M. Pastoureau, vol. 13, *Cahiers du Léopard d'or*, 67–130. Paris, 2013.

Jones, William Jervis. *German Colour Terms: A Study in Their Historical Evolution from Earliest Times to the Present*. Amsterdam, 2013.

Kristol, Andres M. *Color: Les Langues romanes devant le phénomène de la couleur*. Berne, 1978.

Maxwell-Stuart, P. G. *Studies in Greek Colour Terminology*, vol. 2: XAPOIIOE. 2 vols. Leiden, 1998.

Meunier, Annie. "Quelques remarques sur les adjectifs de couleur." *Annales de l'Université de Toulouse* II, no. 5 (1975): 37–62.

Mollard-Desfour, Annie. *Le Dictionnaire des mots et expressions de couleur*. 7 vols. Paris, 2000–2015.

Ott, André. *Études sur les couleurs en vieux français*. Paris, 1899.

Schäfer, Barbara. *Die Semantik der Farbadjektive im Altfranzösischen*. Tübingen, 1987.

Sève, Robert, Michel Indergand, and Philippe Lanthony. *Dictionnaire des termes de la couleur*. Paris, 2007.

Wackernagel, Wilhelm. "Die Farben- und Blumensprache des Mittelalter." In *Abhandlungen zur deutschen Altertumskunde und Kunstgeschichte*, 143–240. Leipzig, 1872.

Wierzbicka, Anna. "The Meaning of Color Terms: Cromatology and Culture." *Cognitive Linguistics* I, no. I (1990): 99–150.

THE HISTORY OF DYES AND DYERS

Brunello, Franco. *L'arte della tintura nella storia dell'umanita*. Vicenza, 1968.

———. *Arti e mestieri a Venezia nel medioevo e nel Rinascimento*. Vicenza, 1980.

Cardon, Dominique. *Mémoires de teinture: Voyage dans le temps chez un maître des couleurs*. Paris 2013.

———. *Le Monde des teintures naturelles*. Paris, 1994.

Cardon, Dominique, and Gaëtan Du Châtenet. *Guide des teintures naturelles*. Neuchâtel and Paris, 1990.

Chevreul, Michel Eugène. *Leçons de chimie appliquées à la teinture*. Paris, 1829.

Edelstein, Sidney M., and Hector C. Borghetty. *The "Plictho" of Giovan Ventura Rosetti*. London and Cambridge, MA, 1969.

Gerschel, Lucien. "Couleurs et teintures chez divers peuples indo-européens." *Annales ESC* 21 (1966): 608–63.

Hellot, Jean. *L'Art de la teinture des laines et des étoffes de laine en grand et petit teint*. Paris, 1750.

Jaoul, Martine, ed. *Des teintes et des couleurs*. Exhibition catalog. Paris, 1988.

Lauterbach, Fritz. *Geschichte der in Deutschland bei der Färberei angewandten Farbstoffe, mit besonderer Berücksichtigung des mittelalterlichen Waidblaues*. Leipzig, 1905.

Legget, William F. *Ancient and Medieval Dyes*. New York, 1944.

Lespinasse, René de. *Histoire générale de Paris: Les métiers et corporations de la ville de Paris*. Vol. 3, *Tissus, étoffes. . . .* Paris, 1897.

Pastoureau, Michel. *Jésus chez le teinturier: Couleurs et teintures dans l'Occident médiéval*. Paris, 1998.

Ploss, Emil Ernst. *Ein Buch von alten Farben: Technologie der Textilfarben im Mittelalter*. 6th ed. Munich, 1989.

Rebora, Giovanni. *Un manuale di tintoria del Quattrocento*. Milan, 1970.

Varichon, Anne. *Couleurs: Pigments et teintures dans les mains des peuples*. 2nd ed. Paris, 2005.

THE HISTORY OF PIGMENTS

Ball, Philip. *Histoire vivante des couleurs: 5000 ans de peinture racontée par les pigments*. Paris, 2005.

Bomford, David, et al. *Art in the Making: Italian Painting before 1400*. London, 1989.

———. *Art in the Making: Impressionism*. London, 1990.

Brunello, Franco. *"De arte illuminandi" e altri trattati sulla tecnica della miniatura medievale*. 2nd ed. Vicenza, 1992.

Feller, Robert L., and Ashok Roy. *Artists' Pigments: A Handbook of Their History and Characteristics*. 2 vols. Washington, DC, 1985–86.

Guineau, Bernard, ed. *Pigments et colorants de l'Antiquité et du Moyen Âge*. Paris, 1990.

Harley, Rosamond D. *Artists' Pigments (c. 1600–1835)*. 2nd ed. London, 1982.

Hills, Paul. *The Venetian Colour*. New Haven, 1999.

Kittel, Hans, ed. *Pigmente*. Stuttgart, 1960.

Laurie, Arthur P. *The Pigments and Mediums of Old Masters*. London, 1914.

Loumyer, Georges. *Les Traditions techniques de la peinture médiévale*. Brussels, 1920.

Merrifield, Mary P. *Original Treatises dating from the XIIth to the XVIIIth Centuries on the Art of Painting*. 2 vols. London, 1849.

Montagna, Giovanni. *I pigmenti: Prontuario per l'arte e il restauro*. Florence, 1993.

Reclams Handbuch der künstlerischen Techniken. Vol. 1, *Farbmittel, Buchmalerei, Tafel- und Leinwandmalerei*. Stuttgart, 1988.

Roosen-Runge, Heinz. *Farbgebung und Technik frühmittelalterlicher Buchmalerei*. 2 vols. Munich, 1967.

Smith, Cyril S., and John G. Hawthorne. *Mappae clavicula: A Little Key to the World of Medieval Techniques*. Philadelphia, 1974. (*Transactions of the American Philosophical Society* 64/4).

Technè: La science au service de l'art et des civilisations. Vol. 4, *La couleur et ses pigments*. 1996.

Thompson, Daniel V. *The Material of Medieval Painting*. London, 1936.

THE HISTORY OF CLOTHING

Baldwin, Frances E. *Sumptuary Legislation and Personal Relation in England*. Baltimore, 1926.

Baur, Veronika. *Kleiderordnungen in Bayern von 14. bis 19. Jahrhundert*. Munich, 1975.

Boehn, Max von. *Die Mode: Menschen und Moden vom Untergang der alten Welt bis zum Beginn des zwanzigsten Jahrhunderts*. 8 vols. Munich, 1907–25.

Boucher, François. *Histoire du costume en Occident de l'Antiquité à nos jours*. Paris, 1965.

Bridbury, Anthony R. *Medieval English Clothmaking: An Economic Survey*. London, 1982.

Eisenbart, Liselotte C. *Kleiderordnungen der deutschen Städte zwischen, 1350-1700*. Göttingen, 1962.

Harte, N. B., and Kenneth G. Ponting, eds. *Cloth and Clothing in Medieval Europe: Essays in Memory of E. M. Carus-Wilson*. London, 1982.

Harvey, John. *Men in Black*. London, 1995. Translated as *Des hommes en noir: Du costume masculin à travers les âges*. Abbeville, 1998.

Hunt, Alan. *Governance of the Consuming Passions: A History of Sumptuary Laws*. London and New York, 1996.

Lurie, Alison. *The Language of Clothes*. London, 1982.

Madou, Mireille. *Le Costume civil: Typologie des sources du Moyen Âge occidental*, vol. 47. Turnhout, 1986.

Mayo, Janet. *A History of Ecclesiastical Dress*. London, 1984.

Nixdorff, Heide, and Heidi Müller, eds. *Weisse Vesten, roten Roben: Von den Farbordnungen des Mittelalters zum individuellen Farbgeschmack*. Exhibition catalog. Berlin, 1983.

Page, Agnès. *Vêtir le prince: Tissus et couleurs à la cour de Savoie (1427-1447)*. Lausanne, 1993.

Pellegrin, Nicole. *Les Vêtements de la liberté: Abécédaires des pratiques vestimentaires françaises de 1780 à 1800*. Paris, 1989.

Piponnier, Françoise. *Costume et vie sociale: La cour d'Anjou, XIVᵉ–XVᵉ siècles*. Paris and The Hague, 1970.

Piponnier, Françoise, and Perrine Mane. *Se vêtir au Moyen Âge*. Paris, 1995.

Quicherat, Jules. *Histoire du costume en France depuis les temps les plus reculés jusqu'à la fin du XVIIIᵉ siècle*. Paris, 1875.

Roche, Daniel. *La Culture des apparences: Une histoire du vêtement (XVIIᵉ–XVIIIᵉ siècles)*. Paris, 1989.

Roche-Bernard, Geneviève, and Alain Ferdière. *Costumes et textiles en Gaule romaine*. Paris, 1993.

Vincent, John M. *Costume and Conduct in the Laws of Basel, Bern, and Zurich*. Baltimore, 1935.

THE PHILOSOPHY AND HISTORY OF SCIENCE

Albert, Jean-Pierre, et al., eds. *Coloris Corpus*. Paris, 2008.

Blay, Michel. *La Conceptualisation newtonienne des phénomènes de la couleur*. Paris, 1983.

———. *Les Figures de l'arc-en-ciel*. Paris, 1995.

Boyer, Carl B. *The Rainbow from Myth to Mathematics*. New York, 1959.

Goethe, Johann Wolfgang von. *Zur Farbenlehre*. 2 vols. Tübingen, 1810.

———. *Materialen zur Geschichte der Farbenlehre*. 2 vols. Munich, 1971.

Halbertsma, Klaas Tjalling Agnus. *A History of the Theory of Colour*. Amsterdam, 1949.

Hardin, Clyde L. *Color for Philosophers: Unweaving the Rainbow*. Cambridge, MA, 1988.

Lindberg, David C. *Theories of Vision from Al-Kindi to Kepler*. Chicago, 1976.

Magnus, Hugo. *Histoire de l'évolution du sens des couleurs*. Paris, 1878.

Newton, Isaac. *Opticks or a Treatise of the Reflexions, Refractions, Inflexions, and Colours of Light*. London, 1704.

Pastore, Nicholas. *Selective History of Theories of Visual Perception, 1650-1950*. Oxford, 1971.

Sepper, Dennis L. *Goethe contra Newton: Polemics and the Project of a New Science of Color*. Cambridge, 1988.

Sherman, Paul D. *Colour Vision in the Nineteenth Century: The Young-Helmholtz-Maxwell Theory*. Cambridge, 1981.

Westphal, John. *Colour: a Philosophical Introduction*. 2nd ed. London, 1991.

Wittgenstein, Ludwig. *Bemerkungen über die Farben*. Frankfurt am Main, 1979.

THE HISTORY AND THEORIES OF ART

Aumont, Jacques. *Introduction à la couleur: Des discours aux images*. Paris, 1994.

Ballas, Guila. *La Couleur dans la peinture moderne: Théorie et pratique*. Paris, 1997.

Barasch, Moshe. *Light and Color in the Italian Renaissance Theory of Art*. New York, 1978.

Dittmann, Lorenz. *Farbgestaltung und Farbtheorie in der abendländischen Malerei*. Stuttgart, 1987.

Gavel, Jonas. *Colour: A Study of Its Position in the Art Theory of the Quattro- and Cinquecento*. Stockholm, 1979.

Hall, Marcia B. *Color and Meaning: Practice and Theory in Renaissance Painting*. Cambridge, MA, 1992.

Imdahl, Max. *Farbe: Kunsttheoretische Reflexionen in Frankreich*. Munich, 1987.

Kandinsky, Wassily. *Über das Geistige in der Kunst*. Munich, 1912.

Le Rider, Jacques. *Les Couleurs et les mots*. Paris, 1997.

Lichtenstein, Jacqueline. *La Couleur éloquent: Rhétorique et peinture à l'âge classique*. Paris, 1989.

Roque, Georges. *Art et science de la couleur: Chevreul et les peintres de Delacroix à l'abstraction*. Nîmes, 1997.

Shapiro, Alan E. "Artists' Colors and Newton's Colors." *Isis* 85 (1994): 600–630.

Teyssèdre, Bernard. *Roger de Piles et les débats sur le coloris au siècle de Louis XIV*. Paris, 1957.

THE HISTORY OF THE COLOR YELLOW

Antiquity and the Middle Ages

Allard, Jean-Paul. "De l'or des Scythes à l'or du Rhin." *Études indo-européennes* (1999): 67–118.

Daumas, François. "La valeur de l'or dans la pensée égyptienne." *Revue de l'histoire des religions* 149, no. 1 (1956): 1–17.

Kisch, Guido. "The Yellow Badge in History." *Historia Judaica* 19 (1957): 89–146.

Lautier, Claudine. "Les débuts du jaune d'argent dans l'art du vitrail, ou le jaune d'argent à la manière d'Antoine de Pise." *Bulletin monumental* 158, no. 2 (2000): 89–107.

Martin, Elisabeth, and Alain R. Duval. "Les deux variétés de jaune de plomb et d'étain: Étude chronologique." *Studies in Conservation* 35, no. 3 (1990): 117–36.

Mellinkoff, Ruth. "Judas's Red Hair and the Jews." *Journal of Jewish Art* 9 (1982): 31–46.

Moulinier-Brogi, Laurance. *L'Uroscopie au Moyen Âge: "Lire dans un verre la nature de l'homme."* Paris, 2012.

Ortalli, Gherardo. *La Peinture infamante du XIIᵉ au XVIᵉ siècle*. Brionne, 1994.

Pastoureau, Michel. "Formes et couleurs du désordre: Le jaune avec le vert." *Médiévales* (1983): 62–73.

——. "L'homme roux: Iconographie médiévale de Judas." In *Une histoire symbolique de Moyen Âge occidental*, 221–36. Paris, 2004.

Plet, Florence. "Yseut est-elle une vraie blonde?" In *La Chevelure dans la littérature et l'art du Moyen Âge*, ed. C. Connochie-Bourgne, 309–24. Aix-en-Provence, 2004.

Ravid, Benjamin. "From Yellow to Red: On the Distinguishing Head Covering of the Jews of Venice." *Jewish History* 6, no. 1–2 (1992): 179–210.

Rolland-Perrin, Myriam. *Blonde comme l'or: La chevelure féminine au Moyen Âge*. Aix-en-Provence, 2010.

Sansy, Danièle. "Chapeau juif ou chapeau pointu: Esquisse d'un signe d'infamie." In *Symbole des Alltags: Alltag der Symbole: Festschrift für Harry Kühnel*, 349–75. Graz, 1992.

——. "Marquer la différence: L'imposition de la rouelle aux XIIIᵉ et XIVᵉ siècles." *Médiévales* 41 (2001): 15–36.

Turcan, Robert. *Héliogabale et la sacre du soleil*. Paris, 1985.

Wiethold, Julian. "La gaude: Une plante tinctoriale importante de l'époque médiévale et du début de la période moderne." *Les Nouvelles de l'archéologie* 114 (2008): 52–58.

Zaitoun, Caroline. "Vêtement et safran dans le rituel: L'importance de la parure dans la société égéenne." In *Costume et société dans l'Antiquité et le haut Moyen Âge*, edited by F. Chausson and H. Inglebert, 7–25. Paris, 2003.

Modern and Contemporary Times

Bailey, Anthony. *Vermeer: A View of Delft*. New York, 2001.

Bourgeois, Guillaume. "Les soubresauts révolutionnaires des débuts du XXIᵉ siècle: Le temps de l'orange?" In *Vert et orange: Deux couleurs à travers l'histoire*, edited by J. Grévy et al., 185–94. Limoges, 2013.

Bui, Véronique. "Le châle jaune des prostituées au XIXᵉ siècle: Signe d'appartenance ou signe de reconnaissance?" In *Fabula: La recherche en littérature; Signe, déchiffrement, et interprétation*. Online seminar, 2008. https://www.fabula.org/colloques/document939.php.

Doran, Sabine. *The Culture of Yellow, or The Visual Politics of Late Modernity*. London, 2013.

Druich, Douglas W., and Peter K. Zegers. *Van Gogh and Gauguin: The Studio of the South*. Chicago, 2001.

Fauche, Xavier. *Roux et rousses: Un éclat très particulier*. Paris, 1997.

Hickey, Helen. "Medical Diagnosis and the Colour Yellow in Early Modern England." *Erea* 12, no. 2 (2015): http://journals.openedition.org/erea/4413; DOI: 10.4000/erea.4413.

Lanoé, Catherine. *La Poudre et le Fard: Une histoire des cosmétiques de la Renaissance aux Lumières*. Seyssel, 2008.

Lazlo, Pierre. *Citrus: A History*. Chicago, 2008.

Maillard, Christophe. *Un syndicalisme impossible? L'aventure oubliée des Jaunes*. Paris, 2016.

Pastoureau, Michel. "Un brève histoire de l'orangé en Occident." In *Roux: L'obsession de la rousseur, de Jean-Jacques Henner à Sonia Rykel*.

Exhibition catalog, Musée Henner, 10–35. Paris, 2019.

Silverman, Debora. *Van Gogh and Gauguin: The Search for Sacred Art*. New York, 2000.

Spence, Jonathan D. *La Chine imaginaire: Les Chinois vus par les Occidentaux de Marco Polo à nos jours*. Montreal, 2001.

Tournier, Maurice. "Le *jaunes*: Un mot-fantasme à la fin du 19e siècle. *Mots* 8 (March 1984): 125–46.

Turrel, Denise. "Le safrané au XVIᵉ siècle: La couleur du mépris." In *Vert et orange: Deux couleurs à travers l'histoire*, edited by J. Grévy et al., 67–88. Limoges, 2013.

ACKNOWLEDGMENTS

Before taking the form of a book, this history of the color yellow in European societies constituted—as did those of blue, black, green, and red—the subject of my teaching and my seminars at the École Pratique des Hautes Études, the École des Hautes Études en Sciences Sociales, and the École des Chartes. I thank all my students and class auditors for the fruitful exchanges we had for over almost forty years.

I would also like to thank all those close to me—friends, relatives, colleagues, students—whose advice, comments, and suggestions I have benefited from, in particular: Thalia Brero, Brigitte Buettner, Pierre Bureau, Perrine Canavaggio, Yvonne Cazal, Marie Clauteaux, Claude Coupry, Eliane Hartmann, François Jacquesson, Philippe Junod, Christine Lapostolle, Christian de Mérindol, Maurice Olender, Anne Ritz-Guilbert, Jean-Claude Schmitt, and Olga Vassilieva-Codognet.

Thanks as well to Éditions du Seuil, especially to the whole Beaux Livres team, Nathalie Beaux, Caroline Fuchs, and also Karine Benzaquin, Elisabetta Trevisan, to iconographer Marie-Anne Méhay, to graphic designer François-Xavier Delarue, to proofreaders Renaud Bezombes and Silvain Chupin, to producer Carine Ruault, and to my publishing assistants, Maud Boulard, Marie-Claire Chalvet, and Laetitia Correia. Everyone has worked to make the present volume a very beautiful one that, like its predecessors, will be available to a wide readership.

Finally, I offer a particularly warm and grateful thanks to my friend Claudia Rabel, who once again has made me the beneficiary of her constructive criticism and efficacious rereadings.

Mark Rothko

Untitled, 1952.
Dallas, Museum of Art.